A SOURCE BOOK

TATTOO HISTORY

STEVE GILBERT

The Marshall Islands ©2000 by Dirk H. R. Spennemann, The Arctic ©2000 by Lars Krutak, Polynesia Today ©2000 Tricia Allen Current Events ©2000 by Don Ed Hardy

Selections from **Tattoo History: A Source Book** can be seen on websites
www.tattoos.com or **www.junobooks.com**

NB: Every effort has been made to contact and obtain permission from owners of copyrighted material quoted in this anthology. In case of oversight please contact Steve Gilbert at **s.gilbert@utoronto.ca**

ISBN 1-890451-07-X
Published in the USA by Juno Books, LLC
A. Juno: Editor-in-Chief

Library of Congress Cataloging-in-Publication Data
Gilbert, Steve.
 Tattoo history: a source book / by Steve Gilbert.
 p. cm.
 ISBN 1-890451-07-X -- ISBN 1-890451-06-1 (pbk.)
 1. Tattooing--History. I. Title.

GN419.3 .G56 2000
391.6'5--dc21

 00-058967

Design: Yuko Uchikawa
Printed in Hong Kong by Colorcraft Ltd

Editorial address for Juno Books and RE/Search Publications:
Juno Books, 111 Third Avenue, Suite 11G, New York, NY 10003
Tel: 212-388-9924, Fax: 212-388-1151, email: ajuno@junobooks.com

For a CATALOG send 6 stamps to:
Juno Books/powerHouse Books
180 Varick Street, Suite 1302, New York, NY 10014-4606
www.JunoBooks.com/www.powerHouseBooks.com

US Bookstore Distribution: Publishers Group West
1700 Fourth Street, Berkeley, CA 94710
Toll free: 800 788 3123, Fax: 510 528 3444

U.K. Distribution: Turnaround
Unit 3, Olympia Trading Estate, Coburg Road
London N22 6TZ, United Kingdom
tel: 0181 829 3000, fax: 0181 881 5088,
e-mail: sales@turnaround-uk.com

Italy Distribution: Logos Art srl
Via Curtatona 5/f
41100 Modena Loc. Fossalta, Italy
tel: 059 41 87 11, fax: 059 28 16 87,
e-mail: logos@books.it

Benelux Distribution: Nilsson & Lamm
Pampuslaan 212, Postbus 195
1380 AD Weesp, The Netherlands
tel: 02 94 494949, fax: 02 94 494455.
e-mail: g.boor@nilsson-lamm.nl

10 9 8 7 6 5 4 3 2 1

A SOURCE BOOK

TATTOO HISTORY

An anthology of historical records of
tattooing throughout the world, edited
and introduced by
STEVE GILBERT
with the collaboration of
CHERALEA GILBERT

With contributions by

KAZUO OGURI

DIRK H.R. SPENNEMANN

LARS KRUTAK

TRICIA ALLEN and

DON ED HARDY

Many individuals have helped me during the writing of this book. I would like to thank my wife, Cheralea. She endured me, encouraged me, edited the manuscript, and offered helpful suggestions; Christopher Gotch wrote me many wonderful letters about tattooing; Stu Kay gave me my first job in a tattoo studio and promoted my hand-poking projects; editors Chris Pfouts, Pat Reshen and Jonathan Shaw published selections from *Tattoo History Source Book* in the magazine *International Tattoo Art*; Debbie Ullman designed outstanding page layouts for those articles; Heide Heim, published parts of the book in *TätowierMagazin*; Anna Roosen-Runge retyped parts of the manuscript and located hard-to-find photos of tattooed circus performers; Damian McGrath of tattoos.com enthusiastically produced and promoted *Tattoo History Source Book* on the web; Jane Arnell's production and design skills were invaluable in creating the website; Kathy Body drew a title page illustration; Dave Mazierski, scanned the illustrations and made the Mac do its tricks; John Woram contributed the Prince Giolo broadsheet and other illustrations; Richard Hill sent the photo of preserved and tattooed skin; Anthropologists Dirk H. R. Spennemann and Lars Krutak contributed original chapters; tattoo artists Tricia Allen, Chuck Eldridge, Don Ed Hardy, Lyle Tuttle and Kazuo Oguri generously consented to be interviewed and contributed invaluable photos and drawings.

STEVE GILBERT

Contents

Introduction

TATTOO HISTORY: A SOURCE BOOK is an anthology of historical writings about tattooing in various parts of the world from the seventeenth century to the present. Among the authors are explorers, journalists, physicians, anthropologists, scholars, novelists, criminologists and tattoo artists. Each author reflects the views of his or her time and place, and some of the selections may therefore seem patronizing and prejudiced if judged by contemporary standards.

But before we laugh too loudly at the opinions of our ancestors, it might be well for us to consider the possibility that at some time in the future our own views will seem dated to our descendants. In the words of Thomas Henry Huxley: "It is easy to sneer at our ancestors, but it is much more profitable to try to discover why they, who were really not one whit less sensible persons than our excellent selves, should have been led to entertain views which strike us as absurd."

I have introduced most of these selections with a brief essay which will set the piece in historical context, but I do so with the caveat that I am approaching the subject matter from the layman's point of view. I am not an art critic, a historian or an academic, and I do not presume to pass judgment on the historical quotations or on the artistic merits of the tattoo designs reproduced in these pages.

The quotations I have selected are but small fractions of what has been written about tattooing, and are presented not as a comprehensive survey, but as a brief and fragmentary introduction. Due to the lack of easily available published information I have not, for instance, included accounts of traditional native tattooing as practiced today in South America, India, Russia, Africa or most Arab countries. Nor have I considered the many scholarly publications by contemporary anthropologists, and sociologists who have treated the social, individual and evolutionary significance of tattooing in various cultures. I will, rather, leave these areas of research to be considered by future writers.

For the general reader, the list of references at the end of each section will provide an introduction to the extensive popular literature which has been inspired by the ancient but neglected art of tattooing.

Confessions of a Tattoo Addict

Some childhood memories remain vivid although the incidents that inspired them were apparently trivial. For me, one such incident was the first time I saw a tattoo. I was ten years old, and it was a few months after the Japanese attack on Pearl Harbor. I was sitting on the couch in the living room of our home in Portland, Oregon, with my baby-sitter and her boyfriend, who was in the Navy. He rolled up his sleeve and showed me a beautiful dragon tattooed on his arm. The red and green colors seemed to glow with a magical light. He told me that the colors would be there for the rest of his life because the tattoo artist had put them under his skin with needles. I was amazed and enchanted. It was love at first sight.

My parents didn't have tattoos, and neither did any of their friends. When I told my father about my discovery, he patiently explained that only criminals, savages, and feeble-minded people had tattoos, and that they did it because they didn't have anything better to do. I said I thought tattoos were interesting anyway, and he told me that tattooing seemed interesting to me because I was a child, but that when I grew up I would change my mind. Dad meant well and he was right about a lot of things, but not about that.

By the time I was 12 my parents allowed me to go downtown by myself, and I made another wonderful discovery. There was a man named Sailor George Fosdick who had a tattoo shop near the waterfront. I longed to go in and talk to him, but I didn't because there was a sign on the door which read: "You must be 18 <u>and prove it</u> to get a tattoo." So I stood outside with my nose pressed to the window and watched. Sailor George used a machine that buzzed and gave off blue sparks. I saw blood on the arm of the man he was tattooing, and sometimes the man winced with pain. On the walls were beautiful drawings of sailing ships, anchors, roses, dragons, eagles, snakes, and naked women. The whole scene seemed at once dangerous and fascinating. The images on the wall spoke to me of travel, adventure, danger, and sex. In my impressionable young mind tattooing became indelibly associated with these things. They were forbidden but infinitely desirable.

When I was 14 my parents sent me away to a boarding school in Boston, and I discovered something else I hadn't known about. In Scollay Square there was a burlesque theater called the *Casino* where women took off their clothes and danced. The *Casino* had a sign like Sailor George's: "You must be 18...." But my friends told me not to believe it, and

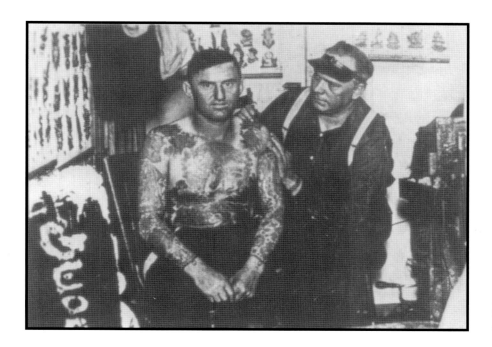

Sailor George Fosdick in his Portland, Oregon tattoo studio circa 1930. (courtesy of tattoo Archive)

I found to my surprise that the girl in the box office was happy to take my money without inquiring about my age. She even smiled and winked at me.

Near the *Casino* was a tattoo shop owned by a man named Dad Liberty. He had one of those "You must be 18" signs in his window too, but by then I was wise in the ways of the world, and one day I screwed up my courage and swaggered into Dad Liberty's shop and asked him to tattoo a little number 13 on my leg. He matter-of-factly told me to roll up my pants leg, and within a few minutes I had my first tattoo. I was hooked. The next week after the burlesque show I came back for crossed swords on the other leg.

I have traveled far through time and space since then, but Dad Liberty's tattoos are still with me, and so is the primitive fascination I felt for tattooing as a child. When I was a teenager I used to think I was something of a freak because no one else I knew had a tattoo, but as I grew older and read about the history of tattooing I discovered that I was not alone. Tattooing in some form has been practiced in most parts of the world since the Stone Age, and has been described by a great variety of authors from ancient times to the present day.

For many years it has been my pleasure to discover historical records of tattooing as it has been practiced in many times and places throughout the world, and in the pages which follow I have quoted some of these accounts. I have introduced most of these selections with a few pages of background information which will serve to place them in context and provide some scenery against which the drama can be played, for tattooing has never existed in a vacuum. It has always played an important role in the social life of those who practiced it, and throughout history it has appeared in many guises: as a distinguishing mark of royalty; a symbol of religious devotion; a decoration for bravery in battle; a sexual lure; a pledge of love; a symbol of group identification; a sign of individuality; a punishment; and a means of marking and identifying slaves, outcasts and convicts. But behind these many uses of tattooing there lurks a mystery. Why tattoo? All of these roles could have been filled by other means. There seems to be another motive beneath the surface: a primitive, profound and inexplicable fascination with the process of puncturing the skin, letting blood, and consenting to change the body for life. This mystery has been touched on by many of the authors whose work is included here, but it remains a mystery: something that is sensed intuitively, but defies rational explanation.

—Steve Gilbert, Toronto 2000.

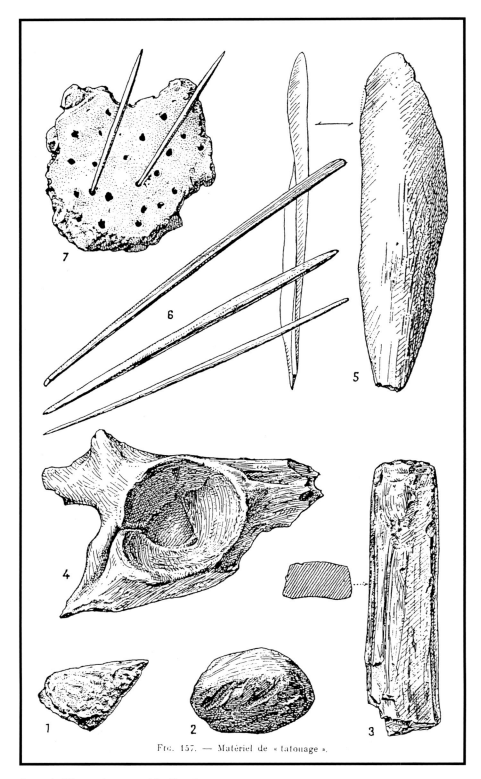

FIG. 157. — Matériel de « tatouage ».

Upper paleolithic tattoo instruments. (after Péquart)

ANCIENT HISTORY

In October 1991, a five thousand year old tattooed man made the headlines of newspapers all over the world when his frozen body was discovered on a mountain between Austria and Italy. He had apparently been hunting and was caught in a snowstorm as he tried to return home. Together with the body were clothing, a bow and arrows, a bronze ax, and flint for making fire.

"I don't like superlatives," said Professor Konrad Spindler of Innsbruck University, "but this is the only body of a Bronze Age man found in a glacier and certainly the best preserved corpse of that period ever found."[1]

The skin is of great interest because it bears several tattoos: a cross on the inside of the left knee, six straight lines 15 centimeters long above the kidneys and numerous parallel lines on the ankles. Spindler stated that the position of the tattoo marks suggests that they were probably applied for therapeutic reasons. (see also Chapter 19)

Instruments that were probably used for tattooing during the Upper Paleolithic (10,000 BC to 38,000 BC) have been discovered at several archaeological sites in Europe. Typically these instruments consist of a disk made of clay and red ochre together with sharp bone needles that are inserted into holes in the top of the disk. The disk served as reservoir and source of pigment, and the needles were used to pierce the skin. Clay and stone figurines with engraved designs, which probably represent tattooing, have been found together with such instruments.[2]

Tattooed mummies have been found in many other parts of the world. One of the best preserved of these mummies is Amunet, who in life was a priestess of the goddess Hathor at Thebes during Dynasty XI (2160-1994 BC). As principal representative of all other Egyptian goddesses, Hathor symbolized the cosmic mother who gave birth to all life on earth. Throughout Egypt, temples were erected and festivals were held in her honor. The most important of these was the festival celebrating her birth, a drunken orgy that was held on New Year's Day. Amunet's mummy is well preserved and the tattooing can be clearly seen. Parallel lines are tattooed on her arms and thighs, and there is an elliptical pattern below her navel. According to Egyptian scholar Robert S. Bianchi, the tattooing has "an undeniably carnal overtone."[3]

Statuettes decorated with designs like those found on Amunet and other mummies have been discovered in many Egyptian tombs. Egyptologists believe that these designs are symbols of fertility and rejuvenation. The statuettes, called "brides of the dead," were buried with male mummies and were supposed to arouse the sexual instincts of the deceased and to ensure his resurrection.

All of the tattooed Egyptian mummies discovered to date are female. Can we conclude that in ancient Egypt only females were tattooed? Probably not. Designs that apparently represent tattoos are seen on paintings of both men and women in Egyptian art and statues of Egyptian kings who reigned toward the end of the New Kingdom are engraved with hieroglyphs and images of Egyptian gods that probably represent tattooing.

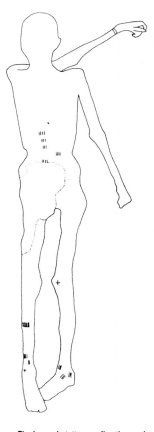

The Iceman's tattoos: a five thousand year old tattooed mummy. (From Konrad Spindler's *The Man in the Ice*. Copyright 1994 by Weidenfeld and Nicolson, and reproduced by kind permission of the publisher)

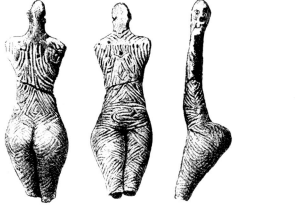
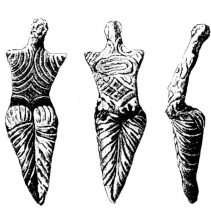

Stone age figurines engraved with geometrical designs. (after Butureanu)

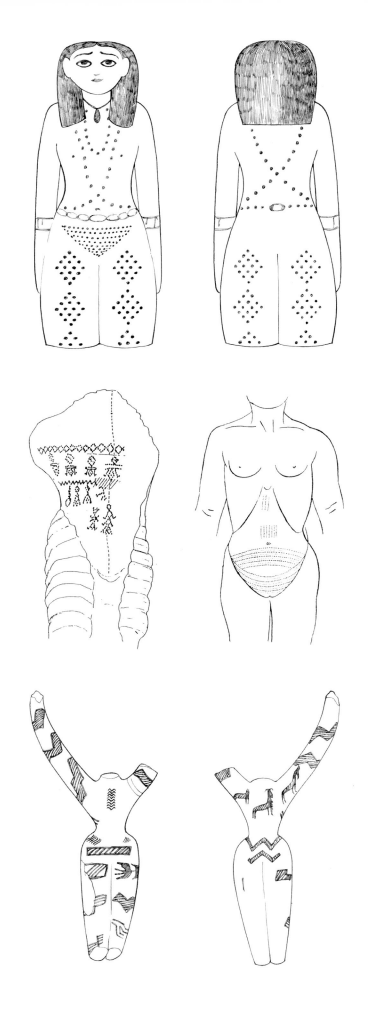

Top: A bride of the dead. (after Keimer)

Middle:
Left: Tattoos on the mummy Amunet. (after Keimer)
Right: Tattoos on a female Nubian mummy dating from the fourth century BC resemble those found on Egyptian mummies dating from 2,000 BC. (after Vila)

Bottom: An Egyptian female figurine (circa 3,000 BC) bears marks thought to represent tattooing. (after Hambly)

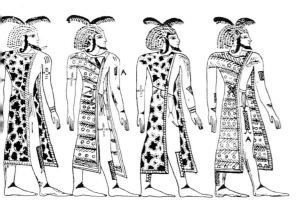

There is no known word for tattooing in ancient Egyptian. However, a line in the papyrus Bremer-Rhind reads: "Their name is inscribed into their arms as Isis and Nephthys..." The hieroglyph *mentenu* that is here translated as "inscribed", has a very general meaning that may also be translated as "etched" or "engraved". This may be a reference to tattooing. However, one female Egyptian mummy has both tattoos and ornamental scars, so *mentenu* may also refer to scarring, branding, or cutting a design with a knife.[4]

In Libya, both male and female tattooed mummies have been discovered. Some male mummies bear tattooed images relating to sun worship, and other male mummies, discovered in the tomb of Seti I dating from about 1300 BC, were tattooed with pictographs symbolizing Neith, a fierce goddess who led warriors into battle.

The earliest known tattoo that is a picture of something, rather than an abstract pattern, represents the god Bes. In Egyptian mythology Bes is the lascivious god of revelry. In addition to his duties as master of ceremonies at orgies, Bes served as the patron god of dancing girls and musicians. Bes is portrayed in many Egyptian works of art as an ugly ape-like dwarf wearing an animal skin. This image is found on steles and vases, while on amulets he is often represented as a phallus. When hung at the head of a bed, these amulets were supposed to ward off evil spirits. Bes's image appears as a tattoo on the thighs of dancers and musicians in many Egyptian paintings, and Bes tattoos have been found on female Nubian mummies dating from about 400 BC.[5]

Bes tattoos. (after Keimer)

Tattooed mummies have also been discovered in South America. In 1920, archaeologists in Peru unearthed tattooed Inca mummies dating from the Eleventh Century AD. In the absence of written records, little is known of the significance of this tattooing within the culture of the Incas, but the elaborate nature of the designs suggests that Inca tattooing underwent a long period of development during the pre-Inca period.[6]

In 1948, the Russian anthropologist, Sergei Ivanovich Rudenko, discovered an elaborately tattooed mummy when he was supervising the excavation of a group of Pazyryk tombs about 120 miles north of the border between China and Russia. The Pazyryks were formidable Iron Age horsemen and warriors who inhabited the steppes of Eastern Europe and Western Asia from the sixth through the second centuries BC. They left no written records, but Pazyryk artifacts demonstrate a sophisticated level of artistry and craftsmanship.

The Pazyryk tombs discovered by Rudenko were in an almost perfect state of preservation. They contained skeletons and intact bodies of horses and embalmed humans, together with a wealth of artifacts including saddles, riding gear, a carriage, rugs, clothing, jewelry, musical instruments,

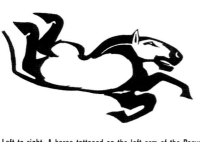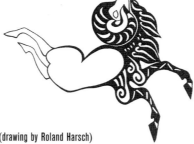

Left to right: A horse tattooed on the left arm of the Pazyryk chief. (drawing by Roland Harsch)
A mountain ram tattooed on the right arm of the Pazyryk chief. (after Rudenko)
A fantastic monster tattooed on the right arm of the Paztryk chief. (after Rudenko)

Fantastic monsters tattooed on the right and left arms of the Pazyryk chief. (after Rudenko)

amulets, tools, and—interestingly—hash pipes! (described by Rudenko as "apparatus for inhaling hemp smoke"). Also found in the tombs were fabrics from Persia and China, which the Pazyryks must have obtained on journeys covering thousands of miles.

Rudenko's most remarkable discovery was the body of a tattooed Pazyryk chief: a thick-set, powerfully built man who had died when he was about 50. Parts of the body had deteriorated, but much of the tattooing was still clearly visible. The chief was elaborately decorated with an interlocking series of designs representing a variety of fantastic beasts.

The best-preserved tattoos were a donkey, a mountain ram, two highly stylized deer with long antlers and an imaginary carnivore on the right arm. Two monsters resembling griffins decorate the chest, and on the left arm are three partially obliterated images that seem to represent two deer and a mountain goat.

Fish tattooed on right leg of Pazyryk Chief. (after Rudenko)

On the front of the right leg, a fish extends from the foot to the knee. A monster crawls over the right foot, and on the inside of the shin is a series of four running rams that touch each other to form a single design. The left leg also bears tattoos, but these designs could not be clearly distinguished. In addition, the chief's back is tattooed with a series of small circles in line with the vertebral column. This tattooing was probably done for therapeutic reasons. Contemporary Siberian tribesmen still practice tattooing of this kind to relieve back pain.[7]

In the summer of 1993, another tattooed Pazyryk mummy was discovered in Siberia's Umok plateau. It had been buried over 2,400 years ago in a casket fashioned from the hollowed-out trunk of a larch tree. On the outside of the casket were stylized images of deer and snow leopards carved in leather. Shortly after the burial, freezing rain had apparently flooded the grave and the entire contents of the burial chamber had remained frozen in permafrost.

The body was that of a young woman whose arms had been tattooed with designs representing mythical creatures similar to those on the previously discovered Pazyryk mummy. She was clad in a voluminous white silk dress, a long crimson woolen skirt and white felt stockings. On her head was an elaborate headdress made of hair and felt— the first of its kind ever found intact. Also discovered in the burial chamber was a variety of artifacts among which were gilded ornaments, dishes, a brush, a pot containing marijuana, and a hand mirror of polished metal on the wooden back of which was a carving of a deer. Six horses wearing elaborate harnesses had been sacrificed and lay on the logs that formed the roof of the burial chamber.

"We wouldn't be as happy if we had found solid gold," said Natalya Polosmak, the Russian archaeologist who discovered the tomb. "These are everyday things. Through them we see life as it was."[8]

Tattooing is mentioned by a remarkable number of Greek and Roman writers including Herodotus, Plutarch, Plato, Galen, Seneca, Petronius, Aristophanes, Dioscorides, Pliny the Elder, and a host of others. Respectable Greeks and Romans did not indulge in decorative tattooing, which they associated with barbarians. The Greeks, however, learned the technique from the Persians, and used it to mark slaves and criminals so they could be identified if they tried to escape. The Romans in turn adopted the practice from the Greeks, and in late antiquity when the Roman army consisted largely of mercenaries; they also were tattooed so that deserters could be identified.[9]

The Latin word for "tattoo" was *stigma*, and the original meaning is reflected in modern dictionaries. Among the definitions of "stigma" listed by Webster are "a prick with a pointed instrument,"..."a distinguishing mark...cut into the flesh of a slave or a criminal," and "a mark of disgrace or reproach."

The oldest known description of tattoo technique, together with a most remarkable formula for tattoo ink, is found in *Medicae artis principes* by the sixth century Roman physician, Aetius. He writes:

> *Stigmates* are the marks that are made on the face and other parts of the body. We see such marks on the hands of soldiers. To perform the operation they use ink made according to this formula: Egyptian pine wood (*acacia*) and especially the bark, one pound; corroded bronze, two ounces; gall, two ounces; vitriol, one ounce. Mix well and sift. Grind the corroded bronze with vinegar and mix it with the other ingredients to make a powder. Soak the powder in two parts of water and one part of leek juice and mix thoroughly. First wash the place to be tattooed with leek juice and then prick in the design with pointed needles until blood is drawn. Then rub in the ink.[10]
> (*translated by Steve Gilbert*)

Because of the disgrace associated with tattooing, Greek and Roman physicians did a brisk business in tattoo removal, and Aetius wisely anticipated the fact that many readers who had followed his directions would also be required to remove tattoos. He wrote:

> In cases where we wish to remove such tattoos, we must use the following preparations...[There follow two prescriptions, one involving lime, gypsum and sodium carbonate, the other pepper, rue and honey]. When applying, first clean the tattoos with nitre, smear them with resin of terebinth, and bandage for five days. On the sixth prick the tattoos with a pin, sponge away the blood, and then spread a little salt on the pricks, then after an interval of ten *stadioi* [presumably the time taken to travel this distance], apply the aforesaid prescription and cover it with a linen bandage. Leave on for five days, and on the sixth smear on some of the prescription with a feather. The tattoos are removed in twenty days, without great ulceration and without a scar.[11] (*translated by C.P. Jones*)

Aetius's prescription probably worked, as any corrosive preparation that causes infection and sloughing of the superficial layers of the skin will to some extent obliterate tattoo marks. Other Greek and Roman physicians had their own special formulas that must have done the job in some cases. Among the more remarkable prescriptions are: the scum on the bottom of a chamber pot mixed with "very strong vinegar" (Archigne, 97 AD); pigeon feces mixed with vinegar and applied as a poultice "for a long time" (Marcellus, 138 AD); Cantharides (popularly known as Spanish Fly - a dried beetle) mixed as a powder with sulfur, wax, and oil (Scribonius Largus 54 AD).[12]

Many Greek and Roman authors mention tattooing as punishment. A few examples:

Plato thought that individuals guilty of sacrilege should be forcibly tattooed and banished from the Republic.

Suetone reports that the degenerate and sadistic Roman Emperor, Caligula, amused himself by capriciously ordering members of his court to be tattooed.

According to the historian, Zonare, the Greek emperor, Theophilus, took revenge on two monks who had publicly criticized him by having eleven verses of obscene iambic pentameter tattooed on their foreheads.[13]

Greek and Roman historians reported that Britons, Iberians, Gauls, Goths, Teutons, Picts and Scots bore tattoo marks. In the third century AD, Herod of Antioch, wrote: "The Britons incise on their bodies colored pictures of animals, of which they are very proud."[14] And in the seventh century AD, St. Isidore of Seville reported that:

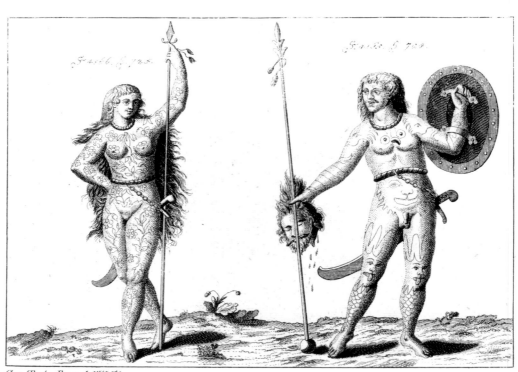

Male and female tattooed Pict warriors, as imagined by an anonymous German illustrator working after drawings by 16th century British artist John White. (after Krünitz)

Oec. Tech. Enc. LXXI Th.

> The Scots derive their name in their own language from their painted bodies, because these are marked with various designs by being pricked with iron needles with ink on them...and the Picts also are thus named because of the absurd marks produced on their bodies by craftsmen with tiny pinpricks and juice extracted from their local grasses.[15]

German archaeologist Konrad Zimmerman discovered evidence of Thracian tattooing in over 40 painted vases dating from the fourth century AD. According to Zimmerman, most of the paintings on these vases portray the murder of Orpheus, who according to myth was inconsolable after the death of his wife, Eurydice. He thereafter avoided women and turned his amorous attentions to young men, whom he hypnotized and seduced with his music. The jilted fiancées and wives of these young men took revenge by hacking Orpheus to pieces with a remarkable variety of instruments, which Zimmerman has painstakingly identified in various vase paintings as shortswords, scythes, lances, double-bladed axes, skewers, pestles, and rocks! According to myth, Thracian women were tattooed to commemorate their victory over Orpheus, and we may speculate that these tattoos also served to

remind Thracian husbands what fate awaited them if they proved unfaithful![16]

As Christianity spread throughout the Roman Empire, the tattooing of slaves and criminals was gradually abandoned. The Roman Emperor Constantine, who declared Christianity the official religion of the Empire in 325 AD, decreed that a man who had been condemned to fight as a gladiator or to work in the mines should be tattooed on the legs or the hands, but not on the face, "so that the face, which has been formed in the image of the divine beauty, should be defiled as little as possible."[17] In 787 AD Pope Hadrian I forbade tattooing of any kind, and the popes who followed him continued in the same tradition. It is for this reason that tattooing was virtually unknown in the Christian world until the 19th century.[18]

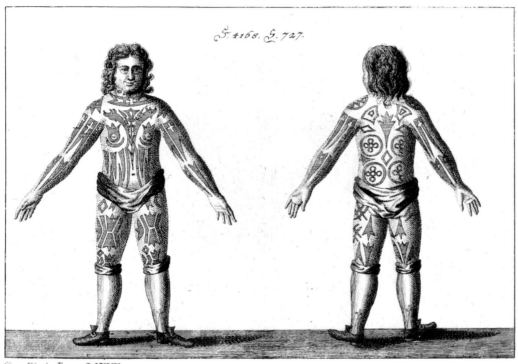

Tattooed barbarians, as imagined by an anonymous 19th century German illustrator. (after Krünitz)

What can we conclude from this fragmentary evidence of tattooing in the ancient world? It is apparent that tattooing was widely practiced and in some cultures, at least, must have been associated with a high level of artistic endeavor. The imagery of ancient tattooing is, in many ways, similar to that of modern tattooing. Throughout history, tattooing, like other forms of body decoration, has been related to the sensual, erotic, and emotional aspects of the psyche. Inca tattooing is characterized by bold abstract patterns that resemble contemporary tribal tattoo designs. All of the known Pazyryk tattoos are images of animals. Animals are the most frequent subject matter of tattooing in many cultures and are traditionally associated with magic, totems, and the desire of the tattooed person to become identified with the spirit of the animal. Thus it seems that tattooing in the ancient world had much in common with modern tattooing, and that tattooing the world over has profound and universal psychic origins.

The following selection is taken from "Remarques sur le Tatouage dans l'Egypte Ancienne" by Ludwig Keimer in *Memoires de l'Institut d'Egypte.* 1948, v. 53.

AMUNET

Although there is no proof that tattooing was practiced in Egypt during the Ancient Empire, we do have evidence that it was prevalent during the Middle Empire. Tattoos have been found on mummies of dancers and royal concubines who lived during the Middle Empire.

In the words of Locard: "Art critics and historians have systematically neglected one of the most interesting aspects of their discipline: the tattoo. It is the only form of art which has for its substratum living tissue, and is therefore the most noble art of all." In speaking of feminine fashions and amorous poetry of the ancient Egyptians, the great Gaston Maspero has expressed somewhat the same idea: "It is almost a paradox to speak of fashion and feminine coquetry among the ancient Egyptians. But spend a quarter of an hour in our Cairo Museum and contemplate the mummies that are to be seen there. Observe the emaciated limbs, the wrinkled skin, the grimacing faces, and imagine that these were once living beings who felt the same joys and sorrows which we feel, who dressed themselves with care and flirted with each other. Or consider such a mummy as that of Turin, a bundle of dried bones covered with shriveled brown skin, and with features contracted by embalming into a lamentable and grotesque expression, and imagine that this was once a young woman, delicate and elegant, whose subtle charm captivated the young gallants of Thebes…"

The first tattooed mummy, which is known to us, is that of Amunet, a priestess of the goddess Hathor. When the tomb of the priests of Amon of the 21st Dynasty was discovered in 1891, an excavation carried out by Grebaut in the valley of Der-el Bahri brought to light an intact tomb of the Eleventh Dynasty. In the funeral chamber there were two large rectangular wooden caskets bearing the name of Amunet, Priestess of Hathor, who was probably one of the royal concubines. One of these caskets contained a mummy in an excellent state of preservation. A study of the jewelry, which included necklaces, bracelets, and rings, will prove to be as interesting as a detailed anatomical examination of the body.

On the first of November, 1938, Mr. M. G. Brunton, curator of the Cairo Museum, allowed me to examine the tattooing found on the mummy of Amunet. Because of the danger of damage to the mummy we did not turn it over, and it is for this reason that we were not able to see all of the tattoos.

As for the sketches that I made by direct observation of the mummy, they convey only an approximate idea of the tattooing rather than a literal representation. The photographs and the sketches prove in any case that the drawing made by Dr. Fouquet of the mummy in question is inexact and incomplete.

[There follows a letter from Professor D.E. Derry, who wrote:]

"The graves containing these mummies were found by Mr. H.E. Winlock early in the year 1923 while excavating in the outer court of the Mentuhotep Temple at Deir el Bahary. They are remarkable in that both of them had been tattooed. Only one other example of a mummy exhibiting this ornamentation is known and this, a woman named Amunet from the same enclosure, is preserved in the Museum of Antiquities in Cairo. She was thought to have been a concubine of Mentuhotep II. The two women who are the subject of this note are believed to have been dancing girls attached to the court.

"Besides the designs tattooed on the arms, legs, and dorsum of the feet, both of the women have the same design tattooed across the abdominal wall in the suprapubic region about the level of the anterior superior iliac spines.

"The object of the present note is to draw attention to a remarkable cicatrix which extends across the abdomen between the anterior superior spines just above the line of tattooing referred to in the last paragraph. The incision, however produced, whether by knife or cautery only affected the skin and did not invade the muscles of the abdominal wall, which are intact. It

is evident that the wound healed slowly by granulation, as the line of union of the stretched and altered skin on either side of the cicatrix is very distinct and characteristic of this mode of healing. Sections taken by Dr. Aziz Girgis across the cicatrix and prepared by Ruffer's method to restore as far as possible the original condition of the tissues for the purpose of microscopical examination, showed very well the unbroken lines of the deeper structures of the wall of the abdomen and the thick connective tissue forming the scar. This was confirmed by Dr. Omar. The cicatrix is continued on both sides to the crest of the ilium which it crosses and terminates just below the highest point of the crest; over the upper part of the gluteal region in large leaf-shaped scars measuring in the case of no. 26 about 5.0 x 3.5 cm. In no. 23 the level of termination is slightly different on the two sides being just above the crest on the left side and just below on the right.

"The explanation of these incisions is perhaps to be found in the suggestion that those were dancing women and associated as the scars are with tattooing gives weight to this idea. Skin incisions are common among some of the tribes of the Sudan either as a curative measure when blood is drawn or purely as a decoration and in the latter case abdominal incisions, particularly among women, are common. In this connection it should be noted that no. 26 exhibits on the right side of the gluteal region a series of small scarifications such as are seen in many of the inhabitants both of Nubia and the Sudan on the face and other parts of the body. The Sudanese women who are thus decorated are either nude or wear only a short skirt that leaves the front of the abdomen exposed. The women which form the subject of this note probably danced without clothes of any sort."

The two mummies [described by Professor Derry] are tattooed on the arms, the chest, the suprapubic region, the legs, and the feet. The tattoo motifs are exactly the same for the two mummies and consist of lozenges composed of sixteen points. Many of these lozenges form groups, and we will see later that these same tattoo motifs are found on many ancient Egyptian figurines representing women. (*translated by Steve Gilbert*) ∎

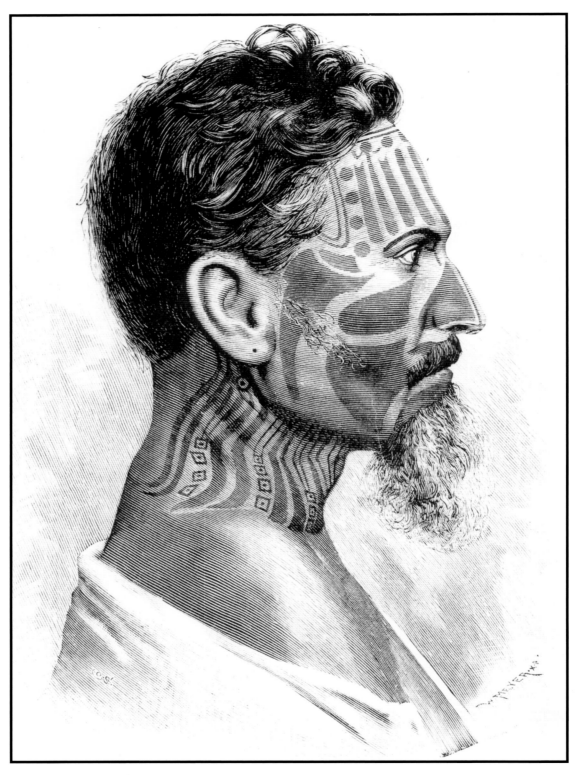

Easter Island facial tattoo. (after Stolpe)

POLYNESIA

It was not until the latter part of the 19th century that western anthropologists made an effort to inquire into the significance of tattooing within the context of traditional Polynesian life. A few papers on Polynesian tattooing appeared in anthropology journals around the turn of the century, and about the same time several anthropologists wrote books that included descriptions of Polynesian tattooing. Unfortunately, however, what we know of Polynesian tattooing is only a small fragment of the whole. The vast majority of the designs, together with the wealth of associated traditions, myths, and religious observances have been lost forever. And we know little of the significance of tattooing as it was perceived by the Polynesians themselves; we know it only as it was seen through European eyes.

BY TRICIA ALLEN AND STEVE GILBERT

Polynesian tattooing, as it existed before the arrival of Europeans in the South Pacific, was the most intricate and skillful tattooing in the ancient world. It had evolved over thousands of years throughout the islands of the Pacific and, in its most highly developed forms, was characterized by elaborate geometrical designs which were often added to, renewed, and embellished throughout the life of the individual until they covered the entire body. In beauty and complexity, ancient Polynesian tattooing rivals the best work of modern masters of the art.

Where did it come from? And why was it so highly developed in Polynesia? For the answers to these questions we must look to the geography of the Pacific islands and to the history and culture of their inhabitants. The tropical islands of the Pacific were characterized by lofty volcanic peaks, wide valleys, fertile soil, lush vegetation and secluded coral lagoons teeming with brightly colored fish. The natives were isolated and protected from natural enemies, predators and disease. To many early European explorers the Polynesians seemed to be the prototype of the mythical noble savage living in a state of innocence. In *Typee,* Herman Melville wrote of the Marquesans:

> In beauty of form they surpassed anything I had ever seen.... Nearly every individual of their number might have been taken for a sculptor's model.... I have seen boys in the Typee Valley of whose "beautiful faces" and "promising animation of countenance" no one who has not beheld them can form any adequate idea. Cook, in the account of his voyages, pronounces the Marquesans as by far the most splendid islanders in the South Seas. Stewart, the chaplain of the U.S. ship Vincennes, in his "Scenes in the South Seas", expresses in more than one place, his amazement at the surpassing loveliness of the women; and says that many of the Nukuheva damsels reminded him forcibly of the most celebrated beauties in his own land.[1]

Unlike the inhabitants of many other parts of the world, Polynesians did not spend their days struggling to obtain the bare necessities of life in a hostile environment. They excelled at arts and crafts. Everything they made was decorated: canoes, bowls, war clubs and tools. Even their bodies were punctured with elaborate designs. Tattooing was a natural part of their life and art; they had the time, the temperament, and the skill to pursue it and bring it to a high degree of perfection.

European seafarers who visited the Pacific during the 18th and 19th centuries recognized the fact that the inhabitants of the islands must have had a common origin. They spoke related languages, were of similar appearance, and shared many cultural traits. But where did they come from, and how did they navigate the thousands of miles of uncharted ocean between the islands? For over two hundred years, academics and popular writers concocted a bewildering variety of theories to answer these questions. Only within the last three decades has the accumulated evidence of discoveries in archaeology, linguistics, physical anthropology and botany made it possible to piece together an accurate picture of the migrations of the ancestors of the Polynesians, who originated in Southeast

Lapita pottery motifs.
From *The Prehistory of Polynesia*,
edited by Jesse D. Jennings.
Copyright 1979.
Reproduced by kind permission
of the publisher, Harvard
University Press

Asia and gradually populated the islands of Northern Melanesia, moving on to New Guinea about 50,000 years ago. A few of the larger islands adjacent to New Guinea were settled significantly later, approximately 11,000 years ago. By 3,000 BC, the inhabitants of these islands had developed agriculture, fishing techniques, and sophisticated watercraft capable of long ocean voyages. Within a span of only 300-400 years, these ancient voyagers, (often called *Lapita* peoples after a type of pottery they produced) successfully colonized the majority of the islands in Melanesia: the Solomons, Hebrides, Fiji, Tonga and Samoa. By 1200 BC, a Proto-Polynesian culture was beginning to develop in Fiji, Samoa and Tonga. Here, over a period of some thousand years, the Polynesian language, culture and art evolved. Not long before the time of Christ these early Polynesians embarked on an unprecedented feat of navigation, voyaging over thousands of miles to discover islands that lay far beyond the horizon. Between 200 and 600 AD they sailed east, establishing settlements in Tahiti, the Marquesas, Easter Island, Hawaii, and most of the approximately 100 smaller habitable islands of the Pacific. About 1,000 AD, they settled in New Zealand, the largest and southernmost of the Polynesian islands.[2]

As they made their way across the Pacific, they left a record of their travels in the form of pottery and other artifacts. The pottery, which was characterized by fine craftsmanship and a refined sense of proportion, was produced from about 1500 BC to the time of Christ, and has been discovered at many archaeological sites throughout Melanesia to Tonga and Samoa. This pottery provides evidence of the existence of the widespread Lapita culture, ancestor to the later Polynesian cultures.

Lapita pottery is of special interest for the history of tattooing because it provides us with the oldest evidence as to the nature of the ancient Polynesian tattoo designs. Much Lapita pottery bore incised decorations consisting of V-shaped elements, interlocking geometrical patterns, and stylized motifs resembling masks and sea creatures. Similar motifs are found in tattoo designs throughout Polynesia, and even the technique of incising the designs as a series of closely spaced punctures or stipples suggests that the technique used in the decoration of pottery was similar to that used in tattooing.[3]

Figurines decorated with similar designs have been found together with tattooing instruments at many Lapita archaeological sites. The instruments, some of which are over 3,000 years old, consist of flat, chisel-shaped pieces of bone measuring two to four centimeters in length and filed sharp at one end to form a comb-like series of pointed teeth. Such an instrument was attached to the end of a long wooden handle. The artist dipped the instrument in a black pigment made of soot and water and executed the tattoo by striking the instrument with a small mallet. This technique, which is not found in any other part of the world, was common throughout the Pacific and is still used today by traditional tattoo artists in Samoa.[4]

Although the production of Lapita pottery had ceased by the time of Christ, the art of tattooing became more and more sophisticated. According to ancient legends, versions of which have been recorded in Fiji, Tonga and Samoa, two female tattooists brought the art of tattooing from Fiji to Tonga and Samoa. They embarked from Fiji chanting "women alone are tattooed, but not the men," but in the course of their voyage they encountered a variety of misadventures ranging from stubbed toes to encounters with hurricanes and giant man-eating clams. By the time they arrived in Tonga, they had become confused and were chanting, "only men are tattooed, but not the women.[5]

It was in Tonga and Samoa that the Polynesian tattoo developed into a highly refined art. Tongan warriors were tattooed from the waist to the knees with a series of geometrical patterns, consisting of repeated triangular motifs, bands, and areas of solid black. Priests who had undergone a long period of training and who followed strictly prescribed rituals and taboos during the process executed the tattooing. For the Tongan, the tattoo carried profound social and cultural significance.

In ancient Samoa, tattooing played an important role in both religious ritual and warfare. The

tattoo artist held a hereditary and highly privileged position. He customarily tattooed young men in groups of six to eight, during a ceremony attended by friends and relatives who participated in special prayers and celebrations associated with the tattooing ritual. The Samoan warrior's tattoo began at the waist and extended to just below the knee. Samoan women were tattooed as well, but female tattooing was limited to a series of delicate flower-like geometrical patterns on the hands and the lower part of the body.[6]

About 200 AD, voyagers from Samoa and Tonga settled in the Marquesas. Here, over a period of more than a thousand years, one of the most complex Polynesian cultures evolved. Marquesan art and architecture were highly developed, and Marquesan tattoo designs, which in many cases covered the entire body, were among the most elaborate in all of Polynesia.

By 1,000 AD the Polynesian peoples had successfully colonized most of the habitable islands east of Samoa. Distinctive cultural traits evolved in each of the Polynesian island groups, and by the time of European contact the peoples of the various islands had their own unique languages, myths, arts and unique tattoo styles.[7]

Polynesian tattooing is briefly mentioned in European ship's logs dating from the 17th and early 18th centuries, but it was not until the first voyage of Captain Cook, in 1769, that it was described in detail by Cook's naturalist, Joseph Banks, who was one of the more enlightened of the early European visitors. Tattooing was also described and illustrated by a few of the naturalists who accompanied later 18th and early 19th century explorers, but most Europeans took little interest in Polynesian art and culture. In many Pacific islands, the first European settlers were missionaries who opposed tattooing because of its association with native religious practices that they saw as superstition and sorcery. Hard on the heels of the missionaries came colonists who squabbled over possession of the islands, plundered the natural resources, and forced the natives to wear European clothing and work at menial jobs. Because tattooing was associated with the traditional Polynesian way of life, it became a symbol of resistance to European influence and was outlawed by many colonial regimes.

Ironically, as tattooing was dying out in the Pacific, it was becoming popular among westerners. Before Cook's voyages, tattooing was virtually unknown in Europe. Members of Cook's crew were the first Europeans to acquire Polynesian tattoos, and the fad spread quickly in the British Navy as sailors returned home with tattoos as souvenirs of their travels to distant lands. Sailors learned the technique from Polynesian artists, practiced it on board ship, and later retired to establish tattoo parlors in European port cities. Tattooing is the only form of Polynesian art that has been widely adopted and imitated by westerners.

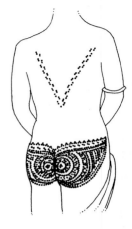

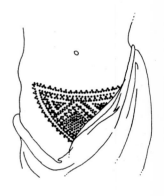

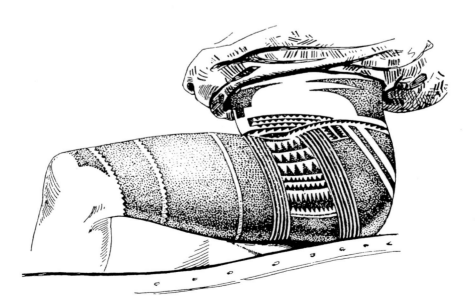

Above: Fijian female tattooing.
(after Kleischmidt)
Left: Tongan male tattoo.
(after Dumont d'Urville)

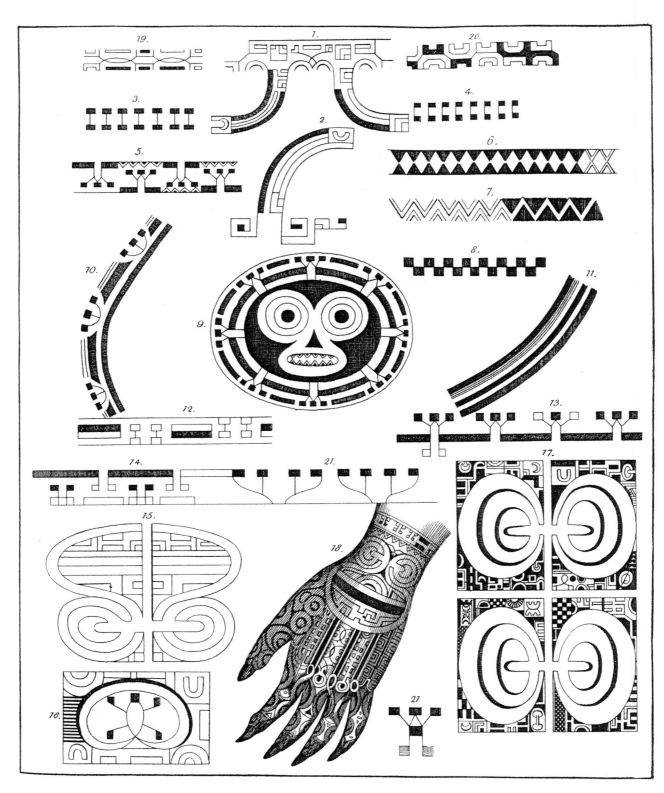

Marquesan tattoo designs. (after Langsdorff)

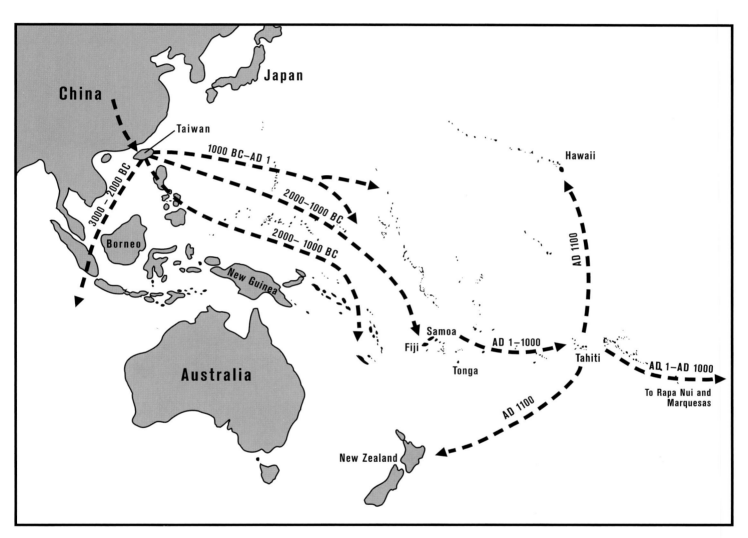

Dotted lines indicate seafaring routes followed by ancestors of modern Polynesians.
(modified after Dodd)

The following selection is taken from *Voyages and Travels in Various Parts of the World* by Georg H. von Langsdorff. London, 1813.

LANGSDORFF IN THE MARQUESAS, CIRCA 1800

The most remarkable and interesting manner which the South-sea islanders have of ornamenting their naked bodies consists in punctuation, or, as they call it, tattooing. This kind of decoration, so common among many nations of the earth, merits greater attention from travelers than it has hitherto received. It is undoubtedly very striking, that nations perfectly remote from each other, who have no means of intercourse whatever, and according to what appears to us never could have had any, should yet be all agreed in this practice.

Among all the known nations of the earth, none has carried the art of tattooing to so high a degree of perfection as the inhabitants of Washington's Islands [the Marquesas]. The regular designs with which the bodies of the men of Nukuhiva are punctured from head to foot supplies in some sort the absence of clothing; for, under so warm a heaven, clothing would be insupportable to them. Many people here seek as much to obtain distinction by the symmetry and regularity with which they are tattooed, as among us by the elegant manner in which they are dressed; and although no real elevation is designated by the greater superiority of these decorations, yet as only persons of rank can afford to be at the expense attendant upon any refinement in the ornament, it does become in fact a badge of distinction.

The operation of tattooing is performed by certain persons, who gain their livelihood from it entirely, and I presume that those who perform it with the greatest dexterity, and evince the greatest degree of taste in the disposition of the ornaments, are as much sought after as among us a particularly good tailor. This much, however, must be said, that the choice made is not a matter of equal indifference with them as it is with us; for if the punctured garment be spoiled in the making, the mischief is irreparable, and it must be worn with all its faults the whole life through.

While we were at the Island, a son of the chief Katanuah was to be tattooed. For this purpose, as belonging to the principal person in the island, he was put into a separate house for several weeks which was tabooed; that is to say, it was forbidden to everybody except those who were exempted from the taboo by his father, to approach the house; here he was to remain during the whole time that the operation continued. All women, even the mother, are prohibited from seeing the youth while the taboo remains in force. Both the operator and the operatee are fed with the very best food during the continuance of the operation: to the former these are days of great festivity. In the first year only the ground-work of the principal figures upon the breast, arms, back and thighs is laid; and in doing this, the first punctures must be entirely healed, and the crust must have come off before new ones are made.

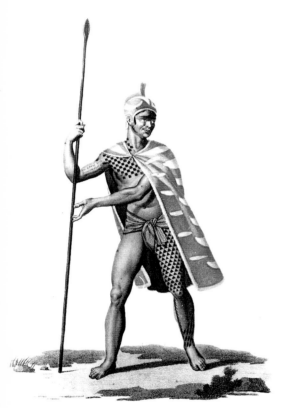

A Hawaiian Chief. (after de Freycinet)

Every single mark takes three or four days to heal; and the first sitting, as it may be called, commonly takes three or four weeks. When once the decorations are begun, some addition is constantly made to them at intervals of from three to six months, and this is not infrequently continued for thirty or forty years before the whole tattooing is complete.

The tattooing of persons in a middling station is performed in houses erected for the purpose by the tattooers, and tabooed by authority. A tattooer, who visited us several times on board the ship, had three of these houses, which could each receive eight or ten persons at a time: they paid for their decorations according to the greater or less quantity of them, and to the trouble the figures required. The poor islanders, who have not a superabundance of hogs to dispose of in luxuries, but live chiefly themselves upon breadfruit, are operated upon by novices in the art, who take them at a very low price as subjects for practice, but their works are easily distinguishable, even by a stranger, from those of an experienced artist. The lowest class of all,

the fishermen principally, but few of whom we saw, are often not able to afford even the pay required by a novice, and are therefore not tattooed at all.

The women of Nukuhiva are very little tattooed, differing in this respect from the females of the other South-Sea islands. The hands are punctured from the ends of the fingers to the wrist, which gives them the appearance of wearing gloves, and our glovers might well borrow from them the patterns, and introduce a new fashion among the ladies, of gloves worked à la Washington. The feet, which among many are tattooed, look like highly ornamented half-boots; long stripes are besides sometimes to be seen down the arms of the women, and circles round them, which have much the same effect as the bracelets worn by many European ladies. Some have also their ears and lips tattooed. The women are not, like the men, shut up in a tabooed house while they are going through this operation: it is performed without any ceremony in their own houses, or in those of their relations.

The figures with which the body is tattooed are chosen with great care, and appropriate ornaments are selected for the different parts. They consist partly of animals, partly of other objects that have some reference to the manners and customs of the islands; and every figure has here, as in the Friendly Islands [Tonga], its particular name. Upon an accurate examination, curved lines, diamonds, and other designs, are often distinguishable between rows of punctures, which resemble very much the ornaments called à la Grecque. The most perfect symmetry is observed over the whole body; the head of a man is tattooed in every part; the breast is commonly ornamented with a figure resembling a shield; on the arms and thighs are stripes, sometimes broader, sometimes narrower, in such directions that these people might very well be presumed to have studied anatomy, and to be acquainted with the course and dimensions of the muscles. Upon the back is a large cross, which begins at the neck, and ends with the last vertebra. In the front of the thigh are often figures, which seem intended to represent the human face. On each side of the calf of the leg is an oval figure, which produces a very good effect. The whole, in short, displays much taste and discrimination. Some of the tenderest parts of the body, the eyelids, for example, are the only parts not tattooed.... ∎

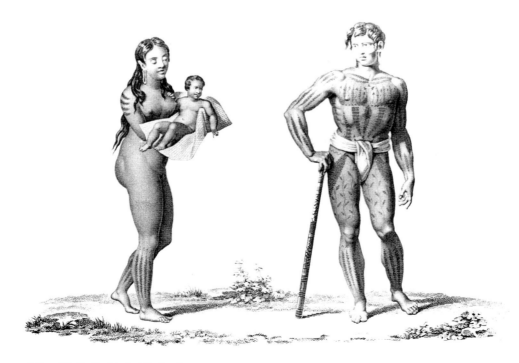

Natives of the Caroline Islands. (after Arago)

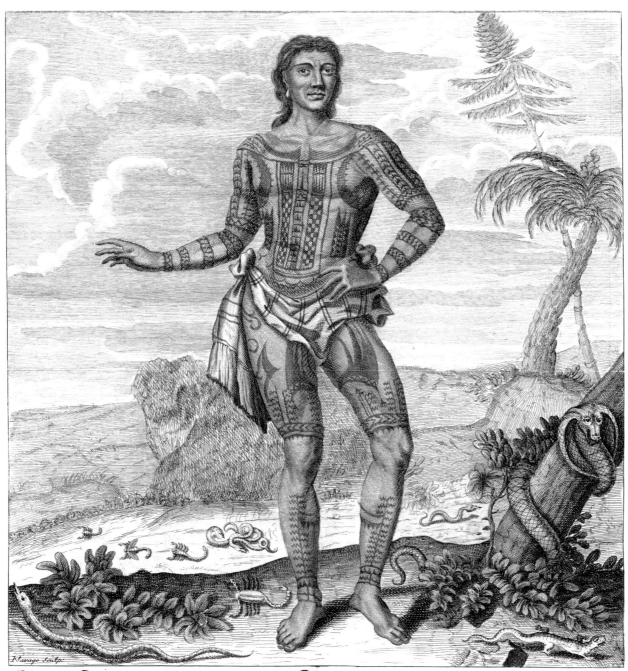

Prince Giolo Son to y̓ King of *Moangis* or *Gilolo*: lying under the *Equator* in the Long. of 152 Deg.
30 Min. a fruitful Iſland abounding with rich Spices and other valuable Commodities. This famous Painted
Prince is the juſt Wonder of y̓ Age, his whole Body (except Face Hands and Feet) is curiouſly and moſt exquiſitely Painted or ſtained
full of Variety and Invention with prodigious Art and Skill perform'd In ſo much, y̓ the ancient and noble Miſtery of Painting or
Staining upon Humane Bodies ſeems to be compriſed in this one ſtately Piece. The Pictures & thoſe other engraven Figures copied
from him & now diſperſed abroad ſerve only to deſcribe as much as they can y̓ Fore-parts of this inimitable Piece of Workmanſhip:
The more admirable Back-parts afford us a Repreſentation of one quarter part of the Sphere upon & betwixt his ſhoulders where
y̓ Arctick & Tropick Circles center in y̓ North Pole of his Neck. And all y̓ other Lines Circles & Characters are done in ſuch exact
Symmetry & Proportion, that it is aſtoniſhing & ſurmounts all y̓ has hitherto been ſeen of this kind The Paint it ſelf is ſo durable, y̓ nothing
can waſh it off, or deface y̓ beauty of it: It is prepared from y̓ Juice of a certaine Herb or Plant, peculiar to that Country, which they eſteem
infallible to preſerve humane Bodies from y̓ deadly poiſon or hurt of any venomous Creature whatſoever: & none but thoſe of y̓ Royal
Family are permitted to be thus painted w̓th it. This excellent Piece has been lately ſeen by many perſons of high Quality & accurately ſurveyed by
ſeveral learned Virtuoſi & ingenious Travellers who have expreſs'd very great ſatiſfaction in ſeeing of it. This admirable Perſon is about y̓ Age
of 30. graceful and well proportioned in all his Limbs, extreamly modeſt & civil, neat & cleanly; but his Language is not underſtood, neither
can he ſpeak Engliſh.

Sold at his Lodgings: and at the Golden-head in the Old-Baily.

An engraving of Prince Giolo published to advertise his appearance in London in 1692.
(poster courtesy John Woram)

3





3 Discovery

PRINCE GIOLO

In September of 1691, a fully tattooed South Sea Islander was brought to London to be exhibited as a curiosity. He was a slave whose owners went to great pains to promote his public appearances: they arranged to have two full-length portraits engraved and published as illustrations for an elegantly printed pamphlet which introduced him as "Giolo, the Famous Painted Prince."

Prince Giolo did not want to visit London. His owners, however, had told him that he would be handsomely paid for his public appearances and would afterward be allowed to return to his home in the Philippines. But the journey to England was arduous and Giolo, who was in poor health when he arrived, soon died of smallpox. This was a great disappointment for his ambitious English owners, who had hoped he would live long enough to make them rich.[1]

Prince Giolo had been brought to London by an adventurer and buccaneer named William Dampier, who for over 12 years had traveled up and down the coast of South America, changing allegiance from one gang of pirates to another as he thought to better his position. But the pirates with whom he traveled did not capture Spanish Galleons. Instead, their routine work consisted of the safer, if less profitable, business of robbing defenseless villages and small coastal vessels. It turned out to be much work for little money, and, after ten years of this strenuous life, Dampier signed on with a ship headed for the Philippines.[2]

It was while he was in the Philippines that Dampier first saw Giolo, whom he acquired from a ship's officer named William Moody. Dampier described his adventures in the Pacific and his meeting with Giolo in a popular travel book.

DAMPIER IN THE PHILIPPINES, 1690

While I was at Fort St. George, about April 1690, there arrived a ship called the Mindanao Merchant, laden with clove-bark from Mindanao. There was upon this ship one Mr. Moody, who had bought at Mindanao the Painted Prince Jeoly [N.B.: in his journals Dampier wrote "Jeoly"; in London the showmen spelled it "Giolo"] and his mother, and brought them to Fort St. George, where they were much admired by all that saw them.

I later entered into certain business arrangements with Mr. Moody, and one of the results of these arrangements was that Mr. Moody agreed to give me the half share of the two painted people, and leave them in my possession, and at my disposal. I accepted of the offer, and writings were immediately drawn between us.

Thus it was that I came to have this Painted Prince, whose name was Jeoly, and his mother. They were born on a small island named Meangis; I saw the island twice, and two more close by it. Each of the three seemed to be about four or five leagues round, and of a good height. Prince Jeoly told me his father was a Raja of the Island where they lived; that there were not above thirty men on the island, and about one hundred women; that he himself had five wives and eight children, and that one of his wives painted him.

He was painted all down the breast, between his shoulders behind; on his thighs (mostly) before; and in the form of several broad rings, or bracelets, round his arms and legs. I cannot liken the drawings to any figure of animals, or the like, but they were very curious, full of great variety of lines, flourishes, checkered work, etc. keeping a very graceful proportion, and appearing very artificial, even to wonder, especially that upon and between his shoulder blades. By the account he gave me of the manner of doing it, I understand that the painting was done in the same manner, as the Jerusalem Cross is made in men's arms, by pricking the skin, and rubbing in a pigment. But whereas [gun] powder is used in making the Jerusalem Cross, they at Meangis use the gum of a tree beaten to a powder called in English, Dammer, which is used instead of pitch in many parts of India. He told me that most of the men and women of the island were thus painted, and also that they all had ear rings made of gold, and gold shackles about

The following selection is

ide note:

The following selection is taken from A New Voyage Round the World (1697), by William Dampier.

ooter

inal

inal

their legs and arms.

He told me that the inhabitants of Meangis had canoes, and went fishing frequently in them; and that they often visited the other two small islands, whose inhabitants spoke the same language as they did; which was so unlike the Malayan, which he had learnt while he was a slave at Mindanao, that when his mother and he were talking together in the Meangian tongue, I could not understand a word they spoke.

He said also that the customs of those other isles, and their manner of living, was like theirs, and that they were the only people with whom they had any converse, and that one time, as he, with his father, mother, and brother, with two or three men more were going to one of these other islands, they were driven by a strong wind on the coast of Mindanao, where they were taken by the fishermen of the island, and carried to shore, and sold as slaves; they being first stripped of their gold ornaments. I did not see any of the gold that they wore, but there were great holes in their ears, by which it was manifest that they had worn some ornaments in them.

Jeoly was sold to one Michael, a Minanayan. He did often beat and abuse his painted servant to make him work, but all in vain, for neither fair means, threats nor blows would make him work, as he would have him. Yet he was very timorous, and could not endure to see any sort of weapons; and he often told me that they had no arms at Meangis, they having no enemies to fight with.

Prince Jeoly lived thus a slave at Mindanao for four or five years, till at last Mr. Moody bought him and his mother for 60 dollars, and as is before related, carried him to Fort St. George, and from thence along with me to Bencouli. Mr. Moody stayed at Bencouli about three weeks, and then went back with Captain Howel, to Indrapore, leaving Jeoly and his mother with me. They lived in a house by themselves without the Fort. I had no employment for them, but they both employed themselves. She used to make and mend their own clothes, at which she was not very expert, for they wear no clothes at Meangis, but only a cloth about their waists; and he busied himself in making a chest with four boards, and a few nails that he begged of me. It was but an ill shaped odd thing, yet he was as proud of it as if it had been the rarest piece in the world.

After some time Jeoly and his mother were both taken sick, and though I took as much care of them as if they had been my brother and sister, yet she died. I did what I could to comfort Jeoly, but he took on extremely, insomuch that I feared for him also. Therefore I caused a grave to be made presently, to hide her out of his sight. I had her shrouded decently in a piece of new calico, but Jeoly was not so satisfied, for he wrapt all her clothes about her, and two new pieces of chintz that Mr. Moody gave her, saying that they were his mother's, and she must have them. I would not disoblige him for fear of endangering his life; and I used all possible means to recover his health. But I found little amendment while we stayed there.

In the little printed relation that was made of him when he was shown for a sight in England, there was a romantic story of a beautiful sister of his who was a slave with them at Mindanao, and of the Sultan's falling in love with her; but these were stories indeed. They reported also that his paint was of such virtue, that serpents and venomous creatures would flee from him, for which reason, I suppose, they represented so many serpents scampering about in the printed picture that was made of him. But I never knew any paint of such virtue, and as for Jeoly, I have seen him as much afraid of snakes, scorpions, or centipedes, as myself.

I began to long after my native country, after so tedious a ramble from it, and I proposed no small advantage to myself from my painted prince, whom Mr. Moody had left entirely to my disposal, only reserving to himself his right to one half share in him. For besides what might be gained by showing him in England, I was in hopes that when I had got some money, I might there obtain what I had in vain sought for in the Indies, a ship from the merchants, wherewith to carry him back to Meangis, and re-instate him there in his own country, and by his favor and negotiation to establish a traffic for the spices and other products of those islands.

But I was no sooner arrived in the Thames, but he was sent ashore to be seen by some eminent persons, and I being in want of money, was prevailed upon to sell first, part of my share in him, and by degrees all of it (I fell amongst rooks). After this I heard he was carried about to be shown as a sight, and that he died of the smallpox at Oxford. ∎

GIOLO BROADSHEET-1692

The following text is taken from the broadsheet advertising Giolo's public appearances, published in London, 1692.

This unfortunate Prince, sailing towards a neighboring Island with his mother and a young sister, to complement the intended marriage betwixt her and the king of that island, a violent tempest surprised them and drove the vessel upon the coast of Mindanao, where they were all made prisoners, except the young lady, with whom the king was so enamored, that he took her to wife, yet suffered the Prince and his mother, Nacatara, to be purchased for money, who were soon after embarked for Europe; the mother died, but the Prince her son arrived in England.

This famous Painted Prince is the just wonder of the age, his whole body (except face, hands and feet) is curiously and most exquisitely painted or stained full of variety of invention, with prodigious art and skill performed. In so much, that the ancient and noble mystery of painting or staining upon human bodies seems to be comprised in this one stately Prince.

The pictures and those other engraven figures copied from him, and now dispersed abroad, serve only to describe as much as they can of the fore parts of this inimitable piece of workmanship; the more admirable back parts afford us a lively representation of one quarter part of the world upon and betwixt his shoulders, where the Arctic and Tropic Circles center in the North Pole on his neck. And all the other lines, circles and characters are done in such exact symmetry and proportion, that it is astonishing and surmounts all that has hitherto been seen of this kind. What wisdom and ancient learning may lie veiled under those other curious figures and mysterious characters scattered up and down his body, must be the work of very ingenious men to discover.

The paint itself is so durable, that nothing can wash it off, or deface the beauty of it: it is prepared from the juice of a certain herb or plant, peculiar to that country, which they esteem infallible to preserve human bodies from the deadly poison or hurt of any venomous creatures whatsoever. This custom they observe, that in some short time after the body is painted, the same body is carried naked, with much ceremony, to a spacious room appointed, which is filled with all sorts of the most venomous, pernicious creatures that can be found; such as snakes, scorpions, vipers, centipedes, etc. (the King himself present). The grandees and multitude of spectators seeing the naked body surrounded with so many venomous creatures, and unable to wound or do any mischief to it, seem to be transported and ready to adore him; for none but those of the Royal Family are permitted to be thus painted with it.

This excellent Prince has been lately seen by many persons of high quality, and accurately surveyed by several learned virtuosi, and ingenious travelers, who have expressed very great satisfaction in seeing of it.

This admirable person is about the age of thirty, graceful, and well proportioned in all his limbs, extremely modest and civil, neat and cleanly, but his language is not understood, neither can he speak English.

He will be exposed to public view every day (during his stay in town) from the 16th day of this instant June, at his lodgings at the Blue Boar's Head in Fleet Street, near Water Lane, where he will continue for some time, if his health will permit.

But if any persons of quality, gentlemen, or ladies, do desire to see this noble person, at their own houses, or any other convenient place, in or about this City of London, they are desired to send timely notice, and he will be ready to wait upon them in a coach or chair, any time they please to appoint, if in the daytime. ∎

Plate *XXII*.

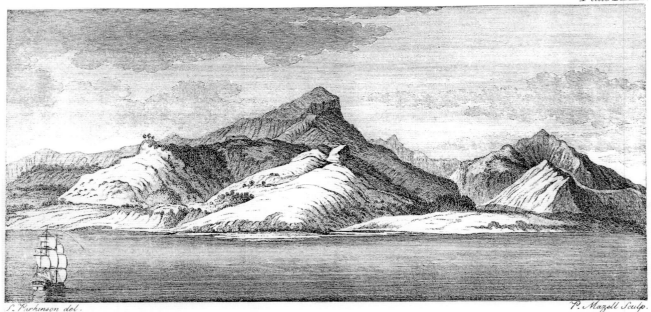

S. Parkinson del. *P. Mazell Sculp.*

View of the great Peak, & the adjacent Country, on the West Coast of New Zealand.

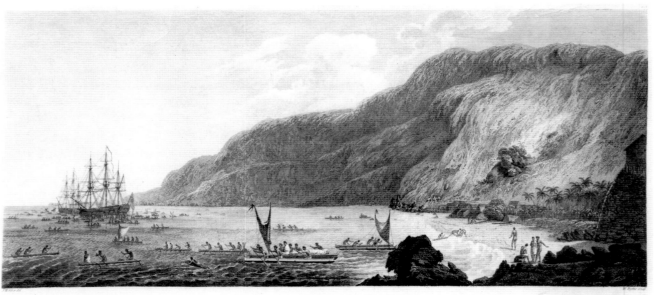

A View of KARAKAKOOA, *in* OWYHEE.

Captain Cook's ship, the *Endeavor*, standing off the west coast of
New Zealand. Engraved after a drawing by Sydney Parkinson, 1770.

Captain Cook's ships at anchor off the coast of Hawaii.
Engraved after a drawing by John Webber, 1779.

4

SIR JOSEPH BANKS

The first account of Polynesian tattooing was written by Joseph Banks, who sailed as naturalist with Captain (then Lieutenant) James Cook on his first voyage to the Pacific (1768-1771). Banks was a wealthy young man with a taste for adventure. He was also a passionate amateur naturalist who, while neglecting his studies at Eton and Oxford, began to amass an invaluable natural history collection including skeletons, insects, pressed plants, minerals and stuffed animals. This collection was ultimately acquired by the Natural History Museum of London where it may still be seen today. Banks so impressed the leading naturalists of his time that, at the age of 23, he became the youngest member of the Royal Society.

In 1767, Banks learned that the Royal Society had chosen James Cook to lead a voyage of exploration to the South Pacific. Cook, who was little known outside naval circles, was a man of working-class origins who had risen through the ranks by making a reputation for himself as an outstanding navigator and cartographer.

Cook was promoted to the rank of lieutenant and charged with two missions. The first was to sail to Tahiti, from which he was to observe the transit of Venus when it passed between the earth and the sun. It was thought that this observation would make it possible to calculate the exact distance between the earth and the sun, and that this in turn would improve the accuracy of mapmaking and navigation.

Cook's second and more important mission was to discover, if possible, a fabled Southern Continent that could provide new sources of colonial wealth. He was therefore ordered to bring back detailed descriptions of the plants, animals, minerals, and other natural resources in any lands he might visit. And for this, he needed a naturalist.

When Joseph Banks heard of the proposed voyage he energetically promoted himself for the position of naturalist. In view of his outstanding record as a collector and also, no doubt, influenced by the ten thousand pounds (a small fortune in those days) which he donated to help finance the expedition, the Royal Society was easily persuaded that Banks was the man best qualified for the post. Banks brought with him Sydney Parkinson, one of the most talented young scientific illustrators of his day.[1]

Cook's ship, the *Endeavour*, sailed from Plymouth on August 16, 1768, carrying 94 men and provisions for 18 months. The voyage, however, was to last for almost three years, during which time 38 men were destined to die. The *Endeavour* rounded Cape Horn and sailed west along the latitude in which Tahiti was known to lie. On April 11, 1769, the *Endeavor* reached Tahiti and anchored in Matavia Bay, where hundreds of islanders rowed out in canoes to welcome Cook and his crew.

In addition to his work as a naturalist, Banks made many notes on the lives and customs of the Tahitians. He participated in native ceremonies, ate native food, and formed friendships with individual Tahitians. He and Parkinson also learned much of the language and worked out the elements of the first Tahitian-English dictionary, which formed the foundation for all subsequent communication between Tahitians and Europeans.[2]

Throughout his stay in Tahiti, Banks had many opportunities to observe tattooing. On July 5, 1769, just eight days before his departure, he wrote a first-hand account of the process. After three months the *Endeavour* left Tahiti and sailed south in search of the Southern Continent. On October 6, 1769, Cook sighted New Zealand, a little known land which had not been visited by Europeans for over a century.

Cook, who was badly in need of food and other provisions, attempted to trade with the natives, but the fierce Maori warriors rejected his overtures. During the first contact there was a skirmish; the British fired, killing one of the Maoris.

Banks examined the dead man and noted in his journal that "he was a middle sized man tattooed

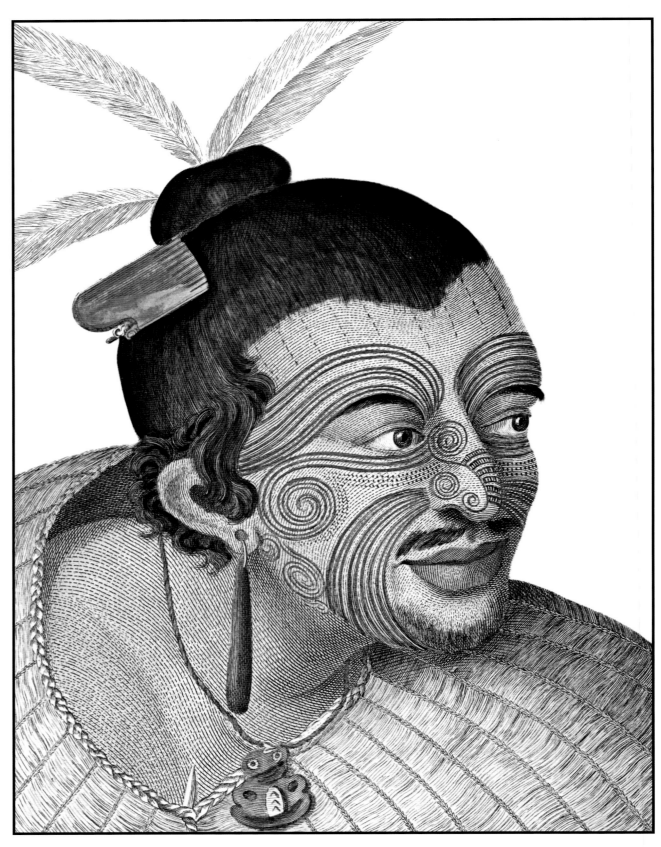

A New Zealand chief, engraved after a drawing by Sydney Parkinson, 1770.

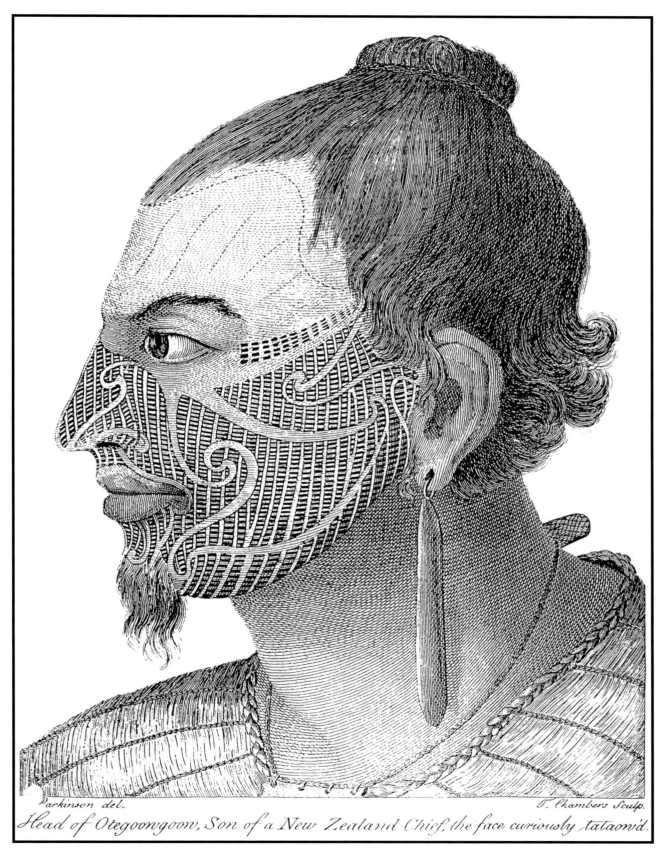

Head of Otegoongoon, Son of a New Zealand Chief, the face curiously tataow'd.

Parkinson del.

T. Chambers Sculp.

A New Zealand warrior, engraved after a drawing by Sydney Parkinson, 1770.

on the face and on one cheek only in spiral lines very regularly formed; he was covered with a fine cloth of a manufacture totally new to us; his hair was tied in a knot on the top of his head; his complexion brown, but not very dark." This was the first account in English of Moko, or Maori facial tattooing.[3]

As the *Endeavor* circumnavigated New Zealand, the British were able to establish more harmonious relations with the Maoris. Banks had the opportunity to study and describe Moko in more detail, and Sydney Parkinson drew the first portraits of tattooed Maori tribesmen. Engravings based on these drawings were published posthumously in Parkinson's *Journal of a Voyage to the South Seas* (1773), and have been reproduced in many works dealing with the exploration of the Pacific. Parkinson also illustrated the tattooing instruments, which he described in detail.[4]

After circumnavigating New Zealand and briefly visiting Australia, The *Endeavour* headed home via the Cape of Good Hope. On the homeward voyage, the gentle and talented artist, Sydney Parkinson, died of malaria and dysentery at the age of 26. It was a tragic loss. The many beautiful illustrations of newly discovered plants and animals which he had made during this thirty months on the *Endeavour* established his reputation as one of the great scientific illustrators of his day. In addition, he was the first artist to set foot on Tahiti, to portray Tahitian and Maori tattooing, and to paint the Australian landscape and natives. Had he lived, he would undoubtedly have enjoyed a long and distinguished career as a naturalist and illustrator.

In June 1771, the *Endeavor* reached England. There were still many who believed in the existence of a Southern Continent, and Cook was commissioned to lead two more voyages of exploration to the South Seas. During the third voyage he discovered the Hawaiian Islands, where he was killed in a skirmish with the natives on January 17, 1779. He was 51 years old.

After his return to England, Banks was much in demand as a guest at fashionable dinner parties, where he thrilled British socialites with tales of stormy seas, exotic islands, and tattooed cannibals. His influential friends in the Royal Society arranged for him to be presented to King George III, who shared his interest in natural history and botany. In 1772 King George appointed Banks Director of the Royal Gardens at Kew, and in 1778 he was elected President of the Royal Society, a position he held for over 40 years. Today he is best remembered for his journals, in which he gives a detailed, readable, and often witty account of his experiences during his voyage with Captain Cook.[5]

The following passages are taken from *The Endeavor Journal of Joseph Banks*, edited by J.C. Beaglehole. 2 vols. Sydney, Australia: Angus & Robertson.

BANKS IN TAHITI, AUGUST, 1769

We have now seen 17 islands in the seas and been ashore upon 5 of the most principal ones. Of these the language, manners and customs have agreed almost exactly. I should therefore be tempted to conclude that those of the islands we have not seen differ not materially at least from them. The account I shall give of them is taken chiefly from Otahite [Tahiti] where I was well acquainted with their most interior policy, as I found them to be a people so free from deceit that I trusted myself among them almost as freely as I could do in my own country, sleeping continually in their houses in the woods with not so much as a single companion. Whether or not I am right in judging their manners and customs to be general throughout these seas anyone who gives himself the trouble of reading this journal will be as good a judge as myself.

So much for their persons. I shall now mention their method of painting their bodies or "tattow" as it is called in their language. This they do by inlaying the color black under their skins in such a manner as to be indelible; everyone is marked thus in different parts of his body according maybe to his humor or different circumstances of his life. Some have ill-designed figures of men, birds or dogs, but they more generally have this figure "Z" either simply, as the women are generally marked with it, on every joint of their fingers and toes and often round the outside of their feet, or in different figures of it as squares, circles, crescents, etc., which both sexes have on their arms and legs. In short they have an infinite diversity of figures in which they place this mark and some of them, we were told, had significations but this we never learnt to

our satisfaction. Their faces are in general left without any marks. I did not see more than one instance to the contrary. Some few old men had the greatest part of their bodies covered with large patches of black which ended in deep indentations like coarse imitations of flame. These we were told were not natives of Otahite but came there from a low island called Noouoora.

Though they are so various in the application of the figures I have mentioned that both the quantity and the situation of them seems to depend entirely upon the humor of each individual, yet all the islanders I have seen (except those of Ohiteroa) agree in having all their buttocks covered with a deep black; over this most have arches drawn one over another as high as their short ribs, which are often one quarter of an inch broad and neatly worked on their edges with indentations, etc. These arches are their great pride: both men and women show them with great pleasure whether as a beauty or a proof of their perseverance and resolution in bearing pain I cannot tell, as the pain of doing this is almost intolerable, especially the arches upon the loins which are so much more susceptible of pain than the fleshy buttocks.

Their method of doing it I will now describe. The color they use is lamp black which they prepare from the smoke of a kind of oily nuts used by them instead of candles [candlenut, *Aleurites moluccana*]. This is kept in coconut shells and mixed with water occasionally for use. Their instruments for pricking this under the skin are made of bone and shell, flat, the lower part of this is cut into sharp teeth from 3 to 20 according to the purpose it is to be used for and the upper fastened to a handle. These teeth are dipped into the black liquor and then driven by quick sharp blows struck upon the handle with a stick for that purpose into the skin so deep that every stroke is followed by a small quantity of blood, or serum at least, and the part so marked remains sore for many days before it heals.

I saw this operation performed on the fifth of July on the buttocks of a girl about 14 years of age. For some time she bore it with great resolution, but afterwards began to complain and in a little time grew so outrageous that all the threats and force her friends could use could hardly oblige her to endure it. I had occasion to remain in an adjoining house an hour at least after this operation began and yet went away before it was finished, though this was the blacking of only one side of her buttocks, the other having been done some weeks before.

It is done between the ages of 14 and 18 and so essential it is that I have never seen one single person of years of maturity without it. What can be a sufficient inducement to suffer so much pain is difficult to say; not one Indian (though I have asked hundreds) would ever give me the least reason for it; possibly superstition may have something to do with it, nothing else in my opinion could be a sufficient cause for so apparently absurd a custom. As for the smaller marks on the fingers, arms, etc. they may be intended only for beauty. Our European ladies have found the convenience of patches, and something of that kind is more useful here, where the best complexions are much inferior to theirs, and yet whiteness is esteemed the first essential in beauty. ■

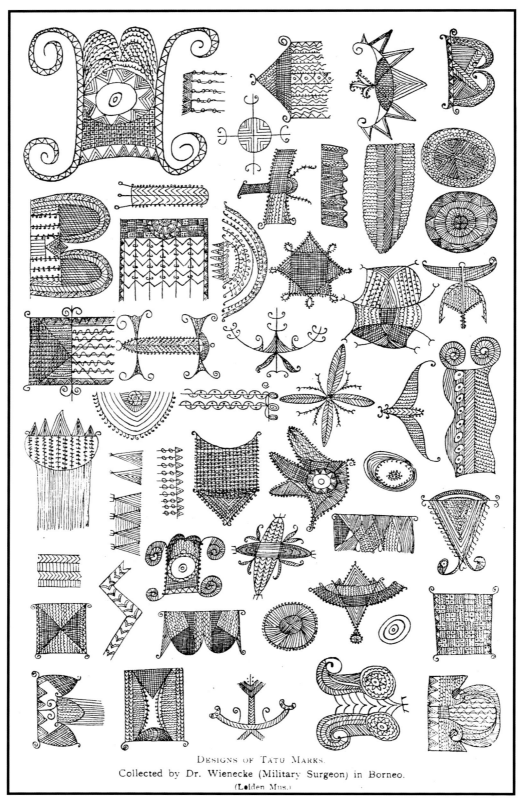

DESIGNS OF TATU MARKS.
Collected by Dr. Wienecke (Military Surgeon) in Borneo.
(Leiden Mus.)

Borneo tattoo designs. (after Roth)

𝕴𝖘𝖑𝖆𝖓𝖉𝖘 𝖎𝖓 𝖙𝖍𝖊 𝖕𝖆𝖈𝖎𝖋𝖎𝖈

BORNEO

Borneo is one of the few places in the world where traditional tribal tattooing is still practiced today, just as it has been for thousands of years. Until recently, many of the inland tribes had little contact with the outside world. As a result, they have preserved many aspects of their traditional way of life, including tattooing.

One reason for the physical and cultural isolation of the inland natives is the sheer size of Borneo. It covers an area five times as large as England and Wales, and ranks as the third largest island in the world (only Greenland and New Guinea are larger). The landscape consists for the most part of steep hills, mountains, and dense rain forests. There are few roads, and most travel occurs by air or by boats that traverse Borneo's many rivers.

Recent archaeological finds indicate that the ancestors of some contemporary native tribes have lived in Borneo for over 50,000 years. Well into the twentieth century many of them lived a Stone Age life. They fished, hunted, and cultivated rice just as their ancestors had. Game was abundant and the forest constantly renewed itself.

The term 'Dayak' is applied to a variety of aboriginal native tribes including the Ibans, Kayans, Kenyahs, and others. Among these people there is great diversity: some Dayak tribes differ from each other as much as they differ from the Chinese and Malays who have established trading settlements along the coast.[1]

Before the middle of the nineteenth century Borneo was largely unknown to the West, and the first published description of the Dayaks appeared toward the end of the nineteenth century. Charles Hose and William

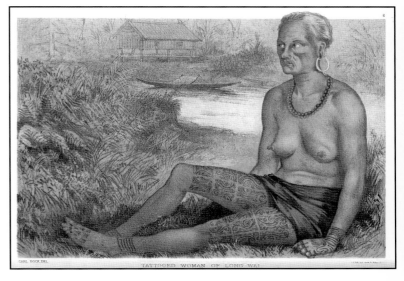

A tattooed woman of Long-Wai. (after Bock)

MacDougall's *The Pagan Tribes of Borneo*, published in 1912, is the classic account of tribal life. Hose and MacDougall traveled extensively in Borneo and collected much first-hand information, including many tattoo designs. Their work remains the classic record of the traditional life and customs of the Dayaks.

The traditional Dayak lifestyle was intensely communal. As many as 60 families lived together under one thatched roof in a longhouse, a large structure made of bamboo and ironwood which stood on stilts near a river. Before the arrival of the British early in the nineteenth century, tribal warfare was endemic. The purpose was not to acquire enemy territory, but to acquire enemy heads. When heads were brought home there was a great celebration at the longhouse of the victors. The heads were later skinned and dried over a fire, and the skulls were hung from the longhouse rafters. The skulls were believed to be a source of spiritual energy that would bring prosperity and good luck to the tribe that had taken them. They were kept warm, protected from the rain, and treated with great respect. Only elders were allowed to touch them.[2]

For over a century the British rulers of Borneo tried to put an end to the tribal wars, and their efforts met with some success. But with the suppression of tribal warfare, headhunting entered a decadent period: defenseless old folks, solitary travelers, individuals who were asleep in the forest, and even corpses were in danger of having their heads removed and hung in the longhouse of a neighboring tribe.[3]

Headhunting and tattooing were intimately connected in the magic, ritual and social life of many Dayak tribes. The hand tattoo was a symbol of status in life and also served an important function

The village of Long-Wai. (after Bock)

after death. It was supposed to illuminate the darkness as the soul wandered in search of the River of the Dead. A spirit called Maligang guarded the River. If the soul could show Maligang a tattooed hand, Maligang would allow it to cross the river on a log. If the soul was that of a warrior killed in battle, it enjoyed special privileges: it had a place reserved near Bawang Daha, the Lake of Blood, where it could grow rich without working and enjoy the companionship of the souls of women who had died in childbirth.

But if Maligang saw that the soul had no hand tattoo, he would roll and tip the log when the soul tried to cross the river, and the soul would fall into the water to be eaten by maggots.[4] Some variation of this belief was found among most of the inland tribes, and it is interesting to note that similar ideas about the function of tattooing in the afterlife have also been recorded in many American Indian tribes (see the Sioux legend, Chapter 10).

In addition to tattooing, the Kayans pierced and stretched their earlobes and other parts of the body. Penis piercing was common among the Kenyahs and other inland tribes. The penis was pierced by placing it in a clamp and driving a six inch nail through just below the glans. The nail was later removed and replaced with a shaft made of bone or hardwood to which knobs were attached at both ends. Many men had two such shafts at right angles to each other. The shaft with the attached knobs was called a palang , and those who enjoyed the benefit of this treatment reported that it made sexual intercourse intensely pleasurable for both partners.[5]

Tattooing, piercing, and other traditional Dayak arts are probably of great antiquity. Many of the traditional tattoo designs recorded by Hose and MacDougal resemble decorative motifs found in the art of Bali and Java, and the tattooing instruments and techniques used by the Dayaks are similar to those found throughout Polynesia. This suggests that Stone Age voyagers like those who populated other Pacific islands imported tattooing and other native arts to Borneo many thousands of years ago.[6]

Today, few Dayak women are tattooed, but the practice is still popular among men. In most cases the technique and the designs are traditional. One still sees many Dayak men who wear the bold abstract tattoos of their ancestors on their shoulders and arms, but some of the younger men who have traveled to other Asian countries in search of employment return with commercial tattoos.

Life is difficult for Dayaks today. Those who attempt to pursue a traditional lifestyle find that game and the forest are rapidly disappearing. In recent decades, over half of Borneo's rain forest has been destroyed or irreparably damaged by forest fires, logging, mining, and oil drilling operations. The ecological disaster and the human tragedy have been compounded by the arrival of tens of thousands of immigrants from overpopulated parts of Indonesia. These changes are unprecedented and irreversible. Ecologists predict that unless drastic measures are taken immediately, Borneo's rain forest, and all the marvels it contains, including tattoo traditions, will be gone within a few decades.[7]

HOSE AND SHELFORD IN BORNEO, CIRCA 1900.

Amongst [the Kayans] the men tattoo chiefly for ornament, and no special significance is attached to the majority of designs employed; nor is there any particular ceremonial or tattoo connected with the process of tattooing the male sex. There is no fixed time of life at which a man can be tattooed, but in most cases the practice is begun early in boyhood....

Amongst the Sarawak Kayans, if a man has taken the head of an enemy he can have the backs of his hands and fingers covered with tattoos, but if he has only had a share in the slaughter, one finger only, and that generally the thumb, can be tattooed. On the Mendalan River, the Kayan braves are tattooed on the left thumb only, not on the carpals and backs of the fingers, and the thigh pattern is also reserved for head-taking heroes.

Of the origin of tattooing the Kayans relate the following story: Long ago when the plumage of birds was dull and sober, the coucal and the argus pheasant agreed to tattoo each other; the coucal began on the pheasant first, and succeeded admirably as the plumage of the pheasant bears witness to the present day; the pheasant then tried his hand on the coucal, but being a stupid bird he was soon in difficulties, and, observing that he would fail miserably to complete the task, he took the black dye and, having smeared it all over his friend, told him to sit in a bowl of samak tan, and, when the coucal did as he was told, flew off remarking that the country was full of enemies, and, therefore, he could not stop; and that is why the coucal to this day has a black head and neck with a tan-colored body...

The design tattooed on the wrists is termed *lukut*, i.e., an antique bead much valued by the Kayans, and the significance of the designs is of some interest. When a man is ill, it is supposed that his soul has escaped from his body, and when he recovers it is supposed that his soul has returned to him; to prevent its departure on some future occasion the man will "tie it in" by fastening round his wrist a piece of string on which is threaded a *lukut* or antique bead, some magic apparently being considered to reside in the bead. However, the string can get broken and the bead lost, wherefore it seems sager to tattoo a representation of the bead on the part of the wrist which it would cover if actually worn. It is of interest to note also that the *lukut* from having been a charm to prevent the second escape of the soul has come to be regarded as a charm to ward off all disease, and the same applies to its tattooed representation...

The dog design figures very prominently in Kayan art, and the fact that the dog is regarded by these people and also by the Kenyahs with a certain degree of veneration may account for its general representation. The design has been copied by a whole host of tribes, with accompanying degradation and change of name.

On the deltoid region of the shoulders and on the breasts, a rosette or star design is found. As already stated, it seems in the highest degree probable that the rosette is derived from the eye in the dog pattern, and it is consequently of some interest to find that the name now given to the rosette pattern is that of the fruit of a plant which was introduced into Borneo certainly within the last fifty or sixty years...its Kayan name is *jalaut*. We have here a good example of the gradual degradation of a design leading to a loss of its original significance and even of its name, another name, which originated probably from some fancied resemblance between pattern and object, being applied at a subsequent date...

Kayan women are tattooed in complicated serial designs over the whole forearm, the backs of the hands, over the whole of the thighs to below the knees, and on the metatarsal surfaces of the feet. The tattooing of a Kayan girl is a serious operation, not only because of the amount of pain caused, but also on account of the elaborate ceremonial attached to this form of body ornamentation. The process is a long one, lasting sometimes as much as four years, since only a small piece can be done at a sitting and several long intervals elapse between the various stages of the work. A girl when about ten years old will probably have her fingers and the upper part of her feet tattooed, and about a year later her forearms should have been completed, the

The following selection is taken from "Materials for a Study of Tatu in Borneo" by Charles Hose and R. Shelford (1906)

Borneo tattoo designs.
(after Hose and Shelford)

Borneo tattoo designs
(after Hose and Shelford)

thighs are partially tattooed during the next year, and in the third or fourth year from the commencement the whole operation should have been accomplished.

A woman endeavors to have her tattoo finished before she becomes pregnant, as it is considered immodest to be tattooed after she has become a mother. If a woman has a severe illness after any portion of her body has been tattooed, the work is not continued for some little time; moreover…a woman cannot be tattooed during seed time nor if a dead person is lying unburied in the house, since it is *pemali* to let blood during these occasions; bad dreams, such as a dream of floods, foretelling much blood-letting, will also interrupt the work. A tattooed woman may not eat the flesh of the monitor lizard or *kavok* nor the scaly manis or *an*, and if she happens to have a husband he also is included in the taboo until the pair have a male and a female child. If they have a daughter only they may not eat the flesh of the monitor until their child has been tattooed; if they have only a son they cannot eat the monitor until they become grand-parents. Should a girl have brothers, but no sisters, some of her tattoo lines must not be joined together, but if she has brothers and sisters, or sisters only, all the lines can be joined.

Tattooing among the Kayan women is universal; they believe the designs act as torches in the next world, and that without these to light them they would remain forever in total darkness; one woman told Dr. Nieuwenhuis that after death she would be recognized by the impregnation of her bones with the tattoo pigment; as amongst the Kayans the bones of the deceased person are placed some time after death in a grave, Dr. Nieuwenhuis's informant evidently imagined that her tattoo would obviate all risk of the confusion of her remains with another's. The operation of tattooing is performed by women, never by men, and it is always the women who are the experts on the significance and quality of tattoo designs, though the men actually carve the designs on the tattoo blocks. Nieuwenhuis states that the office of tattooer is to a certain extent hereditary and that the artists, like smiths and carvers, are under the protection of a tutelary spirit, who must be propitiated with sacrifices before each operation. As long as the children of the artists are of tender age, she is debarred from the practice of her profession. The greater the number of sacrifices offered, or in other words the greater the experience of the artist, the higher is the fee demanded. She is also debarred from eating certain food. It is supposed that if an artist disregards the prohibitions imposed upon her profession, the designs she tattoos will not appear clearly, and she herself may sicken and die. Sometimes women become tattoo artists in order to get cured of a sickness. The priestess, who in Kayan houses is a healer of the sick, as a last resort may advise her patient to place herself under the care of Apu Lagan, the tutelary spirit of tattoo artists, by actually becoming a tattoo artist.

The tools used by a tattoo artist are simple, consisting of two or three prickers and an iron striker that are kept in a wooden case. The prickers are wooden rods with a short pointed head projecting at right angles at one end; to the point of the head is attached a lump of resin in which are embedded three or four short needles, their points alone projecting from the resinous mass. The striker is merely a short iron rod, half of which is covered with a string lashing. The pigment is a mixture of soot, water, and sugar cane juice, and it is kept in a double shallow cup of wood. It is supposed that the best soot is obtained from the bottom of a metal cooking pot, but that derived from burning resin or dammar is also used. The tattoo designs are carved in high relief on blocks of wood that are smeared with the ink and then pressed on the part to be tattooed, leaving an impression of the designs. As will be seen later the designs tattooed on women are in longitudinal rows or transverse bands, and one or more zigzag lines mark the divisions between the rows or bands.

The subject who is to be tattooed lies on the floor, the artist and an assistant squatting on either side of her. The artist first dips a piece of fiber from the sugar palm into the pigment and, pressing this on the limb to be tattooed, plots out the arrangement of the rows or bands of the design. Along these straight lines the artist tattoos the rows of *ikor*, then taking a tattoo block

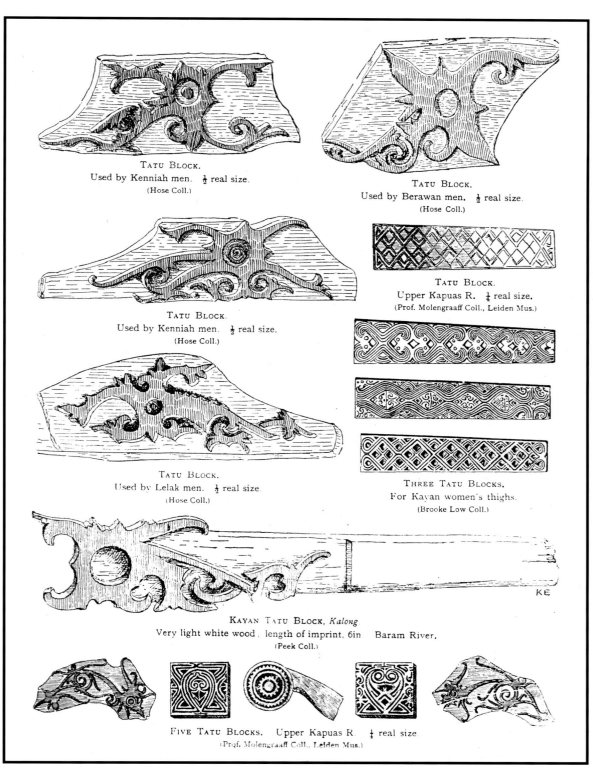

TATU BLOCK.
Used by Kenniah men. ½ real size.
(Hose Coll.)

TATU BLOCK.
Used by Berawan men. ½ real size.
(Hose Coll.)

TATU BLOCK.
Used by Kenniah men. ½ real size.
(Hose Coll.)

TATU BLOCK.
Upper Kapuas R. ¼ real size.
(Prof. Molengraaff Coll., Leiden Mus.)

TATU BLOCK.
Used by Lelak men. ½ real size.
(Hose Coll.)

THREE TATU BLOCKS.
For Kayan women's thighs.
(Brooke Low Coll.)

KAYAN TATU BLOCK, *Kalong.*
Very light white wood. length of imprint, 6in. Baram River.
(Peek Coll.)

FIVE TATU BLOCKS. Upper Kapuas R. ¼ real size.
(Prof. Molengraaff Coll., Leiden Mus.)

Carved wooden blocks used as stencils for tattooing. (after Roth)

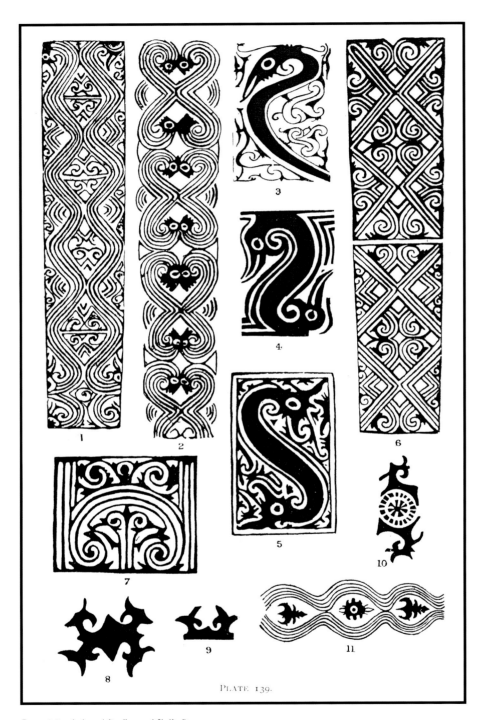

PLATE 139.

Borneo tattoo designs. (after Hose and Shelford)

carved with the required design, she smears it with pigment and presses it onto the limb between two rows of *ikor*. The tattooer or her assistant stretches with her feet the skin of the part to be tattooed, and, dipping a pricker into the pigment, taps its handle with the striker as she works along a line, driving the needle points into the skin. The operation is painful, and the subject can rarely restrain her cries of anguish, but the artist is always quite unmoved by such demonstrations of woe, and proceeds methodically with her task. As no antiseptic precautions are ever taken, a newly tattooed part often ulcerates, much to the detriment of the tattoo, but taking all things into consideration it is wonderful how seldom one meets with a tattoo pattern spoilt by scar tissue.

It is considered bad luck to draw the blood of a friend, and therefore, when first blood is drawn in tattooing, it is customary to give a small present to the artist. The present takes the form of four antique beads or some object worth about a dollar and is termed lasat *mata*, for it is supposed that if it were omitted the artist would go blind and some misfortune would happen to the parents and relations of the girl undergoing the operation of tattooing…

[Long Glat women] believe that after death the completely tattooed women will be allowed to bathe in the mythical river Telang Julan, and that consequently they will be able to pick up the pearls that are found in its bed; incompletely tattooed women can only stand on the river banks, whilst the untattooed will not be allowed to approach its shores at all. This belief appears to be universal amongst the Kenyah-Klemantan of the Upper Mahakam and Batang Kayan. ■

Borneo tattoo designs
(after Hose and Shelford)

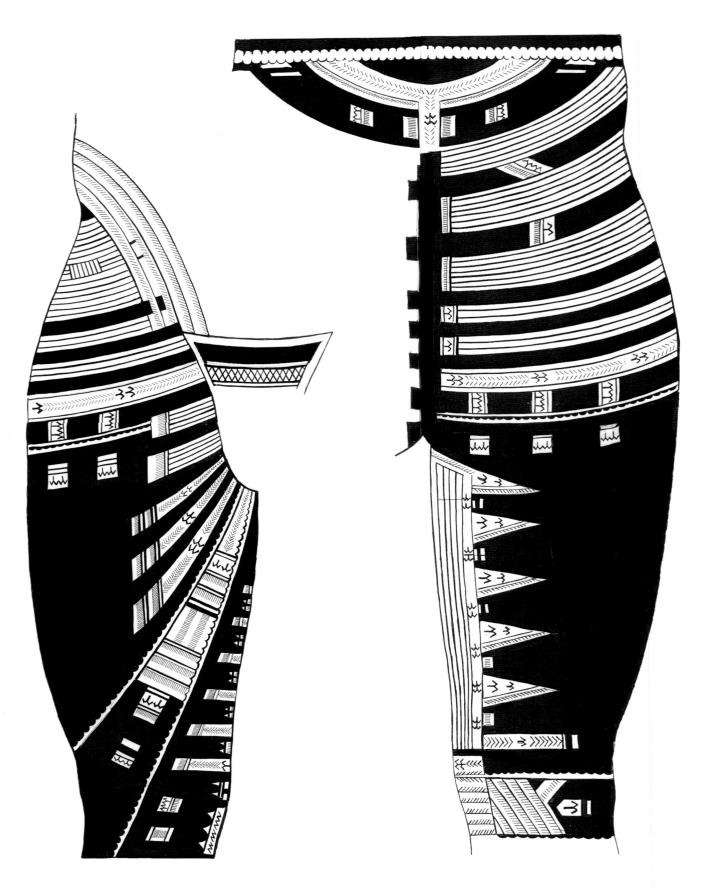

A Samoan design for the front of the male thigh.
(redrawn after Marquardt)

A Samoan design for the back of the male thigh.

SAMOA

Europeans first saw the Samoan Islands in 1722, when three Dutch ships commanded by Jacob Roggewein visited the eastern island known as Manua. A member of Roggewein's expedition described the natives in these words:

> They appeared to be a harmless good sort of people, and very brisk and likely; for they treated each other with visible marks of civility, and had nothing in their behavior that was wild or savage. Their bodies were not painted like those of other *Indians* or *Dutch* we had seen; but were clothed from the girdle downwards with a kind of silk fringes very neatly folded.[1]

The Dutch ships lay at anchor off the islands for several days, but members of the crew did not venture ashore and apparently did not even get close enough to the natives to realize that they were not wearing silk breeches, but tattooing on their legs.

The French navigator, Louis Antoine de Bouganville, who stopped briefly in 1768, led the second European expedition that visited Samoa. Like Roggewein, he was careful not to get too close to the natives. He admired the skill with which the Samoans navigated their canoes but reported that they were ill-mannered compared to the Tahitians, and thought it curious "that their thighs to below the knees were painted a deep blue."[2]

The first Europeans who set foot on Samoan soil were members of the 1787 French expedition commanded by Jan Francoise de la Perouse. La Perouse got a closer look at the natives and reported that "the men have their thighs painted or tattooed in such a way that one would think them clothed, although they are almost naked."

After an initially friendly exchange of trading goods and food, the French caught a Samoan whom they suspected of theft and hoisted him to the top of a mast by his thumbs. This provoked a skirmish in which twelve French sailors and several Samoans were killed. La Perouse later wrote: "I willingly abandoned to others the task of writing the uninteresting history of these barbarous people; a stay of twenty-four hours and the relation of our misfortunes has sufficed to show their atrocious manners."[3]

During the early part of the nineteenth century a number of European and American vessels stopped at Samoa to trade and take on provisions, and in 1830, the Reverend John Williams and the Reverend Charles Barff of the London Missionary Society arrived with the intention of founding a mission. The reverends found that they were not the first Europeans to take up residence on the islands. There was already an established colony of escaped convicts, deserters, and mutineers who were selling muskets and ammunition to the Samoans. Some of them had secured employment with Samoan chiefs, who engaged them as ministers of war and advisors in the use of firearms. According to the missionaries, these scoundrels did incalculable mischief.

The missionaries made many converts, for the Samoans proved to be as keen about Christianity as they were about muskets. Many Samoans believed that Christianity would ensure long life by protecting them against disease and sorcery. They also thought that more

Samoan design for the female hand.
(after Marquardt)

European ships bearing valuable foreign goods for trade would visit Samoa if they became Christians.[4]

One of the most influential early converts to Christianity was Chief Fauea, whose sermons were responsible for saving many souls. "Can the religion of these English be anything but good?" he asked his congregation.

> Behold how rich they are in axes, scissors, and other property, while we have nothing. Their ships are like floating houses, so that they can traverse the tempest-driven ocean for months with perfect safety. Now I conclude that the God who has given to his white worshipers these valuable things must be wiser than our gods, for they have not given the like to us. We want all these articles and my proposition is, that the God who gave them should be our God.[5]

Chief Faueu's congregation was unable to resist the force of his argument, and within a few years many Samoans had accepted the trappings, if not the substance, of Christianity. Tattooing was one of the many native customs that the missionaries tried to suppress. As one divine explained it to his flock: "Tattooing is numbered among the works of darkness and is abandoned wherever Christianity is received." But the Samoans saw Christianity as something to be added to their culture, not as something to replace it. For young Samoan men, tattooing was a rite of passage from boyhood to maturity. A young man who was not tattooed was considered to be still a boy. He could not marry; he could not speak in the presence of grown men; and he was obliged to perform menial tasks. The fact that he sometimes attended Sunday Services held by missionaries was no reason to give up tattooing!

"Where the missionary goes, new channels are cut for the stream of commerce," as the British missionary John Williams observed in 1837. By the middle of the nineteenth century, German entrepreneurs had established a network of trade routes throughout the South Pacific and recognized Samoa as a treasure waiting to be taken. They promoted their interests by instigating intertribal warfare and then trading guns and ammunition for native land. By 1860, almost one third of Samoa had become the private property of a single German company.

The Americans and the British were quick to emulate the Germans, and the result was an unseemly scramble for free real estate. When, toward the end of the century, an attempt was made to untangle the hodgepodge of overlapping titles, it was discovered that the English, Germans, and Americans claimed ownership of over 1,700,000 acres, whereas all the islands of Samoa together totaled less than 800,000 acres.[6]

American historian Joseph Ellison has characterized the history of Samoa in the nineteenth century as:

> a story of native revolution and civil wars, often instigated by intriguing foreign adventurers; of vainglorious, jealous consuls, who hoisted their flags on the islands and schemed to secure commercial and political influence for their respective nations; of blustering, impetuous naval commanders who shelled and burned native villages, of quarreling officials and shouting patriots who almost precipitated an armed international clash of major scale. It is an account of numerous conferences, treaties, and agreements that finally resulted in the partition of the islands between Germany and the United States.[7]

This partition was put into effect in 1899, when Britain accepted a bribe in the form of the Solomon Islands and retired from the squabble. Germany took the islands of Western Samoa, which contained the most profitable plantations, while the United States took the islands of Eastern Samoa and the strategically important naval base at Pago Pago.

The German governors of Western Samoa had little patience with the missionaries. They tolerated and even encouraged tattooing and other native customs that the missionaries had tried to suppress. Chief Justice Schultz, the Second Governor of German Samoa, was himself tattooed by a native artist, and subsequently the Inspector of Customs and several other government officials followed his example.[8]

As a result of this enlightened policy, tattooing in Samoa was never abandoned as it was in many other Polynesian Islands. Historian N.A. Rowe, writing in 1930, reported, "it is satisfactory to record that, despite the attempted prohibitions of the missionaries, tattooing is again practically universal; the native pastors being almost the sole exception."

The definitive accounts of traditional native life and art were written by Germans in the colonial service about the turn of the century. Carl Marquardt's *Die Tätowirung beider Geschlechter in Samoa* (1899) (*The Tattooing of Both Sexes in Samoa*) contains a description of the process and drawings of the traditional tattoo motifs, together with a list of their names and meanings. The classic account of traditional native life is *Die Samoa-Inseln* by Augustin Krämer, published in 1903. Krämer was a German physician and anthropologist who spent several years studying the language, culture, and natural history of Samoa. His two-volume masterpiece includes a detailed account of Samoan tattooing.[9]

Krämer reported that an area about the size of a hand was tattooed in an hour, and the operation would then be continued the following week, so that a tattoo took several months to complete. The entire procedure followed a strict ritual. Each part of the design had a name, and each part was tattooed in a predetermined sequence, starting at the waist and progressing down to the knees. The genitals were tattooed during the second session. This was the most difficult part of the operation for both the tattoo artist and the young man being tattooed. Kramer reported, "the tattoo artist must have good assistants when he works in this area, for penetrating the crack between the buttocks requires great skill and perseverance, as does the tattooing of the anus, the perineum, the scrotum, and the penis, including the glans. This part of the operation is always very unpleasant and painful."[10] As may be imagined there were a few cowards who wished to avoid this test of manhood, but without tattooing they were social pariahs. Women ridiculed them, and no father would accept an untattooed man as a mate for his daughter.

Samoan tattooing was filmed for the first time in 1925, by pioneer documentary filmmaker Robert Flaherty. After spending two years filming the traditional life of the native Samoans, Flaherty felt that he had most of the footage he needed. The only thing lacking was a climax. Instead of contriving a Hollywood ending, Flaherty looked for a dramatic incident which followed logically from the sequences he had already filmed. Up to this point the film followed typical events in the life of a young Samoan man, Moana, who was shown fishing, hunting, canoeing, feasting, and courting a young girl. The next natural event in Moana's life was tattooing. Flaherty persuaded Ta'avale, the young Samoan who played the part of Moana, to submit to the operation and arranged for the services of an old *tufunga* (tattoo artist) to do the work.

Flaherty's wife, Frances, described the tattooing in these words:

The tufunga is a great chief and tattooing is a very expensive affair, attended with great ceremony. To the Samoan man, it is the crucial event in a lifetime, from which all other happenings are dated. Until he is tattooed, no matter how old he may be, the Samoan man is still considered and treated as a boy. Tattooing is the beautification of the body by a race who, without metals, without clay, express their feelings for beauty in the perfection of their own glorious bodies. Deeper than that, however, is its spring in a common human need, the need for struggle and for some test of endurance, some supreme mark of individual worth and proof of the quality of the man....What is it that can keep alive the spirit of man but his own respect for what he is, the God that is within him? And so it is that tattooing stands for valor and courage and all those qualities in which man takes pride.[11]

The following selection is taken from *The Tattooing of Both Sexes in Samoa* by Karl Marquardt (1899). Translated by Sybil Ferner.

MARQUARDT IN SAMOA, CIRCA 1890

An exact knowledge of Samoan tattooing is only held by the tufunga, the Samoan tattooing artists, and possibly, but to a very much lesser extent, by the so-called tulafale, the professional speakers of the village and provinces in Samoa. The "old people" of Samoa can certainly tell many an interesting detail about the subject, but generally they cannot be considered a reliable source of information, especially as far as the explanation of names and the interpretation of the sense of the tattoo patterns in concerned. The younger generation, however, is very unreliable and their knowledge is restricted to a few and rarely only the majority of the tattoo patterns. Everything originating from them is to be accepted only with the greatest caution and not without checking.

All of this made me attempt to bring light into the darkness surrounding this subject after I had permanent contact with Samoans for two years. A longer stay in Samoa provided me with the opportunity to do so. It was especially the total lack of knowledge of the custom of tattooing of women which made necessary a close examination amongst the natives.

Only an insignificant number of Samoans are not tattooed. The influence of the missionaries has so far been practically nil as far as tattooing is concerned. The same applies to some other customs like the way of concluding a marriage and the beheading of enemies killed in battle.

O le ta tatau, the art of tattooing, is still highly respected in Samoa. All men, almost without exception, subject themselves to this painful operation as soon as they reach the age of manhood. However, there have always been individual weaklings who avoided the pain, but such *pala'ai* (cowards) have never enjoyed the least respect. Especially the women despised them and the chiefs refused to accept food from their hands, which they called "stinking." The contempt shown for men who lack the national adornment has been weakened a little by the influence of the missionaries, but nevertheless continues to this day. An untattooed man is still not popular and many a father refuses him his daughter's hand. It is no rarity that young people who are being prepared for the mission service turn their backs on the mission schools for the only reason that the students are forbidden to get tattooed.

The act of tattooing was always carried out in solemn manner. Especially the tattooing of the chief's sons was a celebration for the whole village, in the case of high chiefs even for the province, and this was a big feast for everyone. A number of tattoo artists were called and people came from far and wide to participate in the meals, dances and enjoyments customary at these occasions. An old custom is that at the same time as the chief's sons and the sons of the *tulafale* of the district, who were of the same age group, had to undergo the operation as well. These young people were not only tattooed at the cost of the chief, but after the operation they also received a gift of honour as a recognition that they underwent the pain of the operation at the same time as their young master.

The instruments of the *tufuga*, the so-called *au*, resemble in shape our agricultural tools, the hoe or mattock. They are of varying width. The comb-like serrated part of it, which comes into contact with human skin, is always made of bone. The preferred materials for this purpose are human bones. If there are none available, horse or ox bones are used.

The toothed part of the implement which pierces the human skin is connected to the actual handle by a toe which usually consists of tortoise-shell and sometimes of bone. The handle is made of cane or wood. For this purpose the wood of the *fu'afu'a* tree (*Kleinhovia hospita*) is preferred. These three parts of the implement (serrated blade, handle and the connecting toe) are tied together with coconut fiber. In order to produce the necessary stability the bone and tortoise-shell parts are drilled in various places. A complete set of tattooing instruments consists of eight to twelve implements, depending on the artist. These implements are of varying width at the toothed end and are kept in an open wooden container, the so-called

tunuma, which is widened at the upper end.

For the preparation of the pigment to be inserted into the skin the soot of a burnt nut (*Aleurites Moluncana*) is used. During the burning process it is collected in a coconut shell. The soot now sticking to the inner sides of this nutshell is scraped off and put into another coconut shell, niu, where the pigment is usually kept. It has a pounder and is closed by a roll of siapo.

A short wooden mallet is used for the insertion of the instruments into the skin. It is about 35 cm long and called *auta* or *sausau*. The tattooing instruments are worked with an admirable accuracy. Especially the hair-fine teeth are cut out of the hard bone blade with the utmost precision and can rightly be called little works of art. As a consequence the *tufunga* appreciate their instruments highly and it is difficult to purchase good and usable examples. The *'au* which are sometimes kept in museums are usually old discarded examples which can no longer be used for tattooing.

Nowadays the tattooing procedure is not carried out in such a ceremonial way as in former times. In the good old days the ceremony was usually opened with sham fights and war exercises which were followed by the first distribution of presents to the *tufunga*. After that the young chief delivered himself to the *tufunga* and the operation began. One of the tattoo artists handled the implements and mallets while others tightened the skin on that part of the back where the tattooing process was to begin.

The pattern to be carried out first was the *tua*-stripe which extends over the whole back. The operation lasted until the man to be tattooed found the pain unbearable or until dusk fell. The next day they started again. At times, however, they were forced to interrupt their work for several days to let an inflammation heal. Sometimes the whole process had to be discontinued when the body of the tattooed person showed such malignant signs that it did not seem advisable to continue the tattooing. The whole operation, which was carried out with more than the usual care in the case of chief's sons or members of particularly wealthy families lasted up to three months, depending on the stamina of the person being tattooed.

The tattooing of the common people…was carried out in a less careful manner and it is indeed remarkable how much the tattooing of the chiefs differs at times from the tattooing of other men as far as beauty of workmanship is concerned. The tattooing of the chiefs provided the *tufunga* with the opportunity to sing an ancient song, a free translation of which follows:

> Patience. Only a short while, and you will see your tattoo, which will resemble the fresh leaf of the ti-plant.
> I feel sorry for you. I wish it was a burden which I could take off your shoulders in love and carry for you.
> The blood! It springs out of your body at every stroke. Try to be strong.
> Your necklace may break, the *fau*-tree may burst, but my tattooing is indestructible. It is an everlasting gem that you will take into your grave.
> Chorus: O, I am sad, you are weak, O I feel sorry that the pain follows you even in your sleep and you resist it. ■

The *tufuga* have no tattooing song for common people. In their case the singing is left to relatives and friends. My questions concerning such a song were in fact greeted by the *tufuga* with unmistakable cheerfulness. The very important masters thought it a funny idea to stretch their voices during the tattooing of common people. The melody of the chief's song is strangely monotonous, but for this very reason it serves its purpose of calming the man to be tattooed. Another purpose of the song is said to be to cover up possible groans of pain of the tattooed.

After the day's work had ended the witnesses of the operation used to enjoy the dances, sham fights and sporting exercises such as jumping, wrestling and boxing which were common at these

occasions. When the tattooing process had ended the *tufunga* received the outstanding part of their copious payment, which mainly consisted of fine mats and *siapo*. At the same time the families of the tattooed sons of the *tulafale* received their presents and finally all the relations of the chief, who had participated in the ceremony, received presents as well, as they had contributed to the event by providing food for the many guests.

The distribution of the presents was followed by a solemn procession of the *tufuga* and their assistants carrying burning torches. Then a water vessel was smashed at the feet of the young chief. The whole act and the festivities were then concluded with the *lulu'u* ceremony, the solemn sprinkling of all newly tattooed with the milk of a coconut called *niuui* by a *tufuga*.

On the inner forearms of old Samoans you sometimes find a tattoo usually consisting of points and lines in varying combinations. This only serves as identification in case the bearer loses his head in a battle. In more recent times since the introduction of writing it has become a custom to tattoo the name onto the forearm for the same purpose.

Another old Samoan custom should be mentioned, i.e., the tattooing of the nose as a punishment for crime. I have not been able to obtain confirmation that this custom has been practiced anywhere on the islands in recent times (the missionaries were presumably successful in insisting on the abolition of this tradition) nor have I been able to hear how it was practiced. In any case, however, it was a punishment only for serious crime and to be placed on a more or less equal footing with cutting off an ear.

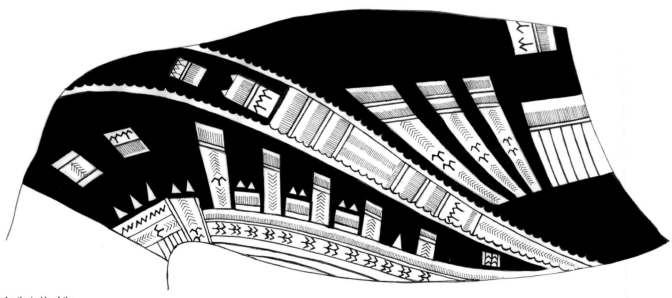

Samoan design for the inside of the male thigh.
(redrawn after Marquardt)

Several ethnologists see the origins of the Samoan custom of tattooing as "god-given" and refer to the well-known legend of the two goddesses, Taema and Tilafaiga who are supposed to have brought the custom from Fiji to Samoan. According to Professor Ratzel, its base is the "teaching of Atua, i.e., the genius in an animal body." I cannot agree with the opinion that the tattooing in Samoa was originally a holy or religious act. They are theories which, to quote Joest, have their origins in the wish to trace back the simplest basic facts and processes in ethnology not to the simplest basic thoughts but to a mystic-symbolical metaphysical and psychologically complicated foundation with the aid of amazing knowledge and learnedness. In my opinion no one can prove that the custom of tattooing was originally linked to religious and political institutions as Meinicke says in his book *The Islands of the Pacific Ocean.*

All attempts to prove such assumptions contradict common sense. Whoever has had contact with native peoples and not just superficially and temporarily but profoundly and for a longer period of time, knows what an important part vanity plays in their lives. To indulge in it they think of the strangest and most painful customs as any ethnologist and any layperson with some ethnological education will know, so that there is no need to provide proof. Here I can again refer to Mr. Joest's excellent work. Tattooing, in my opinion, has always been and still is meant to decorate the body and here we must not use our "refined" taste to set the standards.

The custom must necessarily have evolved from the simplest beginnings. Dots and dashes were probably the first signs to be engraved into the human skin anywhere in the world. And as eating creates appetite to eat, the more intelligent peoples became aware of certain signs and patterns and strove for perfection. Thus beauty, complication and the size of the patterns on the human body increased with growing understanding and taste.

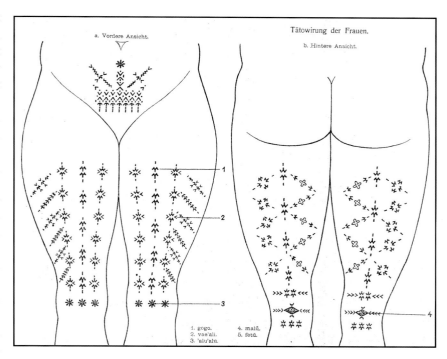

Samoan design for the female thigh.
(after Marquardt)

Men had themselves tattooed to please women and women to increase their attractiveness to men. They only do it to embellish themselves and to make themselves more attractive. When Finsch declares the tattooing of the South Seas a means of decoration which has to do neither with rank, status nor religion he certainly hits the nail on the head. Also the Caroline Islander who answered the question what tattooing was for, saying: "It serves the same purpose as your clothes, to please women," certainly was not lying.

If you consider further that a native man is most of all impressed by strength, courage and perseverance, the assumption can surely not be rebutted that the native when enduring the pain of being tattooed wanted to give proof to the opposite sex of his manhood and his contempt of pain in order to appear more manly and therefore more attractive...

In my opinion it is no coincidence that the act of tattooing is usually carried out at the time of beginning puberty, for the two are connected. At this time sexual feelings start to develop. A girl wants to please a man and therefore she asks for the means to achieve this purpose and she obtains them.

The defenders of the theory that the tattooing custom is of religious origin put forward the fact that the custom is usually, or at least frequently, carried out by priests. I agree with Mr. Joest that the priests initially had nothing to do with it but that later when they realized the profitability of the business they got into it, gave the tattooing custom a religious character, and thus monopolized the business in order to suppress any competition. The high payment for the art was then connected with an "offering." The poor devils who could not pay much were dealt with in short order. The priests, however, in their own interest knew very well how to please the powerful of the world, in this case the chiefs or the wealthy ones, who asked for their services. They obtained a receipt for the delivered in a particularly clear and beautiful writing on their bodies.

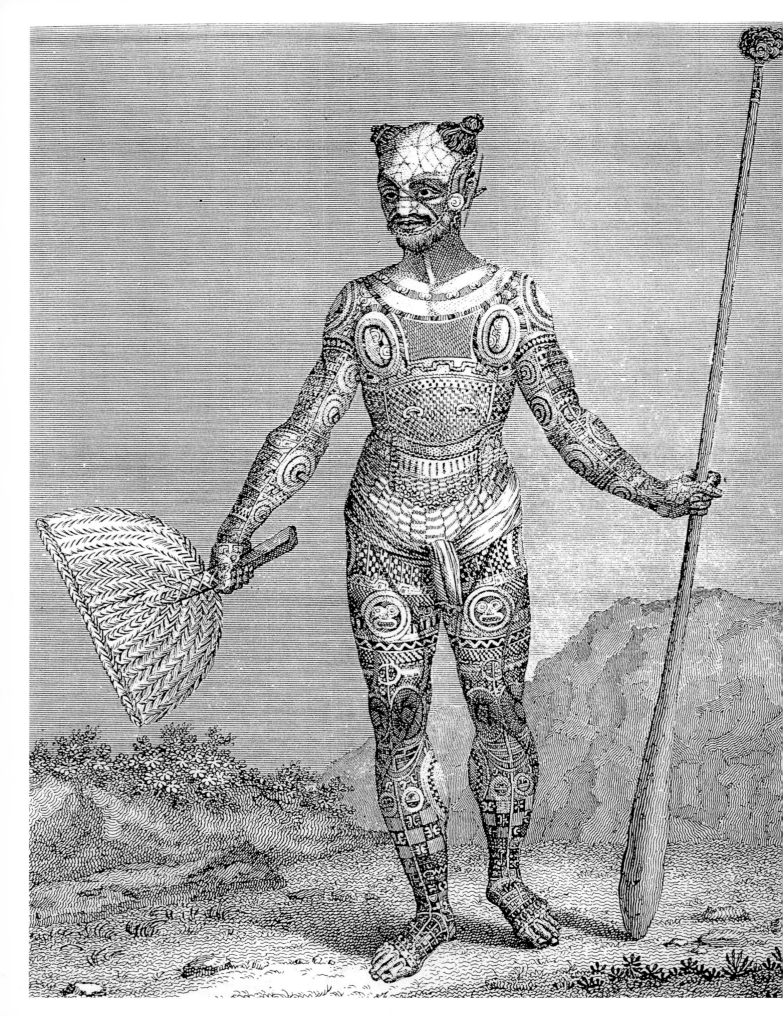

THE MARQUESAS

Isolated in the immense expanse of the Pacific, some 1200 miles due west of Peru, are 12 volcanic islands known as the Marquesas. About 2,000 years ago they were discovered and colonized by Polynesian voyagers who developed a complex culture rich in oral traditions, folklore and the decorative arts. Elaborate wooden carvings, outdoor temples with huge stone *tikis,* and the art of tattooing, reached a high level of sophistication.

**BY TRICIA ALLEN
AND STEVE GILBERT**

The original inhabitants of the Marquesas knew nothing of the outside world until 1595. In that year four ships carrying the Spanish explorer, Alvaro de Mendana, and his crew sailed west from Peru in search of the legendary land of Ophir. Mendana believed that in Ophir he would find King Solomon's mines, a source of gold that had supplied the building material for King Solomon's temple in Jerusalem.

After sailing for a month, Mendana blundered onto the islands, which he at first mistook for Ophir. But he soon realized his mistake, for the islands were populated by ornately tattooed savages who knew nothing of King Solomon's Mines. Mendana called the islands *Las Marquesas* in honor of his sponsor, the Viceroy of Peru, and claimed them as Spanish territory. During their exploration of *Las Marquesas* Mendana and his crew came into frequent conflict with the natives; by the end of their visit they had killed over 200 Marquesans, including many women and children.

Mendana had no accurate method of determining the longitude of the Marquesas and was therefore unable to define their position on a map. Because they lay outside established sailing routes, they were not rediscovered until 1774, when Captain James Cook stopped for four days to take on food and water. Cook and his crew found little of interest in the Marquesas and left after killing only one native.[1]

During the latter part of the eighteenth century explorers, traders, and whalers in need of provisions, occasionally visited the Marquesas. None stayed long, but deserters and mutineers sometimes remained on shore until they could be picked up by another vessel. When the Russian explorer, Ivan Fedorovich Krusenstern, arrived in the Marquesas in 1804, he found two Europeans living among the natives. They were a Frenchman, Jean Baptiste Cabri, and an Englishman, Edward Robarts. Both men had lived in the islands for several years and had been tattooed in the Marquesan fashion. Krusenstern employed them as guides and interpreters, and Georg Heinrich von Langsdorff, the German naturalist who accompanied Krusenstern, used them as informants when he wrote the first published account of native life and customs.[2]

Langsdorff was much interested in Marquesan tattooing, which was far more extensive than tattooing in other Pacific islands. Most Marquesans were completely covered, including hands, feet, and faces, with intricate geometrical designs. Cabri supplied Langsdorff with detailed information on the

An inhabitant of Nukahiwa.
(after Krusenstern)

Opposite page:
A Marquesan warrior.
(after Langsdorff)

A Marquesan tattoo artist at work.
(after Langsdorff)

technique and the significance of the tattooing. W.G. Tilesius von Tilenau, the artist who accompanied the Russian expedition, made the first drawings of tattooed Marquesan natives. Von Tilenau's meticulously accurate illustrations were published in Langsdorff's *Voyages and Travels in Various Parts of the World* (1813). For almost a century, von Tilenau's illustrations were widely reproduced and were the only pictures of Marquesans that had been seen by Europeans. Today they remain an invaluable record of authentic Marquesan tattooing as it was before contact with the outside world. Langsdorff was one of the few European visitors who took an interest in Marquesan culture; other contemporary accounts of the Marquesas focused on the potential strategic and economic value of the islands.[3]

One of Langsdorff's many readers was a young man named Herman Melville, who was inspired to see the Marquesas for himself. In 1841, at the age of 21, Melville shipped out as a common seaman on board a whaling ship. When the whaler stopped to take on provisions in the Marquesas, he deserted and remained in the islands for about six weeks until he was picked up by another ship.

Melville's first two novels, *Omoo* and *Typee*, were romantic fictions inspired by his experiences in the Marquesas, which he embellished and filled in with background material from Langsdorff and other travel books. In both books he described Marquesan tattooing in detail. Melville spent a total of four years as a sailor, beachcomber, and vagabond, and his experiences during this time provided the raw material for six novels, including *Moby Dick*. These books, which were published between 1846 and 1856, reached a wide audience, and many nineteenth century readers discovered the magic of the South Pacific and Polynesian tattooing by reading Melville.

One morning in May 1842, a small group of Marquesans were surprised to see a French Admiral and 60 infantrymen in full ceremonial dress performing what appeared to be a religious ceremony on the beach. One soldier erected a tall pole while other soldiers stood around it in a square. The Admiral said something in French and hit the ground three times with his sword. The soldiers fired their guns into the air, and one of the soldiers pulled a piece of colored cloth up the pole on a rope. The Marquesas had become part of the French Colonial Empire.

With French rule came the advantages of civilization. The French brought newspapers, money, tobacco, guns, liquor and Bibles. They also brought syphilis, dysentery, smallpox, measles, tuberculosis, malaria and leprosy. The Marquesans, who had no natural immunity to these diseases, suffered horribly. Epidemic after epidemic swept the islands. At the beginning of the nineteenth century the native population was about 90,000. When the French took the first census in 1887 they counted only 5,246 natives.

The French military commanders, civil administrators, and missionaries saw Marquesan culture as something to be exterminated. They outlawed traditional native activities such as feasting, chanting, drumbeating, dancing and tattooing. Instead, they advised the Marquesans to take up manly sports and exercises such as soccer, foot racing, boxing, wrestling, and archery.

Marquesan artefacts and works of art were collected by Europeans who exported them to all parts of the world. Statues, bowls, paddles, spears, clubs, bracelets, and even elaborately carved wooden tattoo models of legs and arms found their way into museums and private collections from Cape Town to Leningrad. Under this onslaught, the Marquesan culture collapsed. Native arts and crafts, together with myths and rituals were largely forgotten as the French colonials endeavored to make servants of the men and prostitutes of the women.[4]

It was not until the final decade of the nineteenth century that a serious effort was made to salvage the last remnants of the Marquesan culture. For several years, Karl von den Steinen, a German physician and scholar, searched the museums of the world for Marquesan artefacts. In 1897, he traveled to the Marquesas, where he interviewed the oldest survivors and recorded their myths, legends, and rituals. For 20 years he labored to complete his three volume masterpiece *Die Marquesaner und ihre Kunst*, which was finally published in 1928, the year of his death.

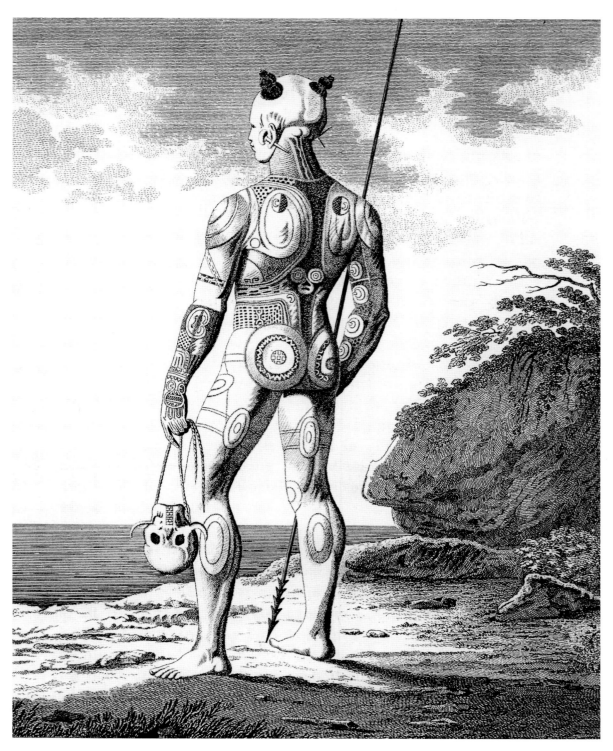

A young Marquesan warrior with unfinished tattooing. (after Langsdorff)

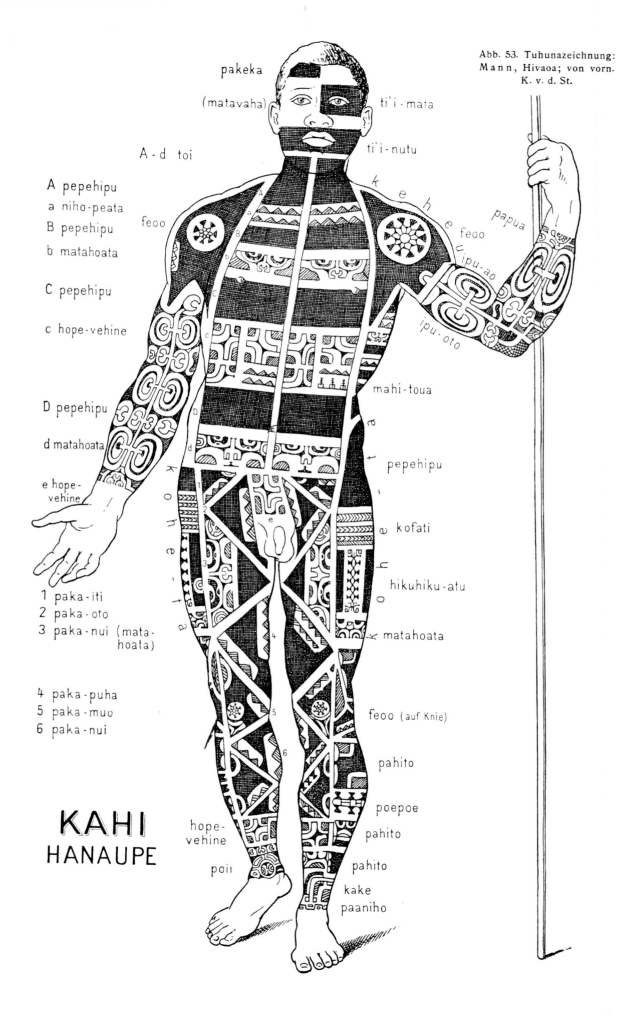

pakeka

(matavaha)

ti'i-mata

A-d toi

ti'i-nutu

A pepehipu
a niho-peata
B pepehipu
b matahoata

C pepehipu

c hope-vehine

feoo

D pepehipu

d matahoata

e hope-
vehine

1 paka-iti
2 paka-oto
3 paka-nui (mata-
hoata)

4 paka-puha
5 paka-muo
6 paka-nui

KAHI
HANAUPE

papua

feoo

ipu-ao

ipu-oto

mahi-toua

pepehipu

kofati

hikuhiku-atu

matahoata

feoo (auf Knie)

pahito

poepoe

pahito

pahito

kake
paaniho

hope-
vehine

poi

Abb. 53. Tuhunazeichnung:
Mann, Hivaoa; von vorn.
K. v. d. St.

58

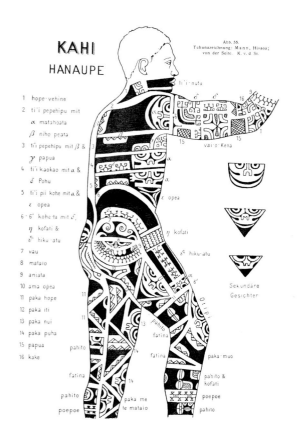

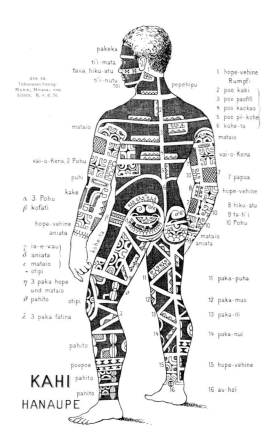

The first volume of von den Steinen's work is devoted to tattooing. Unfortunately, the text has never been translated into English, but the book is of great interest for the illustrations. Von den Steinen includes reproductions of engravings by previous visitors to the islands, together with a wealth of photographs and drawings of tattoo motifs that he describes, analyzes, and compares with motifs found in other Polynesian cultures. The remaining two volumes contain numerous photographs and drawings of superbly crafted carvings in bone, wood, and stone. Von den Steinen's work was a prodigious labor of love and remains today the classic record of traditional Marquesan art.[6]

In 1920, the American anthropologist, E.S.C. Handy and his wife, Willowdean, arrived in the Marquesas. E.S.C. Handy conducted anthropological and archaeological investigations, while his wife studied tattooing. At the time of Willowdean Handy's visit, tattooing was no longer practiced in the Marquesas. The French had outlawed it in 1884, and the prohibition was effective on the two islands occupied by the French at that time. However, tattooing survived for over 25 years in the outlying islands, where many Marquesans were secretly tattooed on parts of the body covered by clothing.

Willowdean Handy traveled on foot through isolated valleys, speaking to the old people and recording everything she could "to the end that the beautiful motifs might at least be partly accounted for and might some day take their merited place in the history of art."[5] In the course of her travels she managed to locate about 125 partially tattooed old people and a single surviving artist who had practiced in his youth. She found only a few women and one very old man who were completely covered in the traditional style.

Handy identified and recorded over 40 designs that she included in her publication, and her field notes include close to a hundred. The Marquesan artists rarely invented new designs, but confined themselves to varying the arrangement and the details of the old designs. Handy's informants told her that many of these designs had purposes and meanings in ancient times, but with the disintegration of the Marquesan culture the meanings had been lost.

Side view of a tattooed Marquesan male. (after von den Steinen)

Back view of a tattooed Marquesan male. (after von den Steinen)

Opposite page: Front view of a tattooed male Marquesan. (after von den Steinen)

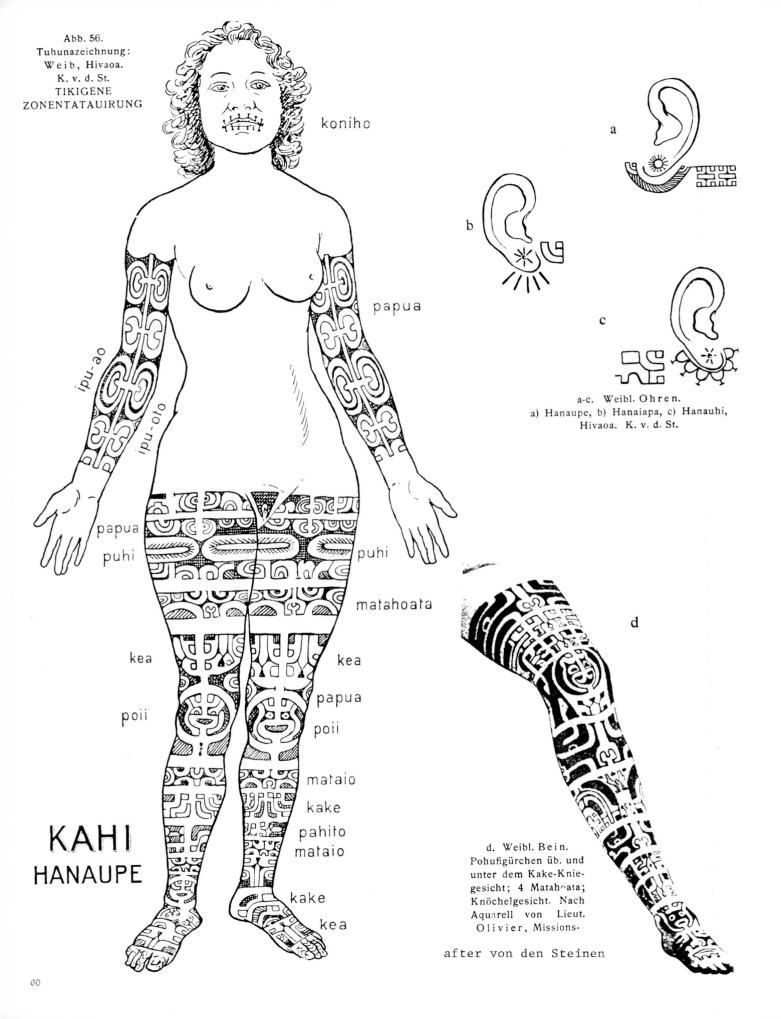

Abb. 56.
Tuhunazeichnung:
Weib, Hivaoa.
K. v. d. St.
TIKIGENE
ZONENTATAUIRUNG

koniho

papua

ipu-ao

ipu-oto

papua
puhi

puhi

matahoata

kea

kea

poii

papua
poii

mataio

kake

pahito
mataio

kake

kea

KAHI
HANAUPE

a

b

c

a-c. Weibl. Ohren.
a) Hanaupe, b) Hanaiapa, c) Hanauhi,
Hivaoa. K. v. d. St.

d

d. Weibl. Bein.
Pohufigürchen üb. und
unter dem Kake-Knie-
gesicht; 4 Matahoata;
Knöchelgesicht. Nach
Aquarell von Lieut.
Olivier, Missions-

after von den Steinen

60

Willowdean Handy wrote three books describing her adventures among the Marquesas: *Tattooing in the Marquesas*, *Forever the Land of Men*, and *Thunder from the Sea*.

Tattooing in the Marquesas contains photographs and many drawings of ancient designs. In addition, Handy summarized the information collected from interviews with informants. She includes only brief references to the earlier accounts, however, and uses only a few of the early illustrations in her analysis.

Forever the Land of Men is an engaging autobiographical account of Handy's experiences in the Marquesas. In it she describes her meetings with the islanders, her travels, and her first-hand impressions of native life.

Of all the Americans and Europeans who visited the Marquesas, only a few made any serious effort to record the tattooing which was unique to the islands. We owe them a great debt, for without them we would know almost nothing of a beautiful and sophisticated art form that took thousands of years to develop but only a few decades to destroy.

MELVILLE IN THE MARQUESAS, 1842

The following selection is taken from T*ypee* by Herman Melville

In one of my strolls with Kory-Kory, in passing along the border of a thick growth of bushes, my attention was arrested by a singular noise. On entering the thicket I witnessed for the first time the operation of tattooing as performed by these islanders.

I beheld a man extended flat upon his back on the ground, and despite the forced composure of his countenance, it was evident that he was suffering agony. His tormentor bent over him, working away for all the world like a stonecutter with mallet and chisel. In one hand he held a short, slender stick, pointed with a shark's tooth, on the upright end of which he tapped with a small hammer-like piece of wood, thus puncturing the skin, and charging it with the colouring matter in which the instrument was dipped. A coconut shell containing this fluid was placed upon the ground. It is prepared by mixing with a vegetable juice the ashes of the "armor," or candle-nut, always preserved for the purpose. Beside the savage, and spread out upon a piece of soiled tappa, were a great number of curious black-looking little implements of bone and wood, used in the various divisions of his art…

The artist was not at this time engaged on an original sketch, his subject being a venerable savage, whose tattooing had become somewhat faded with age and needed a few repairs, and accordingly he was merely employed in touching up the works of some of the old masters of the Typee school, as delineated upon the human canvas before him. The parts operated upon were the eyelids, where a longitudinal streak, like the one which adorned Kory-Kory, crossed the countenance of the victim.

In spite of all the efforts of the poor old man, sundry twitchings and screwings of the muscles of the face denoted the exquisite sensibility of these shutters to the windows of his soul…But the artist, with a heart as callous as that of any Army surgeon, continued his performance, enlivening his labours with a wild chant, tapping away the while as merrily as a woodpecker.

So deeply engaged was he in his work, that he had not observed our approach, until, after having enjoyed an unmolested view of the operation, I chose to attract his attention. As soon as he perceived me, supposing that I sought him in his professional capacity, he seized hold of me in a paroxysm of delight, and was all eagerness to begin work. When, however, I gave him to understand that he had altogether mistaken my views, nothing could exceed his grief and disappointment. But recovering from this, he seemed determined not to credit my assertion, and grasping his implements, he flourished them about in fearful vicinity to my face, going through an imaginary performance of his art, and every moment bursting into some admiring exclamation at the beauty of his designs.

Horrified at the bare thought of being rendered hideous for life if the wretch were to

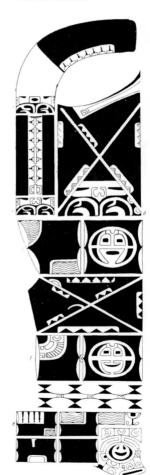

Leg tattoos for men.
(after Willowdean Handy, by permission of the Bishop Museum)

Opposite page: A tattooed Marquesan female. (after von den Steinen)

execute his purpose upon me, I struggled to get away from him, while Kory-Kory, turning traitor, stood by, and besought me to comply with the outrageous requests. On my reiterated refusals the excited artist got half beside himself and was overwhelmed with sorrow at losing so noble an opportunity of distinguishing himself in his profession.

The idea of engrafting his tattooing upon my white skin filled him with all a painter's enthusiasm: again and again he gazed into my countenance, and every fresh glimpse seemed to add to the vehemence of his ambition. Not knowing to what extremities he might proceed, and shuddering at the ruin he might inflict on my figure-head, I now endeavored to draw his attention from it, and holding out my arm in a fit of desperation, signed him to commence operations. But he rejected the compromise indignantly, and still continued his attack on my face, as though nothing short of that would satisfy him. When his forefinger swept across my features, in laying out the borders of those parallel bands which were to encircle my countenance, the flesh fairly crawled upon my bones. At last, half wild with terror and indignation, I succeeded in breaking away from the three savages, and fled toward old Marheyo's house, pursued by the indomitable artist, who ran after me, implements in hand. Kory-Kory, however, at last interfered, and drew him off from the chase.

This incident opened my eyes to a new danger; and now I felt convinced that in some luckless hour I should be disfigured in such a manner as never more to have the *face* to return to my countrymen, even should an opportunity offer. ■

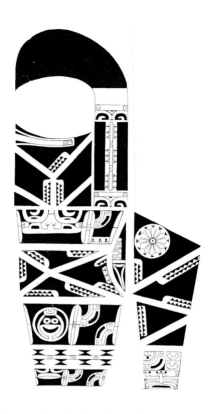

The following selection is taken from *Forever the Land of Men* by Willowdean Handy

HANDY IN THE MARQUESAS, 1920

Tuu-apre stood like a majestic oak in the middle of the pool, dropped her bundle of clothes, then gravely sat on her stone. As I walked away, she was soaping and sousing the contents of the black cloth, beating them with a stick with resounding whacks that drowned the clacking of tongues and the gurgling of the stream.

When I passed that way one hour later, the old woman had slipped down into the pool of suds and was alternately scrubbing herself and a child. Her strong back was modestly presented to the path, and I surmised that she would soon send the child to fetch the clean dress left hanging on a bush. In a sleight of hand privacy in the middle of an open stream she would clothe herself without undue exposure. I had hurried past when her sharply barked *kaoha* arrested me. In the moments of my turning away she had accomplished her robing. Her determined head was emerging from her clean Mother Hubbard as she stepped onto her rock. I gasped with surprise. The old lady's legs were ornamented with the dark blue traceries of tattooing! I could not imagine this dignified grandmother as a lively coquette on the feast place lifting billowing tapa skirts of bark cloth to show off her patterns gleaming under scented yellow oil. I followed her home and wheedled her into letting me copy her amazing decorations.

I discovered immediately that it was not out of shame that she hid her patterned legs but out of fear of the criticism of the authorities who considered it ugly and had forbidden tattooing long ago. Her hard face softened when I exclaimed over the beauty of her lace like stockings. From this moment I knew that I would be doing far more than saving a decorative art from oblivion. I would be giving a boost of self-respect to the old people who so sorely needed it.

That first effort was a task of many hours. I was overwhelmed by the complexity of the

Leg tattoos for men. (after Willowdean Handy, by permission of the Bishop Museum)

designs that covered her from buttocks to toes. There were fifty-five separate units on her legs that were repeats or variations of fourteen different basic motifs, each one with a name. She rattled off the names and I wrote them down, but it was hard to match them with their designs. I couldn't tell the difference between the simple versions of a man, a cockroach, and a turtle. She couldn't tell me the meaning of many of the names, which I had to dig out of the dictionary or out of the memories of other old people. However, from Tuu-ape I did learn the beginning of a vocabulary of tattooing design.

Knowing now the nature of the task ahead of me, I devised a quicker and easier way of recording the patterns. I carried with me outline drawings of legs, hands and faces on which I could chart numbers referring to the motifs drawn separately. The composition of such a mosaic was not so difficult as it seemed at first, for the basic scheme of decoration was one of vertical stripes and horizontal bands made up of smaller units. Before I left the Marquesas, I painted over Tuu-ape's designs with watercolor black so that I could have a photograph to substantiate what I had drawn.

She was the first of more than a hundred people whose designs I copied. Many had been clandestinely decorated because the tattooing experts, *tuhuna patu tiki,* masters of striking images, had been forbidden to operate as long ago as 1858, and again in a final effort to stamp out the custom in 1884. Many remembered the pain and the pride in the operation, but a man on Fatu Hiva was the only one living who had practiced it. Looking at the precise and intricate patterns, it was impossible to imagine how anyone, regardless of how well trained were his eyes and hands, could follow so accurately a charcoal design drawn on pliant skin that oozed blood at every stroke. As for the clients, of course they screamed and cried—the more, the better, since it proved how brave they were under great pain.

I came to evaluate the achievement of these surface decorators not just in terms of their skill. Although they were limited in any artistic conception in applying rectangles to the curves of the human body, still they did achieve real beauty in the lace like mittens, stockings, and full suits they gave their clients. I honestly admired these embellishments, much to the amazement of the women who had been taught to regard them as ugly and disgraceful. They began to remember their favorite practitioners with pride. The consulted one another about the names of their designs and felt erudite when they relayed the information to me…

Haa-pu-ane came to our rescue, offering to lead us to the house of a carver who had once been a practitioner of tattooing, the only one alive today. As we walked we reveled in the lush growth in ravines that were filled with ferns, some with yellow under surfaces, some fragrant, which Haa-pu-ane picked and twined into hat wreaths for us. It made us feel gay and wanted! We needed the boost, for a group of women sitting beneath tall, slender trees of paper mulberry, once furnishing bark for tapa, did not look up at us as we passed, but continued their absorption in making ornamental hat braids from strips of skin from yellow cane reeds and brown midribs of bird's nest ferns.

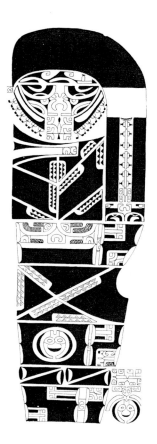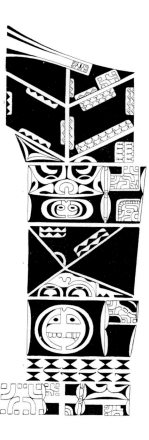

Leg tattoos for men. (after Willowdean Handy, by permission of the Bishop Museum)

We found the carver working on a canoe model, inscribing on its hull and sideboards a maze of angular motifs. His only tools were half a pair of scissors and a piece of umbrella rib. His only patterns were in his head. The accuracy of the geometric arabesques was amazing. Edward offered to buy the canoe, which was just about finished. He shook his head. He worked only for friends. This was for his sister's son.

Light came into his eyes when we asked him about the practice of tattooing. He shed his indifference and began to pantomime the scene, spreading an imaginary piece of tapa on the ground in front of him, removing instruments from a bamboo container, laying them carefully upon the tapa. He named and described the baton of hibiscus wood and the mallets with reed handles and toothed heads made of human and bird bone. "Many teeth for big tikis, one or two for thin lines," he told us.

I think he really saw a young man lying on the mat beside him and his four helpers holding the youth's arms and legs and stretching his skin where the master was outlining a design with a piece of charcoal. He certainly made us see how he held a mallet and a piece of tapa in his left hand, a baton in his right, as he struck the teeth into the skin and wiped away the blood, then dipped a pigment of soot from a coconut shell and smeared it on the teeth. The work proceeded rhythmically, strike, wipe, dip, smear. He began to chant, "It is struck, it is struck, your design. Tap-tapping your design." When he stopped and looked up at us grinning, we all returned to reality with a shock.

I asked him to tell me about the old-time tattooing designs. He took my notebook and drew some of them. For half an hour or more he sat like a man in a trance while some supernatural control manipulated his pencil. He drew designs appropriate for all parts of the body. I watched with growing interest. Though I recognized many as familiar in my collections known as "the Hiva Oa style," and could name them readily, I saw that his versions were simpler and more primitive in form. This was true of such conventional motifs as eyes, ears, teeth, and bent arms. But when he began to depict in seminaturalistic style objects and plants, which I had never seen before, I realized that he was giving me an entirely new dimension in Marquesan decorative design. There were pandanus roots and branches, ikeike vines, a calabash, fishing spear, shell wreath, wreath of cock's plumes, a native garden enclosure, and a chief's bathing pool.

He suddenly thrust the notebook back into my hand, but brushing aside my admiration and gratitude, he rose and marched to and fro illustrating how a man showed his designs to the best advantage. By lifting his hand to strike, he could display his underarm patterns; walking with hands clasped behind his back, he spread his chest designs; sitting with crossed legs, he turned up the motifs on his inner knees. He beckoned to Haa-pu-ane to draw near, so that he could show us what parts of the body he had decorated. He started with the crown of the head, careful not to touch Haa-pu-ane's, but pointing only, then went on with face, eyelids, tongue, back and chest, arms and hands, legs and feet. "All, all!" he exclaimed. Nodding at Haa-pu-ane's whispered suggestion, he added, "Different for women—only lips, ears, hands, legs, maybe on upper arm. Once, a fine girdle on the back of Vae-kehu of Nuku Hiva. I have heard, but never seen."

Then he began to talk in soft, swift words with so many graces of the pure tongue that I was lost in listening and even Edward had to turn to his interpreter for a translation.

"He says that the old-time people knew the true images. There were images for the skin and images for woodcarving. They were different."

"I knew it!" I cried.

My companion grimaced at the next assertion. "Here it is again. 'The old taboos are lies.' He agrees, of course, but he says that only fools put body images on food bowls. He says he questions the carvers, "Do you want to make your friends sick? Very bad to eat from bowls covered with images meant for the body.'"

At this point the old man spat and growled something which I thought meant, "Today nobody knows, nobody cares."

"I care," I assured him, and showed him some of my pen-and-ink drawings of the Hiva Oa patterns. After staring at them in utter immobility, he threw back his head and laughed with pure joy.

"You are a striker of images, a master tattooer," he cried.

Taken aback by such praise and melted by this complete acceptance, I went through a few minutes of confusion. Just how things happened I have no very clear idea. When we left the bare shack of this ardent artisan, he was fingering our gift of an Ingersoll watch with loving incredulity, his wife was staring at a few francs pressed into her hand, I was folding drawings of old tattooing designs into my notebook, and my companion was carrying the beautiful canoe model in his arms. In an atmosphere of spontaneous and genuine *kaoha* an exchange had taken place with satisfaction to all. ∎

HANDY ON MARQUESAN ART, CIRCA 1920

The following selection is taken from *L'art des Iles Marquises* by Willowdean Handy (1922)

In 1921 there did not exist more than a hundred or so old men whose skin bore testimony to the skill of the Marquesans in the art of tattooing, a skill which filled the first voyagers to these islands with astonishment. Nevertheless, the piercing eyes of these unoccupied artists still burn with that fertile intelligence which distinguished their ancestors. Their temperament is no more changed than the rocks of their islands; behind a mask of indifference and reserve, their ancient ideals are like beasts at bay. To know these last descendants is to know the inventors of their arts.

One cannot separate the art of the Marquesas from the fabric of their civilization. All their arts and crafts are related to the supernatural. Their decorative themes have developed from their environment; their style and their manner of composition are the result of their heredity and their development in complete isolation.

For the native of the Marquesas, the making of every new object was literally an act of creation derived from the first act of procreation, in which Atea, the celestial Father, impregnated One-u'i (also called Atanua, the Dark Earth). His generative power, passing through the birth of lands and trees, descends quite naturally to that rock or that tree which the native employs for his work. It was indispensable to mix consciously the new object with all its past evolution: this was the task of the priest of ceremonies, or of a choir of old men, or sometimes old men and women, who chanted the sacred incantations relating to genesis and the growth of the world and of man.

Each new creation was a most grave enterprise. The proof of this lies in the fact that to consecrate a new house, a canoe, or a coffin constructed for a person of high rank, or to celebrate the completion of his tattooing, it was necessary to sacrifice a human victim to the god of the tribe.

The conception of the considerable importance of the creative activity (hana) in the spirit of the native and of the circumstances that presided at the work is indispensable for a comprehension of the professional ideal that animates these artisans. The products of each art are determined by ritual, and the designs are fixed by tradition…. Because he is obliged to conform to classic models, the Marquesan artist must concentrate on the perfection of manual dexterity. His vanity and his ambition incite him to feats of precision and rapidity. Contests between masters are not rare. Two or three may practice tattooing in the same house; they compete by tracing the most complicated designs, and establish records of speed and dexterity.

After the long and painful ordeal of tattooing, after the pitiless puncture of designs into the tender skin, the days of suffering, the feverish nights—there was a festival to celebrate the completion of the work. Drums were heard at dawn. From the site of the festivities chants and incantations echoed through the valley. The natives arrived carrying baskets, buckets, and bowls of food that had taken many days to prepare. The guests were radiant in their finest ornaments; it was a time of relaxation and celebration after a long period of concentrated effort. (*translated by Steve Gilbert*) ∎

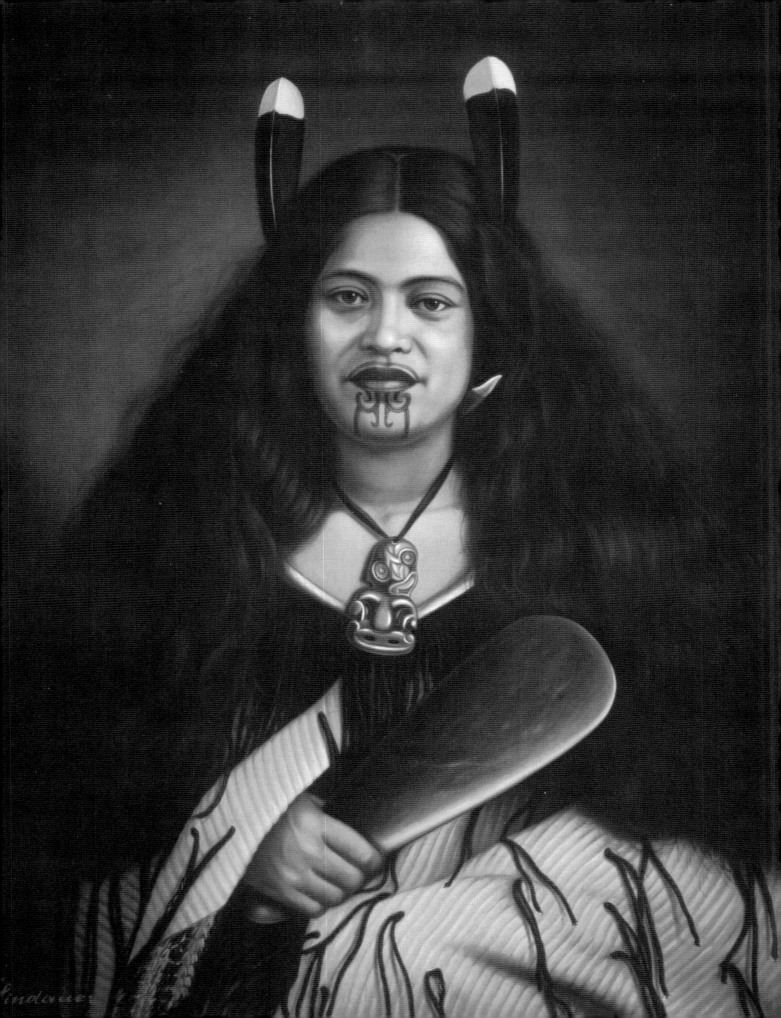

NEW ZEALAND

Major General Horatio Robley was a man of many talents. He distinguished himself in battle against the Maoris during the Maori rebellion of 1865. He was also a writer and illustrator whose work appeared in *Punch, The Illustrated Sporting News*, and other British periodicals. Like most British military men, he had great respect for the courage of the Maori warriors. Unlike most British military men, he took a keen interest in Maori art and was the father of three half-Maori children.

Robley's book, *Moko, or Maori Tattooing*, has remained the standard reference since its publication in 1896. In it Robley summarized all previous accounts of Moko and added much original material based on his own observations, including 180 original drawings and photographs. In the introduction to his book Robley wrote:

> My main object in this book is to present a series of illustrations of the art of moko or tattooing, as practiced by the Maoris. It is fast vanishing, and a record of it by one who has studied the subject for many years may be worth publication. I have learnt all I could of moko in New Zealand, and from the best sources, and such skill as I have as an artist has long been employed in setting down my notes in the form of drawings.[1]

Moko was unique in that the face was decorated with intricate spirals that were not only tattooed but also incised into the skin to make scars in the form of parallel ridges and grooves. With the exception of slaves and commoners, all men were tattooed on the face and most were also tattooed on other parts of the body. An elegantly tattooed face was a great source of pride to a warrior, for it made him fierce in battle and attractive to women.

Women were also tattooed, but not as elaborately as the men. Lips outlined and tattooed solid blue were considered beautiful. The chin was also tattooed, and sometimes a few lines or spirals were worn on the cheeks or the forehead. One early explorer reported seeing Maori women with complete facial tattooing like that of the men, but this was apparently rare. Although tradition limited facial tattooing in women, there were apparently no rules as to what might be done to other parts of the body, and many women were elaborately tattooed on the breasts, thighs, and legs.

Moko designs consisted of a series of traditional components, each of which had a name. These components were varied and elaborated by the artist so that although all facial tattoos resembled each other, no two were identical. Maori chiefs were able to draw their own facial tattoos accurately from memory, and used them as signatures. Many of these moko signatures are preserved on land grants and deeds signed by Maori chiefs whose tribal territories were appropriated by the British.

The tattooing instruments used by the Maoris were small chisel-shaped pieces of bone, shell, or metal that were dipped in pigment and then struck with a mallet. In order to create the scarred ridges and grooves characteristic of moko it was necessary for the instrument to penetrate deeply into the flesh, and the cuts were sometimes so deep that they went through the cheek. The pain was intense and much blood was spilled, but it was a point of pride with Maori warriors never to flinch or make a sound while being tattooed.

The Maoris took heads as trophies during war, and heads were embalmed and preserved during peace as well as war. This honor was usually reserved for persons of importance and their loved ones, including women and children. The heads remained with the families of the deceased, who kept them in ornately carved ceremonial boxes. They were protected by strict taboos and brought out to be viewed during sacred ceremonies.[2]

It was not until the first decade of the 19th century that Europeans made regular contact with Maori tribes living along the coast. European and American whalers employed Maoris to cut timber

Opposite page:
Gottfried Lindauer. Pare Watene. Oil on canvas.
Auckland Art Gallery Toi o Tamaki, presented by Mr. H. E. Partridge, 1915

and help repair damaged sailing ships. Some Maoris were pressed into service to replace crewmembers who had deserted, and gradually trade was established between the Europeans and the Maoris. The Maoris disdained trading items such as cloth, mirrors, beads, and trinkets, but took great interest in knives and guns, for which they traded potatoes, pork, and flax.

By 1810, European settlers began to arrive in New Zealand, and in 1814, three intrepid missionaries undertook to convert the savages. They faced a formidable obstacle in the Maori language, which was complex and ill-suited to the expression of Christian dogma. Maori warriors were skeptical when they were told that they should turn the other cheek and that the meek would inherit the earth.

One early missionary, Thomas Kendall,[3] persuaded a converted chief named Hongi to go with him to England, where he labored with an Oxford professor of linguistics to write a bilingual dictionary and to translate the Bible into the Maori language. While in England, Hongi was presented to polite society, where his dignified bearing and his elegantly tattooed face excited great admiration. King George IV granted him an audience and presented him with a large trunk full of gifts as a reward for his efforts in spreading the gospel.

On his way back to New Zealand, Hongi stopped off in Sydney, where he exchanged King George's gifts for several hundred muskets and a large supply of ammunition. Dressed in a coat of mail that the King had given him, he made a triumphant return to New Zealand, where he promptly forgot his new found faith and used his muskets to launch a series of highly successful raids against his traditional tribal foes.[4]

For a time his enemies were unable to resist him. Muskets were expensive, and Hongi's enemies had little to trade for firearms. A ton of flax, which had to be laboriously scraped and dressed by hand, bought only one musket.

The Maoris soon discovered, however, that European traders would trade a musket for a tattooed head, and before long business was booming. Maori warriors made raids on neighboring tribes for the sole purpose of obtaining tattooed heads to trade for guns. The traders took these heads through Sydney, where they were acquired by dealers who sold them at outrageous prices to museums and private collectors in Europe. As more Maoris acquired muskets, more heads became available, and business prospered.

The supply of guns was inexhaustible, but the supply of heads was not, and before many years had passed the Maoris were forced to resort to desperate measures. Slaves and commoners captured in battle were tattooed and killed so that their heads could be sold. And even heads of poor quality, with mediocre or unfinished tattooing, were offered for sale.

At first the British were content to let the Maoris kill each other off, but, in 1830, sensational accounts of the horrors associated with tribal warfare, headhunting, and the sale of human heads began to appear in the popular press. The Foreign Office was embarrassed. The British were powerless to stop the sale of human heads in New Zealand, which did not become a British colony until 1840, but they did pass a law against importing heads into Australia. This put many of the Australian middlemen out of business, and after 1831 the traffic in heads went into decline.[5]

As more and more British settlers arrived in New Zealand, the Maoris, who were by then well armed, realized they had a common enemy and banded together to attack British farms and settlements. The New Zealand Premier then hit on an ingenious plan: he would punish the Maoris by confiscating their land. To do this he imported British troops, who joined forces with local militia, and forced the Maoris to give up their territory in a series of bloody wars that took place between 1860 and 1870.

The Maoris were superb warriors. They loved their land and defended it courageously, earning the respect of the British for their chivalry and "sporting spirit." On many occasions they agreed to temporary cease-fires and allowed food, ammunition, and prisoners to be exchanged so that the fighting could continue. The British military historian, J. W. Fortescue, wrote that the British soldier

thought the Maoris "on the whole the grandest native enemy that he had ever encountered."[6]

But the courage of the Maoris was no match for the superior firepower of the British. Inevitably, the Maoris lost their land. Much of the Maori territory that was not confiscated by force was acquired by speculators and shysters who got it for a small fraction of its actual value. After the wars, the demoralized Maoris sold the last remnants of their land recklessly. Plots of land went for a few axes and blankets. Even missionaries got in on the act. During the course of the land grab, several prominent Anglican divines availed themselves of the opportunity to acquire estates as large as 2,000 acres.[7]

When the Maoris lost their land they lost their interest in tattooing and other traditional skills. They were proud warriors no longer. Some learned to live on liquor and credit. Others learned to work as sailors and laborers for the British, who made fun of their tattooed faces. Photographs taken during the latter part of the 19th Century show grim Maori men with unfinished facial tattoos, wearing beards and ill-fitting European clothing. On the occasion of his visit to New Zealand in 1872, Anthony Trollope wrote: "There is scope for poetry in their past history. There is room for philanthropy in their present condition. But in regard their future, there is hardly a place for hope."[8]

In 1873, a young Bohemian artist named Gottfried Lindauer arrived in New Zealand. Lindauer was inspired by the landscape and fascinated by the Maoris. Shortly after his arrival he met Henry Partridge, a businessman with whom he formed a fast friendship. Partridge and Lindauer shared an interest in the traditional Maori way of life and resolved to make a record of it.

As part of this project, Partridge commissioned Lindauer to make several portraits of Maori chiefs. Lindauer's first portraits were eminently successful and over the years Partridge continued to support Lindauer's artistic efforts until, by the end of the 19th century, he had completed over 100 portraits. These paintings were eventually purchased by the city of Auckland are now part of the permanent collection of the Auckland Art Gallery.

Lindauer's work is of great historical value because many of the individuals who sat for their portraits had played leading roles during New Zealand's formative years. Most of the Maoris Lindauer painted were heavily tattooed, and in every case Lindauer recorded the tattooing, the tribal dress, weapons, and expressions of his sitters with meticulous accuracy.

When Lindauer's paintings were exhibited, many Maoris came to sit gravely for hours before the portraits, as they shared memories of their ancestors' traditional way of life.

A typical entry in the visitor's book reads: " I greatly wondered and felt delight on seeing the faces of the fathers and chiefs of the Maori people, who have passed away into the night. This is why I am thankful to the man who made these beautiful pictures. The faces of this company of the dead are as if they are living now."[9]

When Lindauer died in 1926 at the age of 88, he left a priceless record of some of the most artistic and sophisticated tattooing that has ever been done. His passionate interest in the Maoris and his love of their art will live on in his paintings and be appreciated by many generations to come.

BANKS IN NEW ZEALAND: MARCH, 1770

Both sexes stain themselves with the color of black in the same manner and something in the same method as the South Sea Islanders, introducing it under the skin by a sharp instrument furnished with many teeth, but the men carry this custom to much greater lengths and the women not so far; they are generally content with having their lips blacked but sometimes have patches of black on different parts of their bodies. The men on the contrary seem to add to their quantity every year of their lives so that some of the elder are almost covered with it. Their faces are the most remarkable; on them, they by some art unknown to me dig furrows in their faces, a line deep at least and as broad, the edges of which are often again indented and most perfectly black. This may be done to make them look more frightful in war; indeed it has the effect of making them most enormously ugly, the old ones at least whose faces are entirely

The following passage is taken from *The Endeavor Journal of Joseph Banks*, edited by J.C. Beaglehole.

covered with it. The young again often have a small patch on one cheek or over an eye and those under a certain age (maybe 25 or 26) have no more than their lips black. Yet ugly as this certainly looks it is impossible to avoid admiring the immense elegance and justness of the figures in which it is formed, which in the face is always different spirals, upon the body generally different figures resembling the foliages of old chasing upon gold or silver; all this is finished with a masterly taste and execution, for of a hundred which at first sight you would judge to be exactly the same, on close examination no two will prove alike; nor do I remember having seen any two alike, for their wild imaginations scorn to copy as appears in almost all their works. In different parts of the coast they varied very much in the quantity and parts of the body on which the *amoco* as they call it was placed, but in the spirals upon their faces they generally agreed, and I have generally observed that the more populous a country was, the greater quantity of this *amoco* they had; possibly in populous countries the emulation of bearing pain with fortitude may be carried to greater lengths than where there are fewer people and consequently fewer examples to encourage. The buttocks which, in the islands, was the principal seat of this ornament in general here escapes untouched: in one place only we saw the contrary. Possibly they might do this to be esteemed more noble, as having transferred the seat of their ornament from the dishonorable cheeks of their tail to the more honorable ones of their heads. ∎

The following selection is taken from *Moko, or Maori Tattooing* by Horatio G. Robley.

ROBLEY IN NEW ZEALAND, CIRCA 1890

On Sunday, October 8th, 1769 Captain Cook records that the first native with moko was shot, and notes that one side of the face was tattooed in spiral lines of a regular pattern. The navigator calls the tattooing "amoko." In recounting his first voyage, Captain Cook says each separate tribe seemed to have a different custom in regard to tattooing; for those in some canoes seemed to be covered with the marking, while those in other canoes showed scarcely a stain except on the lips, which were black in all cases. He says: "The bodies and faces are marked with black stains they call 'amoco', broad spirals on each buttock, the thighs of many were almost entirely black, the faces of the old men are almost covered. By adding to the tattooing they grow old and honourable at the same time.

"The marks in general are spirals drawn with great nicety and even elegance. One side corresponds with the other. The marks on the body resemble the foliage in old chased ornaments, convolutions of filigree work, but in these they have such a luxury of forms that of a hundred which at first appeared exactly the same no two were formed alike on close examination."

And in the course of his first voyage he describes some of the New Zealanders as having their thighs stained entirely black, with the exception of a few narrow lines, "so that at first sight they appeared to wear striped breeches." He observes that the quantity and form of these marks differ widely in different parts of the coast and islands; and that the older men appeared to be more profusely decorated.

One may almost regret that a practice which suited the Maoris and which involves so much art and skill is rapidly dying out under modern influences. In Captain Cook's time it was very generally practiced and was carried to a point of ferocious perfection which never failed to attract the visitor who regained his ship. With Captain Cook was Sydney Parkinson, the clever draughtsman employed by Mr. Joseph Banks; and Parkinson's journal gives some account of moko as it was in 1769, besides the first drawings of it. He says: "As to the tattowing, it is done very curiously in spiral and other figures; and in many places indented into their skins which looks like carving, though at a distance it appears as if it had been only smeared with a black paint. And he adds: "The tattowing is peculiar to the principal men among them."

Also at another part of the coast, he says: "These people were much like them we had seen

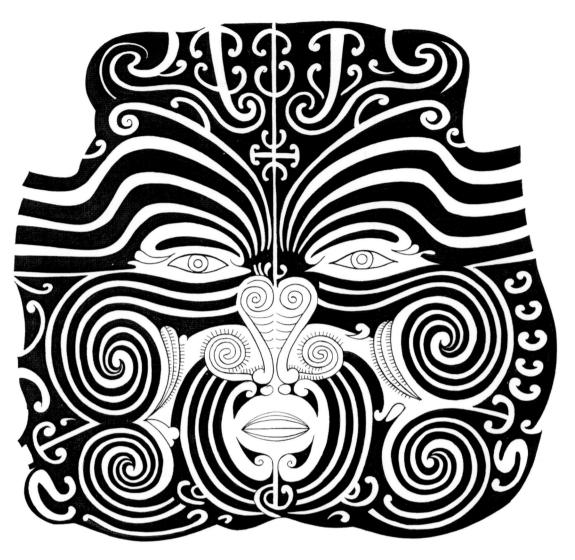

Self portrait by Te Phei Kupe.
(after Craik)

heretofore; excepting that they were more tattowed: most of them had the figures of volutes on their lips, and several had their thighs and part of their bellies marked. The tattoow on their faces was not done in spirals, but in different figures from what we had ever seen before."

The mode of tattooing practised by the Maoris was unlike that of any other race, and their artistic designs were so arranged that the skin of the face was often completely covered up to the corners of the eyes, and even over the eyelids; and that the stains, though tending to diminish in brilliancy, were indelible. But doubtful as the meaning of moko is, there were uses for it. Some portion of it, some distinctive part, was a mark of identity, and has been copied for Europeans by the Maoris as a signature.

Polack speaks of the pride the New Zealanders take in adding the various curvatures of the moko to their signatures: "Our risibility has," he says, "often been excited in viewing an aged chief, whose scant locks have weathered upwards of seventy winters, drawing with intense care his signature, with inclined head and extended tongue, as is the wont of young European practitioners in the art of penmanship."

Another remarkable work of art is a drawing of himself by Te Pehi Kupe, a fine piece of moko which must be taken as correct. His body was also plentifully covered with marks; and his fine muscular arms were in particular furrowed by numerous single black lines, which he said denoted the number of wounds he had received in battle.

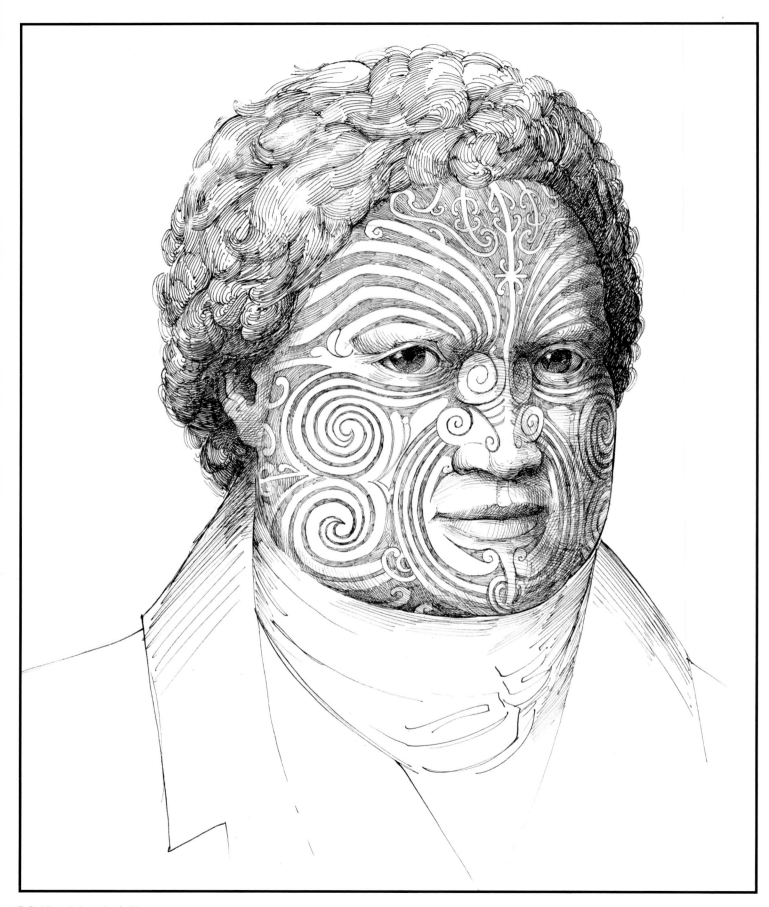

Te Phei Kupe. (redrawn after Craik)

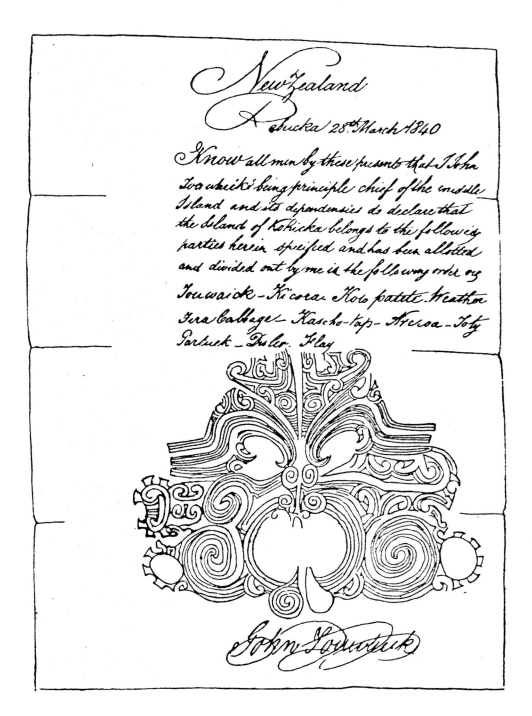

New Zealand

A Pucka 28th March 1840

Know all men by these presents that I John Tou whaiki being principle chief of the middle Island and its dependencies do declare that the Island of Kohicka belongs to the following parties herein specified and has been allotted and divided out by me in the following order viz

Touwaick - Ki cora. Kolo patite. Weathor Fira Cabbage - Kascho tap - Arcroa - Toty Tarluck - Fisler. Flag

John Touwaick

A Moko signature on a land grant signed by Tuawhaiki, a chief of the Otago (Ngaitahu tribe). (after Robley)

Te Pehi Kupe (whose daughter had been killed and cooked) was in England in 1826 to procure arms to revenge the onslaughts of the northern tribes. He gave some valuable information on the subject of moko when sitting for his portrait, for he was very anxious that the marks on his face should be accurately copied. One mark just over his nose was, he said, his name, "Europee man write with pen his name. Te Pehi's is here" (pointing to his forehead); and he delineated on paper the corresponding marks or names of his brother and of his son. Every line, both on his face and on other parts of his body, was firmly registered on his memory. The portrait of his moko was drawn by him without the aid of a mirror. During his stay in Liverpool he was besieged with applications for specimens of his art, and for a fortnight a large part of his time was occupied in turning out sketches of his face. The depth and profusion of the moko, he said, indicated the dignity of the individual; and little of the original surface of his face remained. Some of his sketches represented moko on other portions of his body. He drew for Dr. Traill the mokos of his brother and of his son; and on finishing the latter, he held it up and gazed on it with a murmur of affectionate delight, kissing it many times and, as he presented it, burst into tears.

Te Pehi's statement that the more elaborate the moko the higher was the rank implied may have been true, but it was by no means always the case among the Maoris. The time he had for the artists, and the wishes and power of endurance of the patient, had no doubt much to do with the nature and extent of the pattern. Many of the great chiefs were only partly decorated; and the likeness of the king who was a visitor here in 1884 accompanied by four chiefs will show that even King Tawhiao was far behind Te Pehi in elaborate decoration. It must be admitted that a man with such a pattern drawn on his face as Te Pehi had was entitled to assume the role of a critic on tattooing.

A Maori warrior.
(drawn from life by Robley)

Some reference has already been made to the uncertainty attaching to the object with which moko was practiced by the men of the Maori race; but some further speculations on this subject suggest themselves. Not only to become more terrible in war, when fighting was carried on at close quarters, but to appear more distinguished and attractive to the female sex, must certainly be included. The great chiefs had their faces and bodies covered with designs of extreme delicacy and beauty; and all the men, except the slaves, were more or less decorated with blue-black; and the fact that slaves were excluded from the art is significant of the views of their masters. It has been said that the tattooing on the bodies was for the purpose of identification in case thee head was cut off by the enemy in battle. Moko was a sign of distinction; it told of the noble and freeman from the slave.

Maning, a famous writer on old Maori life before the remembrance of it had quite passed

away, thus describes a war party: "As I have said, the men were all stripped for action, but I also noticed that the appearance of nakedness is completely taken away by the tattooing, the colour of the skin, and the arms and equipments… The men, in fact, look much better than when dressed in their Maori clothing. Every man almost without exception is covered with tattooing from the knees to the waist; the face is also covered with dark spiral lines.

"To have fine tattooed faces was the great ambition among men both to render themselves attractive to the ladies and conspicuous in war. The decorative art of a people reflects their character and the fierceness in their nature. For even if killed by the enemy, whilst the heads of the untattooed were treated with indignity and kicked to one side, those which were conspicuous by their beautiful moko were carefully cut off, stuck on the turuturu, a pole with a cross on it, and preserved; all of which was highly gratifying to the survivors, and the spirits of their late possessor.

"To set off moko to advantage it was necessary to give up all idea of a beard and the wearing of hair on the face, which was not considered in the light of an ornament. Consequently it was necessary for the men to submit to the pain of pulling out the hair by the roots."

A certain Aranghie was one of the most famous of all artists in moko. There is a portrait of him, drawn by Mr. Earle, who was draughtsman to H.M. surveying ship, Beagle, in 1827. Mr. Earle's remarks on this distinguished artist must be quoted: "This professor was considered by his countrymen a perfect master in the art of tattooing, and men of the highest rank and importance were in the habit of traveling long journeys in order to put their skins under his skilful hands. Indeed, so highly were his works esteemed that I have seen many of his drawings exhibited even after his death. A neighbor of mine very lately killed a chief who had been tattooed by Aranghie, and appreciating the artist's work so highly, he skinned the chieftain's thighs, and covered his cartouche-box with it. I was astonished to see with what boldness and precision Aranghie drew his designs on the skin and what beautiful ornaments he produced. No rule and compass could be more exact than the lines and circles he formed. So unrivalled was he in his profession that a highly finished face of a chief from the hands of this artist is as greatly prized in New Zealand as a head from the hands of Sir Thomas Lawrence is amongst us. It was most gratifying to behold the respect these savages pay to the fine arts. This professor was merely a kooky or slave, but by skill and industry he raised himself to an equality with the greatest men of the country, and as every chief who employed him always made him some handsome present he soon became a man of wealth and was constantly surrounded by important personages.

My friend Shulitea (King George) sent him every day the choicest things from his own table. Though thus basking in the full sunshine of court favor, Aranghie, like a true genius, was not puffed up with pride by his success, for he condescended to come and take tea with me almost every evening. He was delighted with my drawings, particularly with a portrait I made of him. He copied so well, and seemed to enter with such interest into the few lessons of painting I gave him, that if I were returning from here direct to England I should certainly bring him with me, as I look upon him as a great natural genius." ∎

JAPAN

The earliest evidence of tattooing in Japan is found in the form of clay figurines that have faces painted or engraved to represent tattoo marks. The oldest figurines of this kind have been recovered from tombs dated 5,000 BC or older, and many other figurines have been found in tombs dating from the second and third millennia BC. These figurines served as stand-ins for living individuals who symbolically accompanied the dead on their journey into the unknown, and it is believed that the tattoo marks had religious or magical significance.[1]

The first written record of Japanese tattooing is found in a Chinese dynastic history compiled in 297 AD. According to this text, Japanese "men young and old, all tattoo their faces and decorate their bodies with designs." Japanese tattooing is also mentioned in other Chinese histories, but always in a negative context. The Chinese considered tattooing a sign of barbarism and used it only as a punishment.

By the seventh century, the rulers of Japan had adopted much of the culture and attitudes of the Chinese, and as a result decorative tattooing fell into official disfavor. The first record of tattooing as punishment in Japan is found in a Japanese history compiled in 720 AD. It reads: "The Emperor summoned before him Hamako, Muraji of Azumi, and commanded him saying: "You have plotted to rebel and overthrow the state. This offense is punishable by death. I shall, however, confer great mercy on you by remitting the death penalty and sentence you to be tattooed."[2]

By the early seventeenth century, a generally recognized codification of tattoo marks was widely used to identify criminals and outcasts. Outcasts were tattooed on the arms: a cross might be tattooed on the inner forearm, or a straight line on the outside of the forearm or on the upper arm. Criminals were marked with a variety of symbols that designated the places where the crimes were committed. In one region, the pictograph for "dog" was tattooed on the criminal's forehead. Other marks included such patterns as bars, crosses, double lines, and circles on the face and arms. Tattooing was reserved for those who had committed serious crimes, and individuals bearing tattoo marks were ostracized by their families and denied all participation in the life of the community. For the Japanese, who valued family membership and social position above all things, tattooing was a particularly severe and terrible form of punishment.[3]

By the end of the seventeenth century, penal tattooing had been largely replaced by other forms of punishment. One reason for this is said to be that about that time decorative tattooing became popular, and criminals covered their penal tattoos with larger decorative patterns. This is also thought to be the historical origin of the association of tattooing with organized crime in Japan.

The earliest reports of decorative tattooing are found in works of fiction published toward the end of the seventeenth century. In a popular erotic novel titled, *The Life of an Amorous Man* (1682), it is reported that tattooed pledges of love were common among many classes, including courtesans, prostitutes, priests, and acolytes. One of the most popular pledges was the character inochi (life),

Penal tattooing (after Tamabayashi)

Opposite page:
Top left: Suikoden hero Kanchikotsuritsu Shuki. A woodblock print by Kuniyoshi from *Suikoden*

Top right: Suikoden hero Kyumonryu Shishin. A woodblock print by Kuniyoshi from *Suikoden*

Bottom left: Suikoden hero Hakutencho Rio and Bossharan Bokuko. A woodblock print by Kuniyoshi from *Suikoden*

Bottom right: Suikoden hero Tanmeijiro Genshogo. A woodblock print by Kuniyoshi from *Suikoden*

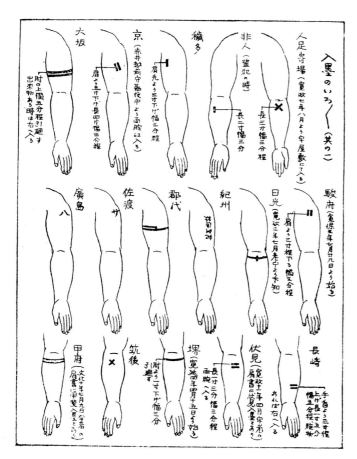

Penal tattooing. (after Tamabayashi)

together with the names of the lovers written in the Japanese phonetic syllabary. Priests and acolytes were sometimes tattooed with religious vows, such as the Buddhist incantation, *Namu Amida Butsu.*[4]

Pictorial tattooing flourished during the eighteenth century in connection with the popular culture of Edo, as Tokyo was then called. Early in the eighteenth century a lively center of business activity, nightlife, and entertainment developed in the area of Edo around *Nihonbashi* (Japan Bridge). Here, the great popular culture of Japan was born: Kabuki theater, Bunraku (puppet theater), and sumo wrestling. Here, too, writers, artists, and publishers became established, and in the nearby Yoshiwara district the geishas received their visitors.

Publishers needed illustrations for their novels, and theatrical producers needed advertisements for their plays. The art of the Japanese wood block print was developed to meet these needs. The publishers dictated the subject matter, and artists turned out images designed to advertise the talents of actors, courtesans, prostitutes, and wrestlers, together with illustrations of scenes from popular plays and novels. These prints were called *ukiyoe,* or "pictures of the floating world." In them we see the passing parade of celebrities, fads, and fashions: images of things transient and illusory.

The development of the wood block print parallels, and had great influence on, the development of tattooing. Many of the *ukiyoe* artists did whatever kind of work they could get: sign painting, fabric design, and others forms of decorative art, including tattoo designs. In addition, tattooing was depicted in many wood block prints, which in turn influenced the style and fashions followed by those who designed tattoos.

Japan, at that time, was ruled by the authoritarian and repressive Tokugawa regime, which prohibited communication with the outside world and viewed any expression of personal liberty as a threat to the established order. Because of the ancient association between tattooing and criminal activity, the Tokugawa lawmakers outlawed tattooing on the grounds that it was "deleterious to public morals."[5]

In spite of efforts by the government to suppress it, tattooing continued to flourish among firemen, laborers, and others at the lower end of the social scale. It was particularly favored by gangs of itinerant gamblers called *Yakuza.* Members of these gangs were recruited from the underworld of outlaws, penniless peasants, laborers, and misfits who migrated to Edo in the hope of improving their lot. Although the Yakuza engaged in a variety of semi-legal and illegal activities, they saw themselves as champions of the common people and adhered to a strict code of honor that specifically prohibited crimes against the people, such as rape and theft.[6]

Like Samurai, they prided themselves on being able to endure pain and privation without flinching. And when loyalty required it, they were willing to sacrifice themselves by facing imprisonment or death to protect the gang.

The Yakuza expressed these ideals in tattooing: Because it was painful, it was proof of courage; because it was permanent, it was evidence of lifelong loyalty to the group; and because it was illegal, it made them forever outlaws.[7]

About the middle of the eighteenth century, the popularity of tattooing was stimulated by the

Opposite page: Suikoden hero Sotoki Sosei. A woodblock print by Kuniyoshi from Suikoden

11図 国芳 「通俗水滸傳豪傑百八人之一個」操刀鬼曹正

translation into Japanese of a Chinese novel titled *Suikoden*, which tells of the adventures of a band of 108 outlaws who defied the corrupt rulers of China between 1117 and 1121. Because of its anti-authoritarian theme, it became a symbol of resistance to the oppressive Tokugawa regime and was a perennial best seller for over a century.[8]

Suikoden's influence on tattooing was due to the fact that many of the novel's heroes were extensively tattooed. One hero, Shishin, was decorated with nine intertwining dragons. Busho, who battled tigers, had a tiger tattooed on his back, while Rochoshin, the romantic hero, was decorated with flowers.

The Japanese versions of *Suikoden* were illustrated by a variety of artists, each of whom created prints in which he rendered new interpretations of the tattoos described in the novel. Tattoo artists copied the tattoo designs in these prints, and as a result of their influence, tattooing enjoyed great popularity and developed rapidly during the latter part of the eighteenth century.

The most prolific and original illustrator of *Suikoden* was Utagawa Kuniyoshi (1798-1861). When the first five plates of Kuniyoshi's *Suikoden* series were published as individual prints in 1827, they were an immediate success. In composition and draftsmanship they were far more dynamic and exciting than the work of his contemporaries. The contorted attitudes of the figures and the fierce expressions of the warriors combined to create a mood of conflict and melodrama that was uniquely suited to the *Suikoden* stories.

Encouraged by the success of his first five *Suikoden* plates, Kuniyoshi completed the series, devoting one plate to each of the 108 heroes. Kuniyoshi's *Suikoden* prints marked a turning point in his career and established his reputation as one of the leading ukiyoe artists of his day. Between 1827 and 1853, while at the same time doing much other work, Kuniyoshi continued to produce hundreds of variations on the *Suikoden* themes.

Kuniyoshi was a masterful draftsman and a great innovator. He worked in every style and attempted every subject known to Japanese printmaking, but he was at his best when portraying scenes of conflict, horror, and fantasy. He is best remembered for his warrior prints, which were designed to illustrate Japanese history and legends. These prints were immensely popular among his contemporaries and are highly prized by collectors today.[9]

Little is known of Kuniyoshi's private life. His friends and contemporaries described him as a man of great warmth and imagination who loved his homeland, its history, and its legends. One of the most revealing accounts of his character is found in a police report written in 1853. Kuniyoshi had been charged with drawing pictures that contained seditious political satires. The police investigator reported that: "He appears vulgar, but he is large minded. He accepts any order from a publisher, if he likes him, regardless of the amount of money he is offered, but refuses it if he is not pleased with him, no matter how much he is willing to pay. He had rather a large income, so that he could afford to distribute it among his apprentices, and to have his wife and children fairly well dressed, but he himself had practically no spare clothing or extra suit, and was even in debt."[10]

Kuniyoshi was one of the last of the great ukiyoe artists. When he died, in 1861, the once mighty Tokugawa regime, which had ruled Japan for over two and a half centuries, was crumbling as the result of internal conflict and external pressures. During the 1850's the Tokugawa shoguns succumbed to the demands of the West and ended their long period of isolation. Japan's ports were opened to trade, an American consulate was set up, and a European colony was established in Yokohama.

As a result, Japanese culture and art were revolutionized at every level. The traditional styles and subject matter of ukiyoe suddenly appeared old fashioned. The Japanese public lost interest in images of Kabuki actors and beautiful ladies. Many ukiyoe artists tried to become modern by adopting western illustration techniques such as perspective, shadow, and three-dimensional modeling.

In 1867, the last of the Tokugawa shoguns was deposed and, after a brief civil war, the emperor was restored to power. The laws against tattooing were strictly enforced by the new rulers who feared that certain Japanese customs would seem barbaric and ridiculous to Westerners. Ironically,

under the new laws, Japanese tattoo artists were allowed to tattoo foreigners but not Japanese. Some of the great tattoo masters established studios in Yokohama and did a brisk business tattooing foreign sailors. Their amazing skills were immediately recognized, and they attracted many distinguished clients, including the Duke of Clarence and his brother, the Duke of York (Later King George V), the Czarevich of Russia (Later Czar Nicholas II), and other European dignitaries.[11]

The Japanese tattoo masters also continued to tattoo Japanese clients illegally, but after the middle of the nineteenth century their themes and techniques remained unchanged. Classical Japanese tattooing is limited to a repertoire of specific designs representing legendary heroes and religious motifs. These may be combined with certain symbolic animals and flowers and set off against a background of waves, clouds and lighting bolts.

The outstanding artistic quality of Japanese tattooing is due to the fact that the original designs were created by some of the greatest ukiyoe artists. The tattoo masters adapted and simplified these designs to make them suitable for tattooing, but did not invent new designs of their own.

The traditional Japanese tattoo differs from the Western tattoo in that it consists of a single major design that covers the back and extends onto the arms, legs and chest. Such a design is not chosen casually, but represents a major commitment of time, money and emotional energy. Each design is associated with an attribute such as courage, loyalty, devotion or obligation, and by being tattooed the individual symbolically makes these virtues part of him or herself.

Japanese tattooing today is still heavily influenced by the great traditions of the ukiyoe artists. Western techniques and modified western designs have been adopted by some of the younger artists, but many laborers and yakuza still wear the classical full body designs created by Kuniyoshi and his contemporaries.

Suikoden hero Roshi Ensei.
A woodblock print by Kuniyoshi from *Suikoden*

Kazuo Oguri was the first Japanese tattoo artist to make contact with the Western World. In 1970 he began to correspond with tattoo artist, Sailor Jerry Collins, of Honolulu, and in 1972 he went to Honolulu, where he met Sailor Jerry and American tattoo artists Mike Malone and Don Ed Hardy. In the summer of 1973, he toured the West Coast of the US as the guest of Hardy, Malone, and others. He has also extended hospitality to many Westerners who have visited him in Japan. His tireless enthusiasm and good will have done much to promote an awareness and appreciation of Japanese tattooing in the West. The following selection is based on two interviews with Steve Gilbert: one in Gifu in 1984, and one in Kobe in 1987.

MY APPRENTICESHIP

BY KAZUO OGURI

I was born in 1933 and grew up in Gifu, a large industrial city in central Japan. Times were tough after World War II. All over Japan people were unemployed and even those who had jobs did not make enough money to live comfortably.

When I was a teenager I was proud of being a tough guy, and by the time I was 19, I was the leader of a street gang. We had fights with other gangs, and in one of these fights I stabbed a guy with a knife. He fell to the ground and we thought he was dead. The members of my gang ran back to my house, but we knew we couldn't stay there because the police would be looking for us. So my gang took up a collection and gave me enough money to get out of town and go to Tokyo.

I stayed in a hotel and went to movies and pretty soon the money was all gone. At the employment center there were long lines of people waiting to find work. They told me there was nothing for me. For three days I slept in a park and didn't have anything to eat.

I was walking the streets, feeling frightened and desperate, when I noticed a sign tacked to the door of a residence. It read "apprentice wanted," but it didn't say what kind of work it was. I knocked, and a kindly looking middle-aged woman opened the door.

"It's about the sign," I said. "I want to be an apprentice. What kind of work is it?"

"My husband will explain that to you," she said. "But I can tell you this. It's very difficult. You have to have a lot of courage and determination to stick with it."

"I'm tough. I need the work and I can do anything."

"You can come in and talk to my husband. He's upstairs working, and he'll be finished in about an hour if you want to wait."

While I waited she brought me some green tea and little rice cakes. At that time it was the custom to give a guest a snack, but it was considered good manners to eat only a little bit. I was so hungry that I forgot all about good manners and ate all the rice cakes.

"I think you haven't eaten for a while," the woman said. "Come into the kitchen and let me give you a good meal." I liked her and I saw that she had a good heart, and so I decided to stay there and become an apprentice no matter what kind of work it was.

When the man who was destined to be my teacher finally came downstairs I was very surprised to see that he had tattoos on his arms, because like most people at that time I thought that anyone who had a tattoo must be a yakuza (gangster). He told me that he was not a yakuza, but a tattoo artist, and he had advertised for an apprentice to learn tattooing. When I heard this I hesitated, because when I was in school I had never been good at drawing. But when I looked into his eyes, I had the feeling that he was a good man, and I thought, " I've got to have work so I'll give it a try," and so I told him I liked to draw and I wanted to learn tattooing.

Young people today do not understand the road I have traveled. I studied tattooing under the old Japanese style of apprenticeship, in which the relationship of the student to the teacher was like that of a disciple to a master. For five years I lived in my teacher's house and did all the chores like cleaning, washing dishes, and chopping wood for the stove. If I made a mistake, my

teacher scolded me and sometimes he even hit me. It was very difficult because I wasn't used to this kind of life. I missed my friends in Gifu and sometimes when I went to bed at night I would cry myself to sleep. But I tried to show the samurai spirit and in the morning I never looked sad. I just did my work.

Every day I watched my teacher while he tattooed. He usually had three or four customers a day and he worked on each customer for about two hours. I helped him by preparing his colors and getting all the things he needed ready for him. But I didn't ask questions, and he didn't explain anything. That was the traditional style of Japanese teaching in all the arts and crafts. Words go in one ear and out the other, but after many hours of observing and thinking about what you have seen, you learn without words. This is the best way.

One time a customer asked my teacher to tattoo a carp on his back. The following Sunday my teacher took me to a carp pond and we sat there all day looking at the carp. After we came home my teacher said, "Do you know why I was watching carp all day?"

"No," I answered.

"It is because I want to study the living carp. I don't like cartoons; I'm a professional artist and I want to tattoo the true spirit of the carp."

At that time I hadn't seen the work of other tattoo artists. In May, my teacher took me to the festival at Sanja Temple where I saw many tattooed men wearing loincloths. Then I understood what he had said about the living spirit of the carp as opposed to tattoo designs that are cartoons. I remember two carp tattoos: one by Hori Bun, which looked like a cartoon, and one by Hori Uno, which had some of the true form of the carp but was still partly a cartoon. It was supposed to be a carp climbing up a waterfall but it looked dead, and a dead carp can't climb a waterfall. The face of the carp climbing a waterfall must be strong, like the face of a samurai, but the face of the carp by Hori Uno was not strong. The expression on the face is very important in a tattoo. For example, in the traditional tattoo of the samurai fighting the giant snake, the samurai doesn't know whether or not he can kill the snake. His face must express this feeling.

My teacher asked me which tattoo I thought was best. I saw a man

Kazuo Oguri in his studio.

with a dragon tattooed on his back which was very powerful and moved as if it were alive when the man walked. The name of the tattoo artist was Hori Sada. I told my teacher that was my favorite, and he said, "You have a true tattoo artist's eye. Most people look only for beauty in a tattoo, but a truly great tattoo must be more than a pretty picture. It must have a life of its own."

My life as an apprentice in those days was not easy. Every day after work my teacher would ask me to bring him his sake, and after he drank a few cups he would become abusive and go on a rampage and hit his wife and me and kick things until I begged him to stop. That's why I never drink alcohol. It changes a man's heart.

Sometimes my teacher hit me in the presence of customers, and the customers would laugh. I was proud and I hated it when they laughed at me, so I told my teacher that I wasn't used to that kind of treatment, and hitting me in private was okay, but not in front of customers. But I wanted to prove to my teacher that I had courage and confidence, so I stuck with it and endured the beatings.

One time I got so discouraged that I packed my suitcase and walked to the train station and sat there all night waiting for the train back to Gifu. But my teacher's wife came and found me in the station.

"Why did you leave?" she asked.

Tiger. Drawing by Kazuo Oguri

"It's too tough," I said. "I don't like the beatings."

"I told you it would be difficult and you said you had the courage to do it, but now you want to give up. When my husband was an apprentice he had it much tougher than you do, but he stuck with it, and now he's a great tattoo artist. You are fortunate to be his apprentice. You are like a son to him. He thinks you have what it takes to be a good tattoo artist. I want you to come back home with me and show him that he was right." So I went back with her.

Every day after my teacher finished work he would give me a drawing assignment. For my first assignment he gave me a picture of a lion he had drawn and told me to copy it. After I copied it he took away his drawing and told me to draw the same lion from memory. I tried, but I couldn't get it right.

"What were you thinking of?" he said. "When you draw you must do it with total concentration. It is the same when you tattoo. You must concentrate on what you are doing and let no other thought enter your mind." Now I can memorize a picture after looking at it for only a few minutes, because my teacher taught me the technique of concentration and drawing from memory.

Japanese tattoo designs are based on drawings that illustrate traditional stories and legends, and these designs have been handed down from generation to generation. When my teacher was an apprentice he got a book of tattoo designs from his teacher, and my teacher gave me this book. My teacher's designs were all based on the work of the nineteenth century Japanese artist Utagawa Kuniyoshi, but my teacher didn't have any of Kunyoshi's prints; he had only copied the designs that his teacher had drawn for him, and he had about 100 designs. Kunyoshi's work is the source of most of our traditional tattoo designs. I read about Kuniyoshi but when I was an apprentice it was very hard to find Kuniyoshi's prints because most of them had been lost in the war. A few of them had survived in small towns which were not bombed, and after the war some dealers bought them and brought them back to Tokyo. But many of them were bought by foreigners who took them out of the country, so that now the great collections of Kuniyoshi's prints are in France, England, and the United States. There are a few collectors of Kuniyoshi prints in Japan, but they will not allow their prints to be shown or photographed. I have collected many reproductions and photographs of Kunyoshi's prints, and I have drawn about 350 designs based on them.

I was an apprentice for three years before my teacher allowed me to tattoo. During that time I was very eager to start tattooing, and every day my enthusiasm grew stronger. It's like when you are longing to meet your girlfriend: the longer you wait, the more you desire her.

Finally, one day, my teacher gave me a bamboo stick and some needles and told me to make a hand tool. I began by practicing on his leg. There is nothing like human skin, and it is the only thing we can practice on. At first I practiced without ink to get the right rhythm and the right sound. When the needles penetrate the skin they make a sound. The sound has to be low-pitched and you have to have the right rhythm. After several weeks of this my teacher let me use ink to tattoo a cherry blossom on his leg, but I didn't do a very good job. My teacher

showed me how to relax, not to hurry, and make a smooth line. Then after he went to bed I would practice on my own leg. For three months I practiced outlining, and then for three more months I practiced shading. My teacher had a big black area on his leg where students had practiced on him. After six months of practice, my teacher let me do my first tattoo on a customer. It was a cover-up consisting of cherry blossoms on a black background.

My teacher did all his work by hand. He had heard about tattooing machines, but at that time, machines were not available in Japan. He had only two colors: brown and reddish orange. After I did that first cover-up my teacher let me help him. He would do the outlining, and I did the black shading. Then he would finish by doing the color.

After five years of apprenticeship it was the custom for a tattoo artist to open his own studio. But because I was grateful to my teacher for all he had taught me, after I completed my apprenticeship I stayed and worked in his studio for another year and gave him the money I earned. After he died, I sent money each month to his widow as long as she lived. That used to be the Japanese custom, but it doesn't exist any more.

After six years in Tokyo, I went back to Gifu. The man I stabbed hadn't died after all, and the police weren't looking for me any more, so I opened a tattoo studio in Gifu.

Now the apprenticeship system is different. I have four apprentices. They begin to work on their own after only two years of study. I give them lots of drawing assignments, and I insist that they try to draw fine designs that have life, and not cartoons. Of course, I don't hit them. Now we do things as they are done in the U.S.A., so apprentices aren't so tough any more. There were many bad things about the old style of teaching. But there were also good things about it. Today many people try to start tattooing without having studied under a master, but they will always be amateurs. They make many mistakes, and merely copy designs without understanding their significance.

At the time I opened my studio I didn't know how to get tattoo supplies from the U.S.A.. One day I saw an American sailor with a good tattoo and I asked him who did it. He told me it was by Sailor Jerry of Honolulu and he gave me Sailor Jerry's business card. I wrote to Sailor Jerry and asked if he would sell me some colors. He wrote back and gave me the address of Spaulding and Rogers in the U.S.A.. But I wanted to meet Sailor Jerry so I wrote him again. He told me he had a friend, Mr. Kida, who was the president of a big company in Tokyo. I wrote to Mr. Kida and he came to Gifu to see me. Mr. Kida told me he thought Sailor Jerry was a good man, and a gentleman, and the greatest American tattoo artist. So I arranged to go to Hawaii and meet Sailor Jerry. This was in 1971. Mr. Kida showed me Sailor Jerry's picture so I could recognize him, and when my plane landed in Hawaii he met me at the airport.

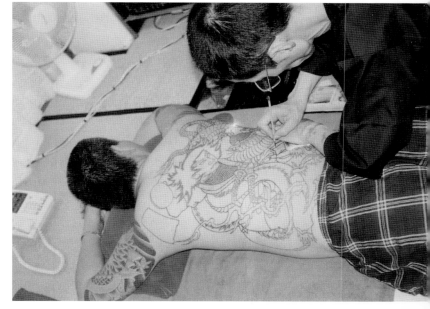

Kazuo Oguri drawing freehand.

I stayed with Sailor Jerry for a week. Every day I watched him work, and at night we went back to his house and had long talks. I liked him. Like me, he was a tough guy who had survived many hardships. Every day I got to like him better. I nicknamed him "Popeye" because he was tough and strong. When it was time for me to go and we said "goodbye" at the airport I called him "Pop." After that when we wrote letters I always called him "Pop" and he called me "son."

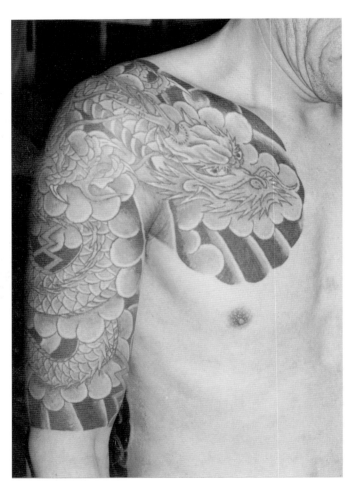

Blue dragon. Tattoo by Kazuo Oguri

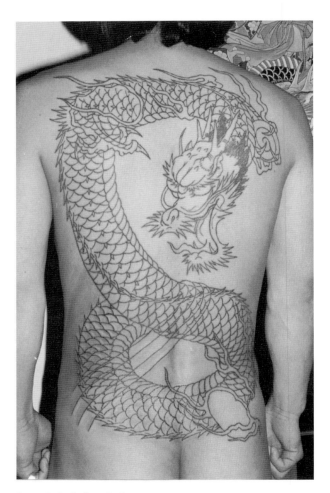

Dragon. Outline by Kazuo Oguri

When I tattoo I always do the outlining and black shading by hand, but I use a machine for putting in the color. There are two kinds of outline, a heavy outline that is used for the outside parts of the design, and finer lines, which are used on the inside and for details. I have tried to outline by machine, but I don't like the results. The line always looks dead to me. I don't know why. Outlining by hand is alive. It's not easy to do, but it's the best.

Today most Japanese tattoo artists use stencils. I am the only one who follows the method of my teacher. This method is to draw a little bit, and tattoo it in, and then draw and tattoo a little more until the design is finished. To do this you have to see the whole design in your imagination before you start.

My teacher gave me a good book about the history of Japanese tattooing: *Bunshin Hyakushi* (A Hundred Styles of Tattooing) by Tamabayashi Haruo, published in 1936. According to *Bunshin Hyakushi,* it was firemen who got big tattoos in the eighteenth and nineteenth centuries. They were heroes because fire was a great danger and Japanese houses, which were made of wood and paper, burned quickly. So sometimes firemen lost their lives to save people. The geisha girls liked the firemen because they were brave. In the Edo period [prior to 1867], it was the firemen, but not the yakuzas, who got tattooed.

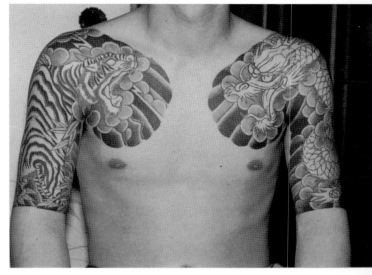

During most of the nineteenth century, an artist and a tattooer worked together. The artist drew the picture with a brush on the customer's skin, and the tattooer just copied it. But then some of the tattooers studied drawing and learned how to draw the designs themselves.

After the Edo period, the yakuzas started getting tattoos because they wanted to look tough. Tattoo artists call yakuza tattoos, *odoshibori.* It means a tattoo that is just meant to frighten people. The yakuzas don't care if it is artistic. The real tattoo lover wants quality, not quantity, and he wants to get the tattoo from a famous artist.

Tiger and dragon. Tattoo by Kazuo Oguri

In 1936, when fighting broke out in China, almost all the young men were drafted into the Army. But people with lots of tattoos were thought to be potential discipline problems, so they weren't drafted. Then a lot of people got tattooed just to avoid the draft, and the government passed a law against tattooing. After that the tattooers had to work in secret. After World War II, General MacArthur liberalized the Japanese laws, and tattooing was legal again. But the tattoo artists continued to work privately by appointment, on customers who were introduced by someone who knew them, and this tradition is still followed today.

We have word a in Japanese: *ishindenshin*, which means telepathy or tacit understanding. This is what happens when I tattoo by hand. My heart and my hand have the same thought, and the thought is transmitted by the tip of my finger to the customer's skin. That's why it is not painful and there is no blood. There is never any swelling or inflammation.

When the tattoo artist's heart is right we call it a "Buddha heart." Maybe someone thinks I have a secret or some magic, but there is no secret and there is no magic. When I tattoo I have what we call *zen* [wholeness or goodness of heart], and I practice total concentration. We also call this state of mind *seishin toitsu* [*seishin* means spirit; *toitsu* means uniformity]. This is the same kind of concentration one must practice if there is a serious problem in one's life. At such a time one must practice total concentration to find the right solution.

(*translated and edited by Steve Gilbert*) ∎

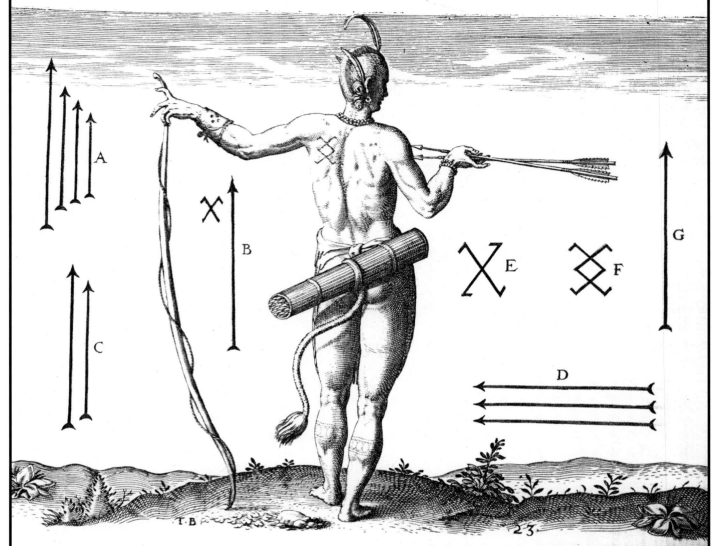

He inhabitãts of all the cuntrie for the moſt parte haue marks raſed on their backs, wherby yt may be knowen what Princes ſubiects they bee, or of what place they haue their originall. For which cauſe we haue ſet downe thoſe marks in this figure, and haue annexed the names of the places, that they might more eaſelye be diſcerned. Which induſtrie hath god indued them withal although they be verye ſinple, and rude. And to confeſſe a truthe I cannot remember, that euer I ſaw a better or quietter people then they.

The marks which I obſerued a monge them, are heere put downe in order folowinge.

The marke which is expreſſed by A. belongeth tho Wingino, the cheefe lorde of Roanoac.

That which hath B. is the marke of Wingino his ſiſters huſbande.

Thoſe which be noted with the letters, of C. and D. belonge vnto diverſe chefe lordes in Secotam.

Thoſe which haue the letters E. F. G. are certaine cheefe men of Pomeiooc, and Aquaſcogoc.

NORTH AMERICA

Most nineteenth century scholars took no interest in North American native tattooing. In 1909, the American anthropologist, A.T. Sinclair, surveyed the literature and noted with dismay that "one of the great difficulties in treating our subject is that details, or even mention, are so often absent when the practice must have been common. Even the slightest hint is sometimes of value."[1] In his definitive paper, "Tattooing of the American Indians", Sinclair surveyed the records of tattooing in each geographical region of North America, but in many cases came up only with fragmentary one-liners such as: "The Algonquin tribes everywhere seem to have practiced the custom."[2]

Seventeenth century French explorers and missionaries in Eastern Canada wrote some of the most interesting descriptions of pre-Columbian tattooing in North America. A typical example is the French explorer, Gabriel Sagard-Thêodat's account of tattooing among the Hurons, written in 1615:

> But that which I find a most strange and conspicuous folly, is that in order to be considered courageous and feared by their enemies [the Hurons] take the bone of a bird or of a fish which they sharpen like a razor, and use it to engrave or decorate their bodies by making many punctures somewhat as we would engrave a copper plate with a burin. During this process they exhibit the most admirable courage and patience. They certainly feel the pain, for they are not insensible, but they remain motionless and mute while their companions wipe away the blood that runs from the incisions. Subsequently they rub a black color or powder into the cuts in order that the engraved figures will remain for life and never be effaced, in much the same manner as the marks which one sees on the arms of pilgrims returning from Jerusalem.[3]
> (*translated by Steve Gilbert*)

Numerous brief references to tattooing are found in writings of 17th century Jesuit missionaries whose reports were forwarded to Paris each year and compiled in volumes titled *Jesuit Relations*. Jesuit missions were scattered throughout eastern Canada, and missionaries reported that tattooing was practiced by almost all of the native tribes they encountered. In 1653 the Jesuit missionary Francois-J. Bressani reported:

> In order to paint permanent marks on themselves they undergo intense pain. To do this they use needles, sharpened awls, or thorns. With these instruments they pierce the skin and trace images of animals or monsters, for example an eagle, a serpent, a dragon, or any other figure they like, which they engrave on their faces, their necks, their chests, or other parts of their bodies. Then, while the punctures which form the designs are fresh and bleeding, they rub in charcoal or some other black color which mixes with the blood and penetrates the wound. The image is then indelibly imprinted on the skin. This custom is so widespread that I believe that in many of these native tribes it would be impossible to find a single individual who is not marked in this way. When this operation is performed over the entire body it is dangerous, especially in cold weather. Many have died after the operation, either as the result of a kind of spasm that it produces, or for other reasons. The natives thus die as martyrs to vanity because of this bizarre custom.[4] (*translated by Steve Gilbert*)

Native North American tattooing was frequently associated with religious and magical practices. It was also employed as a symbolic rite of passage at puberty ceremonies, and as a distinguishing mark that would enable the spirit to overcome obstacles on its journey after death. Such an obstacle

Opposite page: Tattoo marks of the natives of Virginia. Drawing by John White, 1590. (after Hariot)

might be an apparition that blocked the spirit's path and demanded to see a specific tattoo design as evidence of the spirit's right to enter the next world. An example of such a use of tattooing is found among the Sioux, who believed that after death the spirit of the warrior mounts a ghostly horse and sets forth on its journey to the "Many Lodges" of the afterlife. Along the way the spirit of the warrior meets an old woman who blocks his path and demands to see his tattoos. If he has none, she turns him back and condemns him to return to the world of the living as a wandering ghost.[5]

Many native tribes practiced therapeutic tattooing. The Ojibwa, for instance, tattooed the temples, forehead, and cheeks of those suffering from headaches and toothaches that were believed to be caused by malevolent spirits. Songs and dances that were supposed to exorcise the demons accompanied the tattooing ceremony.[6]

Tattooing was also used to honor warriors who had distinguished themselves by bravery in combat. Writing in 1742, the Reverend John Heckwelder of Pennsylvania described an aged warrior of the Lenape Nation and Monsey Tribe as follows:

> This man, who was then at an advanced age, had a most striking appearance, and could not be viewed without astonishment. Besides that his body was full of scars, where he had been struck and pierced by arrows of the enemy, there was not a spot to be seen, on that part of it which was exposed to view, but what was tattooed over with some drawing relative to his achievements, so that the whole together struck the beholder with amazement and terror. On his whole face, neck, shoulders, arms, thighs, and legs, as well as on his breast and back, were represented scenes of the various actions and engagements he had been in; in short, the whole of his history was there deposited, which was well known to those of his nation, and was such that all who heard it thought it could never be surpassed by man.[6]

Other Europeans reported the use of tattooing to record achievements in war. In the *Jesuit Relations* for 1663, it was reported that an Iroquois chief known to the French as "Nero" bore on his thighs 60 tattooed characters, each of which symbolized an enemy killed with his own hand.[7] And in 1720, James Adair wrote of the Chikasas: "They readily know achievements in war by the blue marks over their breasts and arms, they being as legible as our alphabetical characters are to us."[8]

One of the most interesting accounts of Native American tattooing was written by Jean Bernard Bossu (1720-1792), a French naval officer who, between 1757 and 1762, traveled on foot up the Mississippi Valley to what is now Alabama and lived for several months with the Osages. He described his travels in *Nouveaux Voyages aux Indes Occidentales*, (1768), which contains a wealth of

Natives of the St. Lawrence Valley and areas around the Great Lakes. Drawings by de Granville, circa 1700.

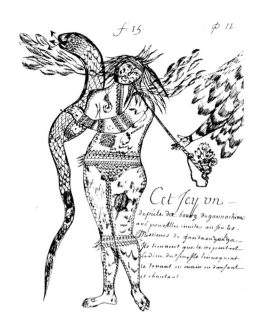
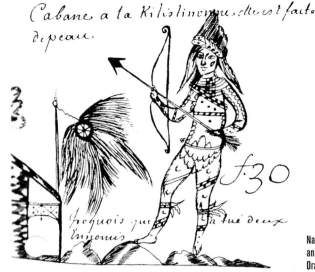

Natives of the St. Lawrence Valley
and areas around the Great Lakes.
Drawings by de Granville, circa 1700.

information on the food, clothing, medicines, and customs of the natives. Bossu's work was well received and widely read in Europe. A reviewer writing in 1768 praised him for his veracity and simplicity of style, remarking, "we see in this work man as he was at the beginning of society, for these nations which we call savage are very civilized."[9]

Unfortunately, there are few surviving illustrations of North American native tattoo designs. The first illustrations which show tattooed natives were published in the Jesuit Missionary Francois Du Creux's *Historiae Canadiensis seu Novae Franciae* (1656). There is, however, no reason to think that the tattoo marks seen in these engravings are accurate representations of native designs. The European-style figures, capes and backgrounds make it clear that the artist worked from imagination and from written descriptions rather than from life. Another artist, (probably Charles Bécart de Granville of Quebec), apparently copied and tried to improve on the *Historiae Canadiensis* illustrations by supplying the figures with appropriate native props such as tobacco pipes, tomahawks, and loincloths. De Granville's drawings, originally published in *Codex Canadiensis* (1701), have since been widely reproduced as the first pictorial record of native tattooing in North America.[10]

In 1593, Captain John Smith wrote that the natives of Virginia and Florida had "their legs, hands, breasts and faces cunningly embroidered with diverse marks, such as beasts and serpents, artificially wrought into their flesh with black spots." The most accurate early illustrations of these tattooed Florida natives were made by John White, a British artist, cartographer and explorer who, in 1585, sailed with Sir Walter Raleigh on an expedition to establish a settlement on Roanoke Island in the territory of Virginia. White was an accomplished illustrator who made hundreds of valuable drawings of the natives and the flora and fauna of the region. In 1590, many of his drawings were published in Thomas Hariot's *Briefe and True report of the New Found Land of Virginia*. In a curious appendix to Hariot's work, White included several drawings of elaborately tattooed Picts to show "how that the Inhabitants of the Great Bretannie have been in times past as savage as those of Virginia."[11] White's original paintings are now in the British Museum.

One of the best examples of Native American tattooing has been recorded in an oil portrait of Sa Ga Yeath Qua Pieth Tow, painted in 1710 by the English artist John Verelst.[12] Sa Ga Yeath Qua Pieth Tow was one of four Mohawk chiefs who visited London in 1710, as part of a delegation led by Peter Schuyler, a member of the New York Indian Commission, who hoped to persuade Queen Anne to assist the British colonials in their conflict with French Canada. Schuyler had the chiefs make speeches in which they promised that their own people would assist the British troops. The mission was a success and the Queen was finally persuaded to send the expedition.

James G. Swan, a native of Boston, wrote the only scholarly first-hand account of native

Left: Detail of "The Death of General Wolfe—September 13, 1759". Engraving by Wm. Woollett. London, 1776. After a painting by Benjamin West.

Right: An Algonquin chief, by John White, circa 1590.

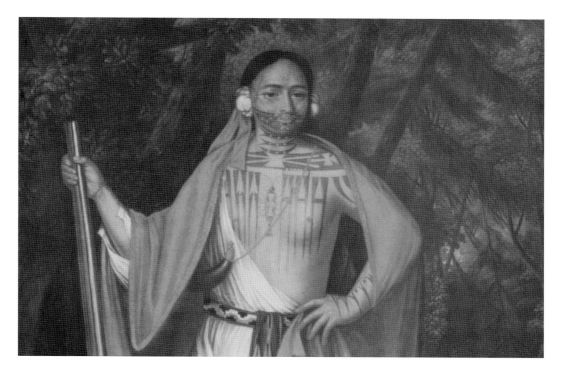

Portrait of Mohawk chief Sa Ga Yeath Qua Pieth Tow by John Verelst, 1710.

tattooing in North America. In 1849 Swan left his wife, two children and a prosperous ship-fitting business to live among the natives of the Pacific Coast. Described by his biographer as "a self-taught scientist, runaway husband, promoter, teacher, essayist, town-boomer, probate judge and alcoholic,"[13] Swan was unique among early settlers in that he considered the natives worthy of respect and attempted to write an account of their rapidly vanishing culture. In this he was far ahead of his time; there was no established discipline of anthropology when Swan wrote his first essays, and his classic, *Pacific Northwest*, published in 1857, was the earliest history of the area and remains vivid and readable today.

The Haida were among the most accomplished of all North American native artists and craftsmen. Their totem poles, canoes, and dwellings were embellished with traditional designs associated with mythical and totemic themes. In 1874, Swan's monograph, *The Haida Indians of Queen Charlotte's Islands, British Columbia* was published by the Smithsonian Institution of Washington DC, and, in 1878, his "Tattoo Marks of the Haida" appeared in the *Fourth Annual Report of the American Bureau of Ethnology*. Swan had hoped to obtain a government grant to support further studies of native tattooing, but, not surprisingly, the US Government was not interested in spending money to decipher the ancient meaning of tattoo designs. Swan's classic monograph, "Tattoo Marks of the Haida", which he financed himself, was the one and only serious study of native North American tattooing.

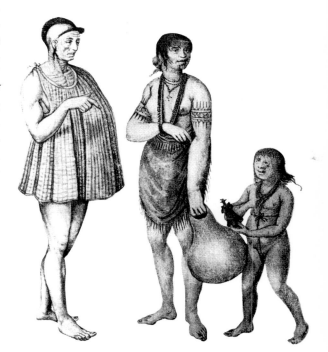

An Algonquian priest and his wife and daughter, painted by John White circa 1590.

The following selection is taken from Jean Bernard Bossu's *Travels in the Interior of North America, 1751-1762*. Translated by Seymour Feller. Copyright 1962 by the University of Oklahoma Press. Quoted by kind permission of the University of Oklahoma Press.

BOSSU AMONG THE OSAGE. CIRCA 1760

I should like to tell you about an event which will seem strange to you, but which, in spite of its insignificance, could be very useful to me during my stay in America. The [Osages] have just adopted me. A deer was tattooed on my thigh as a sign that I have been made a warrior and a chief. I submitted to this painful operation with good grace. I sat on a wildcat skin while an Indian burned some straw. He put the ashes in water and used this simple mixture to draw the deer. He then traced the drawing with big needles pricking me till I bled. The blood mixed with the ashes of the straw formed a tattoo which can never be removed…. They then told me that if I traveled among the tribes allied to them, all that I had to do to receive a warm welcome was to smoke a peace pipe and show my tattoo. They also said that I was their brother and that if I were killed they would avenge my death….

I cannot tell you how much I suffered and how great an effort I made to remain impassive. I even joked with the women who were present. The spectators, surprised by my stoicism, cried out with joy, danced, and told me I was a real man. I was truly in great pain and ran a fever for almost a week. You would never believe how attached to me these people have become since then… It is a kind of knighthood, to which they are only entitled by great actions. These marks multiply their achievements in war. One so tattooed without such deeds is degraded.

Later in his narrative Bossu describes an unusual case of primitive anesthesia and tattoo removal. An Osage man who had never taken part in battle had himself tattooed with the image of a tomahawk in order to impress his intended bride. An assembly of chiefs decreed that the miscreant should be punished by having the tattooed skin cut off with a knife, but Bossu volunteered to remove the tattoo by another method. Bossu wrote:

I gave the false hero a calabash bowl full of maple syrup, into which I had put some opium. While the man was asleep, I applied some cantharides [Spanish fly, a blistering agent] to the tattoo on his chest and then added plantain leaves, which formed blisters or tumors. The skin and the tattoo came off and a serous fluid was secreted. This type of operation amazed the medicine men, who knew nothing of the properties of cantharides, although they are very common in North America. ∎

The following selection is taken from James Swan's *Tattoo Marks of the Haida* (1878).

SWAN AMONG THE HAIDA, 1879

In February 1879 I was fortunate enough to meet a party of Haida men and women in Port Townsend, Washington, who permitted me to copy their tattoo marks.

The tattoo marks of the Haidas are heraldic designs or the family totem, or crests of the wearers, and are similar to the carvings depicted on the pillars and monuments around the homes of the chiefs, which casual observers have thought were idols. These designs are invariably placed on the men between the shoulders just below the back of the neck, on the breast, on the front part of both thighs, and on the legs just below the knees. On the women they are marked on the breast, on both shoulders, on both forearms, from the elbow down over the back of the hands to the knuckles, and on both legs below the knee to the ankle.

When the Haidas visit Victoria or the town on Puget Sound they are dressed in the garb of white people and present a respectable appearance, in marked contrast with the Indians from the west coast of Vancouver Island, or the vicinity of Cape Flattery, who dress in a more primitive manner, and attract notice by their more picturesque costumes than do the Haida, about whom there is nothing outwardly of unusual appearance, except that tattoo marks on the hands of the women, which show their nationality at a glance to the most careless observer.

Almost all of the Indian women of the northwest coast have tattoo marks on their hands and arms, and some on the face; but as a general thing these marks are mere dots or straight lines having no particular significance. With the Haidas, however, every mark has its meaning; those

on the hands and arms of the women indicate the family name, whether they belong to the bear, beaver, wolf or eagle totems, or any of the family of fishes. As one of them quaintly remarked to me, "If you were tattooed with the design of a swan, the Indians would know your family name."...

Although it is very easy to distinguish the Haida women from those of other tribes by seeing the tattoo marks on the backs of their hands, yet very few white persons have cared to know the meaning of these designs, or are aware of the extent of the tattoo marks on the persons of both sexes.

It should be borne in mind that during their festivals and masquerade performances the men are entirely naked and the women have only a short skirt reaching from the waist to the knee; the rest of their persons are exposed, and it is at such times that the tattoo marks show with the best effect, and the rank and family connection are known by the variety of designs.

Like all the other coast tribes, the Haidas are careful not to permit the intrusion of white persons or strangers to their Tomanawos ceremonies,

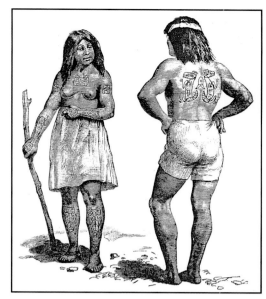

Tattooed Haidas, after James Swan.

and as a consequence but few white people, and certainly none of those who have ever written about those Indians, have been present at their opening ceremonies when the tattoo marks are shown.

My information was derived from the Haidas themselves, who explained to me, while I was making the drawings, and illustrated some of the positions assumed in their dances by both sexes. As the Haidas, both men and women, are very light colored, some of the latter, full blooded Indians too, having their skins as fair as Europeans, the tattoo marks show very distinct.

This tattooing is not all done at one time, nor is it everyone who can tattoo. Certain ones, almost always men, have a natural gift which enables them to excel in this kind of work. One of the young chiefs, named Geneskelos, was the best designer I knew, and ranked among his tribe as a tattooer. He belonged to Laskeek village on the east side of Moresby's Island, one of the Queen Charlotte group. I employed him to decorate the great canoe which I sent to the Centennial Exposition at Philadelphia in 1879, for the National Museum. I was with him a great deal of the time both at Victoria and Port Townsend. He had a little sketchbook in which he had traced designs for tattooing, which he gave to me. He subsequently died in Victoria of smallpox, soon after he had finished decorating the canoe.

He told me the plan he adopted was first to draw the design carefully on the person with

Tattoo Marks Nº 15. Noo-
(Squid octopus)

Tattoo Marks Nº 16.
Tl'kám-kos-tan, *(Frog)*

Haida tattoos representing the octopus, thunder bird, and frog. (after Swan)

some dark pigment, then prick it in with needles, and then rub over the wound with some more coloring matter till it acquired the proper hue. He had a variety of instruments composed of needles tied neatly to sticks. His favorite one was a flat strip of ivory or bone, to which he had firmly tied five or six needles, with their points projecting beyond the end just far enough to raise the skin without inflicting a dangerous wound, but these needle points stuck out quite sufficiently to make the operation very painful, and although he applied some substance to deaden the sensation of the skin, yet the effect was on some to make them quite sick for a few days; consequently, the whole process of tattooing was not done at one time. As this tattooing is a mark of honor, it is generally done at or just prior to a Tomanawos performance and at the time of raising the heraldic columns in front of the chief's house. The tattooing is done in open lodge and is witnessed by the company assembled. Sometimes it takes several years before all the tattooing is done, but when completed and the person well ornamented, then they are happy and can take their seats among the elders.

It is an interesting question, and one worthy of careful and patient investigation, why it is that the Haida Nation alone of all the coast tribes tattoo their persons to such an extent, and how they acquire the art of carving columns which bear such striking similarity to carving in wood and stone by the ancient inhabitants of Central America, as shown by drawings in Bancroft's fourth volume of Native Races and in Habel's investigation in Central and South America.

The tattoo marks, the carvings, and heraldic designs of the Haida are an exceedingly interesting study, and I hope what I have thus hastily and imperfectly written may be the means of awakening an interest to have those questions scientifically discussed, for they seem to me to point to a key which may unlock the mystery which for so many ages has kept us from the knowledge of the origin of the Pacific Tribes. ■

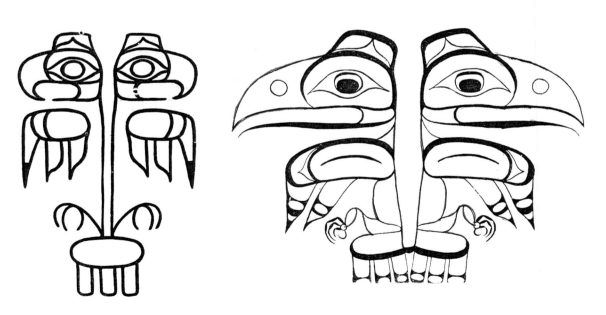

Haida tattoos representing the thunderbird (left)
and raven (right). (after Swan)

SWAN ON QUEEN CHARLOTTE'S ISLANDS, 1874

The following selection is taken from *The Haida Indians of Queen Charlotte's Islands, British Columbia* by **James Swan (1874)**.

The custom which prevails among them, and seems to be a distinctive feature of this tribe, is that of tattooing their bodies with various designs, all of which are fanciful representations of animals, birds, or fishes, either an attempt to represent in a grotesque form those which are known and commonly seen, or their mythological and legendary creations. A recent visit of a party of these Indians to Port Townsend has enabled me to study carefully a variety of their carvings and tattoo marks, and to ascertain with accuracy their true meaning and signification.

I have forwarded to the Smithsonian Institution, to accompany this memoir, several carvings in wood and stone; and, in order the better to describe them, I have made sketches illustrative of these carvings and also of various tattoo designs, which were copied by me from the persons of the Indians, and also have caused photographs to be taken to still further illustrate this subject…

The designs which I have copied and described are but a portion of the whole which were tattooed on the persons of this party; but the limited time they remained did not enable me to make a very extended examination. Enough, however, has been obtained to show that this subject is one of great ethnological value, and if followed up with zeal and intelligence would be certain to produce interesting results.

The method by which I determined with accuracy that meaning of these various carvings and tattoo designs was by natural objects, by alcoholic specimens of frogs and crayfish, by dried specimens, by carvings of bears and seals, and by pictures, and by the mythological drawings of similar objects which I had previously obtained and determined among the Makahs. The Haidas, in explaining to me the meaning of their various designs, pointed to the articles I had, and thus proved to me what they meant to represent.

The tattoo marks of the codfish, squid, humming bird, etc., never could have been determined from any resemblance to those objects, but by having the specimens and pictures before me they could easily point each one out. Nor was I satisfied until I had submitted my drawings to other Indians, and proved by their giving the same names to each, that my first informant had told me correctly. The allegorical meaning, however, will require for determination time and careful study. Indians are very peculiar in giving information relative to their myths and allegories. Even when one is well acquainted with them and has their confidence, much caution is required, and it is useless to attempt to obtain any reliable information unless they are in a humor of imparting it…

I will not, at this time, press further this discussion, upon a subject which to perfectly understand will need extended observations to be made upon the spot, and would require an explanation that would carry me beyond the limits to which I propose to confine myself in this present paper. I trust that it will be sufficient for me to have shown that the subject of the carvings in wood and stone and precious metals, the paintings and tattoo marks of the Haidas, is one of very great interest, and one which not only never has been properly explained, but never properly understood. When we reflect on the great number of centuries during which all knowledge of the interior of the Pyramids of Egypt was hidden from the world, until the researches of Belzoni discovered their secret treasures, and until Champollion, by aid of the Rosetta Stone, was enabled to decipher their hieroglyphic writings, may we not hope that the knowledge of the ancient history of the natives of the northwest coast, which has so long been an enigma, may be traced out by means of the explanation of the meaning of the symbols such as I have been enabled to discover in part, and have in this paper described.

This very brief memoir, made during the visit of a party of Haida Indians for a few weeks in Port Townsend, will serve to show what could be effected if the Government would empower some person here, and appropriate sufficient funds to be expended in these ethnological and archaeological researches. ∎

Two Aztec steles. A priest with tattooed arms and legs pierces his tongue,
allowing blood to flow into the mouth of a serpent.

SOUTH AMERICA

When Cortez and his conquistadors arrived on the coast of Mexico in 1519, they were horrified to discover that the natives not only worshipped devils in the form of statues and idols, but also had somehow managed to imprint indelible images of these idols on their skin. The Spaniards, who had never heard of tattooing, recognized it at once as the work of Satan.

The sixteenth century Spanish historians who chronicled the adventures of Cortez and his conquistadors reported that tattooing was widely practiced by the natives of Central America. Gonzalo Fernández de Oviedo y Valdez, who wrote the first and most complete account of the conquest of Mexico, tells us that the natives "imprinted on their bodies the images of their demons, held and perpetuated in black color for as long as they live, by piercing the flesh and the skin, and fixing in it the cursed figure."[1] The Jesuit missionary, Pierre-François-Xavier de Charlevoix, wrote: "They called their idols *zemes* and then imprinted their image on their own bodies. So it is not astonishing if, having them without ceasing before their eyes and fearing them much, they saw them often in dreams. They were all hideous—as toads, tortoises, snakes, alligators, etc."[2] And the historian, Diego López de Cogulludo, reported that warriors were tattooed to commemorate their achievements in battle, "so the bodies of old heroes were completely covered with hieroglyphics."[3]

As far as we know, only one Spaniard was ever tattooed by the Mayas. His name was Gonzalo Guerrero, and he is mentioned in several early histories of Mexico. The reports of his activities are fragmentary but intriguing. Guerrero was one of 20 sailors who survived a shipwreck off the coast of Jamaica in 1511. He and his companions managed to crowd into a small lifeboat and drifted at sea for two weeks without food or water, during which time several of them died of exposure and starvation.

The survivors finally reached the coast of Yucatan, where they were captured by Mayas. Guerrero and four others managed to escape and make their way through the jungle to Chetumal, a nearby Mayan city-state. The ruler of Chetumal, who was an enemy of their former captors, allowed them to live but made slaves of them. During the next two years three of the Spaniards succumbed to hunger, hard work, and disease. The only survivors were Guerrero and a Catholic priest, Geronimo de Aguilar.

Somehow, de Aguilar had managed to hang onto his breviary during all these adventures. He kept track of the days on a Christian calendar, said his prayers, and resolutely maintained his chastity in spite of many provocations and temptations. The Mayas were properly impressed with this display of self-control and the ruler of Chetumal promoted de Aguilar to the official post of Guardian of the Royal Wives.

Guerrero demonstrated more talent for warfare than he did for celibacy, and, because of his knowledge of Spanish military methods, he was able to improve his lot by making himself useful to the Mayas in their wars against the invaders. After proposing and organizing a successful attack on Spanish ships of the Cordoba expedition, he was made Chief Military Commander. He married the daughter of a noble, by whom he had several children, and became a convert to the Mayan religion. As evidence of the sincerity of his conversion, he had himself completely covered with Mayan tattooing, as was the custom for one of his social position.

When Cortez launched his invasion of Mexico, in 1519, he first stopped on the coast of Yucatan, where he learned from the natives of Cozumel that two Spaniards were living with the Mayas on the mainland. Cortez immediately sent a ship and messengers with ransom to rescue the Spaniards. De Aguilar returned with the messenger, but Guerrero did not. When de Aguilar saw the Spaniards he thanked God, wept, fell to his knees, and asked if the day was Wednesday. It was. He had managed to count the days on a Christian calendar for over eight years.

Because de Aguilar had mastered the Mayan language and knew much of Mayan culture, Cortez used him as an interpreter and advisor. De Aguilar accompanied Cortez throughout his invasion of

A stone figure thought to represent the god Quetzalcoatl. (Museum of Anthropology, Mexico City)

Mexico and proved to be an invaluable asset when Cortez conducted his negotiations with Montezuma. In contrast to de Aguilar, Guerrero disdainfully refused to rejoin his countrymen and continued to help the Mayas in their resistance against the Spanish for over two decades. This was the cause of much distress and embarrassment to the Spanish, who could not understand how a Christian could be converted to the Mayan religion.

A second attempt to induce Guerrero to rejoin his countrymen was made by Francisco de Montejo, a military adventurer who hoped to conquer the Mayas as Cortez had conquered the Aztecs. In 1529, Montejo anchored his ship in the Bay of Chetumal and captured several natives who told him that Guerrero was serving the Lord of Chetumal as Chief Military Commander. Montejo imagined that Guerrero could be of service to him in the same way de Aguilar had been of service to Cortez, and sent one of the captured natives with a message in which he offered Guerrero "a great opportunity to serve God and the Emperor, our Lord, in the pacification and baptism of these people, and more than this, to leave your sins behind you. I beseech you not to let the Devil influence you...so that he will not possess himself of you forever."

Guerrero answered by directing an attack on Montejo's ship. Montejo and his crew were defeated and sailed away in search of easier loot, while Guerrero remained to play a leading role in the Mayan resistance for another decade.

In 1535, a group of Spaniards on the coast of Honduras were approached and attacked by a Mayan war party in canoes. After a bitter struggle the Mayas were defeated, and the Spanish were amazed to find that among their slain enemies was the body of an ornately tattooed white man. It was Gonzalo Guerrero's last battle.[4]

The most complete account of Mayan tattooing is found in *An Account of the Affairs of Yucatan* by Diego de Landa, a Franciscan friar who traveled throughout much of Central America between 1549 and 1562. De Landa was a zealous preacher who labored earnestly to eradicate idolatry, sorcery, tattooing and other diabolical practices. But after 12 years of missionary work he was horrified to discover that many of his converts to Christianity were still secretly being tattooed and worshipping their ancient idols. His superiors authorized him to conduct an inquisition, and de Landa, who maintained that "nothing could be extracted from a Maya without torture,"[5] had his Christian converts tortured until they saw the light.

Spanish eyewitness Bartolomé de Bohorques wrote:

> When the Indians confessed to having so few idols (one, two or three) the friars proceeded to string up many of the Indians, having tied their wrists together with cord, and thus hoisted them from the ground, telling them that they must confess all the idols they had, and where they were. The Indians continued saying they had no more...and so the friars ordered great stones attached to [the Maya's] feet, and so they were left to hang...and if they still did not admit to a greater quantity of idols they were flogged as they hung there, and had burning wax splashed on their bodies."[6]

In all, de Landa ordered the torture of over 4,500 suspected idolaters. Thirty committed suicide in order to avoid torture, and countless others were crippled for life. The few who survived the torture but refused to confess were tried by a court of the inquisition and publicly burned. De Landa observed with satisfaction that "in general, they all showed sincere repentance and a willingness to be good Christians."[7]

The Mayas were then forced to ransack their ancient temples and tombs, and to deliver up to the Inquisition the bones of their idolatrous ancestors, together with all available idols and demonic statues. These were smashed and destroyed in a solemn ceremony presided over by de Landa. De Landa also confiscated and burned thousands of manuscripts in which the Maya had recorded their history, art, mythology, science, astronomy and medicine. In all this he detected nothing but the work of Satan.[8] He wrote: "[The Mayas] used certain glyphs or letters in which they wrote down their ancient history and sciences in the books...We found a great number of these books in Indian characters and because they contained nothing but superstition and the Devil's falsehoods we burned them all; and this they felt most bitterly and it caused them great grief."[9]

As the Spanish continued their invasion of Central and South America, the same pattern of destruction and genocide was repeated. Wherever missionaries encountered tattooing they eradicated it. The only surviving record of pre-Columbian tattooing is found on sculptures in which tattoos are represented by engraved lines on the bodies of human figures. These tattoos had great significance within the context of the cultures of Central and South America, but what that significance was, we will never know.

DE LANDA IN YUCATAN, CIRCA 1550

The following selections are taken from *Diego de Landa's Account of the Affairs of Yukatan: The Maya*, edited and translated by A.R. Pagden. Chicago: J. Philip O'Hara, Inc. (1975)

They tattooed their bodies, and the more they did this the more courageous and brave they were considered to be because tattooing was a great torment. It was done in the following way: the tattooist marked out the place that had been chosen with ink and then delicately cut in the pictures, and thus these marks remained on the body in blood and ink. The work was done little by little on account of the great pain it caused and afterwards they were ill because the work used to fester and ooze, but in spite of all this those who did not tattoo themselves were jeered at. They like to appear pleasant and charming and naturally gifted; and now they eat and drink as we do. (pp 67-68.)

They paid for and punished, theft, even if it were small, by making a slave of the thief. It was for this reason that they enslaved so many, especially in time of famine; and this was also the reason why we, the friars, worked so hard to baptize them so that they might be given their freedom. If they were lords or chieftains, the people of the town gathered, and having caught the criminal, they tattooed his face from chin to forehead on both sides as a punishment, for they held this to be a great disgrace. (p. 87)

[The Mayan women] pierced their noses through the cartilage which divides the nostrils down the middle, and placed in the hole a piece of amber; and this was considered an adornment. They pierced their ears in order to wear earrings after the same fashions as their husbands. They tattooed their bodies from the waist up—but they left the breasts free, so as to be able to give suck—in designs more delicate and beautiful than those of the men. (p. 89) ■

Japanese artists tattooing British naval officers. *The London Daily News*, 1897. (after Burchett)

12

ENGLAND

During the nineteenth century tattooing flourished in England as nowhere else in Europe. This was due in a large part to the tradition of tattooing in the British Navy, which began with the first voyage of Captain Cook in 1769. During the decades that followed, many British seamen returned home bearing souvenirs of their travels in the form of exotic tattoos. Sailors learned the art, and by the middle of the 18th century most British ports had at least one professional tattoo artist in residence.

Tattooing gained royal sanction in 1862 when the Prince of Wales visited the Holy Land and had the Jerusalem Cross tattooed on his arm. In later life, as King Edward VII, he acquired a number of additional tattoos. When his sons, the Duke of Clarence and the Duke of York (later King George V), visited Japan in 1882, Edward VII instructed their tutor to take them to the studio of celebrated master Hori Chiyo, who tattooed dragons on their arms. On the way home the two Dukes visited Jerusalem and were tattooed by the same artist who had tattooed their father 20 years before.[1]

The Duke of York, later King George V, being tattooed by the Japanese tattoo master Hori Chyo in Yokohama, 1882. (after Burchett)

Following the example of the dukes, many wealthy Britons and naval officers acquired tattoos from Japanese masters. By 1890 the fad had spread to the US, and tattoos were to be seen on members of the exclusive New York Racquet Club. Socialite Ward McAllister complained to the press: "It is certainly the most vulgar and barbarous habit the eccentric mind of fashion ever invented. It may do for an illiterate seaman, but hardly for an aristocrat. Society men in England were the victims of circumstance when the Prince of Wales had his body tattooed. Like a flock of sheep driven by their master they had to follow suit."[2]

The first British professional known to us by name was D.W. Purdy, who established a shop in North London around 1870. The only existing record of Purdy's work is a booklet published toward the end of his career. It bears the practical title *Tattooing: how to tattoo, what to use, etc.* (London: Medical Tracts, 1896). Purdy apparently drew all his designs freehand without using stencils, for he admonished the beginner:

> Before you commence to tattoo any individual you must be able to sketch well, as it is a very difficult matter to sketch on a person's arm or on any other part of the body; you will have a good deal of rubbing out to do before you get the figure drawn correctly. Whatever part of the body you have to tattoo you must see that there are no large veins in the way, as they must be avoided.... Before you commence drawing out your figure you must see that hairs are all shaved off or you will have some difficulty in trying to sketch with these in the way; shave them off with a razor and nothing else. You cannot draw the lines of the figure too fine as your needles are fine and you must have a fine line to work on.[3]

As for subjects suitable for tattooing, he suggested such ambitious projects as portraits of sweethearts, the Tower Bridge, the Houses of Parliament, the Imperial Institute and British battleships.

During the 19th century, tattooing was approved of and even encouraged in the British army. Field Marshall Earl Roberts, who was himself tattooed, directed that "every officer in the British Army should be tattooed with his regimental crest. Not only does this encourage *esprit de corps* but also

assists in the identification of casualties."[4] Field Marshall Roberts' own son and Queen Victoria's grandson, Prince Christian Victor, both of whom were tattooed with their regimental crests, were among the approximately 22,000 British soldiers who died during the Boer War.

One of the most prominent British tattoo artists of the late 19th century was Tom Riley. Riley's father was a professional soldier, and as a youth Riley followed his father's example and embarked on a military career. He had a natural talent for drawing that he developed by tattooing thousands of regimental crests and other military designs during the South African War and the Sudan Campaign.

Sutherland Macdonald
(*The Sketch*, Jan. 23, 1895).
(courtesy of Tattoo Archive)

After leaving the army, Riley established himself as a tattoo artist in London. His American cousin, Samuel O'Reilly, was a successful New York tattooer who invented and patented the first electric tattooing machine in 1890. Samuel O'Reilly shared his invention with Tom Riley, who became the first British tattoo artist to use the machine. Riley quickly rose to the top of his profession and enjoyed a long and profitable career, during the course of which he traveled extensively and tattooed many continental aristocrats.

Riley's success was due both to his skill as an artist and to his flair for showmanship. One of his most original publicity stunts was the over-all tattooing of an Indian water buffalo at the Paris Hippodrome in 1904. His performance lasted for three weeks and was widely covered by the press. According to one reporter, "the animal was covered with a lovely variety of ineradicable ornaments...there are now about twenty Indians burning incense and worshipping this animal."[5]

Riley's greatest rival was Sutherland Macdonald. Like Riley, Macdonald learned tattooing while serving in the British Army and later enjoyed the benefit of formal art school training. In 1890 he opened a fashionable London studio and strove to establish himself as a respectable professional. To this end, he dressed formally, cultivated a dignified bearing and called himself a "tattooist" rather than a "tattooer" (the word commonly used at the time) on the grounds that "ist" sounded like "artist" whereas "er" sounded like "plumber."

Macdonald enjoyed a privileged status with the Royal Navy. At Plymouth, he was taken in the admiral's yacht to visit battleships, where he added to the decorations of Admiral Montgomery and other naval officers.

Macdonald also advanced his career by courting journalists, and was the subject of many flattering magazine and newspaper articles. In April of 1897, *The Strand* reported that Macdonald's work was "the very finest tattooing the world has ever seen" and that "he has not only equaled the work by the Japanese, but has excelled them."[6] His fame spread to the Continent, where he received rave reviews in the French press. In 1897, *Le Temps* reported that he had elevated tattooing to an art form, and in 1900 *L'Illustration* referred to him as "the Michelangelo of tattooing."[7] Macdonald continued to tattoo in London until his death in 1937.

The greatest of the early British tattoo artists was George Burchett, who began his professional career in 1900, when Riley and Macdonald were at the height of their fame. Burchett was born in Brighton in 1872. As a child, his imagination was fired by tales of travel and adventure told by old sailors he met on Brighton beach. He was fascinated by their tattoos, inquired as to how they were done, and, at the age of eleven, began tattooing his schoolmates with soot and darning needles. His clients were pleased with Burchett's efforts but their parents were not, and when Burchett refused to give up his art, he was expelled from school. At the age of thirteen, he enlisted in the Royal Navy.

In the navy, he was befriended by an older sailor who was an accomplished tattooist and taught him the rudiments of the art. Burchett was inspired by the superb Burmese and Japanese tattoos on the arms of his shipmates. When his ship docked in Yokohama in 1889, he was tattooed by Hori Chiyo, the same tattoo artist who had tattooed the Duke of Clarence and the Duke of York seven years earlier.

After roaming the world for twelve years as a seamen and itinerant tattoo artist, Burchett returned to England. At the age of 28, he opened his first studio in London and embarked on a career that earned him much fame, a small fortune, and the title "King of Tattooists."[8]

Burchett is the only early British tattoo artist who left a written record of his life and work. Because of his lack of formal education he was reluctant to write for publication, but he kept a diary, wrote many letters and made detailed notes in his appointment book. In addition, he was an avid collector of documents, pictures, memoirs and instruments used in tattooing. Toward the end of his life, he wrote the outline of a book based on his diaries and other material from his collection. Before his death, Burchett completed several chapters, and after his death the remaining material was compiled and edited by his friend, Peter Leighton, with the assistance of Burchett's widow and other family members.

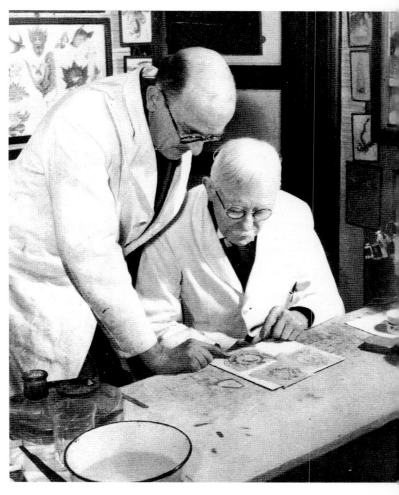

The result of this collaboration was published in 1958 as *Memoirs of a Tattooist*, an informal record of Burchett's experiences and observations during more than half a century of tattooing. In it the author emerges as a man of intelligence and wit who loved his work and felt at ease when dealing with clients from all walks of life, from convicts to royalty.

During his remarkable career, Burchett developed one of the largest practices in the world and employed numerous assistants, including his brothers and his sons, who at one time ran three London studios under the name of Burchett. He was the subject of numerous newspaper and magazine articles, and his royal clients included King Alfonso of Spain, King Frederick IX of Denmark and King George V of England. His energy and enthusiasm did much to promote the popularity of tattooing in England and throughout the world. Burchett continued his busy schedule until he unexpectedly collapsed and died while preparing to go to work on Good Friday, 1953. He was 81.

George Burchett and his son Leslie creating new tattoo designs for the coronation of the Queen in 1953. (after Burchett)

Riley, Macdonald and Burchett were outstanding for several reasons. As young men they had the opportunity to travel and gain much practical experience; they were influenced and inspired by the outstanding artistry of Japanese tattooing; and they worked in London at a time when Japanese prints, Art Nouveau, and the Arts and Crafts Movement were introducing new concepts of design in all forms of graphic art. They enjoyed the patronage of kings and, in addition, had many wealthy customers who paid generously for work of outstanding quality. In this environment they developed their talents to the fullest, and founded a tradition of artistic tattooing which is alive and well in Britain today.

The following selection is taken from *Memoirs of a Tattooist* by George Burchett, and is quoted here by kind permission of George Burchett's son, Leslie Burchett.

BURCHETT IN JAPAN, 1889

The "Victory" dropped anchor in Kobe, Japan, on a fine summer's day in 1889. This port, then the gateway to Japan, had known what it was to have the fleets of Britain, America, France and Holland standing off it, with decks cleared for action. By dint of this encouragement, the deliberations between the Occidental Powers and the representatives of the Imperial Tycoon had been brought to a satisfactory conclusion and the gateway had been opened. By the time I arrived only thirty years had passed since Britain and America had wrung the treaty out of Nippon's rulers which allowed Europeans to settle and open the harbours of Nagasaki, Yokohama and Kobe to foreign ships.

The fantastic tumult of Eastern ports was not new to me. But I expected something new in Japan. I was disillusioned. Kobe and, as I discovered later, Yokohama and Tokyo were less "oriental" and outlandish than the British ports in China and the Straits Settlements. The streets of these Japanese cities seemed to have been westernized overnight. They were broad and straight. Most houses were built of stone and had many stories. There were imposing, dull buildings for banks, offices and shops which would not have looked out of place in the City of London. There was a Japanese quarter in Kobe, of course, but it was not as much in evidence as in Yokohama, which preserved the Eastern look to a greater extent. However, Kobe Harbour itself was then one of the most beautiful in the East. A panorama of countless islands spread out in all directions from the bay, and it was on these islands that the Japanese lived, in tiny houses, built of paper and thin wood. The houses huddled together in little groups, as if to make up for their flimsy weakness by facing the elements together. Their curly roofs looked jaunty and some of the houses overhung the sea. But more people lived on board the junks and sampans with which the bay seemed to be alive.

Over this scene the sun set in wonderful glory. I did not have to wait to see some of Japan's art close-to before I realized what had inspired for centuries the tattoos I had admired. As I looked out to the islands and their delicate silhouettes I was, in my boyish way, moved for perhaps the first time in my life by pure beauty, and I also felt a kind of sadness which I did not understand. Now, I think, it simply meant that I realized that there are some things in life which will always keep on the other side of the shop window. In my case, I would never be able to achieve anything so lovely as the view from H.M.S. "Victory" over Kobe with my own hand.

In the streets of Japan there was a mass of colour. Everyone seemed in a hurry and one had to be agile to keep out of the way of the jinrickshas, the fleet-footed coolies. But I found a corner from which to watch undisturbed and I shall always remember the Japanese girls tripping along in their brightly coloured kimonos, with brilliant reds, greens, yellows and violets. Even the children were dressed in the most extraordinary style. The looked like little cardinals with long robes of scarlet, violet and black, all padded out so that they looked dumpy and very, very serious. In this respect it was as well that my first glimpse of Japan was at Kobe and not Yokohama and Tokyo, where the taste in dress was much quieter. There they wore dark blue and rarely relieved it with any contrasting colour.

But once again it was not until the evening that Japan really came up to my high hopes. Then the lanterns were hung from the shop fronts and the men and women carried more glowing lanterns as they walked through the streets. Possibly my introduction to mulled sake stimulated my imagination, but I returned to the "Victory" like a man who has just visited fairyland. Needless to say, I did not reveal such sloppy thoughts to my shipmates whose requirements of a port were not so delicate.

We were given shore leave at Yokohama and I was able to visit the greatest tattooist there has ever been. Or, to be more accurate, I was able to visit his house…"Hori" is the ancient Japanese title for all tattooists. They are, or were, more like a priesthood than anything else, possessing deft skill which, to my mind, bordered on the supernatural. Not the least wonderful

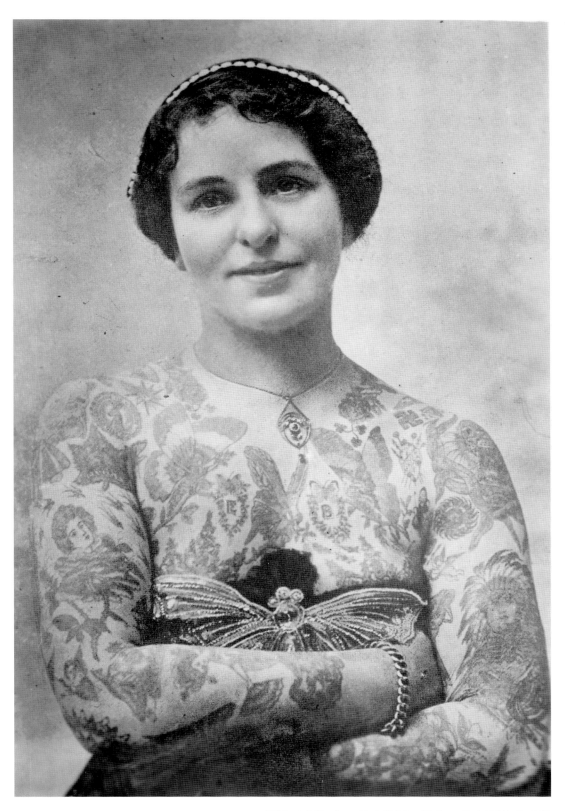

Edith Burchett (Mrs. George Burchett), tattooed by George Burchett. (after Burchett)

aspect of their talent was the speed at which they worked. But no Hori had surpassed the delicacy of line, the precise detail, and, above all, the glowing colours and subtle shading created by Hori Chyo.

Perhaps only an oriental, with his patience and devotion, which is religious in character, could get so near perfection. I knew that Western tattooists, however skilled and gifted, were only imitators of an art which had been cultivated in Japan for 2000 years. Hori Chyo was the inheritor and custodian of this tradition and its secrets which had been handed down for generation after generation.

I decided that somehow, I had to visit the workshops of this master and, if humanly possible, meet him myself. Chyo had his studio at the Esplanade, a westernized thoroughfare. But his house was a Japanese bungalow with an elegant and peaceful forecourt where his servants and pupils greeted the visitor. I was overawed.

Tattooing had just been forbidden in Japan by an Imperial decree in one of a series of measures designed to westernize the Land of the Rising Sun. Forbidden, that is, for Japanese skins, but not so for foreigners. They were free to patronize the horis. This was not logical in the western sense, and I do not think it pleased the Japanese, who continued to be tattooed in secret. But the result was that Chyo was compelled to cultivate western clientele and, as I, a humble rating, stood in the forecourt, I felt embarrassed by the steady procession of officers and wealthy business men who were arriving for their costly appointments with the famous tattooist.

Nevertheless, I was treated with the utmost courtesy. One of the pupils departed bearing my stammered request to meet the master. I did not

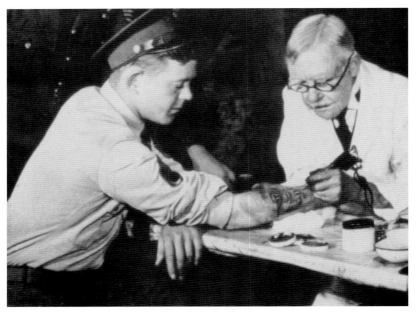

George Burchett tattooing an American soldier during World War II. (after Burchett)

admit that I had never seen any work by Chyo as it was always placed on bodies beyond my rank and station at that time. As I waited I was offered cigarettes and a bowl containing a sort of fish soup. This was given to all visitors, the soup being kept in a large vessel on a bamboo pedestal. For those who fancied it, there was also cold tea, hot water and mulled sake.

I was gingerly testing the fish soup when another pupil came up and asked, in broken English, whether I would like to be attended to by himself or another young hori. Obviously he suspected that I could not afford the master's stiff fee. When I told him that I wished to meet the master because I was an amateur tattooist, he smiled, bowed, and left me alone.

At last I was called forward. In my eagerness I nearly collided, at the entrance, with a Lieutenant, R.N., who gave me a dirty look when I sprang to attention. He acknowledged my salute and departed without saying a word.

Then I saw Hori Chyo. He was sitting on one of the cushions which were laid out all over the room. He smiled and beckoned me forward.

He was a small, slightly built man, with a short, silvery goatee beard. He looked more like a Chinese mandarin than a Japanese Samurai. He was wearing a magnificent yellow silk kimono with rich embroidery showing dragons and chrysanthemums. So this was the man who, in his

youth, had studied with the legendary Hori Yasu of Kyoto, and had then taken the art of Japanese tattooing on to unsurpassed glory.

In excellent English he said he had heard that I was a tattooist and that he was honoured by my call. Hastily I explained that I was just a beginner and that it was the greatest event of my life to be allowed to meet him. This was no attempt at Oriental courtesy on my part. Chyo asked me whether I would like to be tattooed, and I had to explain that I had only a little money and that I could not spend more than fifty yen. It was quite enough for me to spend, as it equaled

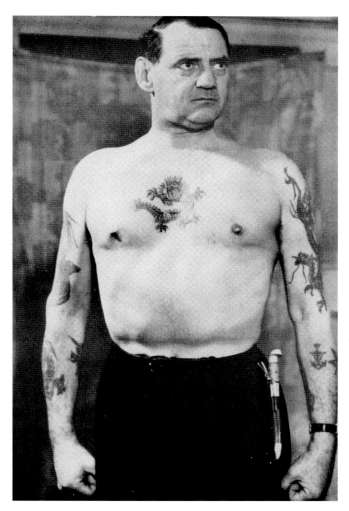

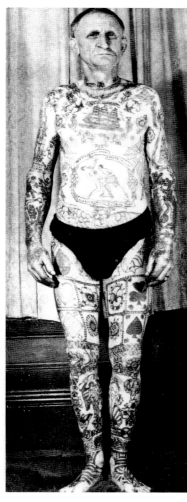

Left: King Frederick IX of Denmark (1899-1972), tattooed by George Burchett. (after Burchett)

Right: One of Burchett's many satisfied customers. The lettering in the banner around the boxers reads: "Blessed is he whose cuase [sic] is just, thrice blessed he who cuts his blow in first." Burchett offered to remove and correct the word "cuase," which he had accidentally misspelled, but the customer liked it as it was.

about five shillings.

He smiled again and said that he would be happy to make a small design as a souvenir of our meeting. But, he added, I might be interested in watching him at work, and he asked me whether I would allow him to ask in another client who had an appointment. I readily agreed and a fat Frenchman, who had arrived aboard a large French merchantman which I had seen in port, was ushered in by a pupil. He was asked to strip and lie on the cushions. Chyo bent over him and, after a short, whispered conversation, apparently the master also spoke French, Chyo murmured a word or two to the pupils kneeling by him.

They all had tattoo needles in their hands and jars containing coloured dyes on small lacquer trays. To my astonishment I discovered that the needles were in fact thin ivory sticks, the size of a pencil, carved and brightly painted with designs. Chyo neither showed his customer a

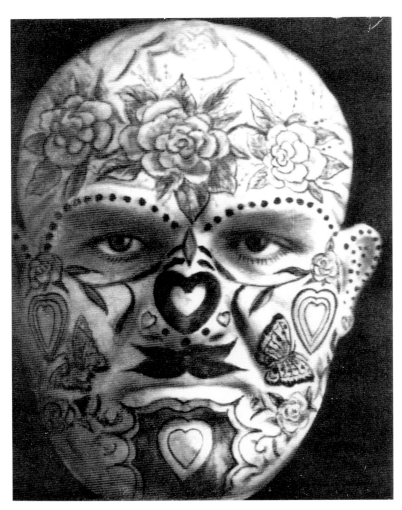

Ex-convict J, P. Van Dyn, formerly of Sing Sing and Devil's Island. Burchett commented: "Very few of my clients, except professional fair-ground artists, would decide to ornament their faces in such an elaborate and distinct manner as Mr. Van Dyn—he sketched some of the designs himself."
(after Burchett)

book of designs nor did he look at one himself. Rapidly he applied the ivory sticks, changing them again and again, using points of varying thickness for the different lines he was so quickly puncturing. In the meantime, several other customers arrived, were told by the pupils to stretch out on the cushions and rugs, and Chyo darted from one to another, while his pupils continued to work, following his outlines.

When at last the master approached me, he asked: "Would you like a little lizard on your arm?" I just nodded, unable to utter a word. A pupil gave him an ivory stick, and he punctured my skin so gently and rapidly that I hardly felt it at all, dipping the stick into jars which another pupil held in front of him. He changed them again and again. Within a few moments I had a wonderful small lizard darting up my forearm, green, brown and yellow, with finely shaded scales and red eyes and tongue.

Before I realized that he had finished, Chyo was already attending another man across the room. My audience was at an end. A pupil wiped my forearm with a pleasantly smelling wet piece of silk or paper and said: "Will the honourable gentleman now be so good as to tender a note of fifty yen?" This I did, bowing now myself as deeply to the little fellow as he did to me. I tried to catch Chyo's eye to bow to him to express my gratitude, but the master was far too busy to see me.

During my shore leave I went three times more to Chyo's bungalow, just to sit in the forecourt and to snatch a glance at his work or even that of his pupils. Although I was never allowed to enter the sanctum again, I could watch some of the pupils tattooing some of the British and American sailors in the forecourt, apparently at cut rates. These pupils, some boys of my own age or even younger (one told me he was fourteen), were tattooists in their own right and as quick as Chyo.

I was told that Chyo was a very rich man. He had tattooed many royal personages, including the Duke of Clarence and the Duke of York, who later became King George V, when the two brothers served as midshipmen aboard H.M.S. "Bacchante", which visited Yokohama in 1882. The two dukes had been on a world tour which lasted nearly three years, and had come from Australia to Japan, where they were received with great ceremony by the Mikado. The Duke of Clarence was eighteen, his brother sixteen months younger. That the two young men were allowed to visit Hori Chyo puzzled many of the informed people in London, because the princes were in the charge of Canon Dalton, their tutor (the father of Dr. Hugh Dalton, who was later a famous Labour Party politician). However, as I later heard, it was the wish of King Edward VII that his sons should acquire some small adornment from the hand of the great Japanese master. I have forgotten what design he gave the Duke of Clarence, who died from a chill in 1892 at only twenty-eight years of age, but I have had the privilege of seeing Chyo's masterpiece, a dragon, on his royal brother's forearm.

Chyo had also tattooed the Czarevitch of Russia, later Czar Nicholas II during the Russian

state visit to Tokyo some years after. When I visited the master his eyesight must have been already failing; indeed, I was told he had only one good eye left. The other had become blind, probably from the constant strain caused by executing the extremely minute details of his designs. But his eye trouble did not prevent him from accepting an invitation to New York. The story was that he had been accused of tattooing a Japanese samurai whom the Mikado disliked. To spite the nobleman, the Emperor arranged that Chyo should be prosecuted by the police for tattooing a subject of the Emperor. The hori staunchly denied the offense, but he was fined. The fine was small, but Chyo's indignation about this treatment was so great he announced that he was leaving the country. He was enabled to do so by an American millionaire, Mr. Max Bandel, of New York, who had acquired some beautiful tattoos during a stay in Yokohama. Mr. Bandel invited Chyo to New York at a retainer of £2,400 a year, which would be in addition to any fees Chyo cared to charge individual customers. Chyo worked for several years in New York, and he and his American pupils were responsible for the designs of some of the monumental works executed for Barnum upon the skins of Mr. and Mrs. Williams and Frank and Emma de Burgh. Frank had a reproduction of Lenoardo da Vinci's "Last Supper," Emma a representation of the crucifixion. While these two pieces were not by Japanese artists, Chyo's influence upon the American tattooists was obvious in the great detail of the picture. ■

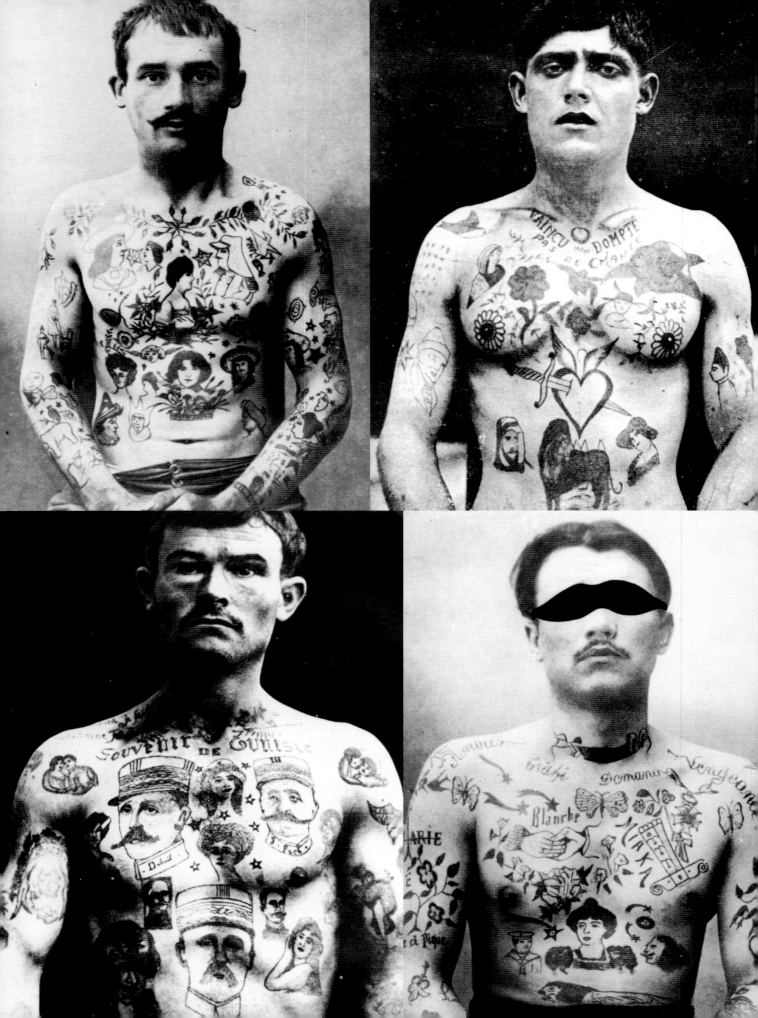

FRANCE AND ITALY

In France, tattooing was popular among seamen, laborers and convicts during the first part of the nineteenth century. Members of the middle and upper classes, however, thought it beneath their dignity, and it was never popular among the titled and the wealthy as it was in England. This was due in part to the influence of the Catholic Church, which had traditionally opposed tattooing on the grounds that it was associated with superstition and paganism.

In addition to the church's disapproval, there was in France a strong opposition to tattooing on the part of the medical profession. Scattered reports of complications resulting from tattooing began to appear in the French medical literature during the early part of the nineteenth century. M. Rayer, the author of a work on dermatology that was published in 1835, reported several cases of severe infections caused by tattooing.[1] In 1837 the first recorded instance of a death following tattooing appeared in a work by Parent-Duchatelet titled: *De la prostitution dans la ville de Paris*. Parent-Duchatelet wrote: "This operation, so simple in appearance, cost the life of an unfortunate young woman who attempted to disguise a name which she had awkwardly tattooed on her left arm. This attempt caused a serious infection which ultimately resulted in her death."[2] (*translated by Steve Gilbert*)

In 1853 a physician, M. Hutin, reported the first case in which syphilis was transmitted by tattooing. He wrote: "A soldier allowed himself to be tattooed by a man who was suffering from syphilis and who had chancres on his lips. The soldier was a virgin and perfectly healthy, and the tattooer only punctured his arm a few times. The Chinese ink used by the tattooer had dried up in a shell and several times the tattooer moistened his needles by spitting on them and diluted the ink with his saliva. In this way he inoculated the soldier with syphilis. This resulted in serious complications and, according to the patient, almost necessitated the amputation of his arm."[3] (*translated by Steve Gilbert*)

A French naval surgeon, Jean-Adam Ernest Berchon, published a paper on medical complications of tattooing. In 1861 he wrote:

> Until 1859 no author had thought of researching the medical complications that can be caused by tattooing. It was generally thought to be innocuous, or, in some cases, followed only by a transient inflammation. And yet there is much to be learned with regard to this subject. After an extensive search of the published literature I have been able to discover only six reports of more or less serious complications caused by tattooing. In addition to these, I was able to present ten additional cases in which tattooing has been followed by amputation, death, and other serious consequences.[4] (*translated by Steve Gilbert*)

To put these medical complications in perspective, it should be remembered that in 1860 no one knew that microorganisms caused infections and disease. Surgeons did not wear gloves or even wash their hands before they operated. They did not sterilize their instruments, and many of them operated wearing blood-encrusted aprons. In maternity wards, doctors spread disease by examining one woman after another without washing their hands. Infections and pus were considered a normal

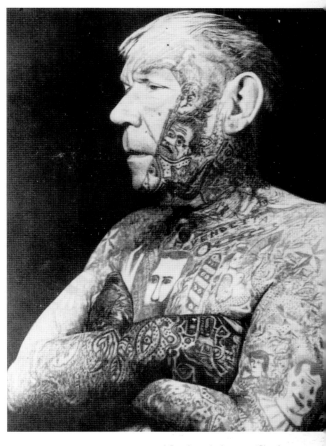

A French convict known as "Ricardo, the most tattooed man in the world." (after Delarue and Giraud)

Opposite page
Top left: A French convict with portraits of women.

Top right: A French convict with winged heart and dagger. The lettering on the chest reads: "Down but not out" and "No luck".

Bottom left: A French convict. The letters on at the top of the chest read: "Souvenir of Tunisia". On the upper left part of the chest is a portrait of General Ferdinand Foch, (1851-1929), commander of Allied Forces during the final months of World War I.

Bottom right: A French convict with women's names "Blanche" and "Miaka". (after Delarue and Giraud)

part of the healing process following surgery, and many surgical procedures that are considered safe and routine today resulted in serious infections, blood poisoning, gangrene and death.

Tattoo artists were no wiser than surgeons. They routinely used the same needles on more than one customer without cleaning them. They mixed their ink in clamshells and diluted it with saliva. It was customary to wash off a fresh tattoo with saliva, tobacco juice or urine. In view of these unsanitary practices, it is remarkable that there were so few reports of serious complications following tattooing. At the time Berchon's paper was published, professional tattoo artists were working in all major French ports. Berchon estimated that most convicts, most sailors, and many soldiers and laborers were tattooed. Thus it is probable that serious infections occurred only a few times in many thousands of tattoos.

Why, Berchon asked, does tattooing cause complications in some cases but not in others? He wrote: "most individuals we have interrogated are almost unanimous in declaring that the operation itself is harmless, but the use of certain pigments, or the unique predisposition of the patient causes certain individuals to have an unfavorable reaction."

Berchon considered this problem at some length and concluded that complications could not be caused by something in the pigments, the use of rusty needles, or by the application of saliva, tobacco juice, or urine to a fresh tattoo. In his conclusion he was ahead of his time and close to the truth. He wrote that infections were caused by

> the action of organic materials which accidentally adhere to the needles and are introduced along with the needles into the skin.... The most serious dangers of tattooing are caused by contaminated needles. It is difficult to avoid this contamination because of the number and arrangement of the needles. Their points are almost contiguous, which makes it impossible to clean them. They can easily be charged with organic matter during the many punctures of the skin which occur during the operation. This matter, which becomes putrefied or fermented during the interval between the sessions, is reintroduced into the skin and causes morbid phenomena analogous to those which occur in cases of anatomical wounds.[6] [i.e. when a surgeon operating on a gangrenous limb cuts himself with a contaminated scalpel.]

Berchon's paper was awarded first prize for papers in medicine and surgery for the year 1861 by the Academy of Sciences. It came to the attention of the Secretary of the Navy, who issued an order prohibiting tattooing in the French Navy. This was soon followed by a similar prohibition in the Army.

Encouraged by the success of his first paper, Berchon continued his researches and wrote a series of articles that he later collected and published in book form under the title *Histoire Medicale du tatouage* (1869). He began by examining Greek and Roman literature for references to tattooing and found that Plato, Plautus, Aristophanes, Galen, Herodotus, Petronius, Julius Caesar and scores of other ancient authors mentioned it. He thus showed tattooing had been practiced in Greece, Rome, and many other ancient civilizations—a fact little known at that time.

Berchon also observed French tattoo artists at work, described their techniques and their designs, analyzed the chemical composition of their pigments, described methods of tattoo removal, examined sections of tattooed skin under the microscope, and considered the medical and legal complications of tattooing. He recommended that legal action be taken against tattooers whose unsanitary practices resulted in infections or the transmission of disease, and made an exhaustive search of the French penal code in an effort to find the sections under which tattooers might be charged. He thought it unlikely that it would be possible to eliminate tattooing completely, but expressed "the hope that the facts we have demonstrated will be sufficient to make clear to physicians and to the public at large the dangers, unrecognized before our study, of a custom for which there can be no rational justification in any civilized country."[7]

Tattooing was never completely outlawed in France, but the fact that it was forbidden in the Army and the Navy put most professionals out of business, and there are few records of tattooing outside of prisons in France during the latter part of the nineteenth century. It was a case of 'when tattoos are outlawed, only outlaws will have tattoos.'

The first written account of tattooing among convicts appeared in Cesare Lombroso's *L'Uomo Deliquente* (1876).[8] Lombroso was a professor of psychiatry and criminal anthropology at the University of Turin. He invented the theory that criminals are throwbacks to an ancient and more primitive type of man in whom the passions are predominant and moral qualities undeveloped. According to Lombroso, such a man is cruel, cowardly, insensitive to the suffering of others, and lives only to gratify his own bestial desires. Lombroso imagined that these criminal types could be identified by a complex series of cranial, facial and bodily measurements. They were supposed to have low foreheads, small brains, heavy jaws and "remind us incontestably far more of the American Black and Mongolian races than the white races, and remind us above all of prehistoric man.... They are the outward and visible signs of a mysterious and complicated process of degeneration, which in the case of the criminal evokes evil impulses that are largely of atavistic origin."[9]

One of the easiest ways to recognize criminals was by their tattoos, and Lombroso considered tattooing so significant that he devoted an entire chapter to it. He examined 5,343 criminals and found that about ten percent of the adults were tattooed. He listed and categorized hundreds of tattoo designs that, he asserted, would be of great significance in the analysis of the criminal mentality. Examples of things to watch out for were: mottoes expressing disrespect for authority or the desire for revenge; obscene words and images; tattoos on the penis (a sure sign that you are dealing with a dangerous criminal!); tattoos signifying membership in a secret criminal organization, and words written in cryptic cipher (often used for conveying secret messages). He recommended that when examining a criminal, prison officials should make a detailed record of his or her tattoos.

Lombroso's significance for the history of tattooing lies in the fact that he made the first statistical records of the frequency of tattooing and the designs among Italian convicts. He was also the first author who published reproductions of 19th century European tattoo designs. His moral judgments and pseudoscienetific theories, although long outmoded, remain interesting as a record of the prejudices and misconceptions that were widely held by his contemporaries.

Numerous references to tattooing are to be found in 18th and 19th century French literature. Some of these focus on the importance of a tattoo in establishing the identity of an individual. In Beaumarchais's 1784 stage play *Le Mariage de Figaro,* the infant Figaro is tattooed by his doctor as a means of identification. Highwaymen later kidnap him, and when he returns after an absence of many years he is able to prove his identity by showing the tattoo on his arm.[10]

In Victor Hugo's *Les Miserables,* ex-convict Jean Valjean proves his identity in court by accurately describing tattoos on two convicts whom he had known many years before in prison. Jean Valjean says:

> "Chenildieu, you gave yourself the nickname "*Je-Nie-Dieu*" [I Deny God]. On your right shoulder you have a scar which was caused when you pressed your shoulder against a red-hot brazier in an attempt to efface the letters T.F.P. [*Travaux Forcés Perpetuels*: Hard Labour for Life]. But the letters can still be faintly seen. Is this true?"
>
> "It is true," said Chenildieu.
>
> Jean Valjean then addressed Cochepaille: "Cochepaille, near the inside of your left elbow you have a date in blue letters which was tattooed with gunpowder. It is the date on which the Emperor [Napoleon] landed at Cannes: March first, 1815. Roll up your sleeve." Cochepaille rolled up his sleeve, and the spectators crowded around to see his bare arm. A guard approached with a lamp, and the tattooed date could be seen.
>
> Jean Valjean turned toward the spectators and the judges with a smile that will

always be remembered with emotion by those who witnessed it. It was a smile of triumph, but it was also a smile of despair.

"You can plainly see that I am Jean Valjean," he said.[11] (*translated by Steve Gilbert*)

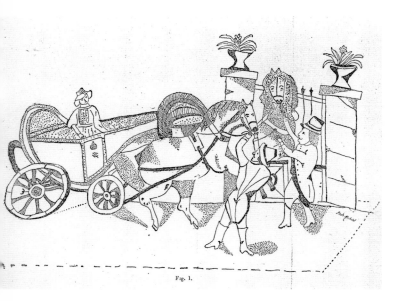

Fig. 1.

A 19th century French tattoo design recorded by Alexandre Lacassagne. (1881)

Tattooing was used as proof of identity in one of the most sensational lawsuits of the 19th century. In April of 1854, a young man named Roger Tichborne disappeared and was presumed dead when the schooner *Bella*, on which he was a passenger, was lost at sea. Some years later, relatives of those who had sailed on the *Bella* advertised for information which might lead to the discovery of survivors. In 1871, a man who had been living under the name of Castro answered one of the advertisements, claimed to be Roger Tichborne, and demanded Tichborne's considerable fortune.

Castro had done his homework well and impersonated Tichborne so convincingly and a number of witnesses identified him as Tichborne. The only apparent flaw in his story was that Tichborne had had a cross, an anchor and his initials "RCT" tattooed on his left arm. Castro explained his lack of the tattoo and the fact that he had changed his name by saying that he had suffered a severe illness that had resulted in amnesia and caused the tattoo to disappear.

After two trials, which lasted for a total of 251 days and created a sensation in the popular press, Tichborne was convicted of "stupendous impostures" and sentenced to 20 years in prison.[12] A contemporary French journalist observed that "it is surprising that this impostor could deceive so many people and escape justice for so long. This indicates the lack of common sense and the imperfect education which are typical of most Englishmen."[13]

Tattoos were often used in French court cases to establish the identity of the accused, and for this reason French prison regulations dating from 1808 required prison officials to make detailed records of the tattoos on each convict. An ambitious survey of 19th century French prison tattooing was undertaken in 1880 by Dr. Alexander Lacassagne, a professor of medical jurisprudence at the Faculty of Medicine in Lyons. While serving as a surgeon in the French Army, Lacassagne observed many tattoos among soldiers of the African Battalions. These battalions were made up of men who had served prison terms for offenses such as murder, desertion and theft. Lacassagne found the variety and the subject matter of the tattoos fascinating. Because the tattoos were difficult to photograph, Lacassagne developed his own method of tracing them on a piece of transparent cloth that he placed on top of the tattoo. In this way he collected over 2,000 tattoo designs, many of which he reproduced in a work titled *Les tatouages, étude anthropologique et médico-légale* (Paris, 1881).

Lacassagne enumerated and classified his collection of tattoo designs according to subject matter and position on the body. Many of the designs were similar to the perennial favorites still seen today. There were stars, anchors, birds, snakes, flowers, butterflies, daggers, clasped hands, hearts pierced by arrows, names, initials and dates. But in other ways, French tattooing was unique. Many convicts had mottoes in large letters tattooed across their chests or backs. Lacassagne collected scores of these, among which were such phrases as "Death to Unfaithful Women;" "Kill the Pigs;" "Death to French Officers;" "Vengeance;" "Liberty or Death;" "Child of Misfortune;" "Born under an Unlucky Star;" "The past has cheated me, the present torments me, the future terrifies me;" "The whole of France is not worth a pile of shit."[14]

Ambitious, full-scale back pieces portrayed scenes from history, mythology and literature. Lacassagne counted over thirty tattoos featuring the Three Musketeers, and observed with approval

Fig. 14

Fig. 15

Left: Tailor. (after Lacassagne)

Right: Fig. 14: Butcher. Fig. 15: Barrel maker. (after Lacassagne)

that "I do not think it would be possible to find a better proof of the impression produced on the people by the novel of Alexander Dumas."[15] Also popular were portraits of Napoleon, Joan of Arc, Charlotte Corday, Garibaldi, Bismarck and other historical figures. The most popular mythological figures were Bacchus, Venus and Apollo.

The most popular erotic designs were the female bust and the nude female figure but Lacassagne also observed "a multitude of lewd images impossible to describe."[16] Among the more unusual tattoos, he reported that "I have seen tattooing covering the entire body, one was the complete uniform of a general. I have even seen designs and inscriptions on the face. One individual had tattooed on his forehead the words "Martyr of Liberty" and a serpent; another had the prophetic inscription "prison awaits me."[17]

He found the following words tattooed below the navel: "Come, ladies, to the fountain of love"; "Pleasure for girls"; "She thinks of me". On the buttocks: a penis with wings; a penis under full sail; a snake with its head directed toward the anus; a pair of eyes; two soldiers holding crossed bayonets and carrying a banner bearing the words "Do not enter."[18]

He reported finding the following designs on the penis: an ace of hearts, an arrow, a lottery number, names and initials. But to his surprise, the most frequently encountered penis tattoo was a riding boot with a spur. He traced fifteen of these designs and observed many more which escaped his pen. He wrote: "It is not, as I thought at first, a sign of pederasty. All of the individuals I questioned on this point agreed that they had this tattoo so they could make the shocking play on words: *Je vais te mettre ma botte au....*"[19] The pun, according to contemporary British journalist Robert Fletcher, is "untranslatable, and too vile to be quoted in full."[20]

Lacassagne did not approve of the English enthusiasm for tattooing. He wrote: "I was astonished to read in a newspaper some months ago—and I repeat this story with reservations—that the Prince of Wales had an anchor tattooed on his arm while on a voyage around the world."[21]

It is ironic that in England, where monarchs and royalty were tattooed, nothing, with the exception of a few newspaper articles, was written on tattooing during the 19th century. Lacassagne himself remarked on this: "The English have made no study of tattooing. Their medicolegal authorities only repeat what the French have written."

Lacassagne concluded by expressing the hope that his book would be a significant contribution to the new sciences of criminal anthropology and criminal psychology, as well as of value from the medicolegal point of view.

That this was the case is doubtful. The pseudoscience of criminal anthropology has long been discredited. From a medicolegal point of view, tattooing was of interest only if it could be used to identify convicts. The 19th century French legal system was one of the most corrupt and repressive in the world. Tens of thousands of Frenchmen who had committed crimes that would be considered minor today were exiled for life to the horrors of the French Guiana penal colony popularly known as "Devil's Island."

His book, however, is a valuable source of information for those interested in the history of tattooing. It contains the first published illustrations of 19th century French tattoo designs and chronicles the historical origins of French prison tattoo art, which developed many unique and unusual themes. It also includes references to everything published on tattooing in Europe up to that time, together with detailed descriptions of techniques, instruments and pigments used by 19th century tattoo artists. It has been referred to by all later writers on the history of European tattooing and remains a classic today.

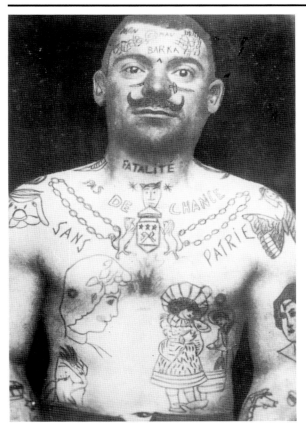

"The Savage Origin of Tattooing" by Cesare Lombroso.
From *Popular Science Monthly*, April, 1896.

LOMBROSO ON ATAVISM, 1896

I have been told that the fashion of tattooing the arm exists among women of prominence in London Society. The taste for this style is not a good indication of the refinement and delicacy of the English ladies: first, it indicates an inferior sensitiveness, for one has to be obtuse to pain to submit to this wholly savage operation without any other object than the gratification of vanity; and it is contrary to progress, for all exaggerations of dress are atavistic. Simplicity in ornamentation and clothing and uniformity are an advance gained during these last centuries by the virile sex, by man, and constitute a superiority in him over woman, who has to spend for dress an enormous amount of time and money, without gaining any real advantage, even to her beauty.

But it is not desirable that so inordinate an accession to ornamentation as tattooing should be adopted; for an observation I have made on more than 5,000 criminals has demonstrated to me that this custom is held in too great honor among them. Thus, while out of 2,739 soldiers I have found tattoo marks only among 1.2 percent, always limited to the arms and breast; among 5,348 criminals, 667 were tattooed, or ten percent of the adults and 3.9 percent of the minors. Baer recently observed tattooing among two percent of German criminals and 9.5 percent of soldiers. (*Der Verbrecher,* 1893)

CHARACTERISTICS OF CRIMINAL TATTOOING: VENGEANCE.

The minute study of the various signs adopted by malefactors shows us not only that they sometimes have a strange frequency, but often also a special stamp. A criminal whom I studied had on his breast between two daggers the fierce threat "Je jure de me venger" (I swear to avenge myself). He was an old Piedmont sailor who had killed and stolen for vengeance.

The famous Neapolitan camorrist Salsano had himself represented in an attitude of bravado. He held a stick in his hand, and was defying a police guard. Under the figure was his sobriquet, "Éventre tout le monde" (disembowel everybody); then came two hearts and keys connected with chains, in allusion to the secrecy of the camorrists. ["Cammora" was the name of a secret society of outlaws in the Neapolitan district of Italy]

We see then, by these few examples, that there is a kind of hieroglyphic writing among criminals, that is not regulated or fixed, but is determined from daily events, and from *argot,* very much as would take place among primitive men. Very often, in fact, the key in the tattoo designs signifies the silence of secrecy, and the death's head signifies vengeance. Sometimes the figures are replaced by points, as when a judicial arrest marked on the arm with seventeen points, which means, according to the criminal, that he intends to strike his enemy that number of times when he falls into his hands.

A French convict with tattooed moustache. The lettering on the neck reads: "fate" or "inevitability". The lettering on the chest reads: "No luck" and "Without Country". (after Delarue and Giraud)

Another characteristic of criminals, which is also common to them with sailors and savages, is to trace the designs not only on the arms and the breast (the most frequent usage), but on nearly all the parts of the body. I have remarked one hundred tattooed on the arms, breast, and abdomen, five on the hands, three on the fingers, and three on the thigh.

A certain T–, thirty-four years of age, who had passed many years in prison, had not, except on his cheeks and loins, a surface the size of a crown that was not tattooed. On his forehead could be read "Martyr de la Liberté"; the words being surmounted by a snake eleven

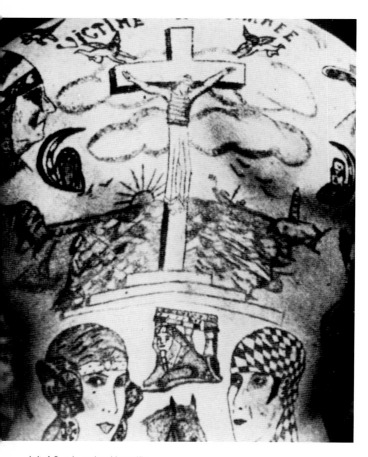

Left: A French convict with crucifix and women's heads.
(after Delarue and Giraud)

Right: A tattoo commemorating the assassination of the Duke of Guise.
(after Delarue and Giraud)

centimeters long. On his nose he had a cross, which he had tried to efface with acid.

A Venetian thief, who had served in the Austrian army, had on his right arm a double-headed eagle, and near it the names of his mother and his mistress Louise, with the strange epigraph for a thief: "Louise, chère amant, mon unique consolation" (Louise, dear loved one, my only consolation). Another thief wore on his right arm a bird holding a heart, stars, and an anchor. On the left arm of a prisoner Lacassagne found the words "Quand la neige tombera noire, B— sortira de ma mémoire." (When the snow falls black, B– will pass out of my memory.)

The multiplicity of marks results from the strange liking these curious heroes have of spreading on their body, just after the fashion of the American Indians, the adventures of their lives. For example, M–C–, twenty-seven years old, who had been condemned at least fifty times for rebellion and assaults on men and horses, who had traveled, or rather wandered, a vagabond, in Spain and Africa with women whom he left suddenly, wore his whole history written on his skin. One design referred to the ship L'Espérance, which was wrecked on the

coast of Ireland, and on which he had gone as a sailor. A horse's head represented an animal which he had killed with a knife, from simple caprice, when twelve years old. A helmet indicated a policeman he had tried to kill. A headless woman with a heart on her neck indicated his mistress, who was frivolous. The portrait of a brigand referred to a robber chief whom he took for his model. A lute recalled a friend, a skillful player of the guitar, with whom he traveled over half of Europe. The star, the evil influence under which he was born. The royal crown, "a political souvenir," he said, but rather, we say, his new trade of a spy—that is, the

Left: Ricardo's back.
(after Delarue and Giraud)

Right: A French convict with crucified Christ, sailor, and woman.
(after Delarue and Giraud)

destruction of the kingdom.

A French deserter who desired to avenge himself against his chief drew a dagger on his breast to signify vengeance, and also a serpent. He further drew the ship on which he wished to escape, the epaulets which had been taken away from him, a dancing girl who had been his mistress, and then the sad inscriptions which were truly appropriate to his unhappy life.

Dr. Spoto sent me a study of the tattooing of a criminal who had been under his care. He wore all his sad adventures painted on his arm (see *Archivo de Psichiatria,* June, 1889). He had one hundred and five signs on his body, ten of which represented mistresses, nine hearts, eight flowers or leaves, five animals, twenty-eight names, surnames, or descriptions, and thirty-one daggers or warriors. On his arm he had a figure of a lady winged and crowned; winged, he said, "because I made her take flight" (he had run away with her); crowned, because she had substituted for the crown of virginity the royal crown in becoming his mistress. She held in her hand a heart and an arrow, signifying her parents, to whom her flight had caused great grief. Beneath her were two branches, which signified that she kept herself always fresh.

A French soldier with romantic scene and lighthouse.

Two other of his loves explained their sad adventures by holding crumpled roses in their hands. In his hand he had an eagle, representing the ship on which he sailed, and beneath it a heart with three points, referring to the sufferings of Christ, whose birthplace he had visited at Bethlehem. A heart on his arm represented a mistress with whom he had lived several years. It was pierced with an arrow, because he had abandoned the woman with two little children, who were represented by two bleeding hearts. Two hearts pierced with swords, on his forearm, represented two mistresses who would not yield to his desires except when threatened with death. They were connected by a chain with an anchor hanging from it, which signified that the women belonged to a sailor family, and a Greek cross above them indicated that they were Greek. On his breast was a dancing girl carrying a bird, because she bounded like a bird. On his sides were a cock and a lion, the cock corresponding to women who wished to be paid: "When the cock sings, Spiritelli will pay." The lion meant that he felt as strong as a lion. A smaller lion a few centimeters from this meant that even among lions the stronger gains the victory over the weaker. So he, the stronger, had overcome those who would play the camorrist with him.

Never, I believe, have we had a more striking proof that tattooing contains real ideological hieroglyphs which take the place of writing. They might be compared to the inscriptions of the ancient Mexicans and Indians, which, like the tattooings we have described, are the more animated history of individuals. Certainly these tattooings declare more than any official brief to reveal to us the fierce and obscene hearts of these unfortunates.

This multiplicity of figures proves also that criminals, like savages, are very little sensitive to pain. Another fact that characterizes tattooing is precocity. According to Tardieu and Berson, tattooing is never remarked in France before the age of sixteen years (excepting, of course, the cases of ship's boys who have borrowed the custom from sailors); yet we have found, even among the general public, four cases in children from seven to nine years of age; and of eighty-nine adult criminals, sixty-six displayed tattooings which were made between nine and sixteen years.

Some tattoo marks are used by societies as signals of recognition. In Bavaria and the south of Germany the highway robbers, who are united into a real association, recognize each other by the epigraphic tattoo marks T. and L., meaning "Thal und Land" (valley and country), words which they exchange with one another, each uttering half the phrase, when they meet. Without that they would betray themselves to the police.

The primary, or chief cause that has spread the custom of tattooing among us is in my opinion atavism, or that other kind of historical atavism that is called tradition. Tattooing is, in fact, one of the essential characteristics of primitive man, and of men who still live in the savage state.

Nothing is more natural than to see a usage so widespread among savages and

prehistoric peoples reappear in classes which, as the deep-sea bottoms retain the same temperature, have preserved the customs and superstitions, even to the hymns, of the primitive peoples, and who have, like them, violent passions, a blunted sensibility, a puerile vanity, long-standing habits of inactivity, and very often nudity. There, indeed, among savages, are the principal models of this curious custom.

After this study, it appears to me to be proved that this custom is a completely savage one, which is found only rarely among some persons who have fallen from our honest classes, and which does not prevail extensively except among criminals, with whom it has had a truly strange, almost professional, diffusion; and, as they sometimes say, it performs the service among them of uniforms among our soldiers. To us they serve a psychological purpose, in enabling us to discern the obscurer sides of the criminal's soul, his remarkable vanity, his thirst for vengeance, and his atavistic character, even in his writing.

Hence, when the attempt is made to introduce it into the respectable world, we feel a genuine disgust, if not for those who practice it, for those who suggest it, and who must have something atavistic and savage in their hearts. It is very much, in its way, like returning to the trials by God of the middle ages, to juridical duels—atavistic returns which we can not contemplate without horror.

O Fashion! You are very frivolous; you have caused many complaints against the most beautiful half of the human race! But you have not come to this, and I believe you will not be permitted to come to it. ∎

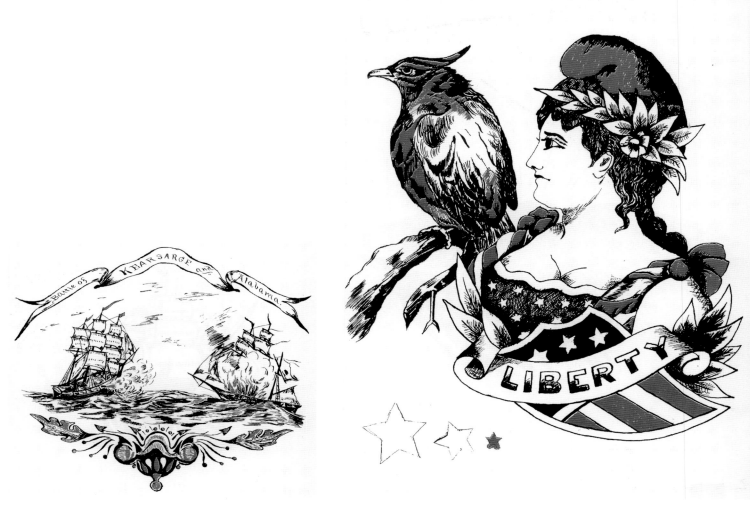

I4

USA

The most popular designs in traditional American tattooing evolved from the efforts of many artists who traded, copied, swiped, and improved on each other's work. In this way they developed a set of stereotyped symbols which were inspired by the spirit of the times, and especially by the experiences of soldiers and sailors during both World Wars. Many of these designs represented courage, patriotism, defiance of death, and longing for family and loved ones left behind.

The earliest written records of American tattooing are found in ships' logs, letters and diaries written by seamen during the early part of the nineteenth century. In his memoirs of life on board a US. Navy frigate in the 1840's, Herman Melville reported that some of his shipmates:

> excelled in tattooing or pricking, as it's called in a man-of-war. Of these prickers, two had long been celebrated, in their way, as consummate masters of the art. Each had a small box full of tools and coloring matter, and they charged so high for their services that at the end of the cruise they were supposed to have cleared upward of $400. They would prick you to order a palm tree, an anchor, a crucifix, a lady, a lion, an eagle or anything else you might want... Roman Catholic sailors usually sported a crucifix on the arm in order to be assured of decent burial in consecrated ground in Catholic lands far afield. There was one foretopman who, during the entire cruise, was having an endless cable pricked round and round his waist, so that, when his frock was off, he looked like a capstan with a hawser coiled round about it. This foretopman paid 18 pence per link... Besides being on the smart the whole cruise, suffering the effects of his repeated puncturings, he paid very dear for his cable.[1]

The USS Hartford, by C. H. Fellowes.

One of the first professional American tattoo artists was C. H. Fellowes, whose design book and tattooing instruments were discovered in 1966 by a Rhode Island antique dealer and are now in the collection of the Mystic Seaport Museum in Mystic, Connecticut. Fellowes left no other record of his life and art. A thorough search of nineteenth-century business directories failed to reveal his name, and it is probable that he followed the fleet and practiced his art on board ship and in various ports.

His book contains over a hundred designs in red and black, many of which are ambitious compositions featuring religious, patriotic and nautical themes. Certain of these are of special interest because they commemorate specific naval engagements that occurred during the Civil War and the Spanish-American War. One of the great naval battles of the Civil War is illustrated in a drawing that shows the northern warship *Kearsage* with guns blazing as a Southern vessel, the *Alabama*, sinks in flames.[2] According to contemporary accounts, the crew and officers of the *Kearsage* had stars tattooed on their foreheads to celebrate their victory over the *Alabama*, which took place on June 19, 1864.[3]

Another ambitious composition shows the battleship *Maine* sinking. A banner above the ship bears the words "Remember the *Maine*", and superimposed on the ship is a portrait of her commander, Charles D. Sigsbee. The sinking of the *Maine* occurred in the harbor of Havana, Cuba, in 1898, and marked the beginning of the Spanish-American War.[4]

Admiral William Thomas Sampson, commander of the fleet that blockaded Spanish warships in the harbor of Santiago de Cuba, is the subject of one of Fellowes's drawings, and two designs portray the USS *Iowa*,[5] one of the battleships that participated in the final defeat of the Spanish Navy. Another of Fellowes's drawings depicts the USS *Hartford*,[6] which was known to many nineteenth-century naval men as a flagship during the Civil War and later enjoyed a long and honorable service as a US Navy training ship.

Several tattoo artists found employment in Washington DC during the Civil War. The best known

Opposite page:
Top left: A drawing by C. H. Fellowes commemorating one of the great naval battles of the civil war: the northern warship *Kearsage* fires on and sinks the southern vessel *Alabama*. The battle took place on June 19, 1864.

Top right: Drawing by 19th century American tattoo artist C. H. Fellowes.

Bottom: A drawing by C. H. Fellowes commemorating the sinking of the American battleship *Maine* in Havana Harbor, Cuba, in 1898.

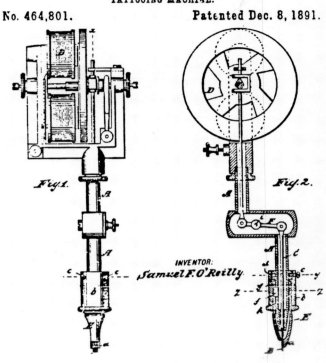

S. F. O'REILLY.
TATTOOING MACHINE.

No. 464,801. Patented Dec. 8, 1891.

Fig.1. *Fig.2.*

INVENTOR:
Samuel F. O'Reilly

Left: Admiral William Thomas Sampson, by C. H. Fellowes.

Right: Samuel O'Reilly's patent drawing for the first electric tattooing machine. (courtesy of Tattoo Archive)

of these artists was Martin Hildebrandt, a German immigrant whose career began in 1846. In addition to working in Washington, he traveled extensively during the war and was welcomed in both Union and Confederate camps, where he kept busy tattooing military insignias and the names of sweethearts. In later life he reminisced, "I must have marked thousands of sailors and soldiers, and am pretty well known all over the United States."[7]

In 1870, Hildebrandt established what he called an "atelier" on Oak Street in New York City. This was, as far as we know, the first American tattoo studio. Hildebrandt worked in the same location for over 20 years, during which time he trained a number of students and tattooed some of the first completely covered circus attractions, including his daughter.

Hildebrandt's success with his New York studio inspired others to imitate him, and soon he had a formidable rival in Samuel O'Reilly, who established a tattoo studio at 11 Chatham Square, in the Chinatown area of the Bowery, in 1875. It was an ideal location. Chatham Square was at the entrance to the Bowery where the recently completed Second and Third Avenue elevated tracks crossed. It boasted a wide variety of entertainment such as gambling halls, burlesque shows, saloons, shooting galleries, houses of prostitution and popular theaters. Thousands of people passed through Chatham Square every day, and among them were many who stopped to get a tattoo from Samuel O'Reilly.

At the time O'Reilly opened his studio, all tattooing was done by hand. The tattooing instrument used by Hildebrandt, O'Reilly and their contemporaries was a set of needles attached to a wooden handle. The tattoo artist dipped the needles in ink and moved his hand up and down rhythmically, puncturing the skin two or three times per second. This technique required great manual dexterity and could be perfected only after years of practice. Tattooing by hand was a slow process, even for the most accomplished masters of the art.

In addition to being a competent artist, O'Reilly was a mechanic and a technician. Early in his career he began working on a machine to speed up the tattooing process. He reasoned that if the needles could be moved up and down automatically in a hand-held machine, the artist could tattoo

as fast as he could draw. O'Reilly was inspired by Thomas Edison's autographic printer, an engraving machine which consisted of a small rotating electric motor with a cam that moved a needle bar up and down inside a brass tube. O'Reilly modified Edison's machine by changing the system of levers and the tube to make the first electric tattooing machine. In 1891 O'Reilly patented his invention and offered it for sale along with colors, designs and other supplies.[8]

Tattooing in the US was revolutionized overnight. O'Reilly was swamped with orders and made a small fortune within a few years. His prestige was such that he was invited to travel to Philadelphia and other major cities, where he made house calls and tattooed wealthy ladies and gentlemen who did not care to be seen in his Bowery tattoo studio.

He also received many commissions from tattooed circus people. He and his assistants executed most of the decorations on sideshow attractions such as Annie Howard, John Hays, and Frank and Emma de Burgh. Business was so good that he imported a famous Japanese tattoo Master, Hori Toyo, who assisted him and satisfied the growing demand for authentic Japanese tattooing. He took on students and dignified himself by assuming the honorary title of "professor."[9]

O'Reilly's career flourished for over two decades, but around the turn of the century his creative energy flagged, and he was overshadowed by some of his younger and more energetic students. At the same time, his rivals manufactured and sold tattooing machines similar to his, and he wasted time and money in unsuccessful lawsuits over patent rights. He died in 1908, after falling off a ladder while he was painting his house in the Bronx.

By 1900 there were tattoo studios in every major American city. "Billboard" and "Police Gazette" carried advertisements for mail order tattoo supply companies, and newspapers throughout the country ran feature articles on the new fad. The flourishing tattoo business created a ready market for designs. Many would-be tattoo artists were competent craftsmen but did not have the ability to draw designs. There were several tattoo artists, however, who excelled at drawing designs. One of the best was Lew Alberts, a former commercial artist and wallpaper designer who took up tattooing while serving in the US Navy during the Spanish-American War. After the war he opened a tattoo shop in the Bronx and turned out thousands of designs, which he sold through tattoo supply companies.

Alberts' designs were inspired by the decorative commercial art of his day. He redrew popular images using bold, flowing lines to make tattoo designs characterized by strength and simplicity. Tattoo artists bought his designs because they were at once artistic and easy to copy. Many of the hearts, roses, snakes, dragons, eagles, sailing ships and other traditional images of American tattooing originated with Lew Alberts. The sentimental, patriotic and religious themes that found expression in his art dominated American tattooing for over 50 years.[10]

The most talented and prolific of the early American tattoo artists was Charles Wagner, who was born in 1875 (the same year O'Reilly opened his studio). Wagner grew up in a New York that was undergoing phenomenal economic growth. The scientific discoveries of the nineteenth century were rapidly being adapted to practical uses, and every year thousands of new mechanical and electrical inventions were patented. These developments were soon to culminate in the mass production of electric lights, cars, radios, airplanes and electric tattooing machines. Charles Wagner was born in the right place and at the right time for his unique talents to find expression.

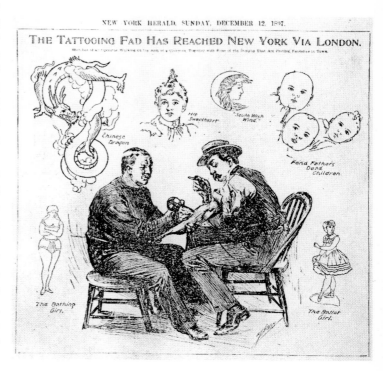

Samuel O'Reilly at work. An illustration published in the *New York Herald*, December 12, 1897.

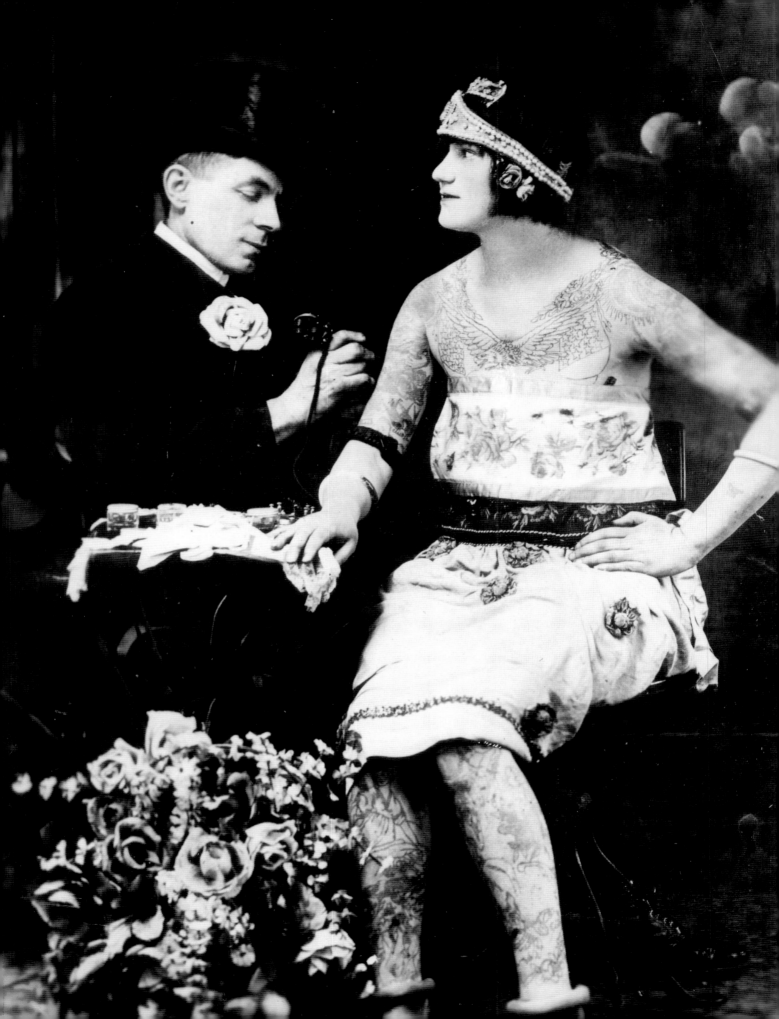

Reminiscing later in life, Wagner told journalist Albert Parry that he became interested in tattooing as a teenager when he saw Prince Constantine, P.T. Barnum's celebrated tattooed circus attraction, in the Grand Museum, (then located in Chatham Square). Wagner remembered:

> He was covered right up to the eyeballs with animals. I found out they paid him sixty dollars a week just to stand there showing them off. I borrowed some ink and a needle and started tattooing myself. I used to do it at night in the tailor shop over on the Bowery where I was a night watchman. I was a good drawer and I got the knack of it right away. In the afternoons I'd go down to the old Third Street pier and pick up customers off the boats. I'd bring them to the tailor shop at night and work on them. That's how I got started.[11]

After practicing his art in the tailor shop for a few years, Wagner was fortunate to be taken on as an apprentice by Samuel O'Reilly. Wagner remembered that during his apprenticeship most of his customers were seamen, and that superstition played a large part in their selection of designs.

> If there was a jackie without a piece of lucky tattooing on him, I'd know it.... When I quit my job as a watchman on the waterfront to learn my art, the old-time tar thought he had to have a crucifix on his chest to keep him from general harm, a pig on his left instep so he couldn't drown, and "hold fast" on his hands, one letter to a finger, so as he couldn't fall from aloft.[12]

During the Spanish-American War, O'Reilly and Wagner worked overtime as sailors lined up to be tattooed with images symbolizing their service in the war. At that time over eighty percent of the enlisted men in the US Navy were tattooed. O'Reilly prided himself on performing a service to his country by providing sailors with tattoos which bolstered their fighting spirit. He wrote:

> The glory of a man-o'-war at Santiago and elsewhere was to be stripped to the waist, his trousers up to his knees, his white skin profusely decorated in tattoo; begrimed with powder, they were the men to do or die. Brave fellows! Little fear had they of shot and shell, amid the smoke of battle and after they scrubbed down they glorified in their tattoos.[13]

When O'Reilly died in 1908, Wagner took over the Chatham Square studio. Wagner patented his own improved electric tattooing machine, which he sold to aspiring tattoo artists by mail along with ink and design sheets. Sailors continued to be his best customers, and Wagner's business got a boost in 1908 when US Navy officials decreed that "indecent or obscene tattooing is a cause for rejection, but the applicant should be given an opportunity to alter the design, in which event he may, if otherwise qualified, be accepted."[14]

When Wagner was interviewed by the newspaper *PM* in 1944, he estimated that next to covering up the names of former sweethearts, the work which had brought him the most money over the years had been complying with the Naval order of 1908. And when, during World War II, he was arraigned in New York's Magistrate's Court on a charge of violating the Sanitary Code, he told the judge he was too busy to sterilize his needles because he was doing essential war work: tattooing clothes on naked women so that more men could join the Navy. The judge apparently felt that this was a reasonable defense. He fined Wagner ten dollars and told him to clean up his needles.[15]

Wagner estimated that during his career he had tattooed tens of thousands of individuals, including over fifty completely covered circus and sideshow attractions. He was particularly proud of the fact that his clients included wealthy ladies and gentlemen whose names could be found in the

Opposite page: Charles Wagner as a young man, circa 1920. (Kobel collection)

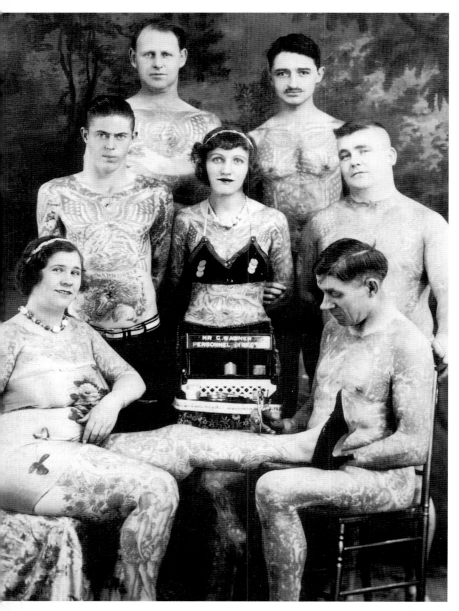

Charles Wagner and tattooed circus people in Chatham Square, circa 1930. The seated woman is tattoo artist Mildred Hull.

social register. Several photographs show him in formal evening attire, complete with top hat and boutonniere, tattooing an elegantly attired society lady.

Wagner introduced many innovations. He was the first American tattoo artist who successfully practiced the cosmetic tattooing of women's lips, cheeks and eyebrows. His other enterprises included the tattooing of dogs and horses so they could be identified in case of theft, experiments with chemical methods of tattoo removal, and the treatment of rheumatism and other complaints by tattooing the afflicted areas with a machine that contained no ink. His forte was the design of large pieces and full body coverage. He was an accomplished freehand artist and excelled at combining and organizing numerous small designs to make a larger harmonious pattern. Surviving publicity photographs of circus performers tattooed by Wagner bear witness to his amazing skill and artistry.

Unfortunately, Wagner left no diaries or memoirs, but he was the subject of several newspaper and magazine articles during his lifetime and he left numerous photos that show him at various stages of a long and full life, during which he enjoyed one of the most remarkable careers in American tattooing. When he did his first tattoo in the late 1880's there were only three of four tattoo artists in the United States. In 1926 interview published in *Collier's Weekly* magazine, he estimated that there were two thousand amateur and professional tattoo artists, many of whom were using his machines and copying his drawings.[16]

Wagner continued to tattoo until the day of his death on January 1, 1953. He was seventy-eight years old and had worked as a professional tattoo artist for over sixty years. After his death his landlord had the entire contents of his studio hauled off to the city dump. All his original drawings were destroyed. There are, however, a few highly prized Wagner machines and printed sheets of designs in private collections.[17]

Art historians never noticed Charles Wagner. His drawings were never exhibited in art galleries or museums. Nevertheless, his art was immensely popular during his lifetime and was exhibited and admired in circuses throughout the US and Europe. After his death it survived on the skins of the many thousands of individuals he tattooed. Hundreds of tattoo artists admired his designs and drew variations of them. Today he is recognized as a major influence in the classic American style of tattooing. ∎

WAGNER IN THE BOWERY, 1945

No. 11 Chatham Square is properly the address of a barber shop. Crowded into a space that would have held two or three persons comfortably were a dozen men, all of them young except one, who was Charlie Wagner himself. Charlie sat under a naked electric light bulb at one end of the booth. He was heavy-faced, unshaven, and had an enormous nose. In one big hand, which was so gnarled that his fingers seemed all out of joint, he held an ordinary pen. Dipping it into a bottle of ink, he sketched an elaborate rose on the muscular arm of a young man facing him.

Charlie worked fast. When he had completed the rose he inked in the words "with love" above it and the single word "Mother" underneath. Then he dropped his pen, picked up the

The following selection was originally published in *Science Digest*, 17: 21-23. March 1945.

Early American tattoos on preserved human skin, circa 1860. (courtesy of Richard Hill)

tattooing machine, flicked on the current, and as the needles buzzed and sparked, pricked in the design in blue and red. His big hand pushed the machine over the boy's skin roughly and it seemed, aimlessly.

The next customer was a handsome blond youngster about 19. He was stripped to the waist.

"Sweet and sour, is that it?" Wagner asked. The boy nodded. The others smiled. On one breast Wagner inked the word "Sweet", on the other, the word "sour".

"Sailor in here yesterday," Wagner said, "had twin screws put on his chest, with "Keep Clear" written under them. Everybody laughed.

"Last week I had a dog," Wagner said, talking along as the needle buzzed and threw sparks. "Blacked out a white spot on his nose so no one could tell he was a mixed breed. A Chauffeur brought him here.

Newspapers had given Wagner's age as 67; he appeared to be about 50. Charlie had been a tattoo artist for over 50 years and had been doing business at 11 Chatham Square since the Spanish-American War.

"Now," he said very seriously, "I'm the original Charles Wagner. A lot of needle men claim they're me, but they're not. A magazine writer once called me the Michelangelo of the Flesh. But I gotta be getting back."

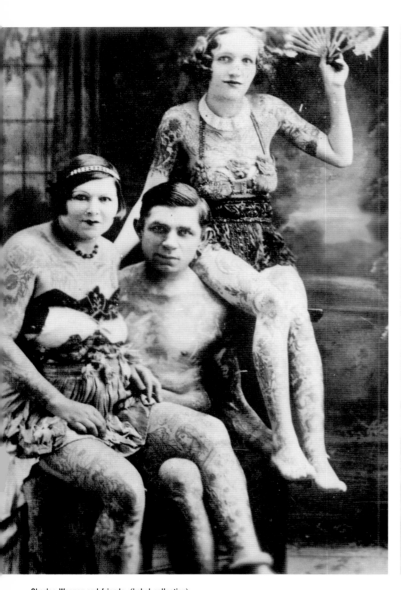

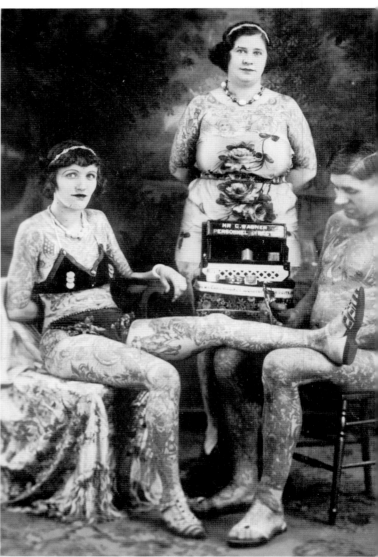

Charles Wagner and friends. (kobel collection)

Back in the booth, the young men were still waiting. While Wagner worked, finishing a design in 12 minutes and charging a quarter for it, he kept talking. He said he had removed a butterfly from the shoulder of a young bride that morning—her husband hadn't liked it.

He then told us about a wealthy man on whom he had recently tattooed a gaudy pair of shorts. This man got married last month, Wagner said, and now he wants the artist to put shorts on his wife too.

Wagner snapped off the current and changed the needles. The machine, which he said he designed and on which he holds a patent, uses eight needles at once. They puncture the skin one thirty-second of an inch and make a total of 24,000 punctures a minute. Wagner is proud of the instrument and showed an order from the Mayo Clinic ordering one directly from him.

"They're using them in plastic surgery," he explained. "I go all over demonstrating them to doctors. Sometimes I'm called into a hospital to do a job myself. Last week I put a nipple on a breast that had been built up by surgery. They got the shape pretty good but then they called me in for the color work."

What type of work brought in the most income? "Changing names," he said. "Men come in one week and tell me to put on "With love, Edith." Couple of weeks later they come back and say: "Take off Edith and put in the name of Helen."

"That goes on all the time. Then, like I told the judge, I do a lot of work putting the panties on pictures of naked women. Sometimes I do it for sailors, but most often some guy gets married and his wife drags him in here because she's jealous of that naked female on his shoulder."

Did Wagner like his life? "Sure," he said. "I meet all kinds of people."

A new customer slipped into the chair. He looked about 15. He kept his mouth drawn down tightly.

"Just a little heart and the word 'Mother,' " he said.

" Better take a double heart," Wagner said. "Cost just the same."

"Gimme the single," the boy said.

"It's bad luck," Wagner replied.

"Just the single."

" You'll get a broken heart," Wagner said seriously.

"Naw," the boy answered, and Wagner went to work. We asked the boy why he was being tattooed.

"Damned if I know," he said. "It's like wearing a ring, like a decoration."

Charlie grinned. "He'll be back for more," he said. "When you start you don't stop. Look at me. I just started with a couple of anchors and a heart or two. Now look."

He pulled up his left pants leg. A closely worked, fading design ran from his knee to his ankle. We could make out, dimly, pictures of the faces of men along his shin.

"Friends of mine," Charlie explained. "Six Chinese. They're all dead now. I've got six more on my right leg. They're not dead. It's funny about that!". ■

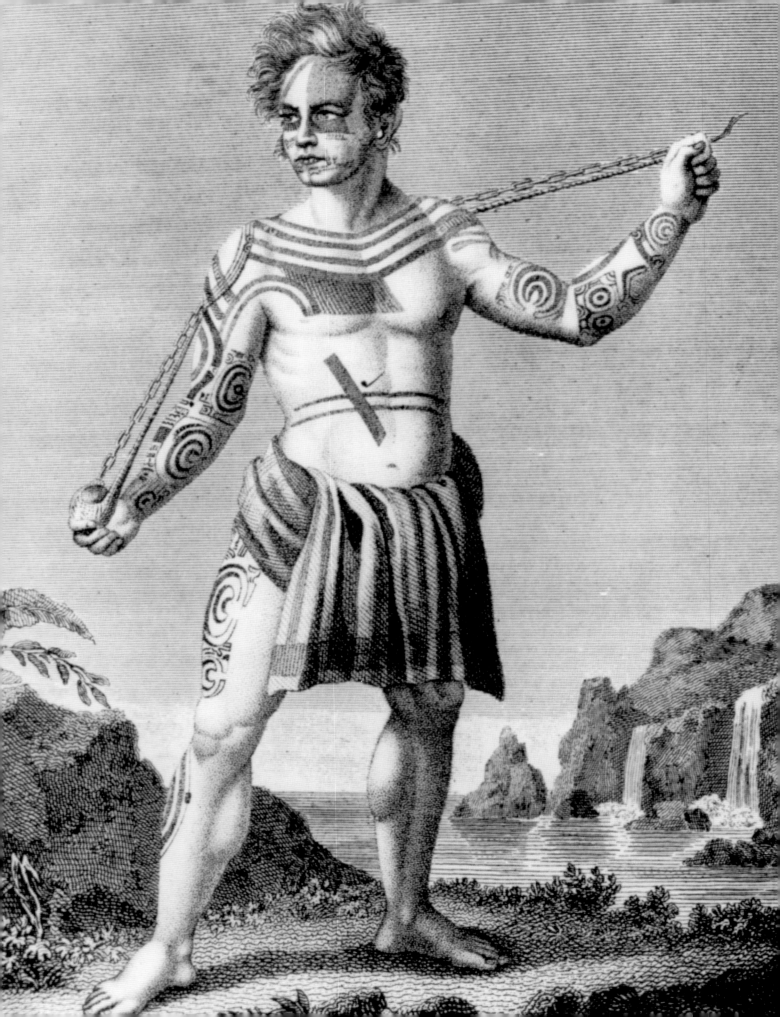

THE CIRCUS

The popularity of tattooing during the latter part of the nineteenth century and the first half of the twentieth century owed much to the circus. When circuses prospered, tattooing prospered. When circuses went bankrupt, tattooed people and tattoo artists were out of work.

For over 70 years every major circus employed several completely tattooed people. Some were exhibited in sideshows; others performed traditional circus acts such as juggling and sword swallowing. Rival circuses competed with each other for the services of the most elaborately tattooed showpeople and paid them handsome salaries. Many of the old-time tattoo artists made most of their money while traveling with circuses during the spring and summer, returning to their shops and homes in the winter. The circus served as a showcase where tattoo artists could attract customers by exhibiting their work to a paying public, and in many cases the only surviving records of the great early tattoo masterpieces has come down to us in the form of photos and posters which were used for circus publicity.

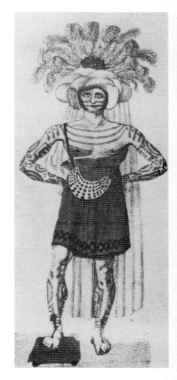

Left: John Rutherford in 1828. (redrawn after Craik)

Top: Jean Baptiste Cabri as a carnival performer in France, circa 1820. (after Danielsson)

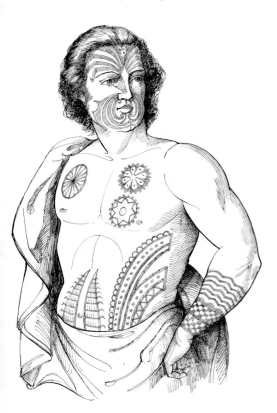

The love affair between tattooing and the circus began in 1804 when the Russian explorer Georg H. von Langsdorff visited the Marquesas. There he found Jean Baptiste Cabri, a French deserter who had lived for many years among the natives. During this time Cabri had been extensively tattooed and had married a Marquesan woman who bore him several children.[1]

Cabri returned with Langsdorff to Russia where he enjoyed a brief but successful theatrical career in Moscow and St. Petersberg. After working for a year as a swimming instructor in the Marine Academy at Cronstadt, Cabri resumed his theatrical career and toured Europe, where he was examined by distinguished physicians and exhibited to royalty. But within a few years his career went into decline. During the last years of his life he was forced to compete with trained dogs and other popular amusements in country fairs. In 1822 he died, poor and forgotten, in his birthplace, Valenciennes.[2]

The first tattooed English showman was John Rutherford. In 1828, an account of his amazing adventures among the Maoris of New Zealand appeared in the popular press. It was reported that he had been captured and held prisoner for ten years. Shortly after his capture he was forcibly tattooed by two priests who performed the four-hour ceremony in the presence of the entire tribe. During the process he lost consciousness and had to spend several weeks convalescing.

After his recovery, Rutherford was adopted into the tribe, promoted to the rank of chief, and treated with great respect. The Maori tribesmen offered him over 60 girls from whom he was told he might choose as many brides as he liked. He prudently chose only two, both of whom were daughters of the ruling chief. During his years with the Maoris he participated in warfare, headhunting, and other tribal activities.

In 1826 Rutherford was rescued by an American brig which took him to Hawaii, where he made good use of his time by marrying yet another native princess. After a year in Hawaii he made his way back to England, where, according to his biographer George Craik, he

Opposite page: Portrait of Jean Baptiste Cabri in the Marquesas, 1804. (after Langsdorff)

Portrait of James F. O'Connell as it appeared on the cover of a pamphlet describing his adventures in the South Seas. (after O'Connell)

maintained himself by accompanying a traveling caravan of wonders, showing his tattooing, and telling something of his extraordinary adventures.... His manners were mild and courteous; he was fond of children, to whom he appeared happy to explain the causes of his singular appearance, and he was evidently a man of very sober habits. He was pleased with the idea of his adventure being published, and was delighted to have his portrait painted, although he suffered much inconvenience in sitting to the artist, with the upper part of his body uncovered, in a severe frost. He greatly disliked being shown for money, which he submitted to principally that he might acquire a sum, in addition to what he received for his manuscript, to return to Otaheite. We have not heard of him since that time [1830] and the probability is that he accomplished his wishes.[3]

The great nineteenth century showman, Phineas T. Barnum, is credited with organizing the first group exhibitions of unusual individuals who were, in his words, "mysterious deviations from nature's usual course." They were exhibited in Barnum's American Museum, which opened in 1841 in New York and soon became one of the largest and most profitable attractions in the city.[4]

Patrons of Barnum's American Museum were treated to a hodgepodge of edifying exhibits and entertainments, such as exotic animals, scientific lectures, magic shows, melodramas and human curiosities, among whom were such novelties as Siamese twins, dwarves, bearded ladies, albinos, gypsies, fat people, skinny people and cannibals. Some were real, some were fakes, and all were introduced with preposterous stories about their exotic origins and adventures.

One of the principal attractions at Barnum's American Museum in 1842 was James F. O'Connell, who enjoyed the honor of being the first tattooed man ever exhibited in the United States. O'Connell had been tattooed on Ponape, in the Caroline Islands, where he had lived among the natives for several years. After leaving the Carolines, O'Connell made his way back to the US, where, in 1834, he published an account of his adventures titled *Eleven Years in New Holland and the Caroline Islands*. For two decades O'Connell performed as an actor, dancer, and acrobat in circuses and vaudeville theatres throughout the eastern US.

He entertained his audiences with tall tales of exotic adventures like those told by Cabri and Rutherford. According to O'Connell, savages on Ponape captured him and forced him to submit to tattooing at the hands of a series of voluptuous virgins. He discovered to his great distress that island custom obliged him to marry the last of the maidens who had tattooed him. She was, of course, a princess, and O'Connell became a chief. A theatrical playbill dated June 15, 1837, advertises O'Connell playing himself in a melodrama based on his adventures in the South Seas.

Unfortunately, no clearly detailed drawing of O'Connell's tattoos has survived, but an engraving of uncertain date suggests that his arms were tattooed with geometrical designs typical of the indigenous art of the Carolines. When O'Connell made his debut there were no professional tattoo artists in the United States. Museum patrons, most of whom had never seen tattooing before, were suitably impressed. According to one contemporary account: "It is reported that on the streets women and children screamed in horror when they met him, and ministers inveighed from the pulpit that unborn children would bear his markings if pregnant women viewed them."[5]

O'Connell gave his last performance in December 1854, at the Dan Rice Amphitheater in New Orleans. Maria Ward Brown, a relative of Dan Rice, described O'Connell's last days in the following words:

James F. O'Connell dancing on stage, circa 1850. (after O'Connell)

While traveling with the show he was taken sick and unable to perform, but he was kindly looked after by Dan Rice and the few members that comprised the company... His malady increased and his condition became hopeless. Finding the closing hour approaching, he made a characteristic request which was finally carried out. When committed to the earth the band played a lively tune and Jean Johnson [who had been O'Connell's traveling companion and partner in many performances] danced a hornpipe over the grave. Poor O'Connell thought that the transition from a life of privation and suffering was more appropriately celebrated by music and mirth than grief and lamentation.[6]

In 1869, the circus was revolutionized when the east and west coasts of the United States were connected by rail for the first time. Traditional circuses had moved in horse-drawn wagons over unpaved roads, advancing slowly from one small town to the next. In contrast, train travel made it possible to move large numbers of people and animals, together with heavy equipment, between major cities in a few days. As a result, profits increased dramatically. The circus entered an era of growth and prosperity that resulted in employment opportunities for many tattooed people and tattoo artists.

In 1871, Barnum joined with two established circuses to form the largest circus in the world: P.T. Barnum's Great Traveling Exposition. It included a museum, a menagerie, and over 30 human curiosities. There was no tattooed man in Barnum's original traveling circus, but the position was filled two years later when Barnum discovered an elaborately tattooed Greek named Constantine.

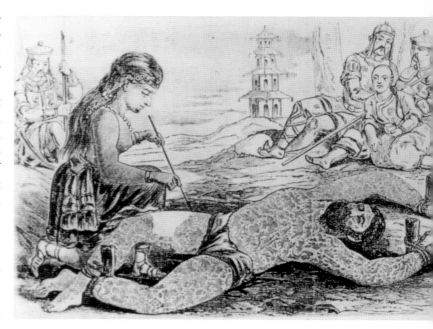

A circus poster, circa 1884, shows Constantine being forcibly tattooed. (after Durant)

Constantine's *curriculum vitae* sounded remarkably like a combination of Cabri's and Rutherford's: he claimed that he had been married to a native princess, taken prisoner, suffered torture by tattooing, and escaped to travel throughout Asia and Africa, where he had one incredible adventure after another. He was, by his own admission, "the greatest rascal and thief in the world, and always much admired by the ladies."[7]

As the skeptical circus patron might have guessed, this was something of an exaggeration. Constantine was a Greek who had spent some years in Burma, where he had himself tattooed with the intention of going into show business. His success was due not to his fanciful stories, but to the fact that he was more elaborately and artistically tattooed than his rivals. The artistry and craftsmanship of Constantine's designs far surpassed anything that had been seen in Europe up to that time.

With the invention of the electric tattooing machine, many individuals were attracted by the possibility of making an easy living in the circus. "La Belle Irene," who had been tattooed by both O'Reilly and Wagner, made her London debut in 1890, claiming to be the first completely tattooed woman ever exhibited in a circus. Her decorations included an artistic assortment of flowers, birds, hearts, cupids, scrolls and sentimental inscriptions borrowed from the ornamental commercial art of the day. Londoners were asked to believe that she had acquired her embellishments in a strange and

La Belle Irene as she appeared in a late 19th century circus poster. (courtesy of Tattoo Archive)

savage land (Texas) as a protection against the unwelcome advances of the natives.

La Belle Irene soon had competition in the form of Emma de Burgh, who was the most famous of O'Reilly's early masterpieces. Mrs. de Burgh was decorated with patriotic and religious motifs, including a rendition of the Last Supper on her back. She and her tattooed husband, Frank, enjoyed a successful tour of England and the continent in 1893, but she rapidly ate up her earnings with the result that her girth increased while her popularity diminished.[8]

During the last decade of the nineteenth century, the circus enjoyed an unprecedented period of growth and prosperity. Giant circuses such as Barnum and Bailey, Cole Brothers and Ringling Brothers traveled from coast to coast putting on shows in all the major U.S. cities. In addition, more than a hundred smaller circuses and carnivals crisscrossed the country, playing shorter engagements in rural areas.

As the circus prospered, the demand for tattooed people increased. The designs favored by circus people were for the most part patriotic and religious. Images of the American flag, the American eagle and the Statue of Liberty were perennial favorites. Also frequently seen were themes such as Christ's head in a crown of thorns, the Crucifix, the Madonna and Child and the Last Supper. These were often accompanied by scrolls and banners bearing mottoes such as "Love One Another" or "Jesus Saves." Such themes undoubtedly helped make tattooing acceptable in the eyes of the predominantly rural and conservative circus patrons.

The competition became intense as circus owners vied with each other to come up with ever more extravagant tattooed novelties. Soon there were tattooed sword swallowers, fire eaters, jugglers, mind readers, dwarves, strong men, fat ladies, wrestlers, knife throwers and even circus animals. It is estimated that, by 1920, over three hundred completely tattooed people were employed in circuses and sideshows. Some earned as much as two hundred dollars a week (a very considerable sum in those days). The prospect of being able to travel with a circus while earning such a salary must have seemed attractive to many an adventurous soul who would otherwise have been confined to a menial job in a rural community.[9]

The most famous tattooed man of this period was Horace Ridler. In 1927, he asked London's leading tattoo artist, George Burchett, to tattoo him all over, including his face, with inch-wide zebra stripes. When the tattooing was complete, Ridler enhanced his appearance by having his teeth filed down to sharp points. He had his nose pierced so he could insert an ivory tusk in it and had his ear lobes pierced and stretched until the holes were more than an inch in diameter. At the end of this ordeal, Horace Ridler had been transformed into The Great Omi, one of the most successful freaks in the history of the circus. He enjoyed a successful career until his retirement in 1950. He and his wife then moved to a small village in Sussex, where The Great Omi died in 1969 at the age of seventy-seven.[10]

The Great Omi succeeded because he was unique. But during the latter part of his career fewer and fewer tattooed people were seen in circuses. They were no longer novelties. Circus patrons were losing interest in seeing yet another man or woman covered with traditional American-style tattooing. Another factor was the demise of the freak show, in which tattooed people were usually

Frank de Burgh circa 1875. (courtesy of Tattoo Archive)

Opposite page: The Great Omi in 1939. (courtesy of Tattoo Archive)

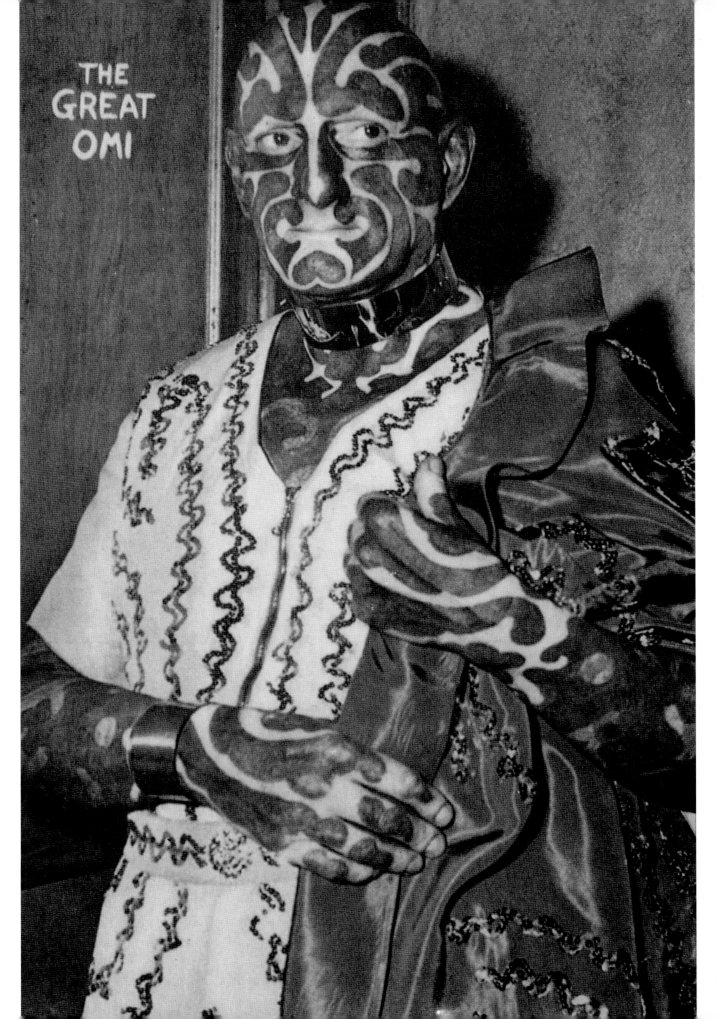

THE GREAT OMI

exhibited. After World War II, freak shows came under attack from medical authorities and social reformers who objected to the practice of exhibiting deformed individuals as a source of amusement and profit. At the same time, medical advances made it possible to treat or prevent many of the hormonal imbalances and other conditions that had caused the physical deformities seen in freak shows and, as a result, fewer people were available and willing to exhibit themselves as freaks. The attitude of the public had changed as well. Circus patrons were better educated and more sophisticated. They no longer believed the ballyhoo and the preposterous stories that were the staple fare of the old-fashioned freak show. The individuals who were exhibited as freaks were considered sick and unfortunate, and parents no longer took their children to laugh at them.[11]

After World War II, a few of the larger circuses still included freak shows and tattooed people. But by this time a host of factors had combined to erode circus profits. Competition from movies and television was blamed for declining circus attendance. The cost of transporting equipment, animals and performers increased as profits diminished. Many circus employees joined unions and demanded higher pay. Smaller circuses went out of business. Larger circuses could no longer compete with each other and joined forces to form virtual monopolies.

On July 16, 1956, Ringling Brothers' Greatest Show on Earth, the last giant traveling three-ring circus in the U.S., gave its final performance in Pittsburgh, Pennsylvania. A clown lifted a little girl onto his lap and said, "Put away a lot of memories tonight. This is the last three-ring big-top anyone will ever see." The Greatest Show on Earth had gone bankrupt in the middle of the summer season. The 80-car circus train was packed for the last time and returned to winter quarters in Florida. The next day the headline in the *New York Times* read: "The Big Top folds its tents for the last time." Some circuses managed to survive on a greatly reduced scale by putting on performances in indoor arenas rather than tents. In these circuses, freaks and tattooed people were seen no more.[12]

When we look at photographs of traditional circus tattooing, we see that the great tattooing of the past is still great today. Constantine and Omi would create a sensation if they appeared at a modern tattoo convention. And there is still magic in Wagner's designs. The crosses, flags, hearts, dragons, and sailing ships that made up the dominant themes of his art symbolized the unabashed expression of profound and simple emotions: faith, patriotism, loyalty, love, and courage.

Tattooing has come a long way since Charlie Wagner laid down his machine for the last time in 1953. Tastes have changed. Many of Wagner's designs seem naive to us now. But at the same time, there is a new appreciation of our tattoo heritage. In the course of our progress we will rediscover the past, see it with new eyes, and find much that endures.

The following selection is taken from *Voyages and Travels in Various Parts of the World* by Georg H. von Langsdorff, London, 1813.

CABRI IN EUROPE, CIRCA 1805

At our departure from Nukuhiva, Jean Baptiste Cabri, a Frenchman, found on the island and there become half a savage, was by accident obliged to leave the island. He was afterward left by us at Kamschatka, whence he traveled overland to St. Petersburg. The extraordinary fate of this man, and the novel appearance of his tattooed body, attracted the attention of everyone. Both at Moscow and St. Petersburg he exhibited upon the stage the dances of savages, and was considered by all the great people of the country as a real curiosity. Although he has by degrees become reconciled to European customs, he still thinks with delight of the men whom he formerly killed and exchanged for swine, or perhaps ate. His dexterity in swimming, in which he is scarcely excelled by the naives of Nukuhiva themselves, has procured him the appointment of teacher of swimming to the Corps of Marine Cadets at Cronstadt, where he now lives. He has almost forgotten the language of Nukuhiva, and made an incredibly rapid progress in the recovery of his native tongue. The story of his marriage with a princess of Nukuhiva, and the details of his exploits on that island, are now so intermixed with the new ideas he has acquired in Europe, that anyone who heard him relate them would think himself listening to a second Munchausen. ■

CONSTANTINE IN GERMANY, 1872

The Tattooed Man from Burma

A communication from Dr. Kaposi (Moriz Kohn), Professor at the University of Vienna.

The following selection was published in *Wiener Medizinische Wochenshrift* No.2, 1872.

A man who has resided in Vienna for several months has aroused considerable interest because of the great number and the artistic quality of his tattoos. Professor Hebra considered it a unique case, and was at some pains to make a record of it for the University and the members of the Faculty of Medicine. At his request, a variety of photographs of the man have been taken by Mr. Angerer. In addition, Dr. Heitzmann has prepared a life-size drawing of his head and torso. This illustration will be published in Volume 8 of Dr. Hebra's *Atlas der Hautkrankheiten [Atlas of Diseases of the Skin]* .

The tattooed man was exhibited to the professors of dermatology and various other faculties on numerous occasions, and I myself exhibited him to a very well attended meeting of the Medical Society on October 27, 1870.

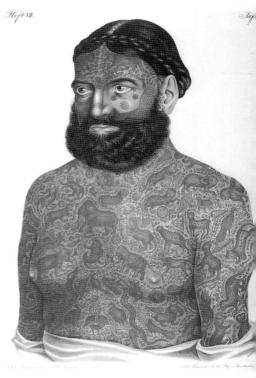

Prince Constantine as he appeared in Hebra's *Atlas der Hautkrankheiten.*

It may be added that members of numerous non-medical groups such as the Anthropological Society and the Artist's Guild have taken a great interest in him and personally observed him, until the novelty of this Walking Art Gallery has begun to wear thin.

And yet, I think, there are still a great many unanswered questions which can only be resolved by experts in the disciplines of medicine, ethnography, linguistics, art, and perhaps also archaeology. Thus it would be desirable to form a committee consisting of specialists in these disciplines together with anatomists, zoologists, dermatologists and surgeons who would be competent to examine and make a scientific study of the skin of the tattooed man.

I have suggested this in the appropriate places and on numerous occasions, but without success. The tattooed man will not be in Vienna much longer, for he plans to travel to Berlin and London, where he will very probably be the object of such a study as I have proposed. It would be unfortunate if the learned societies of Vienna were to miss this opportunity, and, because of their indifference, allow foreign savants to make the definitive study of this remarkable case.

According to his own account, the man is named George Constantine, is 43 years old, a bachelor, and of Albanian origin. In addition to his native tongue (Greek) he speaks fluent Arabic and Persian and (although not fluently) French, Italian, English and German. This was confirmed by Dr. Pollak, formerly personal physician to the Shah of Persia, and by the learned oriental linguist Professor Müller.

He tells the story of his tattooing somewhat as follows:

Five years ago he and 11 of his companions formed a company to establish trade in gold with Chinese Tartars, and, in addition, engaged in selling arms to local rebels. When the rebels were defeated, Constantine and his companions were imprisoned by the victorious Tartars. Nine of his companions were massacred, but he and two others were sentenced to suffer the "torture of tattooing" so that they would be marked for life.

One of them died while being tattooed, either as the result of the pain or a subsequent infection. The other lost his sight due to shock, and lives today in Hong Kong. Constantine himself escaped through China to a port on the Indian Ocean from which he was brought by a British ship to Manilla, from there again to Hong Kong, and finally via Suez to Greece.

He tells different stories at different times. On another occasion he reported that while helping the French to fight the Chinese he was captured by the Chinese, who imprisoned him and tattooed him. Whatever the facts of the case, it is agreed by all who have interviewed him

that he knows much of Southeast Asia from personal observation.

He reports that the tattooing was all done by one and the same man. While four strong men held him down and threatened him with death if he resisted, the tattoo artist worked on him every morning for three hours. After three months the work was completed.

This last account sounds even more unlikely than the rest of his story, considering the consummate artistry of the designs.

The tattooed man is of middle height, handsome, powerfully built and well-nourished. He has a full beard. His long black hair is done up in two braids on top of his head. Viewed without clothing, he seems to be covered with a tight-fitting and fabulously embroidered cloth. From the top of his head to his toes, and even including his penis, the skin is covered with dark blue tattooed figures among which are strewn smaller figures in red. Only the under surface of the penis, the scrotum, and the soles of the feet are untattooed. In the spaces between the figures is some kind of writing consisting of blue and red letters or characters. His hands are also covered with these characters, which run in lines down his fingers and are also to be found on his toes right up to the nails.

His scalp and the skin under his beard are also tattooed. On his forehead on either side of the midline are symmetrical panthers facing each other, and between them are characters. On the parts of the cheeks free of beard are star-like figures.

On the rest of his body I counted 386 of the larger figures, which, if one includes the figures on his forehead, makes a total of 388. These are distributed on the various regions of his body as follows:

chest	50
left arm	51
right arm	50
back	37
neck	8
hips & pelvis	52
penis	1
legs	137
forehead	2
total	**388**

The designs of animals are tattooed in blue, all of medium size, and symmetrically arranged on either side of the midline of the body. For instance, on the upper chest on either side are two crowned sphinxes, two snakes, to elephants, two swans, between which is an owl-like bird.

The additional kinds of animals figured are: apes, leopards, cats, tigers, eagles, storks, pigs, frogs, peacocks, guinea hens, humans, panthers, lions, crocodiles, lizards, salamanders, dragons, fish, gazelles, mussels, and snails, as well as all kinds of other subjects such as bows, quivers, arrows, fruits, leaves, and flowers.

Professor Müller recognized the writing on his hands as being Burmese. (The tattooed man also claims to have been in Burma).

The small areas of skin which remain untattooed seem to be of normal color. Here, as over the tattooed figures, the skin is supple and smooth. There is no swelling of the glands. Cutaneous respiration appears to be good.

The individual tattooed figures are of remarkable artistic quality, graceful in line and finished to perfection. Some are realistic; others are stylized. The wings of the birds seem remarkably lifelike, with each feather beautifully delineated. The tattooed figures are made up of tiny dots

about the size of the point of an embroidery needle, in the center of each is a whitish scar-like pit. Most of the figures and the letters are blue; other letters are red. These dots are appropriate to the tattooing technique.

(One observer, who was not a medical man, remarked that the figures seemed not tattooed, but etched. This is an error, which could only arise as the result of ignorance of anatomy.)

It is probable that the pigment used was derived from plants. European tattoo artists use pigments derived from mineral substances: blue marks are made with gunpowder or charcoal; red with cinnabar [mercuric sulfide]. Microscopic investigations have revealed that the particles of cinnabar, which are introduced through minute holes in the skin, remain trapped and encapsulated in connective tissue (V. Bärensprung, *Die Hautkrankheiten*, Erlanger, 1859, pag. 91). Some of these particles are carried via the lymphatics to lymph glands, where they remain permanently (H. Meckel, Virchow).

In Constantine we found no swelling of the glands. Concerning the relationship of the tattoo pigment to the dermal tissues we could come to no definite conclusion, as the tattooed man would not submit to having a sample of his skin surgically removed. It is interesting to note what he described as the tattooing instruments. As an example he showed us a 5 inch long brass pin, about three inches wide at the top, and tapering to a point at the other end. The pointed end is divided in two by a narrow cleft just like the point of a steel pen. To this he attached a handle, so that the whole instrument was about 15" long and rather heavy.

The tattoo artist controls the angle and direction of the instrument by holding it between the thumb and forefinger of his left hand. The weight of the instrument makes it possible to manipulate it quickly and easily, while at the same ensuring that it penetrates the skin to a consistent depth with each stroke.

The liquid coloring matter is held between the two tines of the tattooing instrument and flows when the instrument enters the skin. By observing the instrument and the demonstrated technique, it was possible to understand how an artist could complete so many beautiful tattooed figures within three months time.

In contrast to this method, European tattooing (sailors, soldiers, laborers; in plastic and reconstructive surgery) is done by puncturing the skin with a bundle of needles and then rubbing in the coloring matter. ■

(translated by Steve Gilbert)

CONSTANTINE IN ENGLAND, 1872

The Tattooed man

Sir: I was present at the Vienna Medical Society when the famous tattooed man was displayed to the members. Many of them were by this time tolerably familiar with his appearance and the real interest of the evening centered in a learned professor who had undertaken to decipher the red dots freely scattered among the many elaborate and beautiful figures on the skin. After some difficulty, arising from the very formless character of the inscriptions, they were at last pronounced to be written in the Burmese language, and much confirmation is thus given to the striking theory of Dr. Gascoigne. It was felt at the time that the man's statement of his own case savored strongly of romance, and that the punishment of a pirate by a semi-barbarous tribe like the Tartars would probably have assumed a more summary form than ornamenting his body with the most exquisitely graven designs. It now seems much more probable, as suggested by the local papers at the time, that he had voluntarily submitted to a painful operation in hopes of reaping his reward from the curiosity of the public. It would be interesting to know whether in Chalmer's case any glandular enlargement was observed. Virchow *(Cellular Pathology)* has described and figured the deposit of pigment which invariably occurs in the first group of lymphatic glands adjoining tattooed skin, and it was considered somewhat remarkable that a

The following selection was published in *The Lancet* on June 1, 1872 (p.777).

careful search could detect none of that engorgement which so extensive a surface irritation might have been expected to produce on the Viennese specimen. ∎

–Robert Farquharson, May, 1872.

The following selection is taken from *Memoirs of a Tattooist* by George Burchett, and quoted here by kind permission of George Burchett's son, Leslie Burchett.

BURCHETT TATTOOS OMI, LONDON, 1927

From time to time I had been given some really big orders—to tattoo a man from head to toes. The world, of course, thought such people rather horrifying freaks. Only very few people who wear such tattoos have them because of some eccentric impulse. One must not forget that one of the most compelling reasons for strange behavior in this rum life is money. If desire for that stuff is dishonorable or freakish, then most of us are in a bad way.

Every showman knows that one can make a good livelihood out of decent respectable people, who come to stare at you if you're a freak. But to become a freak one needs a strong character and unusual determination.

Such a strong character is possessed by my friend the Great Omi, the "zebra man" who became one of the most successful and highest paid showmen in both hemispheres.

The Great Omi, or as he then was, Major R., came to me in 1927. He was a tall, well-built man, with a handsome face. He was cultured, well-spoken and obviously of good education. He wished to become "one of the great human oddities."

He said he had heard about my work and he wanted me to do a very special job. Then he told me his plan. I was to tattoo him all over with a dark blue, or black, zebra pattern, for which he had brought his own designs. When I discovered that he wanted not only his body but also his face tattooed in this manner, I at first refused to do the work. I told him that such heavy tattoos would be indelible. They could never be removed and he would have to bear the design on his face until the end of his days. I told him that his family and friends might turn their backs on him and that his life might become one terrifying ordeal. I told him he might become a complete social outcast. I told him all this, and I might as well have saved my breath because the Great Omi had made up his mind.

Courteously he explained that he had thought carefully about all the possible results of his decision, and that he had discussed them with his wife who, after much heart-searching, had agreed to his plan. I insisted on him giving me his explicit approval, in writing, before I started his transformation. I also warned him that it would take many months, maybe even years, before the work was completed. When everything was settled, I began one of the most difficult tasks I have ever undertaken, to turn a human being into a zebra.

During the months through which I laboriously tattooed the heavy stripes on to the body, arms, legs and head of the Great Omi, he told me the story of his life. Without any self-pity he explained how and why he had decided to make a complete break with the middle-class respectability to which he was heir.

His people were well-to-do and his family had produced civil servants, successful business men, officers, school-masters and gentlemen farmers for generations. His father, who owned a fine country place outside London, was a mild-mannered man with many cultured interests who busied himself with such pleasant hobbies as antiquarianism and collecting rare books.

The Great Omi was the youngest son and his father's favorite. His childhood and youth were spent in comfort and security. He was sent to a well-known public school, where he did fairly well, although showing little inclination towards scholarly pursuits or a university education. With his father's approval he decided on the Army as a career. Before he was commissioned as a second lieutenant in a famous regiment of the line, his father gave him a generous allowance and sent him on a grand tour all over Europe and North Africa. At that time he had no thought other than to devote himself to his chosen profession as a soldier. Yet the fairgrounds and music-halls of Paris, Hamburg and Vienna, the Tivoli at Copenhagen, the pageants of Italy, the

bull-rings of Spain, fascinated and excited him. In the bazaars of North Africa he spent many days among the jugglers and acrobats, fortune-tellers and snake-charmers. But this was all holiday fun and he never dreamed that one day the fairground would become his home.

When his father died the young officer inherited a substantial sum which gave him a comfortable allowance with which to supplement his pay as a subaltern. But in the carefree days before the First World War he did some foolish things. He soon ran through his inheritance and, trying vainly to keep up appearances with some of his wealthy and aristocratic brother-officers, he got into trouble which forced him to resign his commission.

Not being equipped for any profession other than soldiering, the young ex-officer had a rough time, trying many jobs and failing in most. When, in August 1914, war broke out, he rejoined the colors as a trooper in a cavalry regiment. He had been a keen and excellent rider

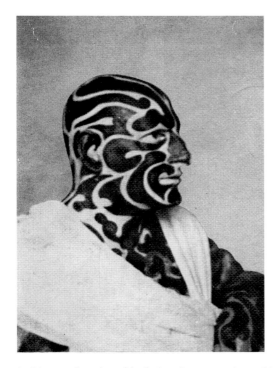 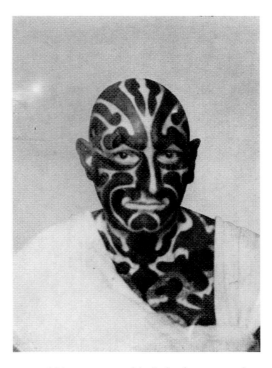

The Great Omi. (after Burchett)

in his youth, when his father kept a string of horses, and his tutor was his father's groom, Joe Green, an old clown who had seen better days as a star in the London Aquarium. Green had also taught him acrobatics and vaulting on horseback and told him many stories of the glittering life of the circus. During the war the Great Omi-to-be fought for two and a half years in Flanders and France, received a commission and was decorated for gallantry. Later he volunteered for the Desert Mountain Corps, fought against the Turks and Germans in Mesopotamia and commanded a squadron of this famous unit.

The war was over and the young officer was demobilized with the rank of major and a modest gratuity. "It was then that my troubles really began," he told me. In common with thousands of other officers he invested his small capital in a chicken farm and, of course, lost everything. He had not the sort of training to fit him for a commercial job, and he had no inclination to become a pen-pusher at an office desk. All his efforts to get a steady employment failed. So he decided to go abroad, trying his luck at many odd jobs and earning a precarious living wherever he could. Eventually, he drifted back to England, determined not to starve. He thought of his old love, the circus; but jobs as a bareback rider or acrobat were hard to get, because there were many men better than him.

However, he had made up his mind that circus and fairground should be his life. But his act was to be something new. He thought of getting tattooed from head to foot and to exhibit himself as a human oddity. He knew from his foreign travels that the bearded ladies, wild men, mermaids, dwarfs and giants, and real or phony freaks had always attracted large crowds and brought good money into the tills of showmen.

It was in 1922 that he began to put his plan into operation and acquired some tattoos, which were executed by a tattooist who pretended to be Chinese. He was not a very highly skilled craftsman, and I had a lot of trouble in covering some of his cruder efforts when the Great Omi came to my consulting rooms. Some of the designs were pictorial and the Great Omi, then still eking out his livelihood with modest side-shows, felt that something much more elaborate and daring had to be done to make him into the great star which he craved to become. Therefore he suggested to me the design of zebra-like stripes. The curved lines, about one inch wide, would mask some of the previous tattoos. His chest and back were to be covered altogether, using black dye that turns cobalt-blue when inserted under the epidermis.

It was necessary to apply plastic surgery to his face and shaven head, and the Great Omi went through as many as 500 operations before his aim was achieved. The tattooing of his head, neck and face and other parts of the body took me more than 150 hours, spread out over more than a year, with many subsequent sittings. I could proceed only at a rate of two inches a day, and we never had more than three sittings a week. It needed more than 15,000,000 needle pricks to complete the facial tattoo, and I should say that I applied as many as 500,000,000 needle pricks to cover his torso. Great care had to be taken to avoid certain parts of the head which must not be tattooed; for instance, the area around the eye cavities and the throat. Yet I had to follow the Great Omi's design closely because he was very particular about its symmetry, and we had to pause, from time to time, for several weeks before the work could be resumed. While the normal tattooing operation is not painful—indeed, as I have said before, many of my clients have assured me that the "prickle" is pleasant and the tingling which follows the setting of the dyes provides an agreeable sensation—the tattooing of such heavy marks as inch-wide lines must have caused some pain and distress. Moreover, it must have been anything but pleasant for the Great Omi to go home with parts of his face already covered with the marks, and looking rather frightening, while the other half of his face was still as "human" and handsome as ever.

The Great Omi certainly showed rare courage and good humor. His wife was no less brave. I have the greatest admiration for these two people. Their devotion to each other was one of the great experiences of my long life, during which I have met many brave and unusual people.

Many improvements were necessary and often I had to go over areas already tattooed in order to make the stripes as thick and heavy as possible. Swellings were unavoidable and at times the Great Omi had to spend long spells in bed, on a strict diet attended by medical specialists. All this never daunted him. He told me that the cost of the tattooing, the fees for plastic surgeons and doctors, the expenditure for invalid food, amount to about £1,000, which was a large sum of money more than twenty-five years ago. Moreover, the Great Omi had to live most of these years on his savings, rarely able to earn a living.

He had left England several times with some of the facial tattoos finished but with the blueing of his body incomplete. He appeared at fairgrounds and in variety in India and the colonies. He avoided the great cities. He was saving them up for the great success which he firmly believed would come to him, once the work was completed.

He had married his attractive wife shortly before he had decided to turn himself into a freak. It must have been shattering news to her. But her devotion for him and her faith in him was such that she had consented to his plan. The Great Omi told me about these talks he had with her.

"We realized, of course, that it meant sacrificing every social asset that we still had. It was

clear to us that our friends and even our families would ostracize us. And I told my wife that she might hate the sight of me and dread to touch me again or even go near me."

But things did not turn out badly at all. His brave wife become "Omette," an artist in her own right, who proved not only a wonderful companion but also a first-class commère. She introduced the Great Omi to the audiences of the world in her melodious voice, in many languages.

"My wife has been wonderful about it," said the Great Omi to me. Some people would say I look pretty terrible and would frighten any woman. But my wife assures me it is only a matter of getting used to it, and I believe she loves me even more than when I looked normal."

To become a freak in order to earn a livelihood was a gamble which might not have come off. Fortunately it did. The Great Omi has now been a star act in all the great and famous halls in the world. In 1934, almost immediately after my work was accomplished, he obtained his first well-paid engagement. He was with Bertram Mills at London's Olympia, and he has never looked back since. Mills took him on tour through the music-halls and varieties of Britain, where tens of thousands queued to see the world's most tattooed man. He made many tours through the great capitals of Europe. Then, in 1938, he went to the United States, where he joined Ripley's famous "Believe It Or Not" show. He spent twenty-six successful weeks at the Odditorium on Broadway and toured with the world-famous Ringling Brothers-Barnum and Bailey Circus. He appeared at Madison Square Garden, was seen at the Toronto Exhibition in 1940 and later Omi and Omette went together from coast to coast of the United States twice over, with full houses everywhere.

Early in the Second World War the Great Omi, no longer a young man, tried to join the British Army to defend his country. He presented himself to the British Consul in New York, but was told that he could not be accepted for active service. Determined to help Britain in her war effort he put on many shows for British war charities and managed to make a large number of appearances in R.A.F. camps in Canada. Success followed success and the Great Omi commanded some of the highest fees paid in show business. But at the height of the war he decided he must go home to battered and beleaguered Britain. He secured passage from Halifax in Canada and immediately after landing appeared on the stage in shows for war charities and in scores of troop concerts. At the end of the war he had more successes in London, at Belle Vue, Manchester, and many other provincial cities.

He had been most careful to preserve his anonymity and had succeeded for many years, for the sake of his relations, in keeping his real name a matter between himself, the Passport Office and Somerset House. But on one occasion his identity was nearly revealed. When attending the World's Congress of Human Oddities in London, he was recognized by Mr. James Harrison, who then lived in Melbourne Square, Brixton. Mr. Harrison had served in the First World War and the Great Omi had been his commanding officer. Mr. Harrison recognized his major, and waited impatiently until he could meet him in his dressing room. They shook hands and the Great Omi asked him to keep his secret, which Mr. Harrison did. Only a very few people know the real name of the Great Omi. I am one of them, but, as I promised this brave man, I shall take it with me to my grave. ∎

Miscellaneous designs of Yezidi, Assyrian, Turkoman, and Sulubba males. (after Smeaton)

16

ARABS, JEWS AND CHRISTIANS

ARABS

Evidence of the antiquity of tattooing in Southwestern Asia was discovered in 1930 by Sir Leonard Woolley, who unearthed painted figurines thought to be more than 6,000 years old at Ur of the Chaldees in the Tigris-Euphrates Valley. Woolley wrote: "On the shoulders of all [the figurines], both back and front, there are marks which in the painted figures are in black, the others rendered by small attached lumps of clay; these I take to be coarse tattooing, like the cicatrices of some modern tribes of savages."[1]

Many nineteenth century travelers to Southwestern Asia described Arab tattooing. In 1827 J.S. Buckingham wrote:

> There are artists in Baghdad, whose profession it is to decorate the forms of ladies with the newest patterns of wreaths, zones and girdles, for the bosom or the waist; and as this operation must occupy a considerable time, and many "sittings," as an English portrait painter would express it, they must possess abundant opportunity for study-ing, in perfection, the beauties of the female form, in a manner not less satisfactory, perhaps, than that which is pursued in the Royal Academies of Sculpture and Painting in Europe.[2]

Unfortunately, there is little published information in English on Arab tattooing. The most complete work is Henry Field's *Body Marking in Southwestern Asia*, a survey that includes tattooing, branding, and the use of henna and kohl. Field, who was a physical anthropologist at the Peabody Museum, Harvard, assembled his data between 1925 and 1955 during a series of expeditions in Iraq, Egypt, Syria, Iran, the Caucasus, and the area around the Persian Gulf. Like his contemporary W.D. Hambly, Field believed that tattooing had originated as part of religious rituals in a "Proto-Mediterranean" culture, and had then been dispersed along prehistoric paths of migration. He found evidence to support this theory by tracing the geographical distribution of contemporary tattoo designs and by examining reports written by early travelers.

Traditionally tattooing in Southwestern Asia was practiced by women, and the associated techniques and beliefs were closely guarded secrets. Field was therefore fortunate to have a gifted collaborator in Winifred Smeaton, an American anthropologist who had studied with Franz Boas. Smeaton was familiar with Arab customs and spoke Arabic fluently. In 1934 she was employed as a tutor to the children of the Iraqi Prime Minister, who granted her a leave of absence to join Field's expedition.[3] Smeaton contributed to Field's book and also independently published her observations in the *American Anthropologist* in 1937. Her paper, "Tattooing Among the Arabs of Iraq", is the most readable and engaging record of Arab tattooing published to date.

JEWS

A passage in the Old Testament has been interpreted as a prohibition of tattooing and scarification. In the King James translation, Leviticus 19:28 reads: "Ye shall not make any cuttings in your flesh for the dead, nor print any marks upon you." But other historical records and biblical passages seem to indicate that some ancient Hebrews practiced religious tattooing. As evidence of the antiquity of tattooing among Semites, Scutt and Gotch report that the sun god Baal required his worshippers to mark their hands with "divine tokens in a mystic attempt to acquire strength."[4] The same authors have discovered what is probably the earliest recorded instance of the sacrilegious use of tattooing: a certain Jehoaikim defied the Almighty by having the Sacred Name tattooed on his penis and then compounded the insult by indiscriminately committing incest with family members.[5]

IERVSALEM.
1612.

The Armes of Jerusalem

King James his foure Crownes

Designs tattooed on William Lithgow by Elias Areacheros in 1612. (after Lithgow, p. 252)

The tattooed arm of a 17th century pilgrim from Hamburg. (after Carswell)

According to biblical scholar William McClure Thomson, Moses "either instituted such a custom [tattooing] or appropriated one already existing to a religious purpose."[6] Thomson quotes Exodus 9 & 16: "And thou shalt show thy son in that day, saying, this is done because of that which the Lord did unto me when I came forth out of Egypt; and it shall be for a sign unto thee upon thine hand, and for a memorial between thine eyes." Thomson theorizes that Moses borrowed tattooing from the Arabs, who tattooed magical symbols on their hands and foreheads. Moses supposedly adapted this custom to his own purposes, creating patterns "so devised as to commemorate the deliverance of the Children of Israel from bondage."[7] According to Thomson, the prohibition in Leviticus referred only to heathen tattooing which had to do with idolatry and superstition, and not to the Moses-approved tattoo designs.

Thomson goes on to cite a number of other Old Testament references to tattooing. In Deuteronomy Moses scolds those who have "the spot which is not the spot of God's children."[8] In Revelation there are numerous allusions to religious marks that may have been tattoos. For instance: "And he hath...on his thigh a name written, King of Kings and Lord of Lords." (19:16). In Isaiah there is an apparent reference to tattooing in the following passage: (49: 15 & 16): "Can a woman forget her sucking child, that she should not have compassion on the son of her womb? Yea, they may forget, yet will I not forget thee. Behold I have graven thee on the palms of my hands; thy walls are continually before me."[9]

Thomson's speculations are intriguing, but not all Biblical scholars agree with him. Did the Jews tattoo? There's no point in passing a law against something that doesn't exist, and therefore the most convincing evidence that tattooing was practiced by the ancient Hebrews is the fact that it was prohibited in Leviticus.

CHRISTIANS

The biblical scholar Franz Joseph Dölger made a diligent search of early Christian documents in an effort to discover records of religious tattooing. He reports that in the fourth century AD Saint Basil the Great, one of the most distinguished doctors of the Church, admonished the faithful: "No man shall let his hair grow long or tattoo himself as do the heathen, those apostles of Satan who make themselves despicable by indulging in lewd and lascivious thoughts. Do not associate with those who mark themselves with thorns and needles so that their blood flows to the earth. Guard yourselves against all unchaste persons, so that it cannot be said of you that in your hearts you lie with harlots."[10] (*translated by Steve Gilbert*) The quotation might be interpreted as a ban on tattooing in general, but Dölger believes that the fact that it was linked to a prohibition of impure thoughts indicates that it referred to the Arab custom of tattooing the name of a lover on the hand.

Paul's statement "I bear on my body the marks of the Lord Jesus" (Galatians 6: 17) is thought by many scholars to refer to tattooing. In a commentary on Isaiah written in 528 AD, Procopius of Gaza reported that many Christians were tattooed on the arms with a cross or Christ's name.[11]

An edict issued by the Council of Northumberland in 787 makes it clear that the Fathers of the Church distinguished between profane tattoos and Christian tattoos. They wrote: "When an individual undergoes the ordeal of tattooing for the sake of God, he is to be greatly praised. But one who submits himself to be tattooed for superstitious reasons in the manner of the heathens will derive no benefit therefrom."[12] The heathen tattooing referred to by the Council was the traditional tattooing of the native Britons, which was still practiced at that time.

Dölger found numerous other references to tattooing in ancient texts. Although brief, these sources indicate that among many early Christian sects a tattoo of a cross, a lamb, a fish or Christ's name was used as a sign of identification and recognition.[13]

According to Ludwig Keimer, medieval crusaders who reached the Holy Land had crosses tattooed on their arms as souvenirs of their travels, and it is likely that this custom continued throughout the Middle Ages. One of the oldest known descriptions of souvenir religious tattooing is

found in a manuscript written by William Lithgow, who made a pilgrimage to the Holy Land in 1612. He wrote:

> Earley on the morrow there came a fellow to us, one Elias Areacheros, a Christian habitour at Bethlehem, and perveier for the Friers; who did ingrave on our severall Armes upon Christ's Sepulchur the name of Jesus, and the Holy Crosse; being our owne option, and desire; here is the Modell thereof. But I decyphered, and subjoyned below mine, the four incorporate Crowns of King James, with this Inscription, in the lower circle of the Crowne, Vivat Jacobus Rex; returning to the fellow two Piasters for his reward.[14]

Numerous similar accounts of tattooing in Palestine are to be found in the travel journals of Christian pilgrims, and the practice has apparently continued without interruption into the twentieth century. When John Carswell visited Jerusalem in 1956 he found a professional tattooist, Jacob Razzouk, who was still using tattoo designs carved on woodblocks that had been handed down from father to son in his family since the seventeenth century.

Razzouk allowed Carswell to borrow his blocks and print them on paper. Carswell's book *Coptic Tattoo Designs*, printed in a limited edition of 200 copies in 1956, contains reproductions of 184 prints together with descriptions of the traditions and symbolism associated with each design. In this book Carswell has preserved a fascinating record of an art form of great antiquity that is virtually unknown to most westerners.

SWEATON IN IRAQ, CIRCA 1935

The following selection is taken from Winifred Smeaton's "Tattooing Among the Arabs of Iraq", *American Anthropologist.* 1937. Volume 39, pages 53-61.

During the period 1933-35 residence in Iraq gave me the opportunity of making certain observations on tattooing among Arabs and other peoples living in the country. Comparable material is to be found not only in Egypt and North Africa, but also on the other side of the Arabian Peninsula, in Iran and India.

Tattooing, which is a widespread practice in Iraq, is known colloquially as *daqq* or *dagg*, from a root meaning to strike or knock, and as the name implies, it is tattooing by puncture. Occasionally a man with a literary background will employ the classical word *washm*, but *daqq* is the generally accepted Arabic word. Tattooing is a custom which already shows signs of disappearing, especially in the cities. It is rarely observed among the upper classes, and is despised by city-dwellers of the lower classes as well. On the other hand, the tribespeople and *fellahin* still esteem it, particularly if the operation is performed in the town, and above all in Baghdad. Very often the tattooing is done by a townsman, but in the towns themselves, according to an informant in An-Nasiriya, it is considered shameful to tattoo.

In Iraq it is found that tattooing is divided into two kinds, broadly speaking: ornamental or decorative tattooing, and tattooing applied for magic or therapeutic reasons. This statement is based simply on observation, and does not take into account the ultimate origins of the practice. Probably most tattooing has an ultimate magico-religious purpose, whatever may be its course of evolution.

Generally the therapeutic and magic designs are simple and crude in form, with curative tattooing applied to the seat of pain or injury, whereas the tattooing done for the sake of beauty (*lil-hila*) is more extensive and elaborate. But sometimes the divisions overlap, and simple design will have no other reason than to be decorative, or an ornamental design will be employed for a therapeutic reason.

The most common kind of curative tattooing is for sprains. Another is tattooing against headache and eye diseases. The tattooing is applied to the temple or forehead near the eye. Tattooing is also used as a cure for local skin infection, and localized pain generally, and very

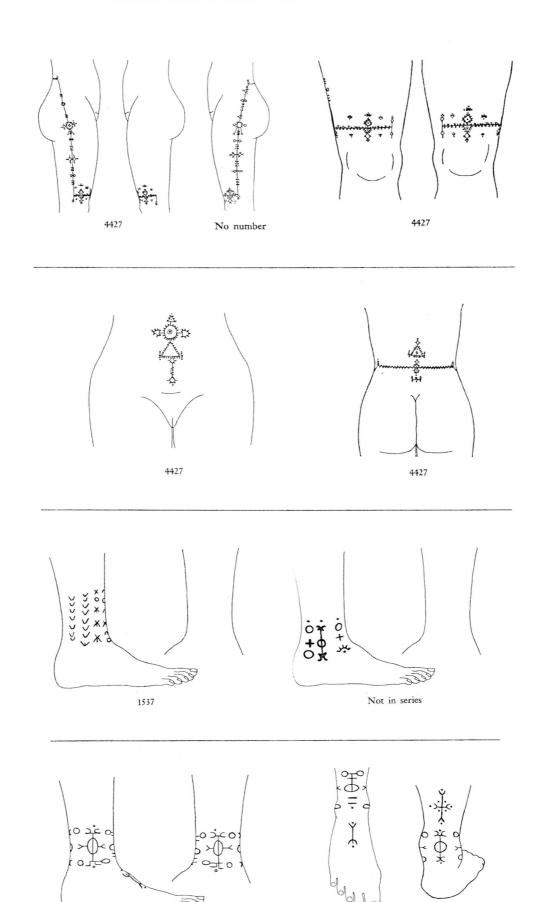

4427 No number 4427

4427 4427

1537 Not in series

Body and leg designs of An Nasiriya Hospital Series and Iraqui tattooers. (after Smeaton)
Ankle and foot designs of Shammar, Turkoman, and Yezidi females. (after Smeaton)

often against rheumatism and cold.

All of these, to our way of thinking, tend to be magical, but there is another type of tattooing which is avowedly magical, in which the tattooing is applied with the intention of helping to bring about some desired contingency. Magical tattooing is chiefly the concern of women, for here we enter a world of old wives' lore. Three recognizable varieties are found among the instances which came under my observation. The first is designed to induce pregnancy, a matter of great concern to Arab women; the second has the purpose of guarding children, especially boys, against death; and the third consists of charms for love or against other magic.

Tattooing to induce pregnancy was observed in only one case, but the practice was confirmed by statements from two other informants. One woman in the Baghdad hospital had three large dots irregularly placed on the lower abdomen, as well as a design around the navel. The dots in particular were to ensure her having children, but she said she had already borne one child when the tattooing was applied. This was done on the third day of menstruation. A midwife from Al-Kadhimain, one of the best informants on the magic aspects of tattooing, also mentioned the practice of tattooing to ensure child-bearing. According to her, the tattooing may be a single dot or a small design consisting of three or five dots, applied below the navel, or on the back just above the buttocks. It must be done on the second or third day of menstruation. A single dot in the center of the navel was specified by Kulthuman, the tattooer in An-Nasiriya.

A dot on the end of a child's nose is the most general form of magic tattooing encountered. In a country where the infant mortality is high, magic practices to preserve a child's life will be highly in favor. If a woman has lost several children, she will have the successive ones tattooed with a single dot, either on the end of the nose or on the lower abdomen. Some informants said that the magic effect was extended to later-born children, but others said that it was not effective for more than one child, and later-born children would have to be tattooed likewise. The tattooer in An-Nasiriya said that all the men in the village of Samawa are tattooed with a dot on the end of the nose, and one above the mouth on either side. This is done when they are children to make them look like girls so they will not die. A variation was observed in the case of a policeman in Baghdad who came of the Uzairij tribe. Instead of a dot on the nose he had on each temple a cross with a dot on each angle. His mother's previous children had all died, he said. So she had had him tattooed in this way to preserve him…

The efficacy of the third type of magical tattooing, which is a form of sympathetic magic, is aided by having someone read the Qur'an while the tattooing is being applied. This is practiced secretly by women, and I came across only two instances. In Baghdad I saw a woman with three dots tattooed in a triangle on the palm of her right hand to ensure her keeping a husband's love. A similar design on the left hand would mean that the woman no longer wanted her husband's devotion. The midwife in Al-Kadhimain had a circle of five dots on the palm or her right hand. She said that she was her husband's second wife, and when he took a third, she decided that something must be done to ward of any possible conjuring on the part of the new wife. So one Friday noon, the most effective time, she had her right palm tattooed while a woman mullah read the Qur'an. The potency of the tattooing could not be doubted for the result was that her husband had divorced his other wives and kept her!

CARSWELL IN JERUSALEM, 1961

In the old City of Jerusalem one afternoon in 1956 I discovered a collection of woodblocks which struck me as unique in character. They were owned by a Coptic tattooer who used them to stamp designs onto pilgrim's arms as a guide for his needle. With his permission I borrowed the blocks and had them printed on paper; I was so impressed with the charm and variety of the designs that I started to make inquiries into their origins and also the extent and purpose of their present use. The artistic, anthropological, religious and iconographic interest of the designs will

The following selection is taken from *Coptic Tattoo Designs* by John Carswell.

Left to right: The Annunciation;
Saint Veronica and the Veil;
The Madonna and Child.
(after Carswell)

be apparent and there are many scholars more competent than I to comment on these special aspects of the collection...

The tattooer, Jacob Razzouk, is the head of a family belonging to the small Coptic community in Jerusalem, where his ancestors settled in the eighteenth century, coming from Egypt. I was first attracted to his shop, a coffin-maker's, by a sign on the door advertising tattooing; this seemed to me such an odd combination of activities that I questioned him about it. He told me that he was both the proprietor and the tattooer, but that there was no direct association between his two occupations. When I showed an interest in tattooing he told me about his craft and offered to show me his tools and methods; it was then that I first saw the wooden blocks.

The craft has been passed down in the Razzouk family for generations; the majority of his customers are Copts from Egypt who want a permanent souvenir of their visit to the Holy Land. Tattooing is a seasonal trade with a peak period of business at Easter; this is therefore his reason for combining it with another profession. In an average year he tattoos at least two hundred Copts. All Coptic pilgrims are virtually obliged to be tattooed as their compatriots would not consider a pilgrimage valid without this visible sign. As for his other customers, they include pilgrims of most of the Christian denominations. This is confirmed by the presence of Armenian, Syrian, Latin, Abyssinian and Slav designs in the collection; one curiosity is a Hebrew design.

The blocks are the most important part of Razzouk's equipment. They serve a double function: firstly, they provide his customers with a rudimentary catalog from which a design may be chosen, and secondly, provide the means whereby the desired design can be stamped onto the skin. This is accomplished by lightly inking the surface of the block and pressing it firmly on the flesh, leaving the reversed image as a guide for his needle. Personally, I do not know of another instance of a tattooer having a similar set of blocks. Usually tattooers either copy designs by eye, or the designs are composed and drawn directly onto the skin. The idea of having the design permanently carved on blocks may have been introduced for the sake of speed; obviously it is quicker to stamp the design than to draw it out laboriously and Razzouk is obliged to work under exceptional conditions, as most of his customers come at the same time. I myself have seen more than twenty Copts waiting to be tattooed in his house at Easter; often whole families are tattooed simultaneously.

The designs are carved on blocks of closely grained olive wood. Varying greatly in size, they range from quarter of an inch to an inch in thickness. Some of the blocks are carved on both faces. A glance at the prints will show great variety of style and execution, indicating they were carved by different hands; Razzouk says by different members of his family. The blocks are carved in the cameo technique, i.e. the printing surface is a relief line standing away from the body of the block. There is no record of what tools were used to cut them, as none of them were cut during Razzouk's memory; the intricacy and depth of some of the carving suggests that special tools, like gouges, must have been employed as well as a sharp knife. The procedure can be seen in a few places where the blocks were abandoned before being completed. They show that the design was carved first in silhouette, possibly following finely engraved guidelines,

and then completed by cutting away the details within the silhouette.

After the design has been transferred to the skin it is pricked into the flesh with a needle dipped in ink. Razzouk's technique differs from that of his ancestors, as he owns an electric automatic needle sent to him by a brother in America. This instrument has the commercial advantage of tattooing in several different colors. Until he acquired it he used the old method of a set of needles bound in a stick, which was a long and painful process...

Razzouk tattoos men, women and children. The position of the tattoo varies according to the sex of the customer and the design. The cross, for instance, is one of the symbols commonly placed on the inside of the right wrist. The more complicated designs tend to be tattooed on the upper arm. Some female customers prefer designs on the inside of the upper arm, or on the leg just above the knee. The back of the hand is the usual location for small crosses with equal arms. Also, four dots in the shape of a cross are often placed at the base of one or more fingers. His

own family are all tattooed with such crosses. Persons who have sprained or injured arms are occasionally tattooed with a continuous band of dots...

There are only two definite dates in the collection of woodblocks. One is the Armenian inscription for the year 1749, and the other is a Resurrection incorporating the date 1912. Some of the blocks are extremely worn and would certainly seem to be of the antiquity claimed for them by Razzouk, who asserts that they have been in his family since the seventeenth century... Apart from stating that the blocks may come from any part of the period within the two dates shown more accurate dating is impossible; nor can a chronological dating of style and development be traced since primitive art of this kind shows no appreciable pattern of development. In Jerusalem the traditional demand for tattooing continues and is in no way diminished. Winifred Smeaton remarks in her study of Arab tattooing in Iraq that urbanization seems to have adversely affected the popularity of tattooing; this is not the case amongst the

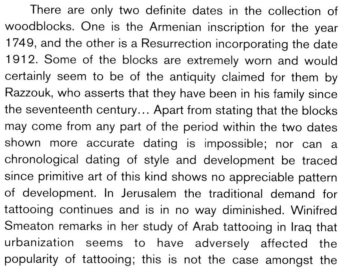

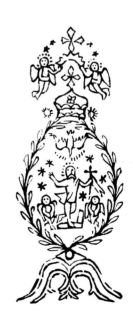

eastern Christians. I have talked to many educated Armenians and Copts who unanimously agreed that a pilgrimage to Jerusalem should be recorded by a tattoo. I sat recently beside an elegantly dressed young woman in a public taxi in Beirut, who had a freshly executed tattoo on her forearm dated 1958—one of the designs in the collection...

It is a curious fact that Jerusalem contains no masterpieces of Christian art and architecture, indeed little of any distinction at all. The modern traveler is more likely to be inspired by its associations than its monuments. How many a visitor to the Holy Sepulchure has been disappointed by the chaotic jumble of dimly-lit chapels, lacking in any focal point, and outside, shocked by the gaudy commercialism and religious trumpery that fight for attention at every turn. Yet this is no modern development; Felix Fabri says of his fellow pilgrims to the Holy Sepulchure in the fifteenth century: "There was no lack of vainglory... for some had candles twisted and decorated with gilding and painting, which they carried with ostentation and looked with scorn on those who carried plain candles." The same candles are on sale in the little shops around the Church today. These shops are crammed with every conceivable kind of souvenir; traditional olive wood and mother of pearl carvings, medallions of gilded incense, silver crosses, carved bread-pats, handblocked shrouds, rosaries and a plethora of cheap pictures. Entirely devoid of artistic pretensions, in a humble way they are a measure of the faith of pilgrims down the ages. Along with such souvenirs, the tattoo designs illustrate one of the more charming aspects of the piety of generations of pilgrims to Jerusalem.

The Crucifixion; The Resurrection. (after Carswell)

Saint George and the dragon, a print taken from
a woodblock in the collection of Jacob Razzouk. (after Carswell)

PROFESSIONAL OPINIONS

Sir Joseph Banks was the first European on record who speculated as to the motives for tattooing among the natives of Polynesia. During his visit to Tahiti in 1769, Banks wrote: "What can be a sufficient inducement to suffer so much pain is difficult to say; not one Indian (though I have asked hundreds) would ever give me the least reason for it; possibly superstition may have something to do with it. Nothing else in my opinion could be a sufficient cause for so apparently absurd a custom." (see Chapter 2).

The eminent German anthropologist Wilhelm Joest thought he had the answer. In his opinion tattooing was motivated not by superstition, but by vanity. The year 1887 saw the publication of Joest's *Tätowiren, Narbenzeichnen und Körperbemalen: Ein Beitrag zur vergleichende Ethnologie.* (Tattooing, Scarring and Body Painting: A Contribution to Comparative Ethnology.) In his introduction Joest informs his readers that he has researched his subject by first-hand observations of native tattooing in America, Asia, Indonesia and Africa, and by careful examination of accounts of tattooing in scholarly journals. Joest asks: how did tattooing originate, and why is it found in so many disparate cultures? The question, he thinks, is not difficult to answer. Tattooing, body painting, scarification, and all other forms of personal adornment are motivated by nothing more mysterious than the elemental desire of "natural man" to decorate the body.[1] Joest disagrees with his colleagues who maintain that tattooing has religious significance in ancient cultures, and warns his readers that this heresy "threatens to become generally accepted as fact in textbooks."[2] Joest wrote:

> In all of the islands I visited, I found no evidence to support the assertion that tattooing has any kind of religious significance. It is true that the actual process of tattooing is everywhere associated with certain ceremonies that are supposed to ensure the successful outcome of this painful operation... On closer examination, however, I found that the motives for tattooing were not religious, but were rather more closely related to the intimate association of the sexes. It is therefore easy to conclude that the primary motivation is that of personal adornment. The idea that one should undergo a painful operation for the sake of a god is completely inconsistent with the general attitude of the natives, who expect of their gods only benefits and, where possible, relief from pain.[3] (*translated by Steve Gilbert*)

In the years which followed the publication of Joest's work, numerous other theories were proposed by rival anthropologists. In 1925 Oxford anthropologist Wilfrid Dyson Hambly published his classic *The History of Tattooing and its Significance*, in which he observed, "There is certainly a most interesting variety of opinion concerning the significance of tattooing." He listed the following:[4]

> 1. "Promptings of the esthetic sense."
> 2. "A means of artificially aiding the process of natural selection."
> 3. "A survival of the ancient rites of bloodletting."
> 4. "A means of readily recognizing friends and foes."
> 5. "Atavism."
> 6. "A religious dynamic force."

While acknowledging the importance of Joest's work in recording specific tattoo motifs and techniques, Hambly took exception to his theory that tattooing is motivated solely by vanity and the desire for personal adornment. This, wrote Hambly, is "the facile explanation."[5] Since the publication of Joest's book anthropological research had revealed much new evidence as to the association of

Opposite page: Circus performer and bareback rider, Betty Broadbent. (courtesy of Tattoo Archive)

tattooing with religious and magical beliefs.

Hambly retailed a wealth of examples which he had culled from field work by anthropologists in many parts of the world. Tattooing was supposed to: prevent pain; protect against gunshot wounds; cure illness; confer superhuman strength; preserve youth; enhance the supernatural powers of a shaman; ensure the survival of the soul after death; identify the soul in the hereafter; attract good luck; protect against witchcraft; ensure the protection of a deity; confer occult powers; prevent drowning; exorcise demons; ensure the protection of a totemic animal or spiritual guardian; record a pilgrimage to a holy place, etc.

Hambly reported that previous investigators had often been misled because obtaining information as to the religious and magical uses of tattooing was fraught with difficulties. In the myths of many cultures tattooing was of divine origin. The actual tattooing process, which involved complex rituals and taboos, could only be done by priests and was associated with beliefs which were secrets known only to members of the priestly caste. Anthropologists were often misled because their informants either did not know or would not reveal the secret significance of the rituals and taboos.[6]

Hambly concluded that historically tattooing had originated in connection with ancient rites of scarification and bloodletting which were associated with religious practices intended to put the human soul in harmony with supernatural forces and ensure continuity between this life and the next. He wrote:

> Primitive man approaches non-human forces by positive rites carried out with meticulous accuracy, and at the same time he employs a number of negative rites in the form of prohibitions or "taboos." Association of such ceremonial with body marking is a sure indication of its importance. When, in addition to caution, secrecy, and ritual there are definite beliefs relating to the value of tattoo marks in heaven, dedication to a deity, relegation of the tattooer's craft to priests, or other clearly expressed concepts of the like kind, the evidence for a religious dynamic force in body marking is incontrovertible.[7]

Hambly's book remains today an invaluable survey of the accounts of tattooing which had appeared in scholarly publications up to 1925. It also marks the end of a significant period in anthropological fieldwork. By the time Hambly's book was published, the efforts of missionaries and the impact of European imperialism had suppressed the last vestiges of indigenous native tattoo traditions in most parts of the world, and subsequent opportunities for original field work in tattooing were rare.

Most physicians and psychiatrists who wrote on tattooing ignored Hambly's work. Focusing on twentieth century Europe and the Americas, they discovered that tattooing was motivated not by religious beliefs, but by repressed sexual desires and perversions. One of the most influential writers who attempted to analyze the subconscious motivations in tattooing was Albert Parry. In his book *Tattoo* he wrote:

> Very seldom are the tattooed aware of the true motives responsible for their visits to the tattooers... Tattooing is mostly the recording of dreams, whether or not the tattooed are consciously aware of it. Much of man's dreaming is, of course, of his true love—of his repressed sexual world fighting its way to the surface. Thus we should expect that tattooing, the recording of dreams, would be of a decidedly sexual character.
>
> The very process of tattooing is essentially sexual. There are the long, sharp needles. There is the liquid poured into the pricked skin. There are the two participants of the act, one active, the other passive. There is the curious marriage of pleasure and pain.[8]

Reviewing *Tattoo* in *The Psychoanalytic Quarterly*, Susanna S. Haigh praised Parry for the accuracy of his insights but faulted him for failing to discuss "the anal element in the tattoo," and went on to say that "there is surely a definite relationship between the impulse of the child to smear itself with feces and that of the adult to have himself smeared with indelible paint."[9]

In the same year Parry's book was published, psychoanalyst Walter Bromberg examined tattooing in the light of Freudian theory and discovered a wealth of pathological motives. He analyzed the most popular tattoo designs and found that they symbolized sadistic fantasies, masochistic fantasies, sadomasochistic fantasies, guilt arising from incestuous wishes, masturbation, repressed homosexual desires, and a host of related motives. There was only one case too tough for Bromberg to analyze. He had to confess that "it is difficult to account psychologically for tattooed pictures of Mickey Mouse."[10] Bromberg's study established him as an authority on tattooing and the subconscious, and was cited by most subsequent writers on the subject.

According to a theory proposed by psychiatrist Shirley M. Ferguson-Rayport in 1950, tattoos have "diagnostic significance for particular psychiatric conditions". For example, the tattooed image of a horseshoe and the words "good luck" mean that the patient is a "psychopathic deviant" who is unable to direct his own destiny and subconsciously believes that fate controls his life. "Schizophrenic tattoos" are characterized by stars, drops of blood, and secret symbols which have magical properties. A female figure draped in a flag symbolizes the schizophrenic's "detachment and distance from normal, especially sexual, contacts." Such tattoos, wrote Ferguson-Rayport, "pictorialize the deep uncertainty of the self and the tangential, distant, concrete attitude of the schizophrenic."[11]

In 1990 Robert F. Raspa objected that "if [Ferguson-Rayport's] theory were correct, a diagnosis could be achieved easily by categorizing the tattoo. Evidence indicates that it is the mere presence of the tattoo, not its artistic content, that correlates with certain diagnoses. Thus, any tattoo can be viewed as a warning sign that should alert the practicing physician to look for underlying psychiatric conditions."[12] Among these conditions Raspa cited: impulsiveness, low self esteem, lack of self control, homosexual orientation, sexual sadomasochism, bondage, fetishism, bisexuality, Lesbianism, antisocial personality disorder, alcohol abuse and dependence, psychoactive substance abuse and dependence, borderline personality disorder, schizotypal personality disorder, mania and bipolar disorder, and schizophrenia.[13]

Psychiatrist Armando R. Favazza summarizes the attitude of the psychiatric establishment in the following words:

> Current thinking holds that many people—especially those belonging to nonconformist groups—get tattoos to demonstrate their defiance of traditional authority, to display a stereotyped symbol of physical strength and aggressiveness, and to provide a sense of identity and solidarity with other group members... Many studies link multiple tattoos with antisocial personality, an increased incidence of assaultive behavior, impulsivity, and difficulties in heterosexual adjustment.[14]

Anthropologist Kathryn Coe has pointed out that tattooing is not always associated with psychopathology and antisocial activities. It may also be a relatively normal activity which is motivated by a desire to enhance the sense of pride and honor associated with membership in the military or in some other form of male alliance by externalizing and objectifying group identity. Male bonding is manifested in the activity of being tattooed together with members of the group, having identical or similar designs, and the ritual demonstration of courage through shared pain.[15]

These motives, however, do not seem to characterize tattooing among women.
According to some postmodern feminist theorists, a woman may become heavily tattooed as an act of empowerment to express her defiance of convention and male domination, and to symbolize the fact that she is reclaiming her body and taking charge of her life. But anthropologist Margo DeMello

observes that conflicting and ambiguous motives are sometimes involved. A woman may also allow herself to be elaborately tattooed because she is dominated by a male who wishes to mark her as his property, as in the case of female circus performers who were tattooed, owned, and exploited by their husbands. DeMello writes: "It could be argued that, contrary to empowering women, tattoos contribute to their further objectification in a male-dominated society."[16] But she concludes that the choice is "a political as well as a personal statement in that heavily and publicly tattooed female bodies are an attempt to liberate the objectified body, literally inscribing it with alternative forms of power."[17]

Some contemporary cultural anthropologists have interpreted tattooing as an integral part of a larger phenomenon of body modification, including branding, scarring and piercing, inspired by the global disintegration of cultural frontiers. This phenomenon is seen as a spiritual quest motivated by the desire of alienated youth to defy the repressive conventions of western industrialized society by participating in a primitive ritual designed to put the individual in touch with archetypal images which define the meaning of life in subliminal nonverbal terms, while at the same time expressing psychic idiosyncrasies which have been repressed by contemporary societal norms. In the words of cultural anthropologist Daniel Rosenblatt, "bodily adornment can become resistance because it is able to use the idea of 'the primitive' to explore the 'self,' and...such self-exploration is able to be fig-ured as a threat to society at large."[18] The tattoo is thus culturally defined as "a therapeutic ethos based on the recovery of the self in response to the experience of consumer capitalism."[19]

Darren Boode, who has worked as a professional tattoo artist in Toronto for over ten years, thinks studies such as Rosenblatt's are unnecessarily theoretical. He commented: "The guy's got a nice theory, but I don't see it in action. Most people I tattoo do it because they want a picture on their arm and they've got money burning a hole in their pockets. That's about as profound as it gets around here" (personal communication).

Can the motivation for tattooing be explained in Darwinian terms? Is there an analogy in the behavior of animals? Ethologists Amotz and Avishag Zahavi have suggested that horns and patterns on scales, feathers and hair convey messages that have survival value. The stag's antlers and the peacock's tail, for instance, have no apparent utilitarian function. They are, in fact, handicaps, because it takes energy to produce and carry them. But in terms of survival value they serve a purpose which more than compensates for the handicap: they advertise the fact that their proud owners have abundant energy to expend. Such advertisement serves to attract mates, intimidate rivals, increase reproductive success, and produce offspring with big antlers and long tail feathers.[20]

Does tattooing serve a similar function? It's a handicap in that it's expensive, painful and potentially dangerous. But the elaborate tattoos of the Marquesan warrior, the Japanese Yakuza and the American biker have something in common: they advertise the fact that the owners of the tattoos have money, can endure pain, are deadly serious, and will be dangerous adversaries in battle. And a warrior who can win by intimidation instead of fighting his enemy will live to come home and father children. Or so goes one variation of the argument according to Darwin. It is an interesting field of inquiry that deserves to be explored further.

"What could be a sufficient cause for so apparently absurd a custom?" We now have an abundance of answers to Sir Joseph Banks's question, but no "right answer." Theories as to what motivates tattooing have taken many forms, depending on the viewpoint of the author and his or her time and place in history. And yet, Banks's original speculation that "possibly superstition may have something to do with it" has proved to be prescient. Don Ed Hardy, one of the most perceptive and articulate observers of the contemporary tattoo scene, points out that in most cultures magical and supernatural themes have been associated with tattooing. He writes:

> Today, the old primal pull of tattooing is stronger than ever, and along with it, both
> deliberate and unconscious magical connotations. These might range from specific

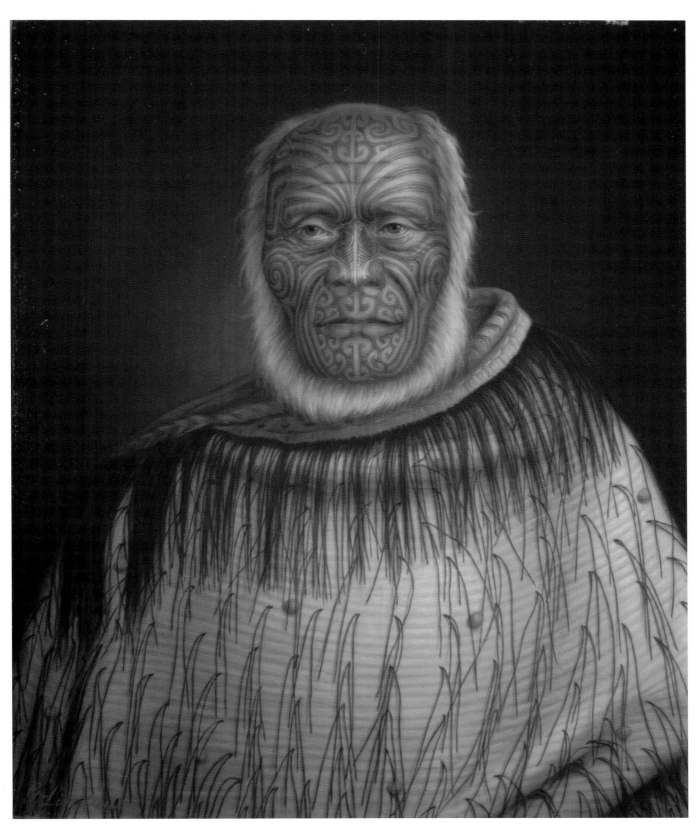

The following portraits of Maoris were painted by European artists Charles Frederick Goldie (1870-1947) and Gottfried Lindauer (1839-1926). These portraits are in the permanent collection of the Auckland Art Gallery and are reproduced here by kind permission of Ngahiraka Mason, Kaitiaki Maori Curator. Gottfried Lindauer, Ihaka Whanga, oil on canvas, Auckland Art Gallery Toi o Tamaki, presented by Mr. H. H. Partridge, 1915. (See chapter 8, New Zealand)

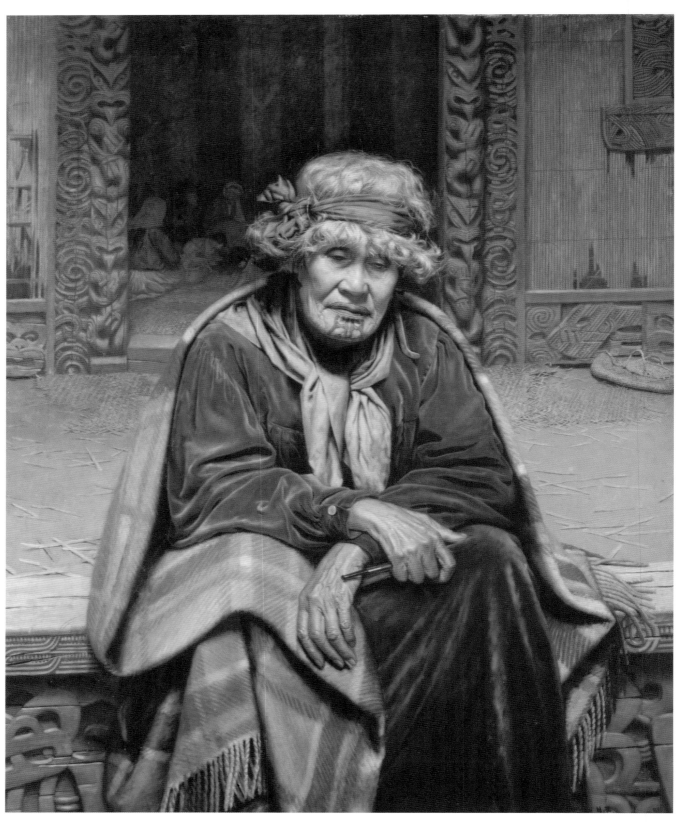

Charles Goldie, Memories: Ena Te Papatahi, a Chieftaness of the Ngapuhi Tribe, oil on canvas
Auckland Art Gallery Toi o Tamaki, bequest of Emily and Alfred Nathan, 1952.
(See chapter 8, New Zealand)

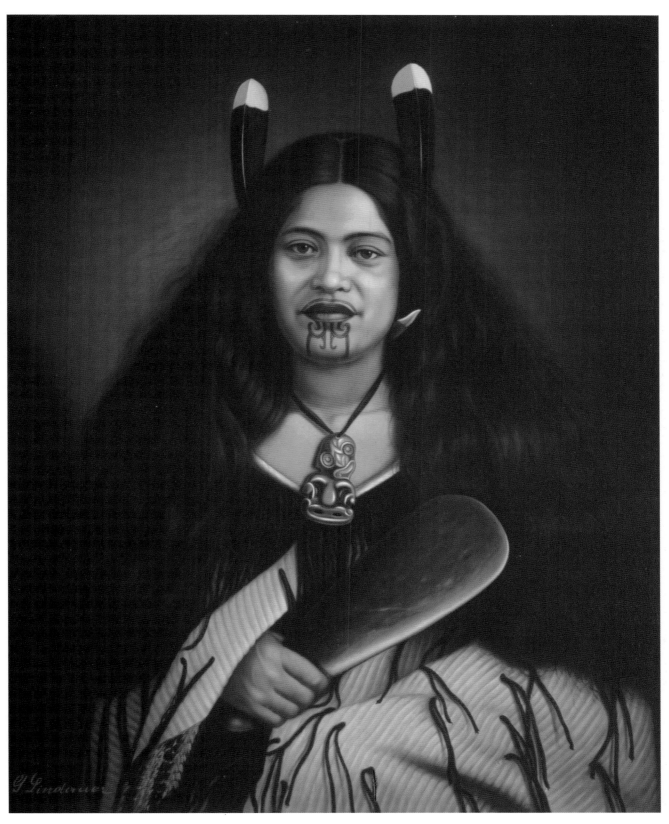

Gottfried Lindauer, Pare Watene, oil on canvas, Auckland Art Gallery Toi o Tamaki, presented by Mr. H. E. Partridge, 1915.
(See chapter 8, New Zealand)

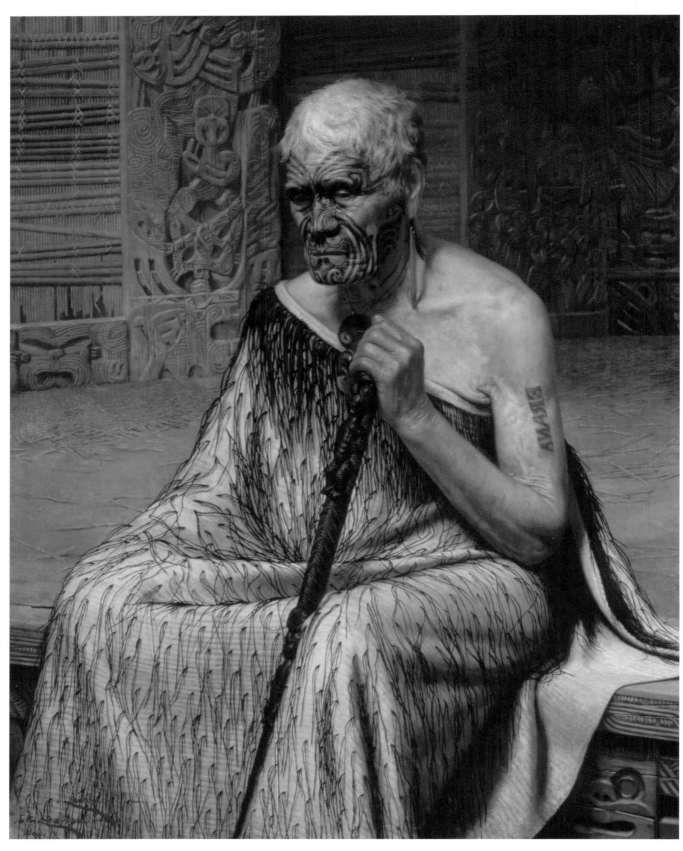

Charles Goldie, Te Ahote Te Rangi Wharepu Ngati Mahata, oil on canvas, Auckland Art Gallery Toi o Tamaki, bequest
of Emily and Alfred Nathan, 1952.
(See chapter 8, New Zealand)

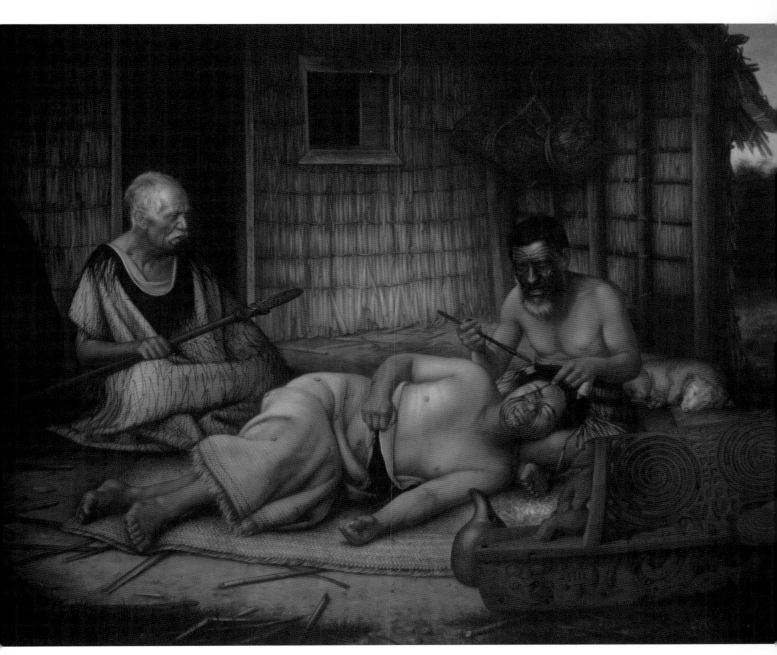

Gottfried Lindauer, The Tohunga-ta-moko at Work, oil on canvas, Auckland Art Gallery
Toi o Tamaki, presented by Mr. H.E. Partridge, 1915.
(See chapter 8, New Zealand)

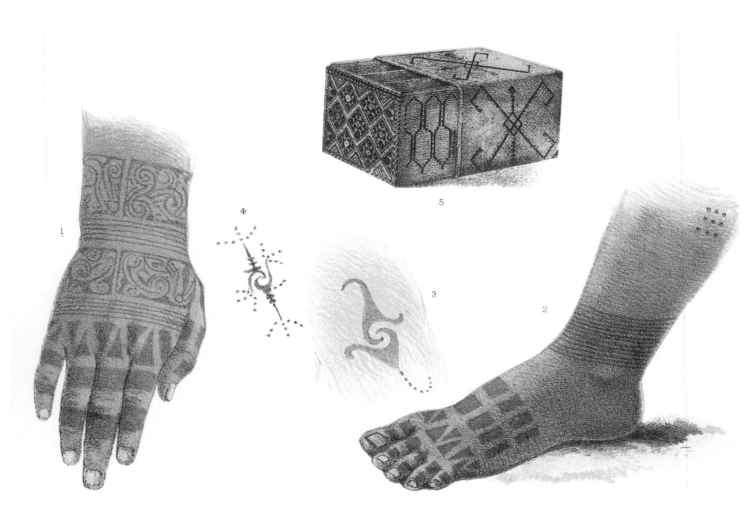

Borneo tattoo designs for the hand and foot. A lithograph published in 19th century German explorer Carl Bock's
"The Headhunters of Borneo", London, 1881.
(See Chapter 5, Borneo)

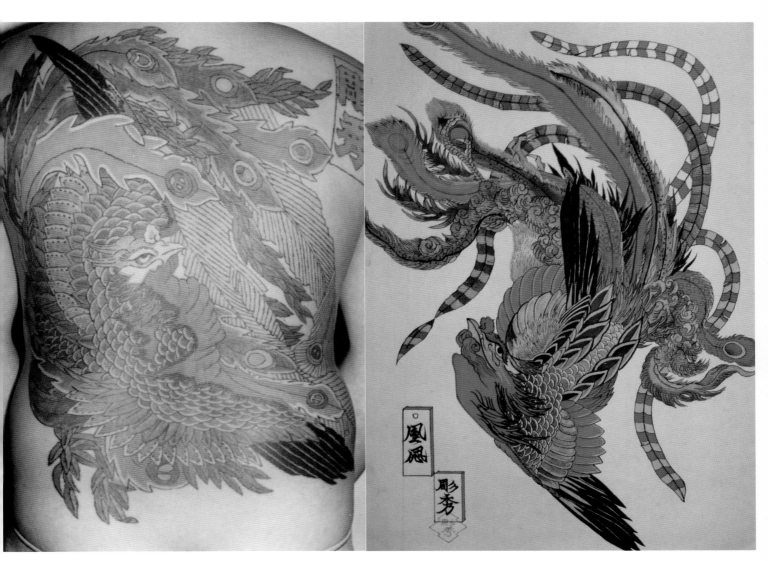

Left: Phoenix. Tattooed by hand in the traditional style (tebori) by contemporary Japanese tattoo artist Kazuo Oguri.

Right: Phoenix drawing.
Watercolor on paper by Kazuo Oguri.
(See Chapter 9, Japan)

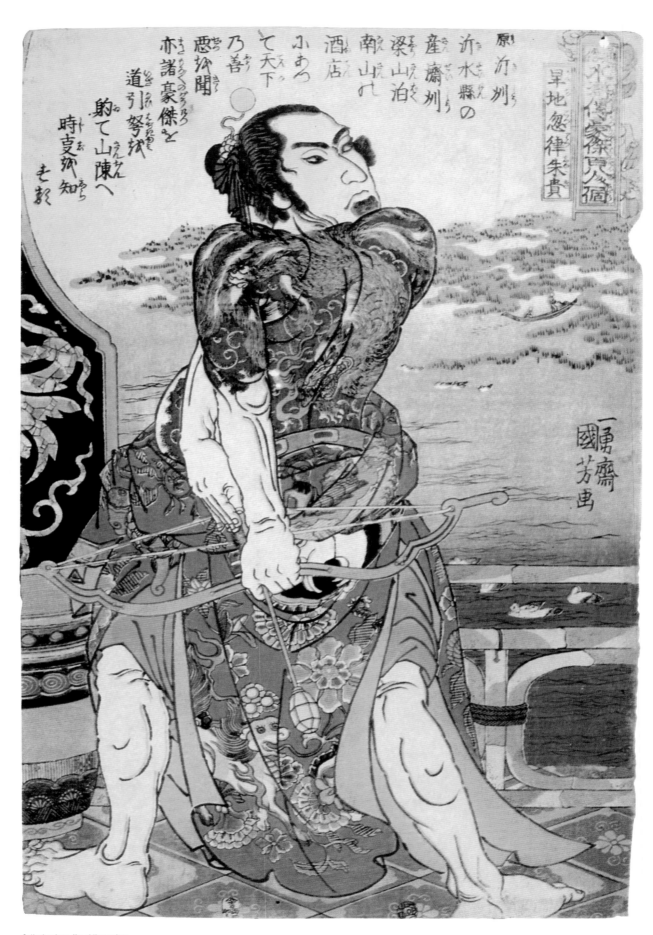

Suikoden hero Kanchikotsuritsu.
A woodblock print by 19th century Japanese ukiyoe artist and tattoo designer Utagawa Kuniyoshi.
Published in 1827 to illustrate the popular adventure novel "Suikoden." (See Chapter 9, Japan)

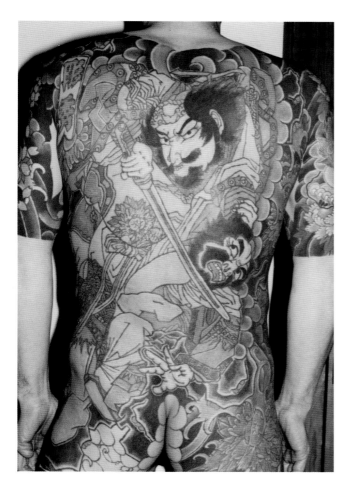

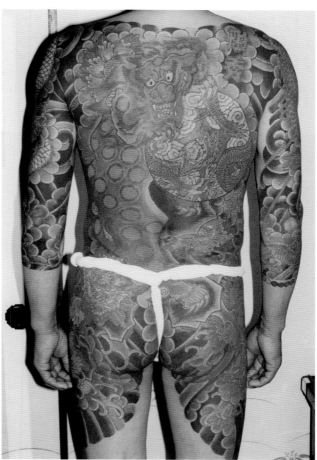

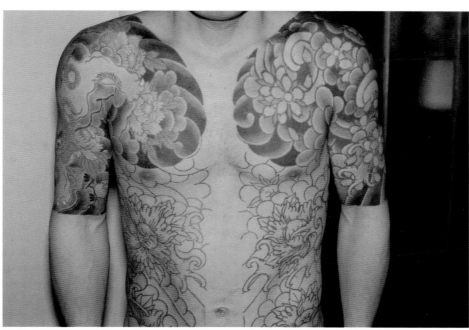

Top left: Suikoden hero. Tattoo by Kazuo Oguri.
Top right:Chinese Lion and Peonies. Tattoo by Kazuo Oguri.
Bottom: Peonies and cherry blossoms. Tattoo by Kazuo Oguri.
(See Chapter 9, Japan)

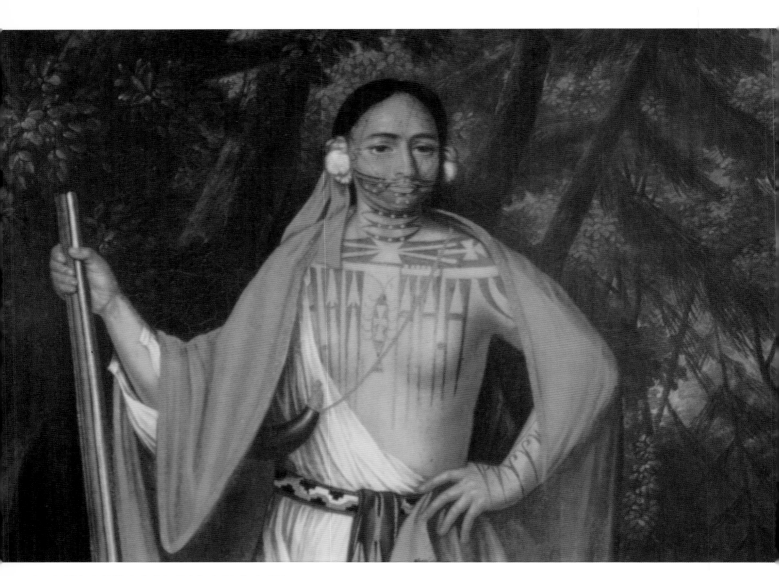

Portrait of Mohawk chief Sa Ga Yeath Qua Pieth Tow by John Verelst, 1710.
(See Chapter 10, North America)

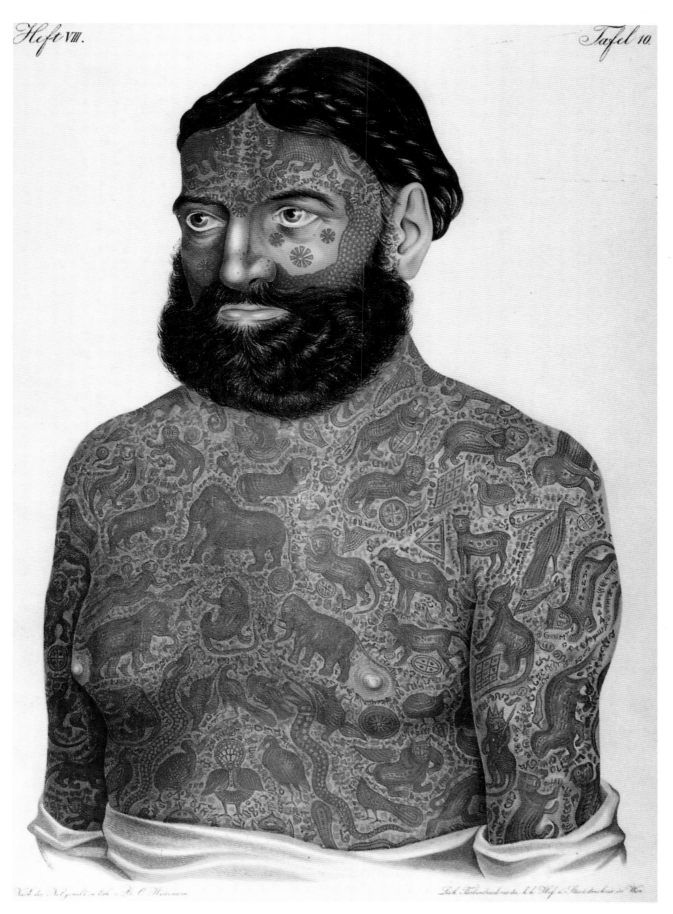

Nineteenth century Circus and sideshow performer George ("Prince") Constantine. A lithograph published in German by dermatologist
Ferdinand Hebra's "Atlas of Portraits of Diseases of the Skin," London, 1875. (See Chapter 15, The Circus)

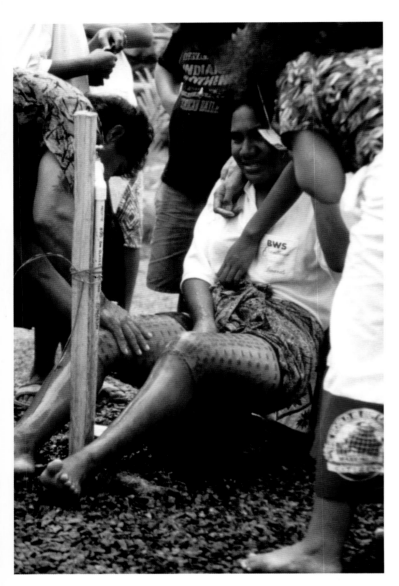

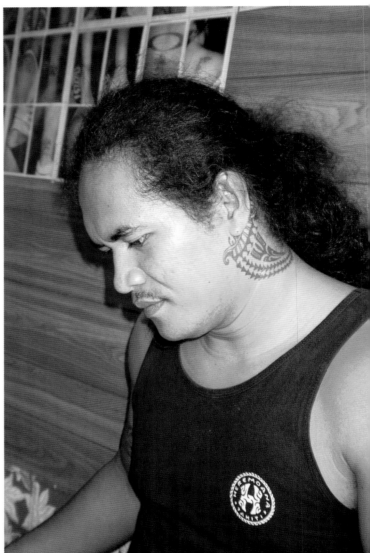

Women in Samoa wear a malu, or tattoo that extends from the upper thigh to just below the knees. In ancient times, the tattoo continued higher, ending just above the pubic area, but this is considered improper by todays Christian standards. In ancient times women had their hands tattooed as well. Today, the tradition of tattooing the hands is still practiced, but is uncommon.
(See chapter 20, Polynesia Today)

Efraima Hu'uti is from the island of Ua Pou in the Marquesas. He and his younger brother Simion are perhaps the best Marquesan tattooists today, however, they now reside and tattoo on Tahiti in a small shop upstairs at the marketplace. Efraima's tattoo is a modern design inspired by the ancient practice of Marquesan women being tattooed behind the ear. Today, the placement is more common among men than women.
(See chapter 20, Polynesia Today)

A Tahitian style tattoo shop on the island of Moorea.
Here, Thomas uses the home-made razor machine typical of what many tattooists
in the Pacific use today.
(See chapter 20, Polynesia Today)

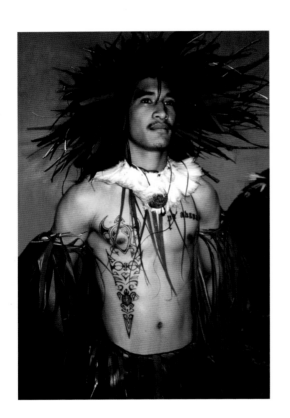

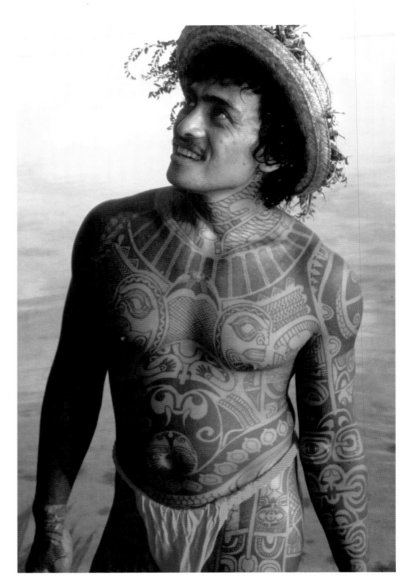

Left: Kristofer (pa'ahana) Manaois is a Tahitian dancer residing in California. His tattoo is a modern neo-Marquesan design that represents himself, his parents and his son (tattoo by Tricia Allen).

Right: Ro'onui is one of the top tattooists in Tahiti today. He is originally from the northern Tuamotus, but wears a full-body tattoo largely inspired by Marquesan design (tattooed by himself, Chime and Purotu). (See chapter 20, Polynesia Today)

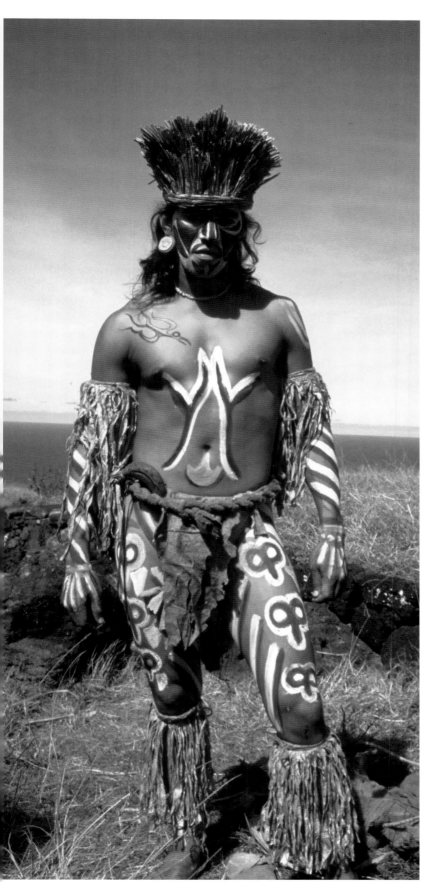

Left: For festivals and performances today, Easter Islanders paint the patterns that once would have been tattooed.

Right: Samoa is the only place in Polynesia that has enjoyed a continuous history of tattooing. Here the traditional techniques are still practiced today. Matai or chiefs wear the pe'a or tattoo from the waist extending just below the knees, as well as the traditional tapa cloth lavalava or wrap-garment.
(See chapter 20, Polynesia Today)

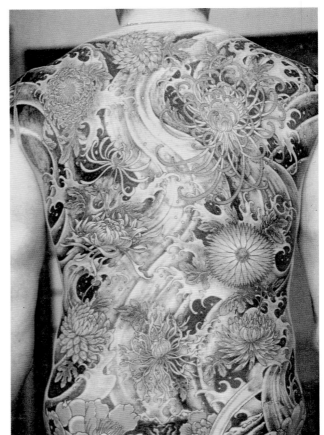

Left: D.E. Hardy. 1977. Chrysanthemums and water. (from *Tattootime* #3)

Right: D.E. Hardy. 1980. Bandit leader receiving books of knowledge from Empress of Heaven. (13th century Chinese epic). (from *Tattootime* #2)
(See Chapter 21 Current Events)

ancient symbols to images with complex personal meanings unique to the wearer. A lot of people are eager to link up with 'something beyond,' reaffirm their connections with greater forces beyond this mundane daily life.... The essential magic of the tattoo for us now, as ever, is the chance to hook up with the sympathetic powers of the chosen subject, participate in a meaningful rite of passage (even if it's getting Popeye on the forearm during one's first Navy liberty) and help keep away evil spirits—these days, often members of the Moral Majority and other repressive Thought Police types... [The tattoos] might only be epidermal placebos. But if they make us feel better about ourselves, and by extension others around us, the magic works. We are wearing our dreams.[21]

HAMBLY ON MAGIC AND RELIGION, 1925

The following selections are taken from W.D. Hambly's *The History of Tattooing and its Significance* (London: H.F. & G. Witherby, 1925).

To readers who are acquainted with the contents of "Die Tätowirung," published by Joest some forty years ago, an addition to the subject of body marking may on first consideration appear to be a work of supererogation. This, however, is far from being the case, and in this connection it should not be forgotten that "Die Tätowirung" (1887) antedated the advent of modern anthropological inquiry. Consequently Joest has concerned himself chiefly with painting, tattooing and scarification in their technological aspects, and of necessity without reference to the research of the past twenty years, which reveals the existence of taboo, ceremonial and belief, forming the raison d'être of body marking in New Guinea, Borneo, Assam and North America...

Of these main aspects of the problem the psychological, sociological and esthetic present fewest difficulties, for as a mental and social process body marking forms part of a congruous whole including totemism, exogamy, and the search for immortality. This harmonious entity of magico-religious beliefs, so closely interwoven with body marking, illustrates the view...that there is a logic of primitive man though his premises may be false owing to absence of a system of natural science.

The historical aspect introduces many difficult, one fears insuperable problems, for a review of archaeological evidence and artifacts in the way of marked female figures, and the use of red ochre in interments, takes the investigator far beyond the narrow confines of 6,000 years of recorded history to the dim recesses of Paleolithic times. Consideration of the antiquity of body marking in culture centres of the world, including, of course, Babylon, Egypt, Peru, Mexico and China, brings to light many interesting facts, and in addition gives a reasonable dateable sequence of the migration of tattooing. From the thirteenth to the nineteenth centuries there is no paucity of dated testimony relating to the existence of body marking. But early observers contented themselves with casual references to, or at best a description of technique and *modus operandi.* Not until the last quarter of the nineteenth century was there detailed anthropological field inquiry which supplied knowledge of taboo, ritual and belief connected with body marking. Ceremonial provides evidence of migration of culture as opposed to the older idea of a psychic unity accounting for the appearance of identical beliefs, taboos and practices at disparate points all over the globe...

In this connection I suggest that there is a helpful sense in which the term "psychic unity" may be legitimately used to express a uniform emotional tendency including curiosity with regard to a future life, self-assertion, sympathy, power of suggestion and suggestibility. All these aspects of mental activity are common to man, and some are noticeable in present-day representatives of his anthropoid precursors.

This common emotional trend accounts for the rapid spread of cultures, especially when these in certain aspects and doctrines satisfy an insistent demand for acquisition or preservation of social status; answer a query respecting survival after physical death; offer a means of

escape from demons of pain or sickness; show a safe passage from puberty to maturity; or present some positive means of alluring good luck and avoiding the evil eye. These are a few of the desiderata conferred by systems of body-marking which have a world-wide distribution.

The reasons why puncturing the skin should be regarded with some degree of awe are not far to seek, for in the first place, there is the drawing of blood, which to the savage world over is full of significance as a rejuvenating and immortalizing factor. There is in addition the opening of numerous inlets for evil to enter and, perhaps most important of all, the marking is connected with some crisis, some stepping over the threshold of a phase of social intercourse, some advance from boyhood to manhood, from girlhood to womanhood. Marking during initiation is most important in showing the relation of painting and tattooing to one of their original cultural factors, namely fertility rites.

In the data relating to magico-religious beliefs we have shown that in approaching a supreme being or supra-human force, likewise in appeasing ghosts or placating demons of disease and pain, corporal markings are part of a system of ideas in general congruous. Burial of red ochre with the deceased, reddening of skeletons, and similar practices in prehistoric times may rightly be regarded as the earliest attempts to secure continuity of existence and rejuvenation by blood symbols. Long before the dawn of history, possibly in the period preceding the first wide dispersal of man, a strong magico-religious system of ideas had centred around the use of pigments as an aid to solving the problem of continued existence after death. (p. 233) ■

The following selection is taken from: Walter Bromberg. 1935. Psychologic Motives in Tattooing. *A.M.A. Archives of Neurology and Psychiatry.* 33: 228-232.

BROMBERG ON SUBCONSCIOUS MOTIVATION, 1935

The material on which this brief study is based is taken from the Psychiatric Clinic of the Court of General Sessions. During the past year (1933) I had an opportunity in the routine examination of prisoners to study young men who were tattooed. Many of the principles brought forth tonight in the discussion of the psychology of the skin are illustrated by tattooed persons. The first striking observation which was made was that in all of the persons who were tattooed the decision to have a design applied was made impulsively. It was as if some great resistance had to be overcome. The resistance took two forms: in one, it was the overcoming of the social taboo against marring the skin; in the second instance it was the natural dislike to injure the narcissistic organ, i.e., the skin. From a deeper point of view the skin is to most persons a perfect organ. It is sacred when it is unadorned (except by nature) and contains all of the elements of beauty. The skin is indeed a reservoir of narcissism. The impulsive decision to be tattooed was usually carried out under the influence of friends. Often men who were tattooed had the tattooing done while they were in an alcoholic state, and almost always the friends who accompanied them were themselves tattooed. Thus one sees in operation the influence of a latent homosexual factor. Another instance of the activity of the homosexual factor is expressed in the very symbolism of the tattooing needle and the fluid, the infliction of pain by an older man (i.e., the tattooer), by the absorption of sadomasochistic feelings in the subject and by the fact that the repression against homosexuality is weakened by alcoholic intoxication....

In a general way there are two types of men who bear tattooed designs. There is the older, usually more virile type of man, often a sailor, who is satisfied with his designs and who adds to his collection slowly over a period of years. This type is clearly exhibitionistic. At the extreme end of this group are the professional tattooer and the performer in a circus. The other group is comprised of young men who wish to bolster their feelings of inferiority by being identified with strong men, for instance, young sailors. These men quickly become disgusted with their pictures and do not have new designs put on except during a few years in their adolescence. The social taboo is on the surface in these men, and they will often say that the tattooing makes one look "vulgar and rough." Fundamentally, however, this feeling is a counterpart of the fear of castration. These men are apt to choose designs which express anthropomorphism, such as

pictures of stalwart warrior, boxers, Indian braves and so forth. They feel the need of increasing their aggressive tendencies by wearing tattooed designs depicting strength. Exhibitionism and aggression are united, for example, in the sailor who is not afraid to display his tattooed designs on his bulging arm muscles, broad chest, etc. In this connection, it is interesting to see the relation of the tattooing of the sailor to narcissism. In the days of sailing vessels, sailors on their long trips frequently tattooed each other; in fact, it is thought by some to be the origin and development of American tattooing. In the older days sailors, because of the infrequent association with women, the absence of a heterosexual love object and their intimate association with each other, were apt to express their latent homosexual feelings in tattooing; moreover, the arms and the chest were frequently used as sites for their designs. According to the theory of "Genitalization of the body" described by Lewin and others in which the arms and even the chest are a phallic representation, tattooing on the body should provide a direct type of narcissistic and auto-erotic gratification....[22]

The types of pictures which are tattooed are strikingly diverse, but they are all illustrative of important principles. The most frequent type is the pictures of sexual objects, usually nude women accompanied by obscene statements. Frequently one sees homosexual pictures such as the design on a man's back of a cat chasing a mouse toward the anus, in which the mouse has half buried itself. In the majority of instances the pictures of sexual objects proclaim the heterosexuality of man. At the same time they represent the final expression of the Oedipus situation combined with a marked sense of the guilt arising therefrom...

A third and common type of tattoo design is the sadistic: pictures of skulls, daggers, blood, etc. all representing strong sadistic fantasies. I have often seen knives with an unusually liberal supply of blood. One of the tattooers of New York City is famous for and proud of the livid dyes he uses for representing blood...

A fourth type of frequent tattooing motifs is pictures concerned with death and questions of honor and guilt. Frequently these are represented by a picture of a cross with the word "Mother" beneath, with the date of her death or with no date if she is living.... At the bottom of this type of picture, particularly tombstones with dates and names referring to the mother, is the strong feeling of guilt involving the Oedipus situation...

A youth, age 19, with marked emotional and vasomotor instability and of an egocentric immature type, who has assumed an air of callousness as a shell to cover feelings of inferiority, bears a design on his left arm of a skull with the words "Death Before Dishonor." He said he took the tattoo on a dare. From a psychologic point of view it was a challenge to his sadomasochistic and narcissistic tendencies.... He said that his mother threatened to cut off his arm while he slept when he came home with a tattooed design.... Whereas he was previously proud of his design, he became extremely sorry that he had had it done and was frightened and ashamed. He said that he was ashamed because "people see you at the beaches and think you are a rowdy." This boy then transposed the fear of castration (in this case the threat was administered by the mother) to a fear of social condemnation, i.e., that people would not like him at the beaches.

The fifth type of pictures, in a rough way, represent those of the professional tattooer and the exhibitioner, who have new designs applied from time to time, some of the men being tattooed from head to foot. The pictures of the professional tattooers represent a special type. These men exhibitionize with little sense of guilt, regard their craft as a profession and derive constant gratification from the pictures on their skin. There are a few tattooers who are not tattooed extensively and are sorry that they ever went into the business. Most of the tattooers show by their placidity the lack of a feeling of guilt and the constant pleasure derived from erotization of the skin through tattooing. ■

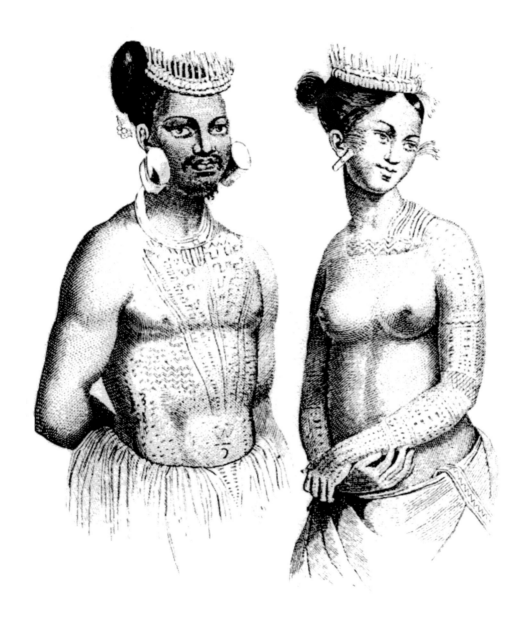

Marshallese tattoos in 1817.
(de Renzi 1840 after Choris 1828)

THE MARSHALL ISLANDS

Contemporary Contributions

BY DIRK H.R. SPENNEMANN

Dirk H.R. Spennemann, Ph.D., is Senior Lecturer, Cultural Heritage Studies, School of Environmental and Information Sciences, Charles Sturt University, New South Wales, Australia.

The Marshall Islands, comprising 29 atolls and 5 islands, are located in the north-west equatorial Pacific. The atolls of the Marshall Islands, comprising well over 1200 islands and islets are scattered about in an ocean area of well over 600,000 square miles. The atolls support narrow sand cays set on the more or less ring-like reef platform. Only few of the islands on the atolls have a land area greater than one square kilometer and on most of them the distance between the lagoon and the ocean side is less than 300 meters.

Today traditional Marshallese tattooing is no longer practiced and the meaning of most of the ornaments and ornament fields is no longer known. In fact, only very few Marshallese of the 1990's can remember having seen people with full traditional tattoos. Thus we have to turn to historic sources. Aspects of tattooing in the Marshall Islands are described by a variety of ethnographic sources mainly of the late 19th and early 20th century, but a comprehensive treatment of the topic was not compiled until 1992.

An in-depth reading of these sources made it clear how little information had in fact been recorded at a time when a large number of people still wore tattoos and knew their meanings, as well as the traditions related to the motifs and the chants sung at the ceremonies. Then, there were still people who knew how to tattoo, although with the progressive impact of the Christian faith the ceremony itself had become more or less extinct. Language problems, and possibly also psychological aversion on behalf of the Marshallese, probably due to Christianity-induced guilt complexes, may have been inhibitive factors in the transmission of knowledge.

HISTORY OF TATTOOING IN THE MARSHALLS

Based on archaeological evidence, the first people to settle on the atolls which now make up the Republic of the Marshall Islands arrived between 1000 and 500 B.C. Over the centuries they maximized the horticultural potential offered by the scarce land on the atolls and developed a complex social system with little emphasis on permanent structures. Transmission of information was oral, by word of mouth; a reliable method to hand down one's skills, information and social regulations, but subject to as much intentional modification and alteration of content as is provided by modern news coverage.

Over two millennia after settlement the first European visitors arrived on the scene and the first written accounts appear. Most likely the first Europeans to touch upon the atolls of the Marshall Islands were members of a Spanish expedition under the command of Alvaro de Saavedra, who arrived in October 1529 on a return voyage from the Philippines to Mexico. Saavedra encountered a northwestern atoll of the Marshall Islands, possibly Ujelang. A brief encounter with the heavily tattooed natives seems to have impressed the Spaniards so much that they named the entire island group "Los Pintados"—the painted. No details of the appearance of the tattoos are known.

The first British visitors to stumble upon the atolls were Captains Gilbert and Marshall, *en route* from Port Jackson (Sydney, Australia) to the United Kingdom via China. Their observations, like those of several subsequent visitors, Spanish, British and American, do not touch on tattooing. The earliest detailed descriptions we have of Marshallese tattooing stem from members of the Russian Exploring Expedition under the command of Captain Otto von Kotzebue, who visited the northeastern Marshall Islands first in 1816 and 1817, and then again in 1824. The German Adelbert von Chamisso, naturalist on the expedition, even desperately ventured to obtain a tattoo—to no avail. In his eyes,

> tattooing neither covers nor disfigures the body, but rather blends in with it in graceful adornment and seems to enhance its beauty.

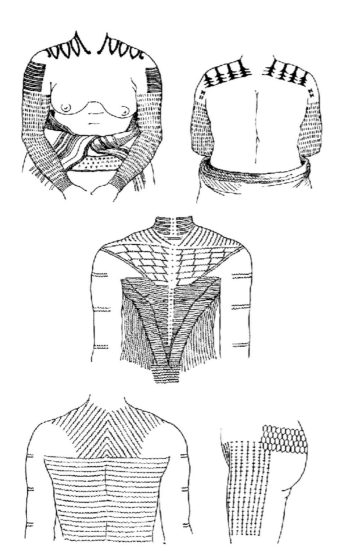

Marshallese tattoos drawn by
Eduard Hernsheim in 1887.

The expedition's artist, Choris, provided a number of studies of tattooed men and women. After the Russians left, little ethnographic work was done in the Marshall Islands for over half a century.

The later part of the 19th century saw the Marshall Islands becoming drawn into the German sphere of commercial interests and ultimately in 1885 a German protectorate. Subsequently a great number of German scholars, priests and administrators dealt with Marshallese ethnography in general and Marshallese tattooing in particular either in passing or in greater detail. The traders Hernsheim and Hager provided short summaries of Marshallese life and custom for an interested audience in Germany, but mainly dwelt on the potential economic importance of the atolls of the Marshall Islands for fledgling German colonial aspirations.

The descriptions of the scholars Finsch and Kubary are more detailed than those of the traders although the descriptions especially of Finsch, contain some misconceptions, possibly caused by the inability to speak Marshallese. Some other information dating to the late 19th century is provided by accounts of shipwrecked people, such as Eisenhardt or Humphrey.

German colonial administrators and doctors filed a number of formal reports, most of which were published in the official journals. The administrators, their spouses, as well as naval officers and civilian visitors also published a number of informal articles in colonial newspapers and magazines, which contain additional information although mainly of a more general nature.

Soon after its establishment in 1904, the Catholic mission in Jaluit began to compete with the Protestant missionaries who had been well entrenched for almost half a century. The Catholic fathers collected traditions and ethnographic information, as well as worked on the Marshallese language. Father Erdland published a comprehensive ethnography and a dictionary, both of which discuss tattooing at length. Erdland's dictionary lists a number of terms for tattooing on body parts, some of which seem to refer to motifs commonly used on that body part or ornament zone.

Following his two months sojourn in the Marshall Islands in 1897/1898, Augustin Krämer wrote a paper on mat weaving and tattooing in 1904, and included tattooing in a monograph on his trip published two years later. In 1910 Krämer again visited the Marshall Islands, this time with the German South Sea Expedition, and published the entire ethnographic material together with Hans Nevermann in 1938 as a volume of a series covering the 1910 expedition. Tattooing is again reviewed, and all other German sources are commented upon.

THE DEMISE OF TATTOOING

Tattooing had largely ceased in the second half of the 19th century, so that Otto Finsch, discussing tattooing needles was forced to state "in 1879 it was no longer easy to obtain such implements."

Along with the teachings of the Bible, the missionaries brought along their set of moral, ethical and aesthetical values, which were—of course—those of the contemporary society of their home

country, and more to the point, the values of their own class level. It was these values then, which they superimposed by persuasion or force on the peoples of the Pacific, who until then had been able to survive quite well without the doubtful blessings of Christendom and European society. Throughout the Pacific, tattooing, traditional attire, as well as traditional dancing was considered to be the apex of heathenism and therefore banned by missionaries of any denomination, be they Marists, London Missionary Society, Wesleyan, or American Protestant Revivalists.

In the Marshall Islands, the Protestant missionaries of the American Board of Commissioners for Foreign Missions ("Boston Mission") were noted for interfering with domestic Marshallese issues. This disruption of Marshallese customs encompassed almost all aspects of daily social interaction. Tattooing was a custom which the missionaries had to put an end to for a number of reasons, each equally compelling to the self—righteous souls from rural backgrounds:

- Tattooing was connected with the old traditional way of life and the very expression of both status and group identity they were set to modify.
- Tattooing was closely interwoven with traditional religious and spiritual beliefs, and thus "heathen".
- Tattooing was perceived to be aesthetically offensive to the European eye.
- In the 19th century both British and U.S. penal systems identified released convicts and Army deserters by their tattoos.
- A Bible reference existed mentioning that the Israelites shall not be tattooed (Leviticus XIX:28)—hence tattooing was thought to be un-Christian.

On the balance, therefore, the missionary abhorrence towards tattooing was partially based on European narrow—mindedness and European ideals of beauty and aesthetics, and—for a fundamentalist—was morally justifiable by the bible.

Often, however, the missionary impact is downplayed and the general Europeanisation is blamed for the demise of the social systems. The fact that it was the Christian missionaries and not the general Europeanisation of the Marshall Islands which brought about the departure from clothing and body ornamentation customs becomes clear if one considers that in the mid-1880s tattooing was still practiced in the northern atolls, where Christian religion had not yet gained a foothold:

> the Christian influence of the mission has changed the original hairdo of the natives, and long hair is forbidden as unchristian... Where the missionaries have not penetrated, on all northern islands and [the] Ratak [Chain], the old customs still prevail, as does the characteristic hairdo...and
>
> The original native customs are still to be firmly entrenched in the northern islands of the group. Here tattooing and flower decorations are still en vogue, as well as the enormous distention of the ear lobes.

The speed with which the missionaries could effect this change is astonishing. Tattooing was banned soon after the missionaries' arrival on Ebon. Since the special rites associated with tattooing in the Marshall Islands had also a religious significance, the Ebonese shortly after the arrival of the European missionaries showed reluctance to carry out these rites in the missionaries presence; about 800 people left for Jaluit to do it in safety there

It seems that the German colonial authorities had nothing or only little to say about tattooing. A survey of the Colonial Records showed that this matter played no role in the correspondence between the Station Chief in Jaluit and the Governour General in Rabaul, New Britain.

Following the outbreak of World War I, Japan seized the Marshall Islands from Germany in October 1914. Her possession of Micronesia was formalized in 1922 by the League of Nations. Unlike the Germans, the Japanese authorities, who took over the administration of the Marshall Islands following the outbreak of World War I, banned tattooing. According to a U.S. government publication of 1943:

Blue Yellow White

The Regal Angelfish (Pygoplites diacanthus) was for the Marshallese the apex of clear lines and example for tattoos.

"In 1922 the Japanese made tattooing or marking of one's own or another's body a police offense under penalty of enforced labor for a period not to exceed 30 days. This law may have been an effort to erase the physical marks of distinction separating chiefs from commoners. Or it may have been designed to eliminate a source of infection, since it is reported that, after being tattooed, a person usually develops a high fever."

A number of Japanese ethnographers worked in the Marshall Islands, some of whom dealt with the topic of tattooing. The main Japanese work on Micronesian tattooing was done by Hasebe Kotond, who published a paper on Marshallese tattooing in 1930, wherein he discussed contemporary tattooing motifs and the decline of traditional Marshallese tattooing.

A census of 238 men conducted in 1930 showed only 56 to be tattooed with indigenous motifs. Of these the overwhelming majority (48) had only horizontal bands around their arms, as well as their legs. Most of these tattoos would have been completed during German colonial times, indicating how far the demise had gone.

In 1945 following Japan's defeat in World War II the Marshall Islands became a Trust Territory of the United Nations, under administration by the United States of America. Ethnographic work conducted immediately after World War II shows that traditional tattooing was no longer practiced.

TRADITIONAL MARSHALLESE TATTOOS

Spiritually and conceptually Marshallese tattoos and their motifs are firmly rooted in the marine environment and Marshallese tattooing has drawn its elements and ideas for motifs from the sea. Many motifs, for example, are abstract forms of specific fish, or are to represent canoe parts or the canoe's movements.

Even more to the point, tattooing in general is called eo, which according to the German ethnographer Krämer means the drawing of lines in general, because the lines of the blue-striped or regal angelfish (Pygoplites diacanthus), also called eo, were considered to be exemplary.

The Marshallese tattoo motifs are in general character very abstract pictographs, their meaning, as outlined above, finds its roots in the environment: markings of fish, tooth marks of fish bites, motifs resembling shells or their ornaments and so on.

Marshallese tattooing motifs (right) and their natural examples (left).
1—*Conus ebraeus* and the *addilajju* motif;
2—*Lepas anserifera* and the *eloñwā* motif;
3—Back of a turtle's carapace and the *bōd* motif;
4—Back of crab's carapace and the *addijokur* motif; Shark's teeth and the *pako* motif.

THE MEN'S TATTOOS

Marshallese tattooing was executed in a systematic manner and none of the motifs were of accidental creation; they, as well their arrangement, follow strict patterns. In their entirety, Marshallese men's tattoos are very striking. As a number of nineteenth century observers have pointed out, a completely tattooed man appears to be dressed in a chainsuit, resembling a medieval knight.

A men's tattoo is laid out in a series of ornament zones which bear descriptive names, such as "mast", "ocean swell", "boat", "clouds" and the like, which find their origin in the seafaring nature of Marshallese men.

A complete man's chest tattoo consists of three main tattoo components, which can be added to. These main ones are the upper and the lower chest triangle as well as a central vertical ornament field. Added to these three main components could be other ornament fields, such as a shoulder tattoo, a tattoo on the side of the chest or a stomach band.

Apart from the shoulder zone, the tattoos on the men's back consist of three ornament fields, the back triangle and upper back band and the lower back field.

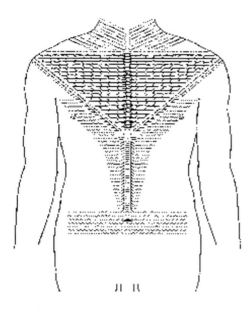

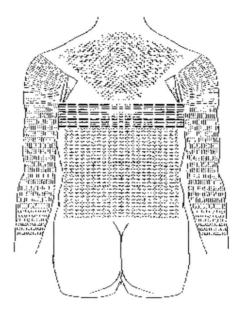

Men's tattoos. Chest tattoo of a young chief from Mile Atoll, (left) and a back tattoo from a young chief from Jaluit Atoll (right).

Neck and head tattoos were restricted to males of chiefly rank. The neck tattoo (*eoten-bōro*) consists of horizontal bands running around the neck, leaving only the area of the Adam's apple free. Above the level of the lower jaw, this tattoo continues at the back of the neck all the way up to the hairline, but ends at the ears, to make space for the face tattoo. This tattoo has the meaning of a magic necklace.

The face tattoo (*eoon-māj*) consists of vertical lines running from the eyes to the rim of the lower jaw. In the front these lines can also extend onto part of the neck. Forehead, face and chin are commonly free of any tattooing. Often, the frontal parts are the cheeks are also left unornamented.

The tattooing of the arms is very variable. It can consist of a few lines and in its full extent can reach from the armpits to the wrists. A full tattoo is traditionally divided into three main areas, the area of the upper arm, the area of the lower arm and the central part in between. Unlike other areas the inside of the arms was commonly not tattooed in the Marshallese tattoos.

The area of the upper arm covering the deltoid muscle, is bordered by a line drawn between the armpit and the shoulder (onset of the *caput humeri*), while the lower border is less well defined, but often matches the upper margin of the upper back band. Very common is the tattooing of only a couple of bands around the upper arm. These bands, mainly using the zigzag line, go all around the arm in the form of a bracelet (*lukwo* or *rojañpe*).

The area of the lower arm extends about halfway between the elbow and the wrist to the wrists itself. Tattoo motifs are arranged vertically and are aligned in small horizontal groups, giving the arm a ringed appearance.

Leg tattoos (*wünne*) are commonly restricted to the front and the middle of the outside of the upper thigh. Most leg tattoos are restricted to a few double lines or bands of the wavy-line or zigzag motif on their thighs and their calves.

In addition to the main tattoos mentioned, men were sometimes tattooed next to the armpits, the buttocks, and the penis.

The buttock tattoo consists of a rectangular band which covers the lower os sacrum area and the occasionally the side of the buttocks.

The tattoo next to the armpits was executed on the

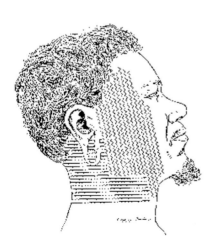

Head tattoo of chief Laninat (Mile).
Note the pierced and extended earlobes.

person's back. It was a small triangle with a base pointing upwards and the tip pointing towards the side. This tattoo, which was very rare even at the end of the nineteenth century, was primarily a chiefly tattoo, but may have been permitted for other men as well.

WOMEN'S TATTOOS

The data available on women's tattoos are, overall, less frequent than data on men's tattoos. This is mainly due to the fact that the ethnographers were mostly men, who of course had little access to the female world—both by inclination and by cultural opportunity. Few, like Erdland, would expressedly state that their knowledge of women's tattoos is limited. Others such as some German government officials, would simply deny that women were tattooed, which nicely reflects the gender bias in their reports:

> Men in the entire group are tattooed on the back and breast, varying according to rank
> Tattooing is not practiced in the case of women.

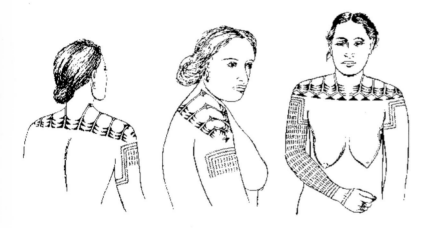

Tattooed Marshallese women.
(after Krämer)

In fact, those Marshallese who maintained the practice of tattooing after the intervention of outside forces were women, rather than the men. One exception in recording was that done by Elisabeth Krämer, who accompanied her husband Augustin to the Marshalls, and who could break through the gender barrier. According to all descriptions, women's tattoos are substantially more uniform than men's. Women's tattoos are also laid out in a fixed system of ornament zones, and the tattoos are restricted to the shoulders, arms, legs, and fingers."

According to Father Erdland, the Marshallese placed great importance on the female shoulder tattoo, "because as it is explained in sorcery rhymes and chants, the popularity of a woman is placed in her shoulders." The shoulder tattoo is very complex and consists of a number of motifs. The female shoulder tattoo is also the only tattoo where pigment is used in a more surface-covering manner. Tattooing motifs seen in this ornament field include almost exclusively the *bwilak* motif of which several variations and combinations have been used.

We can distinguish two major types of women's shoulder tattoos: Type I consists of the *bwilak* motif both on the back and the chest, while type II has this motif only on the back.

Type I has on either shoulder four sets of the *bwilak* motif of the back, ending at the shoulder ridge in a single set of triangles. On the chest side, there are again four sets of *bwilak* motifs on either shoulder, again with the little triangles added at the shoulder ridge. These sets of motifs, however, have a different lower end, where a double set of lines is added creating a zigzag border, from which

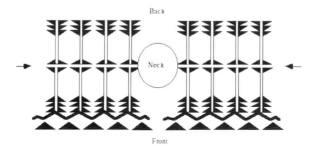

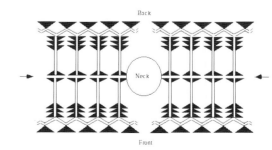

small triangles are suspended. Two variants are known, one where the zigzag lines are made up of double lines with a space in between and one where the zigzag line is a broad pigment band. At another variant the back also has the small triangles suspended.

The arm tattoo consists of two main parts, the decoration of the deltoid muscle and the decoration of the remaining arm to the wrist. The wrist area itself has another small ornament band. The deltoid muscle is commonly tattooed with a multiple zigzag band, which runs across the arm, then downwards at the side, across the back of the arm and up again on the inside. There can be three or four parallel bands of zigzags. Hasebe, relying on information by the tattooed person herself, identifies the deltoid muscle ornamentation as *eo idikdik*, or small tattoo. The area between the wrist and the deltoid muscle is tattooed with vertically aligned *looj* motifs. The E-shaped motifs commonly open towards the front of the person. On occasion the looj motif may be present, but the zigzag lines may be absent. The *wrist area* was tattooed with ornament bands running at right angles to the arm, providing the appearance of cuffs or armbands. Tattooing motifs seen in this zone are predominantly zigzag and wavy-line bands. Often the complex arm tattoo was replaced by some simpler armband-like tattoos.

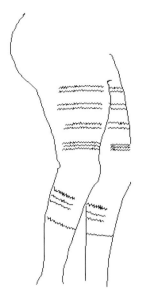

Women's leg tattoo

On the whole, documented women's leg tattoos were fairly rare. If recorded they consisted of a tattoo of the thighs and a separate and unconnected tattoo of the calf. The tattoos of the thighs were apparently confined to thin bands or single lines and were restricted to the front of the leg. The calf was decorated with horizontal lines only. Tattooing motifs seen in this ornament field include the zigzag tattoo.

The tattoo on the back of a hand (*eo in peden-pa*) consists of wavy-line (*kōdo*) and zigzag lines, the *kein kōm* motif running across the back of the hand. Hand tattoos were apparently not only restricted to women of chiefly rank, but were also very personalized, so that women could be identified by the tattoo of their hand. A folk tale speaks of an ogress, who had died during childbirth and had come to annoy people. She detached her hand and sent it to steal bananas, but was recognized by the tattoo.

The finger tattoo (*eoon-addin*) is restricted to women of chiefly rank and consists of small ring-like bands around the entire finger, or, more commonly, only on the backside of the middle digit. Tattooing motifs seen in this ornament field include zigzag bands (*eodikdik*). The most commonly tattooed finger is the middle finger, and only occasionally the ring finger or the little finger are tattooed. The ring-like motifs mentioned for the first digits, appear to be a European-influenced design motif, imitating European finger rings. Traditionally, the Marshallese had no rings on their fingers.

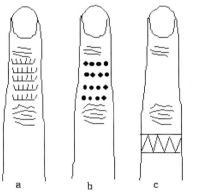

Marshallese finger tattoos

In addition, women could have a "secret" tattoo (*bōd en Lōbōllōñ*) which is "commonly invisible to the eyes". It appears that this tattoo covered the mons veneris, similar to the tattoos in other parts of Micronesia.

Female shoulder tattoos.
(the arrows indicate the shoulder line)

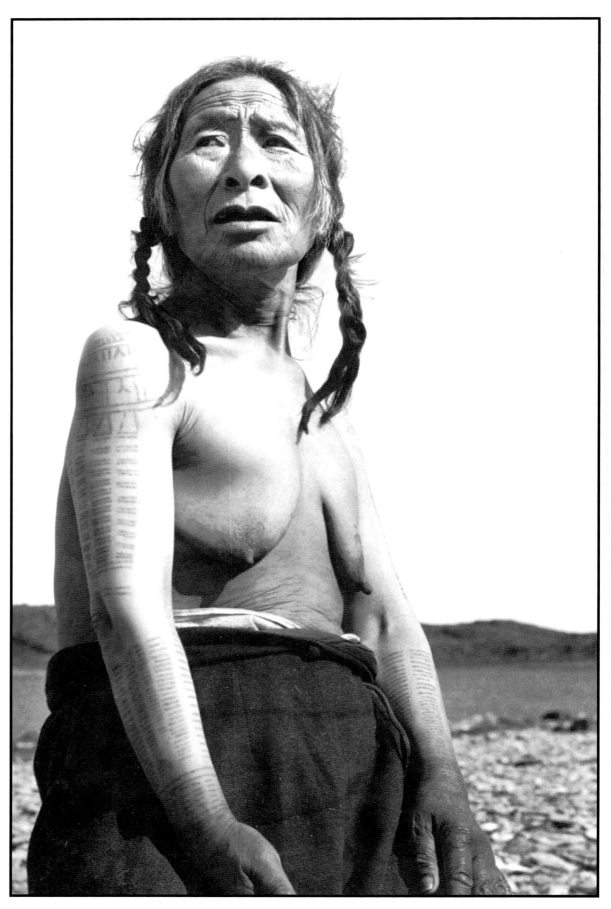

Tattooed Canadian Inuit woman.

THE ARCTIC

Standing sentinel in the frozen waters of Bering Sea, St. Lawrence Island fosters a complex of remarkable tattooing traditions spanning 2000 years. Ancient maritime peoples from Asia first colonized this windswept outpost lured by vast herds of ivory-bearing walrus and other sea-mammals. Bringing with them new advances in hunting technology and material culture, the Old Bering Sea/Okvik and Punuk peoples quickly adapted to their insular environment. As the forces of nature were quite often difficult to master, they developed an intricate religion centered on animism. Appeasing their gods through sacrifice and ritual, these mariners attempted to harness their forbidding world by satisfying the spiritual entities that controlled it. Not surprisingly, tattooing became a powerful tool in these efforts: for once the pigment was laid upon the skin, the indelible mark served as both protective shield and sacrifice to the supernatural.

In the last century, however, tattoo on St. Lawrence Island, and more generally the Arctic, has been a dying, if not already dead, traditional practice. Disruptions to native society as a result of disease, missionization, and modernity paved the way for a relinquishing of ancient customs. For example, fewer than ten St. Lawrence Yupiget retain traditional tattoos: all date from the 1920's. Alice Yavaseuk (age 93) is the last living tattoo artist and designer. Thus, any student of tattooing must work with tidbits of information to unravel the vast complexities of a fast disappearing "magical art."

This essay focuses upon a comparative analysis of tattooing practices among the St. Lawrence Island Yupiget, the Inuit peoples of Alaska, Canada, Greenland, and tattooed mummies from Europe and Asia. While often dismissed as a somewhat "mystical" and "incomprehensible" aesthetic, Arctic tattoo was a lived symbol of common participation in the cyclical and subsistence culture of the arctic hunter-gatherer. Tattoo recorded the "biographies" of personhood, reflecting individual and social experience through an array of significant relationships that oscillated between the poles of masculine and feminine, human and animal, sickness and health, the living and the dead. Arguably, tattoos provided a nexus between the individual and communally defined forces that shaped Inuit and Yupiget perceptions of existence.

BY LARS KRUTAK

Lars Krutak is an anthropologist and Repatriation Research Specialist working with the National Museum of the American Indian, Smithsonian Institution, Washington, DC.

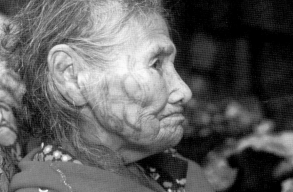

Facial tutaaq of a St. Lawrence Island Yupiget woman, 1997.

HISTORY OF TATTOOING IN THE ARCTIC

Archaeological evidence in the form of a carved human figurine demonstrates that tattooing was practiced as early as 3,500 years ago in the Arctic. Moreover, the remains of several mummies discovered in Bering Strait and Greenland indicate that tattooing was an element basic to ancient traditions. This is corroborated in mythology since the origin of tattooing is clearly associated with the creation of the sun and moon. The naturalist Lucien M. Turner, speaking of the Fort-Chimo Inuit of Quebec, wrote in 1887:

> The sun is supposed to be a woman. The moon is a man and the brother of the woman who is the sun. She was accustomed to lie on her bed in the house [of her parents] and was finally visited during the night by a man whom she could never discover the identity. She determined to ascertain who it was and in order to do so blackened her nipples with a mixture of oil and lampblack. She was visited again and when the man applied his lips to her breast they became black. The next morning she discovered to her horror that her own brother had the mark on his lips. Her emoternation knew no

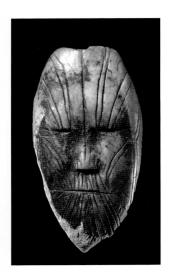

3,500 year old ivory maskette from the Dorset culture. This sculpture represents the oldest known human portrait from the Arctic.

bounds and her parents discovered her agitation and made her reveal the cause. The parents were so indignant that they upbraided them and the girl in her shame fled from the village at night. As she ran past the fire she seized an ember and fled beyond the earth. Her brother pursued her and so the sparks fell from the torch [and] they became the stars in the sky. The brother pursued her but is able to overtake her except on rare occasions. These occasions are eclipses. When the moon wanes from sight the brother is supposed to be hiding for the approach of his sister.

Ethnographically, tattooing was practiced by all Eskimos and was most common among women. While there are a multitude of localized references to tattooing practices in the Arctic, the first was probably recorded by Sir Martin Frobisher in 1576. Frobisher's account describes the Eskimos he encountered in the bay that now bears his name:

> The women are marked on the face with blewe streekes down the cheekes and round about the eies... Also, some of their women race [scratch or pierce] their faces proportionally, as chinne, cheekes, and forehead, and the wristes of their hands, whereupon they lay a colour, which continueth dark azurine.

As a general rule, expert tattoo artists were respected elderly women. Their extensive training as skin seamstresses (parkas, pants, boots, boat covers, etc.) facilitated the need for precision when "stitching the human skin" with tattoos. Tattoo designs were usually made freehand but in some instances a rough outline was first sketched upon the area of application. A typical 19th century account provided by William Gilder illustrates the tattooing process among the Central Eskimo living near Daly Bay, a branch of the great Hudson Bay:

> The wife has her face tattooed with lamp-black and is regarded as a matron in society. The method of tattooing is to pass a needle under the skin, and as soon as it is withdrawn its course is followed by a thin piece of pine stick dipped in oil and rubbed in the soot from the bottom of a kettle. The forehead is decorated with a letter V in double lines, the angle very acute, passing down between the eyes almost to the bridge of the nose, and sloping gracefully to the right and left before reaching the roots of the hair. Each cheek is adorned with an egg-shaped pattern, commencing near the wing of the nose and sloping upward toward the corner of the eye; these lines are also double. The most ornamented part, however, is the chin, which receives a gridiron pattern; the lines double from the edge of the lower lip, and reaching to the throat toward the corners of the mouth, sloping outward to the angle of the lower jaw. This is all that is required by custom, but some of the belles do not stop here. Their hands, arms, legs, feet, and in fact their whole bodies are covered with blue tracery that would throw Captain Constantinus completely in the shade.

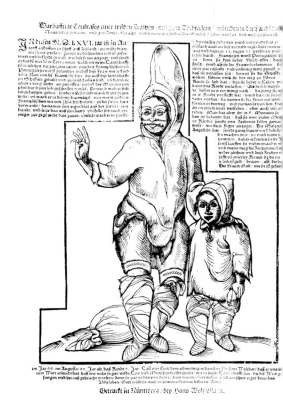

These Canadian Inuit were kidnapped by French sailors in 1566. (Notice the tattoos that appear on the woman's face.) This woodblock print is the oldest known European depiction of Eskimos drawn from lif

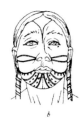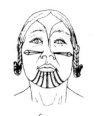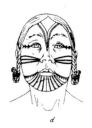

Central Canadian Inuit tattoos, late 19th century.

Around Bering Strait, the tattooing method reveals continuity in application, as observed by Gilder, yet the pigments employed were more varied. According to the Alaskan archaeologist Otto W. Geist, the St. Lawrence Island Yupiget tattoo artist drew a string of sinew thread through the eye of a steel or bone needle. The thread was then thoroughly soaked in a liquid pigment of lampblack, urine, and graphite. The needle and sinew were drawn through the skin: as the needle was inserted and pushed just under the epidermis about a thirty-second of an inch. These typical tattoo "operations" required several sittings with the tattoo artist. The results were often accompanied by great pain, swelling, and in some cases, infection and even death.

Whatever the outcome, the process in which the physical body became transformed and metamorphosed corresponded, in part, to the nature of the tattooing pigments used, as well as to the social precepts circumscribing them. Among the Siberian Chukchi and St. Lawrence Island Yupiget, lampblack was considered to be highly efficacious against evil as shamans utilized it in drawing magic circles around houses to ward off spirits. Graphite had similar powers as the Russian anthropologist Voblov stated in the 1930's, "[t]he stone spirit—graphite—'guards' [humankind] from evil spirits and from the sickness brought by them." Urine, on the other hand, was an element that malevolent entities abhorred. Waldemar Bogoras, the eminent ethnographer of the Chukchi and Asiatic Eskimo, stated that urine, when poured over a spirit's head, froze upon contact immediately repelling the spiritual entity. In this connection, it is not surprising that several St. Lawrence Islanders told me that urine (*tequq*) was poured around the outside of houses to insure the same effect. In regards to tattooing, however, the ammonia content in urine probably helped cleanse and control the suppuration that resulted from the ritual.

CONCEPTS OF TATTOOING IN THE ARCTIC

Inuit (or Eskimos generally) and St. Lawrence Island Yupiget, in particular, like many other circumpolar peoples, regarded living bodies as inhabited by multiple souls, each soul residing in a particular joint. The anthropologist Robert Petersen has noted that the soul is the element that gives the body life processes, breath, warmth, feelings, and the ability to think and speak. Accordingly, the Eskimologist Edward Weyer stated in his tome, *The Eskimos*, that, "[a]ll disease is nothing but the loss of a soul; in every part of the human body there resides a little soul, and if part of the man's body is sick, it is because the little soul had abandoned that part, [namely, the joints]."

From this perspective, it is not surprising that tattoos had significant importance in funerary events, especially on St. Lawrence Island, Alaska. Funerary tattoos (*nafluq*) consisted of small dots at the convergence of various joints: shoulders, elbows, hip, wrist, knee, ankle, neck, and waist joints. For applying them, the female tattooist, in cases of both men and women, used a large, skin-sewing needle with whale sinew dipped into a mixture of lubricating seal oil, urine, and lampblack scraped from a cooking pot. Lifting a fold of skin she passed the needle through one side and out the other, leaving two "spots" under the epidermis.

Paul Silook, a native of St. Lawrence Island, explained that these tattoos protected a pallbearer from spiritual attack. Death was characterized as a dangerous time in which the living could become possessed by the "shade" or malevolent spirit of the deceased. A spirit of the dead was believed to linger for some time in the vicinity of its former village. Though not visible to all, the "shade" was

Asiatic Eskimos "stitching the skin" at Indian Point, Chukotka, 1901.

conceived as an absolute material double of the corpse. And because pallbearers were in direct contact with this spiritual entity, they were ritualistically tattooed to repel it. Their joints became the locus of tattoo because it was believed that the evil spirit entered the body at these points, as they were the seats of the soul(s). Urine and tattoo pigments, as the nexus of dynamic and apotropaic power, prevented the evil spirit from penetrating the pallbearer's body.

Interestingly, nearly every attribute of the human dead was also believed to be equally characteristic of the animal dead, as the spirit of every animal was believed to possess semi-human form. Men, and more rarely women, were tattooed on St. Lawrence Island when they killed seal, polar bear, or harpooned a bowhead whale (*aghveq*) for the first time. Like the tattoo of the pallbearer, "first-kill" tattoos (*kakileq*) consisted of small dots at the convergence of various joints: shoulders, elbows, hip, wrist, knee, ankle, neck, and waist. Again, the application of these tattoos impeded the future instances of spirit possession at these vulnerable points.

However, *kakileq* were also important to other aspects of the hunt. One of the old hunters in Gambell told me that "one reason for [the tattoos] is to hit the target, sometimes they don't [and] I think these are for that purpose, to hit the target." This is not surprising, since the anthropologist Robert Spencer remarked that tattoos on the North Slope of Alaska and other forms of adornment doubled as whaling charms, "serving to bring the whale closer to the boat, to make the animal more tractable and amenable to the harpooner." This type of sympathetic magic was also manifest in the stylized "whale-fluke" tattoos adorning the corners of men's mouths. Fittingly, these symbols were applied as part of first-kill observances among the Yupiget of St. Lawrence Island and Chukotka, as well as by other groups in the Arctic.

It seems that the issue of death, whether human or animal, cast into symbolic tattooed relief important cultural values by which circumpolar peoples lived their lives and evaluated their experiences. But, and for the sake of traveling to a higher level, tattoos also recalled an ancestral presence and could be understood to function as the conduit for a "visiting" spiritual entity, coming from the different temporal dimensions into the contemporary world. For example, in many shamanistic performances in the Arctic, the human body was altered (via masking, body painting, vestments, or tattoo) to facilitate the entry of a "spirit helper." This is not entirely surprising since tattoos and other forms of adornment acted as magnets attracting a spiritual force — one that was channeled through the ceremonial attire and into the body.

The tattooing process involved iconographic manifestation of the "other side," acknowledgment of the manifestation's power, and harnessing that power within the corporeal envelope of human skin. On St. Lawrence Island, men and women tattooed anthropomorphic spirit-helpers onto their foreheads and limbs. These stick-like figures, more appropriately named "guardians" or "assistants," protected individuals from evil spirits, disasters at sea, unknown areas where one traveled, strangers, and even in the case of new mothers, the loss of their children. In Chukotka, murderers inscribed these types of markings onto their shoulders in

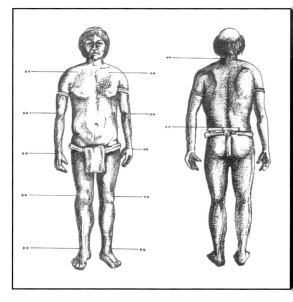

St. Lawrence Island joint-tattooing.
(sketch courtesy of Mark Planisek)

hopes of appropriating the soul of a murdered man, thus transforming it into an "assistant," or even into a part of himself.

Apart from these concepts, there seems to have been some relationship between labrets and tattoos, at least in the Bering Strait region. Adelbert von Chamisso, a naturalist with Kotzebue's expedition of 1815-1818, noted that labrets were rare among St. Lawrence Island men and often replaced by a tattooed spot. Edward W. Nelson, a naturalist working for the U.S. Army Signal Service in the late 19th century, also suggested that these circular tattoos were a relic of wearing a lip-plug or labret. Bogoras believed that this was probably true, though their position did not quite "correspond to the usual position of the labret. These marks are now intended only as charms against the spirits." Dewey Anderson and Walter Eells, two sociologists from Stanford University who visited St. Lawrence Island in the 1930's, recorded that "a small circle on the lower lip under the corners of the mouth [was tattooed] to prevent a man who has repeatedly fallen into the sea from drowning." Similarly, a Diomede Islander from Bering Strait was seen at the turn of the century with a mark tattooed at each corner of the mouth. He explained it as a preventive prescribed by his mother against the fate that had befallen his father—death by drowning.

From the preceding remarks, it seems that the aesthetics of circles were important in Bering Strait culture, especially when speaking about life and death encounters at sea. Folk-belief suggests

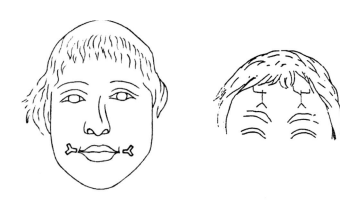

Left to right:
Men's fluke tail tattoos.
"Guardian" or "assistant" tattoos.
Tuutaq or tattooing.

that men who were hunting on the water or ice risked serious injury and death by drowning. However, according to Smithsonian archaeologist Henry B. Collins, men specifically risked injury due to walrus attack:

"Walrus are believed to eat seals, and even humans, in addition to their usual food of seaweeds and molluscs. Paul [Silook's] father tells of two times he was chased by walrus. It is believed that walrus that thus depart from their customary diet were left motherless when very young and so did not learn the proper method of eating."

Consequently, it is possible that Bering Strait society fashioned labret-like tattoos to forestall these aggressions. Aspects of folklore suggest that labret-like tattoos recalled in symbolic form the appearance of a killer whale (*mesungesak*):

"Killer whales are said to have a white spot at each side of the mouth like the labrets of the mainland Siberian natives."

Appropriately, these representations of the killer whale ideologically rebuffed the pursuing walrus, in turn, extending a hunter's safe passage through dangerous waters. On the other hand, the art historian Ralph Coe believes that labret-like tattoos mimicked walrus's tusks, especially since many labrets were carved from walrus ivory:

"The ivory seems to stand for the interchangeability of the animal or human, his soul[s], and the recipient, just as the Eskimo himself thought of wood as a symbol of strength: 'to the Eskimo, dwarf willow is a symbol of strength and suppleness against an overwhelming Arctic background, where

Tattoo foils.

survival depends upon a man's ability to contend with the forces of nature, while at the same time yielding to them and conforming with them.'"

Adopting the anatomical characteristic of the walrus (tusks) may have ideologically captured the essence of its aggressive behavior or transformed the hunter into this creature. This would not be surprising since the concept of transformation—men into animals, animals into men, and animals into animals—permeates all aspects of life in the Bering Strait and is expressed on all kinds of objects. No doubt this deceptive "tattoo foil" subverted the attention of the foe and safeguarded the hunter from malicious attack.

Tattoo foils were not only confined to labret-like tattoos. Instead, men and women were variably tattooed on each upper arm and underneath the lip with circles, half-circles, or with cruciform elements at both corners of the mouth to disguise the wearers from disease-bearing spirits. Paul Silook explained: "[y]ou know some families have the same kind of sickness that contin-ues, and people believed that these marks should be put on a child so the spirits might think he is a different person, a person that is not from that family. In this way people tried to cut off trouble."

The multiplicity of "guardian" forms and the various tattoo motifs related to them suggests, in all probability, that specific tattoo "remedies" were believed to differ from individual to individual, or more appropriately, from family to family. An account from a Chaplino Yupiget [Indian Point] visiting Gambell, St. Lawrence Island in 1940, reveals that this was the case, at least in mainland Siberia:

> I was the oldest child in my family. In trying to save my brothers and sisters my father ask[ed] some woman to have me tattooed. The woman had all kinds of prayer when she tattooed me. While [a] woman [is] tattooing a person, every stitch as she goes has something to say with. My father[,] trying to save me as best he can, he put leather bands around my wrist and forehead, with beads hanging down all over my eyes, and beads on each sole of [my] stocking, stitched through...to save his child from death. Also on every joint beads are stitched, and sometimes little bells on elbows. My father sewed little pieces of squirrel's kettle on the band around my shoulders and under [my] arm. Part of parents' idea to save children.

WOMEN'S FACIAL AND BODY TATTOOS

There seems to have been no widely distributed tattoo design among Eskimo women, although chin stripes (*tamlughun*) were more commonly found than any other. Chin stripes served multiple purposes in social contexts. Most notably, they were tattooed on the chin as part of the ritual of social maturity, a signal to men that a woman had reached puberty. Chin stripes also served to protect women during enemy raids. Traditionally, fighting among the Siberians and St. Lawrence Islanders took place in close quarters, namely in various forms of semi-subterranean dwellings called *nenglu*. Raiding parties usually attacked in the early morning hours, at or

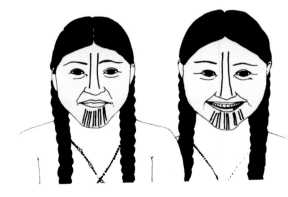

Florence Nupaaq's drawing of chin stripes. Gambell, 1929.

before first light, hoping to catch their enemies while asleep. Women, valued as important "commodities" during these times, were highly prized for their many abilities. Not being distinguish-able from the men by their clothing in the dim light of the *nenglu*, their chin stripes made them more recognizable as females and their lives would be spared. Once captured, however, they were bartered off as slaves.

More generally, the chin stripe aesthetic was important to the Diomede Islanders living in Bering

178

Strait. Ideally, thin lines tattooed onto the chin were valuable indicators for choosing a wife, according to anthropologist Sergei Bogojavlensky:

> It was believed that a girl who smiled and laughed too much would cause the lines to spread and get thick. A girl with a full set of lines on the chin, all of them thin, was considered to be a good prospect as a wife, for she was clearly serious and hard working.

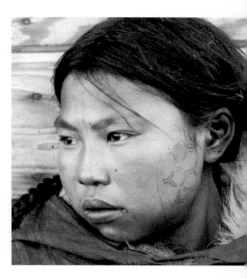

A full set of lines was not only a powerful physical statement of the ability to endure great pain but also an attestation to a woman's powers of "animal" attraction. In the St. Lawrence and Chaplino Yupik area of the early 20th century, women painted and tattooed their faces in ritual ceremonies in order to imitate, venerate, honor, and/or attract those animals that "will bring good fortune" to the family. Waldemar Bogoras noted, "[i]t is a mistake to think that women are weaker then men in hunting-pursuits," since as a man wanders in vain about the wilderness, searching, women "that sit by the lamp are really string, for they know how to call the game to the shore."

Left: Tattooed Chukchi woman with fertility tattoo on cheek and tattoo-foil near mouth, 1901.

Right: Veghaq or fluke tails, Indian Point, Siberia, 1901.

Bering Strait Eskimo myths tell that the spirit and life force of the whale is a young woman: "Her home is the inside of the whale, her burning lamp its heart. As the young woman moves in and out of the house doorway, so the giant creature breathes."

It seems that tattoos assured a kind of spiritual permanency: they lured into the house a part of the sea, and along with that, part of its animal and spiritual life. Not surprisingly, unusual events, such as the capture of a whale by a young woman's father, was commemorated on her cheek(s) by fluke tails, which advertised her father's prowess to members of Asiatic Eskimo society.

Slightly sloping parallel lines, usually consisting of three tightly grouped bands on the face, were also tattooed on women. Bogoras mentioned that childless Chukchi women "tattoo on both cheeks three equidistant lines running all the way around. This is considered one of the charms against sterility." There is a similar belief related in the story of *Ayngaangaawen*, a woman from the extinct St. Lawrence Island village of Kookoolok. *Ayngaangaawen* refused to get her tattoo marks. She could not bear healthy children, and as a result, they all died as infants. Supposedly, "when she got some marks she had children" and they lived into adulthood.

Other tattoos from the same region are not so easy to decipher. For example, two slightly diverging lines ran from high up on the forehead down over the full length of the nose. These tattoos were quite often the first ones to be placed upon pre-pubescent girls (6-10 years of age). Daniel S. Neuman, a doctor living in Nome, Alaska, wrote in 1917 that these tattoos (*atngaghun*) distin-guished a woman "in after life from a man, on account of the similarity of [their] dress." Chukchi myths illustrate that these tattoos were the symbol *par excellence* of the woman herself. Tattoos also marked the thighs of young St. Lawrence Island women when they reached puberty. In Igloolik, Canada, some 2,500 miles east of St. Lawrence Island, the tattooing of women's thighs ensured that the first thing a newborn infant saw would be something of beauty. They also made labor much

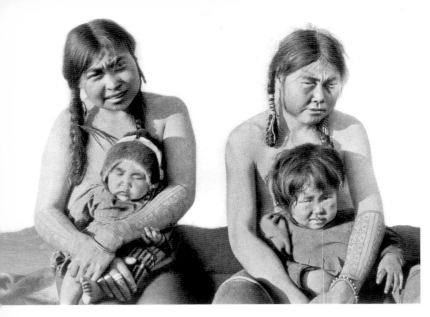

King Island women displaying iqalleq, arm tattoos, ca. 1900.

easier for the woman.

Intricate scrollwork found on the cheeks (*qilak*), and tattoos on the arms of women (*iqalleq*), possibly form elements of a genealogical puzzle. Most women of St. Lawrence Island say these tattoos are simply "make-up," beautifying their bodies. Dr. Neuman verified that this was the case in 1917, but he also believed that "[e]ach tribe adhered to their own design but with a slight modification for their own individual members. The designs on the hands and arms often combined tribal and family designs and formed, so to speak, a family tree." On the arms of one my female informants, rows of fluke tails extend from her wrists to the middle of her forearms. These symbols represent her clan (*Aymaramket*), an honored lineage of great whale hunters.

From the preceding remarks, it seems as though a woman's tattoo designs were individualistic. However, tattoos found on the back of the hand (*igaq*) were not. These motifs seem to mark the identities of individuals belonging to a cohort. For example, the women that retain *igaq* (two are shown below) have identical tattoo patterns and it is these women that were the last age group to be tattooed on St. Lawrence Island ca. 1920.

MEDICINAL FUNCTION OF TATTOOS

In the previous sections, the apotropaic aspect of tattoo has been discussed, specifically as a remedy against supernatural possession. In the light of indigenous theory of disease causation—evil spirits—it is not surprising that tattoo was considered as a form of medicine against a variety of ills. This medicine was believed to act as a preventive or as a curative one.

Paramount to these concepts was the role of the preventive function. Circumpolar peoples were socialized and trained from their earliest days to build their bodies into pillars of strength through running, calisthenics, weightlifting, wading into frigid waters, etc. Only when a biological disorder rose to life threatening levels, where "preventive" medicinal practice had failed the cure, it then became the responsibility of the shaman to summon his or her spiritual powers to safeguard and restore health. Disorders, as well as other inexplicable misfortunes, were attributed to supernatural agency and were believed to be remediable through the use of tattoo. Oftentimes, these types of medicinal tattoos were applied by shamans, though not always.

Tattoo, as a curative agent, was often disorder-specific. Some maladies were cured with the application of small lines or marks on or near afflicted areas. Some examples from St. Lawrence Island are as follows:

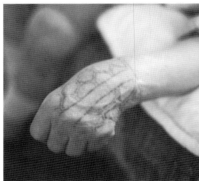

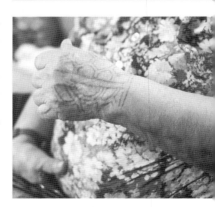

St. Lawrence Island igaq.

1. A mark over the sternum, which is the shaman's cure for heart trouble.
2. A small straight mark over each eye, the cure for eye trouble.
3. Various other small marks on the body used as remedies from time to time by the shaman.

Thus, two small lines placed near the eye of a man from St. Lawrence Island observed by Edward

Nelson in the 1890's represented one of these types of medicinal marking. In the Bering Strait area, the ethnologist George B. Gordon observed a Diomede Island man with tattooed marks on either cheek, close to the mouth, another on the temple and two more on the forehead. These three sets of marks on his face were explained as "medicine" and their presence was said to have directly affected the welfare of the possessor.

Bering Strait medicinal tattoos.

In northwest Alaska, traditional practices of tattoo and ritually induced bleeding were often related and may have even overlapped to some extent. Around Bering Strait, shamans commonly performed bloodletting to relieve aching or inflamed parts of the body. Nelson watched a shaman "lancing the scalp of his little girl's head, the long, thin iron point of the instrument being thrust twelve to fifteen times between the scalp and skull." Similarly, the Alaskan Aleuts performed bloodletting as remedies for numerous ailments attributed to "bad blood." On St. Lawrence Island, bleeding was resorted to in cases of severe migraine headache or, as one St. Lawrence Islander has said, "to release anything with a high blood pressure...the [ancestors] kn[e]w that." The Chugach Eskimo treated sore eyes by bleeding at the root of the nose or at the temples. Then, the patient was made to swallow the blood, which affected the cure.

It is plausible that the release of blood functioned to appease various ills and spiritual manifestations. For instance, several St. Lawrence Islanders explained to me the importance of licking the blood that was released during tattoo "operations." The female tattoo artist, who performed the skin-stitching, licked the blood sometimes, "because that helps, to a, for them to have a good sight." Evidently, bad blood released from the tattoo rite acted as a supplementary healing agent remedying specific ailments. Reliance on this expedient might seem to have grown out of the impression that the expulsion of the evil spirit would be facilitated through the escaping stream of blood. Thus, by harnessing blood orally, and/or neutralizing it with saliva, the tattoo artist transformed it into a sanctifying substance.

TATTOO AS ACUPUNCTURE TOOL

The shaman's prophetic role in medicinal practice was closely paralleled by that of the Chinese acupuncturist. Both were consulted to identify the causes of a disease, by differentiation of symptoms and signs, to provide suitable treatments. In acupuncture, pathogenic forces are thought to invade the human body from the exterior via the mouth, nose or body surfaces and the resultant diseases are called exogenous disease. In circumpolar cultures, and especially on St. Lawrence Island, the primary factor determining sickness was the intrusion of an evil spirit from outside the body into one of the souls of the afflicted individual. These types of malevolent actions of the spirit upon the body were traced to disordered behavior, possession, illness, and ultimately death. Consequently, and as a form of spiritual/medicinal practice, St. Lawrence Islanders tattooed specific joints. As mentioned earlier, joints served as the vehicular "highways" which evil entities traveled to enter the human body and injure it. Thus, joint-tattoos protected individuals by closing these pathways, since the substances utilized to produce tattoo pigment—urine, soot, seal-oil, and sometimes graphite— were the nexus of dynamic and apotropaic power, preventing an evil spirit from penetrating the human body. In both Chinese acupuncture theory and in St. Lawrence Island medicinal theory, it is believed that all ailments of the body, whether internal or external, are

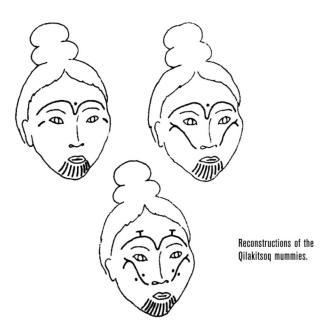

Reconstructions of the Qilakitsoq mummies.

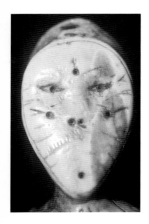

Left: Old Bering Sea/Okvik culture doll-head with tattoo-puncture.

Right: Punuk culture doll-head with tattoo-puncture.

reflected at specific points either on the surface of the skin or just beneath it. In acupuncture, many of these points occur at the articulation of major joints and lie along specific pathways called meridians. Meridians connect the internal organs with specific points that are located either on or in the epidermis, often in close proximity to nerves and blood vessels. Evoking the Chinese acupuncturists' yin/yang cosmology, the body is in a perpetual state of dynamic equilibrium, oscillating between the poles of masculine and feminine, man and animal, sickness and health. Thus, relieving excess pressure at these points enables the body to regain its former state of homeostasis (harmony) within and outside of the body. As one can imagine, it is believed that there are many possible interrelationships and connections between organs, points, joints, and tattoos.

Analysis of traditional St. Lawrence Island tattoo practices suggests that several tattooed areas on the body directly correspond to classical acupuncture points. In the recent past, these parallels were known to the St. Lawrence Islanders themselves. For example, one woman explained to me that one of the areas tattoos were placed upon coincides with the acupuncture point *Yang Pai*—utilized to remedy frontal headache and pain in the eye.

> Grandparents, when they were pricking that [point when they] hurt from headache,
> when [they] thought that [the] eyes are bothering you...they use, a, acupuncture.

Of course, this type of remedy is quite ancient. The earliest known reference to acupuncture analgesia of this kind is in a legend about Hua To (A.D. 110-207), the first-known Chinese surgeon, who used acupuncture for headache.

The Aleuts, as well as the ancient Chinese and St. Lawrence Islanders, utilized acupuncture in medicinal therapy. Acupuncture was resorted to in cases of headache, eye disorders, colic, and lumbago. Like the St. Lawrence Islanders, the Aleuts "tattoo-punctured" to relieve aching joints. The anthropologist Margaret Lantis observed that Aleut Atka Islanders, "moistened thread covered with gunpowder (probably soot in former times) sew[ing] through the pinched-up skin near an aching joint or across the back over the region of a pain."

Apparently, the use of this potent medical technology was not confined to the North Pacific Rim, since it also reached Greenland in the distant past. Radiocarbon dated to the 15th century A.D., the mummies of Qilakitsoq have revealed that a conscious, exacting attempt was made to place dot-motif tattoos at important facial loci. Being that these dot-motif tattoos are suggestive of acupuncture points, and coupled with the fact that each actually designates a classical acupuncture point, cultural affinity must be suggested. Besides, Danish ethnologist Gustav Holm reported in 1914 that East Greenlanders "now and then...resort to tattooing in cases of sickness." Although we are not entirely sure if Holm was specifically referring to "tattoo-puncture" in his statement, two intriguing 1,500 year old "doll-heads" excavated from St. Lawrence Island illustrate ancient continuity spanning thousand of miles and hundreds of years.

In the early 1970's beach erosion exposed the heavily tattooed, mummified body of an Old Bering Sea/Okvik

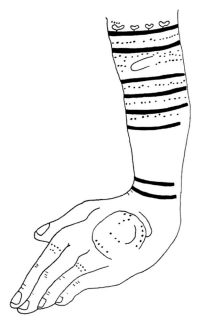

Kialegak mummy's forearm tattoo.

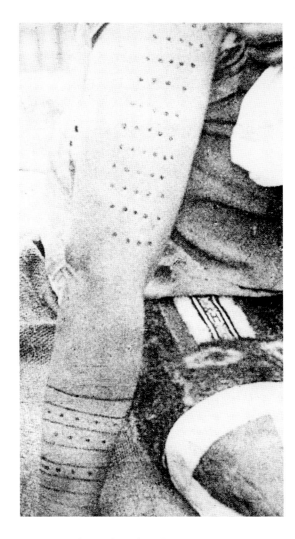

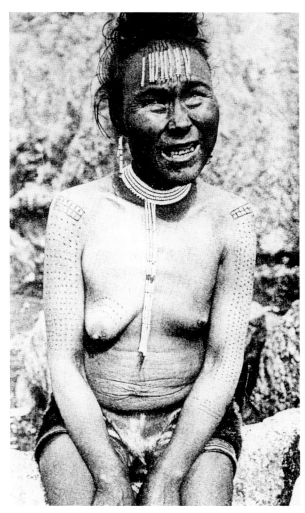

woman radio-carbon dated to 1600 years ago corrected at A.D. 390-370 (90 years) at Cape Kialegak, St. Lawrence Island. Her forearm tattoos were very reminiscent of those seen in late 19th century photographs of East Greenlanders at Ammassalik. Other Ammassalimniut women displayed breast and arm tattoos similar to engraved female ivory figurines from the Punuk culture of St. Lawrence Island, suggesting that these practices persisted remarkably over the centuries. Therefore, it seems that the related styles of unilateral tattooing of the breast and the bilateral marking of the upper arms stress cultural unity for the Eskimo area as a whole and, more specifically, of material culture from Greenland to the ancient cultures of St. Lawrence Island.

"OETZI" AND THE PAZYRYK "CHIEF"

In 1991, an alpine "Iceman" some 5,500 years old was discovered in the Tyrolean Alps. The Iceman "Oetzi" is the oldest known human to have tattoos preserved upon his mummified skin. His tattoos, according to Conrad Spindler, were located as follows:

> Four groups of lines to the left of the lumbar spine; one group of lines to the right of the lumbar spine; a cruciform mark on the inside of the right knee; three groups of lines on the left calf; a small cruciform mark to the left of the left Achilles tendon; a

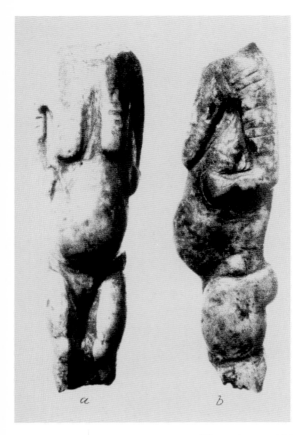

Ivory figurine from the Punuk culture displaying breast and arm tattoos.

group of lines on the back of the right foot; a group of lines next to the right outer ankle; a group of lines above the right inner ankle.

The precise location of these groupings attests to the exact location of major joint articulations in these areas. These groupings, coupled with the fact that 80% of the tattoo locations correspond to classical acupuncture points, combine to form the most common acupuncture convention for treating rheumatic illness. Thus, when X-ray analyses of Oetzi's body were performed, they revealed that he had considerable arthritis in the neck, lower back and right hip as well as a chronic arthritic condition in one of his little toes, probably due to severe frostbite. Therefore, it can be hypothesized that these results of degeneration, and the bluish tattoos associated with them, most certainly had the purpose of relieving pain in the joints—a folk remedy utilized in the Alps today.

However, when these results are coupled with a reconstruction of a male mummy from the Altaian Pazyryk culture of the Russian steppes, excavated by archaeologist Sergei Rudenko in 1947-48, tattoo similarities become more compelling. This Pazyryk "chief" had dot-shaped tattoos on either side of the lumbar spine and on the right ankle, almost in the exact regions as that of the Iceman. Rudenko stated:

"Tattooing could be done either by stitching or by pricking in order to introduce a black colouring substance, probably soot, under the skin. The method of pricking is more likely than sewing, although the Altaians of this time had very fine needles and thread with which to have executed this..."

Not only did Pazyryk tattooing coincide with that of the Iceman in placement and function, it relates directly to the tattooing of St. Lawrence Island. First, the tattoo methods (pricking and sewing) practiced by the ancient Pazyryk tattooist were the same as those on St. Lawrence Island. Second, the raw materials are essentially the same: soot, fine needles, and sinew. Third, and although Pazyryk tattoos are not linear like Oetzi's, they occur in the dot-motif—exactly the same as on St. Lawrence Island. Fourth, the placement of the Pazyryk chief's tattoos are in the same general region as those applied during funeral ceremonies and first-kill observations on St. Lawrence Island: on the lower back or waist and at the ankle joint.

When the therapeutic indications associated with Chinese acupuncture and St. Lawrence Island joint-tattoos are reviewed, then combined with comments on Aleut acupuncture, the Qilakitsoq mummies, Oetzi and the Pazyryk Chief, there is no doubt that the "tattoo-puncture" of the Aleuts, the ancient Greenlanders, the tattooing of the Iceman, the Pazyryk Chief, St. Lawrence Island pallbearers and first-kill participants provide striking parallels, the only variation

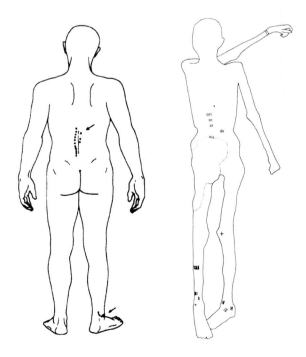

Left: The Pazyryk "Chief."
Right: The Iceman. (see also pg. 11)

being the numbers, aesthetics, and types of joint-tattoos. But do these apparent similarities relay more information than meets the eye? Obviously, all the marked evidence suggests that elements of Far-East Asian and surrounding regional cultures were likely sources of early influence upon early Bering Strait cultures, who, in turn, filtered these traits across the Arctic into Greenland. Therefore, it seems probable that each example of joint-tattooing may have been a sort of pan-human phenomenon, or better perhaps a pan-Eurasian one, encompassing the ages. Alternatively, this supposition could also suggest independent development of tattoo concepts and associative curative practices.

CONCLUSION

Regardless of the medical implications of tattoo and its origins, it is apparent that the practice of tattooing among Arctic peoples was quite homogenous. Considering the vast expanse of this culture area, the largest in the world, this may seem surprising. However, as a people unified by environment, language, custom, and belief, the distinction is quite clear: as tattoo became part of the skin, the body became a part of Arctic culture. Tattooing was a graphic image of social beliefs and values expressing the many ways in which Arctic peoples attempted to control their bodies, lives, and experiences. Tattoos provided a nexus between individual and communally defined forces that shaped perceptions of existence.

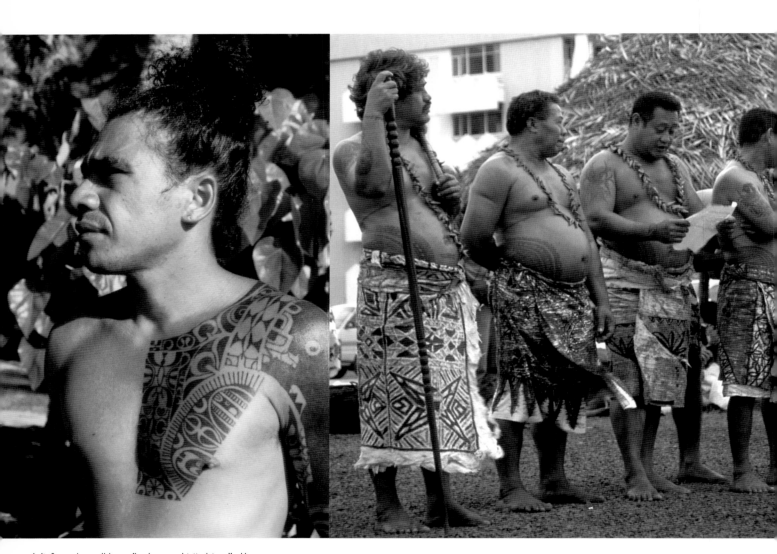

Left: George is a well known fire-dancer and tattooist on Huahine in the outer Society Islands. He was tattooed in the Marquesas on the island of Tahuata by Fati Fi'i. His tattoo is in the half-body style popular in the Marquesas in the later half of the 17th century.

Right: Samoa is the only place in Polynesia that has enjoyed a continuous history of tattooing. Here the traditional techniques are still practiced today. Matai or chiefs wear the pe'a or tattoo from the waist extending just below the knees, as well as the traditional tapa cloth lavalava or wrap-garment.

POLYNESIA TODAY

Steve Gilbert: I didn't know anything about a tattoo revival in Polynesia until I began corresponding with you. I thought the missionaries had stamped out tattooing in the 19th century. I, like a lot of people, thought they had put a stop to it everywhere because that's what you read in the histories of tattooing. So tell me in general what's going on in Polynesia today?

Tricia Allen: There is a revival of all of the ancient arts: tattooing, tapa making, weaving, carving, dance, chanting and firewalking. There is a whole resurgence of Polynesian culture, and tattooing is just a part of that. In my mind it is one of the most significant parts of the revival because it's such a permanent statement: "I'm Polynesian." And to some degree in many cases it is a political statement, or a statement of allegiance to the traditional culture.

SG: How and when did this revival get started?

TA: It varies quite a bit from island group to island group. In most cases it's been within the last 20 years. In Tahiti it was 1981. There was a nightclub that featured a Polynesian Revue in Waikiki. The owner left Hawai'i in about 1980 and traveled to Samoa, where he was partially tattooed. Then he took the Samoan tufuga or tattooist back to Tahiti, where they demonstrated tattooing in the Bastille Day Festival. In Tahiti, Bastille Day is a month-long festival. It includes traditional arts, dance competitions, and so on. So it was through watching these Samoans work that the Tahitians got inspired to recreate a tattoo form of their own. And at first they started with traditional tools based on the Samoan tools but in 1986 the French Ministry of Health banned tattooing with traditional tools in French Polynesia. That's when they started using the machines which they make from electric razors that they're using today.

SG: Why did the Ministry of Health ban tattooing?

TA: Because of health risks. The porous materials (bone and wood) that the tools are made from cannot be easily sterilized.

SG: Did they demonstrate that tattooing had transmitted disease?

TA: Not to my knowledge. It's just because it's such a likely means of transmission.

SG: If they banned it with traditional tools, why do they think it's safer with machines?

TA: Because the needles are disposable, it probably is safer. If adequate precautions were taken with the traditional style tools, such as carving a new set of tools for each tattoo, it would be safe. This would be terribly time consuming, as the tools are not quick or easy to make. Other precautions like soaking the tools in bleach before each use would certainly help. But this would be difficult to regulate, so the Ministry of Health just banned it altogether.

SG: But the tubes aren't disposable, and if they don't sterilize them...

TA: Right. But they don't use tubes. In Tahiti most tattooists are using a machine that they have created from an electric shaver or razor. They just attach the needles to a wooden matchstick and attach that to the head of the razor. It's not an elaborate rotary type razor; it's the old basic type where the head just goes back and forth. You could pull the head off and pull the section off the head of the razor that has the blades in it and then just attach a wooden matchstick that has the sewing needle tied on to it.

SG: How is the ink held onto the needle?

TA: They use a sewing thread and wrap the length of the needle tightly to within an eighth of an inch of the point.

SG: Can they do shading with that?



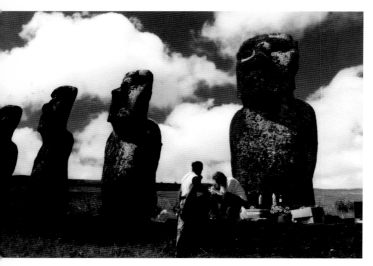

Tricia Allen tattooing Pascual Pakarati under the shade of a moai (statue) at Ahu Akivi on Rapa Nui (Easter Island) in 1992.

TA: No. There are only a few tattooists that I know of down there who are doing shading at all. Most strictly do traditional style designs that are composed of the big black areas without shading. If you're referring to this, they are able to do big fill-work pretty well, but would have a hard time with grey work.

SG: How about the big areas of solid black? Does it result in scarring?

TA: It's pretty slow but they can do it. I've used their homemade machines quite a bit and let them try my machines. The problem I've found with their machines is that you get a lot of skin snag. I don't see many tattoos that are scarred, in Tahiti, that is. The Samoan method definitely can result in scarring. Most Samoan tattoos have a lot of scar tissue because they tend to go so deep. And there's a lot more blurring of the lines. But with the Tahitian homemade machines they are doing really good clean work.

SG: So back to the history. They started using machines in Tahiti about 1987—then what happened?

TA: By 1987, when they banned traditional tattooing, there were quite a few Tahitians who had gotten involved in the revival. At least five or six were tattooing regularly, doing very good work, and doing what research they could considering the limited resources available to them. And it really took off.

SG: Why?

TA: Well, Teve, who was the first completely tattooed Tahitian, is a professional dancer. His full body suit was completed in 1982. And he was really successful. He was in all sorts of advertisements: television, beer commercials, posters, post cards, calendars, and all of the hotels wanted him, either as a door man or in the dance shows. And so in part due to his success, other dancers and other people were inspired to do large tattoos. It's probably equally or even more influenced by the whole political and social climate. Tahitians are seventy percent of the population of the Society Islands (Tahiti and her Isles), and in many cases they very much resent the French presence.

Teve is still working as a dancer. Lately he has been traveling Europe doing dance demonstrations and performances for a tourist establishment called Tiki Village Theater.

SG: So he made a career of being an authentic tattooed man? And did other people try to do the same thing?

TA: Yes, there are several others who wear full body suits. There are hundreds, if not thousands, of people walking around on the island of Tahiti with a full arm or a full leg tattoo. In 1993 I sat downtown by the post office where there's a nice park one day and counted 150 major tattoos go by in about 5 hours: either a full arm or a full leg piece.

SG: What kinds of designs are they?

TA: Most of these are Marquesan designs. There are fewer than 20 known illustrations of authentic ancient Tahitian tattoos. The arts in general in Tahiti were not highly decorative as they were elsewhere. So today they are borrowing tattoo designs from the Marquesas, where the art was very well documented.

SG: Where do they find pictures of Marquesan designs?

TA: Most tattooists have photocopies of pages from the book by Karl von den Steinen [*Die Marquesaner und ihre Kunst*, Berlin: D. Remier, 1928]. Very few have the full text and they don't read German. So they don't necessarily understand or know the meanings of the designs. Although a few do, as the Marquesan motif names are included, and the names of some patterns are still known by some Marquesans. Those that were involved in the early revival in Tahiti (Tavana, Chime, Raymond and Porutu) know their stuff. But most have just adopted the Marquesan style as their own style and

call it "Maohi."

SG: What about the Willowdean Handy Book [*Tattooing in the Marquesas*, Honolulu: The Bishop Museum. 1922]? Do they have that?

TA: Some do, but again, just little bits and pieces.

SG: Why wouldn't they have the whole book?

TA: These books are rare, even in the better libraries here, but they are very rare in Tahiti. They simply can't get such sources. In fact, I don't own either of these two books, but rather I have photocopies from our library. If one of them gets copies of a few pages, they will usually make copies and give it to their friends. And material gets spread around this way pretty quickly!

Sometimes the fact that they only have such limited access to these early sources causes some major misinterpretations. One of the funniest situations happened on one of the outer Society or Tahitian islands. Willowdean Handy, who wrote the book *Tattooing in the Marquesas*, the Bishop Museum publication, in 1922, also wrote a French book, *The Art of the Marquesas* that was published in 1935. In this French book are 20 to 30 pages of motifs that are lettered "a", "b", "c" on through the alphabet, and then when there are more than 26 motifs to a page, "aa", "bb", "cc" and the pages or plates are numbered one, two, three and so on. Now a young Tahitian tattooist had a photocopy of one of these pages and somehow mistook this to be an ancient Tahitian alphabet. He would ask the name of his customer and then look at the letters and then find the corresponding design elements and incorporate these into a band or a tattoo so that it spelled out the person's name. What was really amusing to me was my reactions. My first thought was "what about Q's, and other letters that the Polynesian language doesn't use"? As there are only about 12 letters that most Polynesian languages utilize. My next thought was: "this isn't Tahitian at all, it's Marquesan." It was a minute or so later that I realized the most important point of all, that Polynesian languages were not written. The idea of a Tahitian alphabet is absurd! Anyway, I kept my thoughts to myself. I told the tattoo artist that I had the whole book that his page came from, and I would bring it to him. I spent 15 hours on the inter-island freighter going back to the main island, paid fifty cents a page to photocopy the entire book and went clear back out to Bora Bora again, about 300 miles, just to give him the full text, thinking that maybe he would then see for himself what this was. That it isn't a Tahitian alphabet, it was just the author's way of categorizing and discussing the motifs. So I took him the book and he said "Oh, good, there are many pages. I can split it up among my two brothers who are also tattooists." I said, "No you don't." and I showed him how it worked. The book is in French which he does read. So I told him he should keep all these pages together and loan your brothers the entire set. But I realized shortly after and, again, 300 miles away back on Tahiti, when I met a girl on the street who had a beautiful tattoo, and I stopped her and asked her, in Tahitian, "Who made that? That's very nice." She proudly said, "It's my name in ancient Tahitian." And I realized then that of course it is! If that's what it meant to her, who are we to say that it isn't?

Anyway, most tattooists have a collection of photocopied pages from various sources. Although there is some rivalry between tattooists there, they do tend to share their sources, at least with a friend or two, who with share it with their friends, and so on. My first time in Tahiti in 1991 I had taken a bunch of *Tattootime* magazines [published by Don Ed Hardy] and gave them to maybe eight or ten tattooists, and the next time I was there about a year and a half later it was really amazing to see how widely photocopies of those had been distributed. I would be on an island three hundred miles away and the guys would pull out their drawings or their portfolios and they would have photocopies from *Tattootime*. And *Tattootime* you certainly don't find down in Tahiti.

SG: Why not?

TA: They're not available for sale. Neither are tattoo magazines.

SG: Couldn't people order them?

TA: Sure, they could order them, but for many of these guys it's just not in the Polynesian or Tahitian way of thinking to do something like mail order away for a magazine. If it can't be gotten locally, in

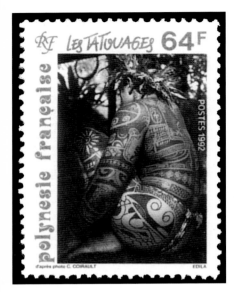

Tattooing has become so popular and accepted in French Polynesia (Tahiti and the Marquesas) that tattooed individuals have been featured on a series of postage stamps.

their minds it's something unobtainable. For example, some that have traveled to the States went to tattoo shops and asked to buy equipment. They thought that tattoo shops in America would sell tattoo machines. And they were quite surprised to find that they couldn't buy them in shops. You have to mail order.

SG: And so then did the tattoo revival spread from Tahiti to the other islands?

TA: Today there's a lot of inter-island contact and travel between Tahiti and the Marquesas because they're both part of French Polynesia. The only TV stations are in Tahiti. So in the Marquesas you get Tahitian news, which they give both in French and Tahitian. In order to finish a high school degree until fairly recently one had to travel to Tahiti. Tahitians and Marquesans—all French Polynesians—do a mandatory two years of military service. Usually they are sent to Tahiti for their military service. Also there are a fair number of Marquesans living in Tahiti that migrated a generation or two ago. A few of the Marquesans living in Tahiti really developed an interest in tattooing early on. So it was, in part, the Tahitian influence that to some degree started the Marquesan revivial.

SG: What year did the Marquesan revival start?

TA: Within a couple of years of the revived interest in Tahiti, the mid-eighties.

SG: And what's the population of Tahiti?

TA: 80,000 in the early 1990's. I don't know an exact figure today.

SG: How many tattoo artists are working in Tahiti, and how many in the Marquesas?

TA: In 1993, I compiled a list of three hundred on the main island of Tahiti. Most of those three hundred are what you'd call scratchers. They're not all serious tattooists. There are maybe about 20 who are doing really good high quality work on the main island. In the Marquesas there are about eight to ten that I would call top-notch semi-professional tattooists. Probably an overall count would be 25 to 30 in the Marquesas. The population of the Marquesas is significantly smaller than that of Tahiti.

SG: What about tattooing in Samoa? How is it different from the other islands?

TA: Samoa is the only place that has a continuous history of tattooing from ancient to modern times. In Samoa, the government never banned tattooing. The missionaries tried to discourage it, but they couldn't ban it. There are certain Samoans today who think that it shouldn't be done. Samoa is extremely Christian, and they are quite strict in some ways. That isn't the case in the Marquesas or Tahiti.

SG: It seems ironic that they have this heavy Christian tradition and yet they continued to tattoo.

TA: Right. And they still continue to drink kava or ava-ava. There are some very weird contradictions and dichotomies within Samoan culture.

SG: Are the Samoans still using the traditional hand tools for tattooing?

TA: Yes. There are some that are using homemade machines. Near a fruit market there is a little stand or booth where someone is doing machine tattoos: Samoan style, but mostly armbands using a homemade machine. I only know of two tattooists in Samoa that has professional machines: Petelo Suluape and another named Watti.

SG: So what about the designs? Do they tattoo traditional Samoan designs?

TA: For the most part now they're only doing traditional designs. There was a period when a lot of Samoans were getting western style tattoos. Many of them were either in the merchant marine or in the military. They didn't get the tattoos in Samoa, but when they traveled to other countries. And there are some amateurs in Samoa who have done some very poor quality imitations of American style tattoo designs. But primarily what you see today is traditional Samoan designs.

SG: Is that related to an interest in Samoan history and traditional culture?

TA: Sure, the Samoan tattoo is still a mark of respect for the ancient culture and has a real depth of meaning and symbolism. Perhaps though, it is less politically motivated than in places where there is a strong colonial (or post-colonial) presence, like Tahiti, the Marquesas, Hawai'i and New Zealand.

SG: What's going on in New Zealand today?

TA: New Zealand has a really strong revival. Like elsewhere in the Pacific, the tattooing that was done continuously was western or American style, so that kept tattooing alive as part of the subculture. But I think it was largely through the efforts of Roger Ingerton in the 1970's and '80's that the Maori people got a renewed interest in the traditional designs. Roger still tattoos there, but it was his early work that was so instrumental in the Maori revival. Roger is a Westerner, but the Maori community respects him. He started tattooing a lot of Maori with traditional designs. He was probably the first tattoo artist in 150 years to do a facial moko on a Maori person. Roger's work was perhaps the springboard for the renaissance of Maori tattoo. But that wouldn't have happened if it weren't for this whole resurgence of the indigenous culture: the language, indigenous rights, to some degree the sovereignty and independence movements, the fight to get traditional land back. So you can't really isolate it. It wasn't solely Roger's presence that's responsible. But the Maori people were really ready for a change. Many Maori artists have since learned to tattoo. There are today maybe a dozen doing ancestral moko, that is, ancient genealogical tattoo designs.

SG: Are there Maori women with traditional chin tattoos?

TA: There are. There have been quite a few done in the last two decades.

SG: How many facial mokos would you say are walking around in New Zealand?

TA: I couldn't say. I do know that Roger had done two or three women by about 1992, and there have been probably dozens done by Maori artists since then.

SG: How about full facial tattoos on men?

TA: Yes, men's facial moko is also being revived, but I see two things happening. There are two revivals happening and they are very different: the gang thing, and then there is the more traditional Maori movement. There are gangs in Auckland in the more urban areas that are doing facial tattoos as their gang symbol. But there are also—and again, this is a different phenomenon in a different group of people—there are some Maori largely in the north island who certainly aren't affiliated with the gangs, like the type of gangs that were portrayed in the movie "Once Were Warriors". That movie is not very representative of the Maori community. Many Maori are well grounded, balanced people who are successfully merging their ancient cultural values with their modern lifestyles. For example, many Maori people are involved with the revival of the language and getting it taught in schools. In New Zealand there are language immersion schools where the kids are learning only in Maori, learning Maori history. These Maori wear moko as a true mark of respect for their roots.

SG: You traveled to Rapa Nui (Easter Island) several times. What's happening there in the way of tattooing?

TA: When I first arrived there in 1991, according to our estimates, about one in five of every Rapa Nui men between the ages of 15 and 25 wore a tattoo, but all of it was hand-poked single-needle stuff, done with a sewing needle tied to a match stick. Very few of them were traditional, or even Rapa Nui designs. Most were initials and western symbols, although a few bore tattoos with designs that were used in ancient times on the island. These are not necessarily traditional tattoo designs, but rather, the designs are based largely on the old rock art and wooden carvings. The type of tattoos that were done in ancient times on Rapa Nui was full body. There were no motifs that could be isolated and incorporated into a band or on a shoulder. So modern Rapa Nui people have turned to the rock art and other sources.

SG: Really? They had full body tattoos on Rapa Nui?

TA: Yes. We know that from the old illustrations. The women sometimes had tattoos on their lower backs. But again, not the type of thing you could incorporate into a smaller piece.

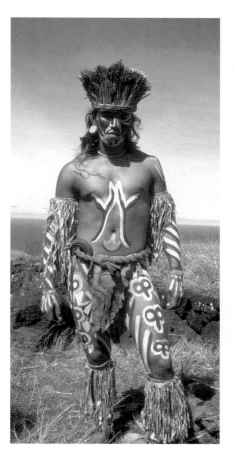

For festivals and performances today, Easter Islanders paint the patterns that once would have been tattooed.

SG: When I saw the movie "Rapa Nui" there were lots of tattoos. How authentic were those designs?

TA: Not terribly, although about half way through the filming there were two strikes that involved the Rapa Nui people. What they really wanted was just more say. They were really resentful over the fact that Maori actors and other westerners were brought in to portray their people, and that their history was distorted. There were also some real problems with the working conditions. Anyway, during one of the strikes, they were told that they could do their own body painting. And from that point on it was a little bit more authentic.

SG: How many records of authentic ancient Rapa Nui tattoo designs are there?

TA: I'm just going to guess between 20 and 25. These are old drawings, predating the demise of tattooing. So we have a fairly good idea of what Rapa Nui tattoos looked like. We know nothing of what they meant.

SG: Tell me about your own work. Do you do tattoos yourself?

TA: Yes.

SG: How did you learn?

TA: Some friends or academics that had worked on Rapa Nui had come back to Honolulu and I had asked them if there was anyone tattooing there—anyone that had a real interest—and what sort of art was being done. And they gave me five names of artists, a schoolteacher and one librarian that had a real interest in tattoos. There were no tattooists there, but at least there were people with the interest. So I started to write to these people and sent them all a list of our bibliography—what we have in our libraries in Honolulu, because we do have one of the best collections in the Pacific. I wrote to them that if they didn't have any of those sources on the island, to let me know and I would see what I could do to send them photocopies or whatever. I got three letters back stating that they did have all of those books but islanders weren't allowed access to the museum or to the library.

It seemed outrageous and I didn't really believe it. It didn't really sink in until I got there much later and I was denied access. So, I had no intention of ever going there at this point, but I just started buying books about Rapa Nui and making photocopies to mail. Shortly after this I was told of a scientific research vessel that was going to Rapa Nui and they were looking for volunteers to work mapping seafloor spreading and stand watches on the ship in trade for travel. I wound up taking this volunteer position on board the ship. I worked 45 days at sea getting there. Because I did go by ship and not by plane, I didn't have the usual baggage restrictions. So I took down a big box of books to give to these artists.

Ed Hardy was living in Honolulu at the time, and we were getting together for lunch once in a while. When I found out I'd be going to Rapa Nui, I brought this stack of copies of the old Rapa Nui tattoos to show Ed. He was looking through them and he said, "Wouldn't it be fun to give them the real thing instead of a photocopy?" And I said, "Yeah."

So he taught a Tahitian friend, Eriki Marchand, and me to tattoo at my house, largely in preparation for my trip. Eriki had a strong interest in Marquesan art, as I do, particularly Marquesan tattooing. He's a professional dancer and a graphic artist and had done a lot of paint-on tattoos at the Polynesian Cultural Center. So Ed basically just helped us in setting up the machines and watched over our shoulders while we tattooed ourselves. I did several dozen tattoos on friends, sometimes with the benefit of Ed's critiquing my finished work, until I figured I was ready for Rapa Nui.

While I was on Rapa Nui, I met a dancer with a traditional dance group there who was really intrigued with tattoos and wanted one. His name was Pascal Pakarati. I did a full arm piece on him. And the more time I spent with him the more I realized he was really a good artist. When we were sitting in a restaurant, often he would be drawing on napkins or whatever was available. After about a week I asked him, "Do you want to learn to tattoo?" So I taught him and the local dentist, who had also expressed an interest in learning to tattoo. I thought if I taught Pascal to tattoo at the hospital, along with the dentist, that would give the local guys access to sterilization. I did the outline and then handed him the machine and he did the fill-in. He had been with me almost every time I had done a

tattoo. He was assisting me by setting up the machine, hooking me up to a car battery, watched me put in tubes, and all of this. Before I left the island we meet with a sculptor on the island, who is tattooed, and his wife who has done a lot of research on Rapa Nui tattooing. She was educated in Chile. They translated information on sterilization and disease transmission and sterilization, as I couldn't afford miscommunications in that area.

I've made two recent trips back to Rapa Nui in October 1998 and in February of 2000 and was pleased to find that there are now three tattooists working there. Pascal Pakarati is still tattooing, although he is even busier with his dance troupe. On of his cousins, André (Panda) Pakarati returned from studying in Chile a few years ago and is now a dedicated, serious tattooist. And another professional dancer, who goes by Tito, is doing top-notch work. It's great to see that the tattoo of Easter Island is once again thriving!

SG: Did you find that some of the Polynesians had a negative attitude about a western woman tattooing traditional designs?

TA: For the most part, no. I didn't get nearly as much static as I expected to have in Tahiti, because tattooing is an all-male occupation there, as it is in the Marquesas. No Polynesian woman had ever tattooed down there. With certain tattooists, there was at first a certain reluctance to let me photograph them. They've been taken advantage of so many times, particularly by photographers who go down, take their photo, make books, never send them copies, make promises they don't keep, that the Polynesian tattooists are pretty leery, and rightfully so. So in many cases, they were some- what hesitant at first and I had, to some degree, prove myself. Prove that I had some knowledge and respect for their culture, that my intentions were good, and that I follow through with my word. If I tell them that I'll send them something, then I do. It seems though, that there is always somebody who takes offence no matter what, in anything that you do. My first trip to Rapa Nui, there was one young man who didn't like what I was doing, but out of a population of 2500, that isn't bad. I tattooed 45 Rapa Nui people free, so there were lots who thought I was ok. I think anywhere you go, no matter what you do, there will be somebody who is offended, for whatever reason.

SG: So do you do a lot of work there?

TA: No, not really. I do more photographic work than tattooing. On my first few trips, my purpose was to document the tattoos that were being done by photographing them and I made a point to meet the tattooists. They were all totally intrigued and fascinated with seeing an American machine. They had never seen one before, let alone used one. I told them they could use my machine if they wanted, and they did. I did a lot of tattooing, but most often on tattooists or friends that might be housing me. So the local tattoo artists know that I'm not competition. I'm not there to work and make money. Now, I travel mostly to visit my friends and to bring supplies. I'm there to help them. I only tattoo tattooists, and a few dancers and friends. But I don't tattoo commercially. I go there to visit and to document the revival and to visit with my friends, who mostly happen to be tattooists.

SG: Do you find that speaking Tahitian helped in gaining access to the tattoo communities?

TA: Yes, it helped quite a bit. They're usually astounded that there's a white woman, blond and blue eyed, speaking some Tahitian.

SG: How do the tattooists there feel about westerners copying their designs?

TA: Often times, offended. In many cases the Islanders feel that their art should be reserved for them and not shared with the public. This is perhaps most common today among the Maori and is, in part, due to the fact that their tattoos are ancestral. Their attitude is more understandable when we realize that the Maori facial moko was as distinct as an individual's signature. In fact, when it came time to sign treatise and documents, the Maori would often draw their moko, as Maori was not a written language. These attitudes are less common elsewhere in the Pacific where tattoos did not have ancestral associations, but in many cases the islanders believe that outsiders should not be wearing their art unless the person has made a commitment or shown proper respect to that culture. This touches on issues of cultural copyright.

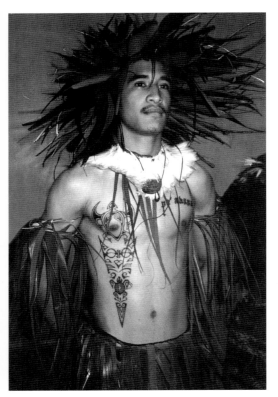

Kristofer (pa'ahana) Manaois is a Tahitian dancer residing in California. His tattoo is a modern neo-Marquesan design that represents himself, his parents and his son (tattoo by Tricia Allen).

In Tahiti and the Marquesas, many tattooists and many of those who are involved with various aspects of the culture feel it's ok for outsiders to wear their old designs if they change them, make some modifications, and make them their own. Their general rule of the thumb is: they won't put an old design, from one of the old illustrations, on someone that's not of the blood, or even someone that's of the blood, unless there's a real good reason for doing it—say if that person is heavily involved with language or culture, or with the arts organization, or one of those fighting to get language taught in the schools. They have a real commitment to the old culture and the old traditions. But most of them feel that we are modern people and we should be wearing more modern designs. They are often offended by some of the photos that appear in tattoo magazines that are direct lifts of the old Marquesan patterns. Many feel strongly that those who don't even know where the Marquesas are, for example, shouldn't be wearing a Marquesan tattoo.

SG: How long have you been traveling to the islands?

TA: I started on Rapa Nui in 1991, and since then I have made seven trips to Tahiti, five to the Marquesas, three to Rapa Nui and one to Samoa.

SG: Tell me about your academic research into authentic ancient Polynesian tattoo designs. What is the primary source material?

TA: What you really have to do is look at everything that was written by every explorer who visited Polynesia in the 18th and 19th centuries. And many of those aren't indexed. There is no table of contents. And so in most cases you have to read the whole book. And you might only find one sentence about tattooing. Most of these explorers had artists on board who were sketching their observations of plants and animals, and in many cases tattoos. But sometimes there are no illustrations, and only a sentence or two. But sometimes those are really critical key sentences. Sometimes they're not. The only way to find this stuff is to look through everything. All the ship's logs, all the published and unpublished journals of these early explorers.

SG: Did you do that?

TA: Yes. At least I've gotten through nearly all the material in collections in Hawai'i, at UCLA, and the Smithsonian. At least I'm off to a very good start. These journals were illustrated by artists or in some cases, someone else on board. Some of the captains enjoyed drawing. Some of the drawings are pretty accurate and others aren't. The other thing that happens is that these drawings get borrowed and copied by armchair anthropologists. So you might see a very similar drawing that was lifted and see it published 50 years later, which can really throw you off. Sometimes early publishers even took one drawing from one source and another drawing from another source and combined the two. In some cases the artist might have made the drawing from memory five years after the fact when they went back home, rather than drawing it on the spot.

SG: How long did you spend on this project of researching the original sources?

TA: I spent about three years researching for my master's thesis, going through these old ship's logs and books and various sources trying to locate all of these early illustrations and early references to tattooing.

SG: How many did you find?

TA: A lot. I found over two thousand illustrations that predate 1900. If they could be photocopied, if they are not rare books that could be damaged by putting them on a xerox machine, I made xerox copies. In the case of rare books they won't let you use a flash or photocopy, so you have to bring in a tripod or some sort of stand and photograph it fairly slowly with a cable release.

SG: I've heard something recently about tattoo conventions in Polynesia. Can you tell me more about these events?

TA: In October and November of 1999 there were tattoo conventions in both Samoa and Aoteraroa (New Zealand). The Samoan event was held in Apia, on Upolu, the main island of Western Samoa, and was attended by just under a hundred people. I know a little less about the event that took place in Aotearoa, although unfortunately shortly after the festival ended Paulo Suluape (perhaps the best technical Samoan tattooists ever) was brutally murdered.

At the end of April 2000 there is a big event being held on Raiatea, one of the outer Society Islands (not quite 300 miles from Tahiti) that I'll be somewhat involved in. It will take place at an ancient marae (ancient outdoor Polynesian temple platform) called Taputapuatea. It is not a competition, but rather a festival, and will feature tattooists from Samoa, the Marquesas, Rapa Nui, Aotearoa, the Society Islands, as well as Japan and Europe. Tentative plans are to hold the festival every two years, if all goes well.

SG: Tell me about your tours of the islands.

TA: In December of 1999 I led a group of nine tattooists and tattoo collectors to the Marquesas. We started off in Tahiti, visiting artists, fire dancers, knife dancers, tattooists and sculptors on the island of Moorea before we set sail. The ship is called the Aranui. It sails from Papette. It's a 16-day loop. The ship is a working ship. It's a copra cargo ship that was recently outfitted to have 60 first-class passenger cabins, and there are also dormitory type accommodations. There is a small swimming pool, a very nice lounge, and a bar on the ship as well. They primarily pick up copra, which is still the primary export and income of many of the Pacific island people, and they drop off supplies on almost all of the islands. We saw all of the inhabited islands in the Marquesas, and saw a lot of the valleys, because the terrain in the Marquesas is really rough. There are huge, beautiful rock formations all over the islands. But the terrain is so rugged that in many cases you can't get from one valley to the next unless you go by sea. We goy into each of these valleys where they have excursions, like four wheel jeeps, up to the big tikis, which are very similar to the Rapa Nui tikis only slightly smaller. They are usually placed on these big, beautiful outdoor paved temple-like platforms. We saw a lot of these old ancient sites, visited a lot of contemporary artists, watched things like tapa, or bark cloth making demonstrations, and visited tattooists. On the way back we stopped on Rangiroa where there is a glass bottom boat that took us shark-feeding and some of the most fantastic snorkeling and swimming anywhere. The Aranui crewmembers are nearly all Marquesan and are wonderful. There's enough time and opportunity to really get to know them. They're all heavily tattooed, and we all did a fair amount of tattooing as well. So it's really a lot of fun to meet the local tattoo community and to be on board ship with these guys, and to tattoo at sea.

SG: Will you be leading more tours?

TA: Yes. There is a link from my web page to announce future tours. There are also several articles there on the tattoo traditions of other Polynesian Islands.

<div align="center">Check out **http://www.tattootraditions.alohaworld.com**</div>

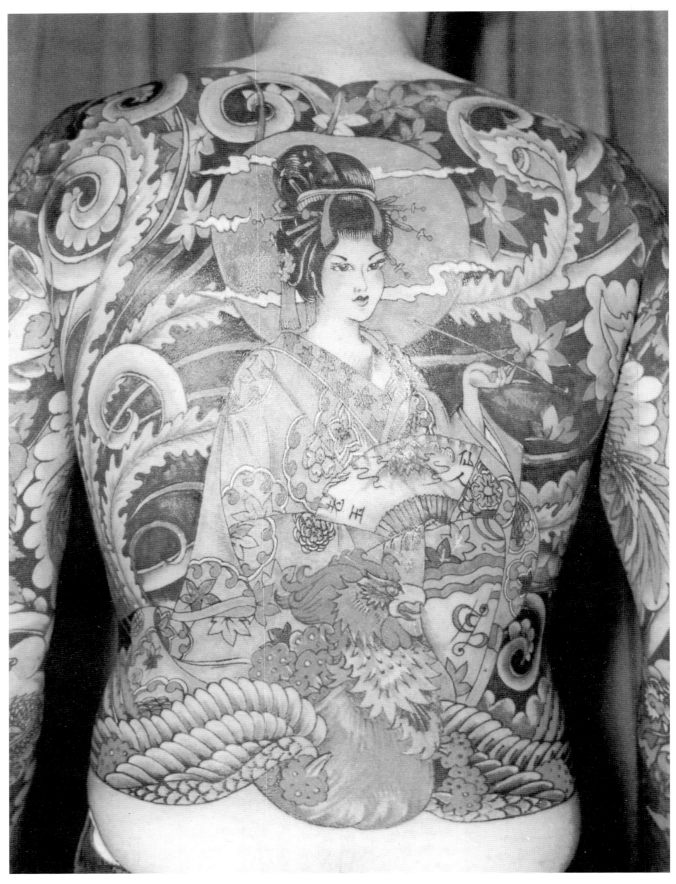

Sailor Jerry Collins: Moon Goddess (work in progress), 1972. (from *Tattootime* #1)

CURRENT EVENTS

I think the real breakthrough in the late sixties and early seventies began with Sailor Jerry. He was the Cezanne of modern tattooing. He was greatly influenced by Japanese and Asian art, and he was actually more partial to Chinese culture than Japanese. He tried to integrate that real exotic stuff with contemporary western styles and with a greater range of pigment, and in this way he expanded the repertoire of images he used for tattoo designs. That's what got me started. I got into tattooing because Phil Sparrow showed me a book of photographs of Japanese tattooing. So I think that the Japanese example was really responsible for what Arnold Rubin used to call "the tattoo renaissance," when Cliff Raven and Don Nolan and Mike Malone and I got into it. After I got the introduction to Kazuo Oguri through Sailor Jerry and went to Japan in 1973 with the fantasy that I would stay over there for several years and develop my tattooing and fit right into the culture.

But I found out that my fantasy and reality were quite different. After less than six months I came back to the States and soon after that I opened Realistic Studio in San Francisco. As far as I know it was the first studio in which a tattoo artist worked by appointment only and with the mandate that all work would be one-of-a-kind original designs developed in collaboration with the client instead of offering a set image bank into which the customer had to fit his or her psyche. And immediately I began getting a lot of other tattoo artists as clients because the tattoo community was still quite small then and the grapevine was pretty rapid and a lot of people had heard that I was in Japan and they were curious to see what I had gleaned from over there.

I already had a reputation before I left for doing big Japanese style work because I had been doing some of that in the San Diego shop in the late sixties and early seventies. So I started getting all these tattoo artists in and tattooing them and they would see the environment I was working in, which was a funky little office in the back of an office building. It was the complete opposite of the conventional high profile shop covered with neon signs in the middle of the honky-tonk district. It was attracting people through word of mouth who wanted to be there and who were curious about it and had some previous knowledge of, and interest in, tattooing.

One of my first clients for large piece was the London tattooist Dennis Cockell. He was originally going to go to Japan to get tattooed by me and missed out because I had left there, and he tracked me down in San Francisco and got this whole torso tattoo. After that I began getting people who were very serious about it and wanted epic work, and also a lot of people wanting just very strange one-of-a-kind designs. So the word got around that there was a studio where you could get a unique tattoo in a private environment, and it began to kind of catch on, and it escalated through a widespread adaptation of the Japanese look with tattoo artists, at first primarily in America and then some in Canada such as Dave Shore were interested in it, and then it began to spread to Europe. Cockell was pushing that Japanese look in his shop in London, and then there was George Bone who was an established London tattooist and was doing Asian style work.

The first tattoo convention was held in January of 1976 in Houston, Texas. Dave Yurkew, who was tattooing at that time in Houston, organized it and it turned out to be kind of a momentous event, because it was the first time there had ever been so many tattooers under one roof. The standard joke was that if you got all these tattooers in one room and then turned the lights out five minutes later you'd turn it on and see how many dead there were, because people seemed to be so at odds with each other in the business. But in fact, when they got together, both the artists and the fans realized that they had a lot in common and a lot of old grievances and mistrusts were washed away and people began sharing ideas. So I think the idea of organizing events where people can gather on neutral ground was tremendously important.

The National Tattoo Association had been formed right around that time by Crazy Eddie Funk and Terry Wrigley and a whole crew of old guard tattooers. There had been some tattoo clubs before. Les

BY DON ED HARDY

Don Ed Hardy is a graduate of the San Francisco Art Institute. Since the late sixties he has been the leading figure in the avant-garde of the American tattoo renaissance. Through his innovative work as a tattoo artist and his numerous publications he has done more than any other individual to create new directions in American tattooing.

Based on an interview taped in Williamstown, Massachusetts, in February, 1996.

Skuse had the Bristol Tattoo Club, and there used to be a club based in New York that was called the Tattoo Club of the United States in the sixties, and there had been some other small clubs. As a historic note, Chuck Eldridge turned up a newspaper article about a tattoo convention held somewhere in the south in Atlanta or Augusta, Georgia, in the 1880's. So this notion had been around but when the National Club held its first convention in Reno in 1977 it was really heavily attended. There was a great deal of interest and a lot of activity in tattooing.

Jack Rudy, 1981.
40's movie start Frances Farmer
before and after. (from *Tattootime* #4)

A lot of Europeans turned up and at that convention I met Good Time Charlie Cartwright and Jack Rudy, who were doing monochromatic single-needle photo-realist style tattooing with an image base that came from traditional Latino street culture and mimicked the kind of tattooing that's usually associated with jailhouse stuff. It had this very fine pointillist kind of look. There were portraits of loved ones and a lot of themes were street-related, with a very dark kind of beautiful Spanish feel to it. Mike Malone and Bob Roberts and I were all completely knocked out by it. This was the first kind of counterpoint to the Japanese tradition as another way to tattoo. We were very taken with the whole idea of the single needle style and all rushed to learn and to develop that.

There had of course been historic precedents. The earliest Japanese masters had done single-needle work by hand, and probably most of the earliest machine tattooing was single-needle outline. Certainly George Burchett and his British contemporaries all did single-needle work. At the most he may have used three-needle outlines. So this was a look that had been around probably 70 or 80 years earlier, but had not been much in use since.

In 1977 I went so far as to open a new tattoo shop in the Mission District of San Francisco, the original Tattoo City. Bob Roberts, who had been working with Cliff Raven, came up to work at Realistic with me, and I opened Tattoo City and we broke in Chuck Eldridge and Jamie Summers to tattoo there, and positioned it specifically as a street shop that would be in a mainstream heavily Latino part of town. My theory was that we would get to do a lot of that imagery if we were around the right kind of people who wanted it. I eventually bought Good Time Charlie's shop in East Lost Angeles. He and Jack Rudy had been running that shop but Charlie had a religious vision and decided he was going to get out of tattooing, and I bought the shop really to keep it going as a base of expression for that kind of work. I thought it was an incredible and really creative thing that was happening with it. So Jack managed that shop for me. We eventually had to move the location to a block down the street and we called it "Tattooland".

So it was all word-of-mouth among tattooers, because people were more in touch with each other by then. They traded business cards; they got on the phone; they began flying around visiting each other, and as a result a large part of my clientele consisted of other tattoo artists who had come from all parts of the US and even Australia and Europe, and then they would take these new ideas back to their respective areas. The number of tattoo artists was also increasing at that time. So into the very late seventies there was a pretty even mixture of explorations of this kind of fantasy art subject matter done with single-needle. A lot of it was based on science fiction illustrations by people like Virgil Finley, a famous illustrator of science fantasy stories in the 1940's. I actually discovered a book of Finley's illustrations and brought it in to show it to Jack Rudy and that opened a whole new door.

Mike Malone also had a great impact on disseminating awareness of modern tattooing by going over to Europe. He and Kandi Everett began living together in the late 70's and she inspired Malone to travel and they went to Europe where conditions then were really abysmal and behind the times. They met a lot of young German and Danish tattooers and got them hip to what was gong on in the US. So there was all this cross-fertilization of ideas. At the same time Cliff Raven had left Chicago and

moved out to tattoo in Hollywood. So by the late seventies the old main stream western tattoo tradition of hearts and anchors and stuff like that was only surviving at a low voltage in the shops that had determined to remain traditional, most of which were on the Eastern seaboard.

Also about that time more and more people started getting into tattooing, and of course as the case has always been there were a lot of fans who began putting on tattoos after they get a whole bunch of them, and they would go into business. Equipment was easier to obtain. Of course, tattoo supplies had always been available. The old time tattooers at the turn of the century would have on their business cards "supplier to the trade". Percy Waters and those guys would all sell machines and pigments, and then Wagner in New York City sold tons of stuff. Of course the official line was that they only sold it to other professionals, but in fact they sold it to anyone. I think most people who took it up seriously got into tattooing simply by becoming pests and wearing down the resistance of an established tattooer. That's how I got into it.

But information got disseminated faster as people got together at these conventions. Just the speed of modern communication had a lot to do with it. It was easier to get good cameras and take good photos of the tattoos that were to be seen at conventions. And by the early eighties the conventions had become a regular thing. There was one big convention each year in different cities and they became more and more heavily attended. But some others and I became kind of disillusioned. We wanted the convention to be more than just a chance to get together and get really whacked out and take as many drugs and drink as much as you could with friends that you only saw once a year. We thought we should have conventions where we focused on really informing people about tattooing.

In 1982 I was thinking of trying to produce a book on contemporary tattooing, and was trying to figure out how to get an agent in New York to front the book. So in my quest for an agent I met Ernie Carafa, who was a tattoo artist in New Jersey. In 1982 Carafa said he would finance a tattoo publication or magazine. I think that he wanted it to be a springboard for his supply business, which was not my intention at all. He said I could do whatever I wanted in the magazine, and we also cooked up the idea to do a tattoo convention that would do something very different from what people had seen up to that time. He and I and a San Francisco silk screen printer, Ed Nolte, a tattoo fan with whom I had done a lot of T-shirt design, collaborated to put together this tattoo show in the Los Angeles area.

I organized the whole liaison, and by chance the Queen Mary was one of the possible convention sites, and I thought that would be the best place for the convention because of the whole seafaring tradition of tattooing. So we arranged for a convention on the Queen Mary and in the fall of 1982 we held a convention that we called "Tattoo Expo '82". It was a very information-intensive show. We had as many videos and films as we could, and talks, and I presented a whole series of slide shows. It was a huge success.

A contingent from Japan came over. I had written to every Japanese artist that I knew. Kazuo Oguri was supposed to come over but he couldn't make it. But a Japanese publisher who at that time was publishing a big book on Horiyoshi II (Mr. Kuronuma) did come over from Tokyo and put up a photo display of tattoos by Horiyoshi II and also brought one of Horiyoshi's clients who had a full-body tattoo.

About the same time we launched the first issue of *Tattootime*, called "New Tribalism", which Leo Zulueta and I pasted up together. Cliff Raven contributed a brilliantly succinct piece on "tribal" tattooing (which he was the first artist to really pioneer, in the 60s) and Leo contributed a piece on the swastika as a primary ancient iconic emblem. I wrote most of the rest of it. So we got all this rolling. *Tattootime* started out a little slow, but it had an immediate effect on the tattoo artists who did see it. Leo was a friend of mine from San Francisco who was involved in the Punk Rock scene and was doing posters for punk bands. In other words, things that he would do on his own and just paste up around town using really confrontational imagery from S&M books and all that kind of stuff. Leo

had me tattoo him with this black pattern tattooing. I hadn't ever done anything remotely like that. I had done a little bit of abstract work, but nothing like this really bold black stuff which was based on Pacific island cultures. He had me do both his arms around 1979. I was encouraging him to get into tattooing himself.

D.E. Hardy. 1982. Polynesian/Japanese fusion. The cover of *Tattootime* #1.

So for the cover of the first *Tattootime* we used a photo of a leg tattoo which was inspired by Samoan designs but with a big Japanese serpent intertwined, and Leo and I made up the name "Tribalism" for this style. It had an immediate impact. I believe that convention on the Queen Mary was in October of 1982 and in the spring of 1983 I went to a National Convention in Arizona and tattoo artists started coming up to me and saying "check out this tribalism I've been doing on my girl friend," and at that moment I realized the power of the press and the influence you could have by getting these images out in a more widely distributed format. As of that moment black graphic tattooing took off. The only precedent that I know of outside of pre-technological societies was work that Cliff Raven had been doing in Chicago. Actually Cliff had always been very interested in Marquesan work and had been doing work of that kind on a guy that owned an influential fashion store called "Hot Flash" in San Francisco.

The other one who took an interest in it was Mike Malone, who, in 1978, drew up a sheet of traditional Hawaiian patterns, or his perception of traditional Hawaiian tattooing, and tried to rekindle an interest in a design form which had completely died out among native Hawaiians. And gradually he got people of Hawaiian descent who lived in the area to rediscover their heritage and they began getting black graphic work. This was in the late seventies.

So after we featured tribalism in the first *Tattootime* it took off and became the buzzword for the 80's. They took everything from Celtic knot work to Pacific Island designs and Northwest Coast Haida designs. I think tattooing is the great art of piracy. In fine art it's fashionable to talk about "appropriation" in the post-modern visual arts and architecture of the 1980's. It's certainly always been going on in tattooing because it's a totally bastardized art. Tattoo artists have always taken images from anything available that customers might want to have tattooed on them. The customer might ask for a design from a church pew or an acid rock album cover or the tattooer might choose a black panther design out of a 1934 kid's book and adapt it to make a tattoo design. But I think tribal tattoo designs continue to be a pretty even balance of literal transcriptions of images that some anthropologist recorded in a study of a pre-industrial culture and then tattoo artists started doing spin-offs of that.

The tribal style was good because it liberated tattooing from being totally content-oriented. There's even a weird sort of snobbery among people who get black pattern tattooing. Some of them take the attitude that their tattoos are somehow more refined or pure because they are not pictures of something and they don't tell a story. When in fact, I think it's just a particular style.

When I was tattooing in San Diego in the sixties, I had old Sailor Jerry flash on the wall. Sailors would come in and they'd laugh at the Betty Boop design, and then they'd get a Road Runner tattoo.

I think the black tribal stuff is going to be exactly the same. Thirty years from now there will be all these old farts kicking around with their tribal tattoos and some twenty-year-old will say "haw haw you must have got that in the 80's." Someday it will be dated just as any style becomes dated. It's going to continue to be part of the mix, because it's just like making more flavors available. But it really added to the visual interest of what was available, and as a counterpoint to this whole explosion of color tattooing. And a lot of people did really amazing work, getting beautiful results by incorporating untattooed areas of skin as part of the design instead of going for that blanket coverage look. So much of the Japanese work had been done poorly and just ended up in a big mess that you couldn't read too well.

In 1983 I had made connection with Mr. Tamotsu Kuronuma, whom I considered the greatest living tattoo artist in the world. He was someone whom I knew about through very scant photos of his work. He was one of those legendary tattooers who was supposed to be, and was, very very difficult to get through to. But I got an introduction through his publisher, and Kuronuma agreed to put a big tattoo on me.

So I went back to Japan in 1983, after an absence of ten years, and it was a very strange seminal kind of trip for me because I not only went to Japan, but I brought my tattoo gear with me at the urging of an artist friend of mine from San Francisco, Bob Basile. He is very interested in Rockabilly culture and the whole fifties thing: the Elvis phenomenon. He was tending bar at this trendy place in Tokyo. All the people around there were totally into that Rockabilly scene and were worshipping their conceptions of James Dean and Elvis and what the American fifties stood for with the Cadillacs with their big tail fins and all that.

He said, "All these Rockabilly kids want tattoos," but I didn't believe him because I knew how transgressive tattooing was in Japan. But I brought my gear over anyway and as it turned out I did

Mike Malone. 1982. New Tribalism. (from *Tattootime* #1)

PUNK ROCK TATTOOING by LEO ZULUETA

Leo Zulueta, 1982.
(from *Tattootime* #1)

tattoo a lot of people in Japan who wanted totally retro 40's and 50's Americana imagery, which I had not been doing at all. That stuff was not cool to get in the West at that point. And I also made a side trip with Dan Thomé down to Guam and Palau. In Palau I tattooed a lot of natives with, again, very 40's Americana kind of stuff. I had an album of classic flash with me (my own and Jerry's) and these natives of Palau worshipped the US Marine Corps because they had liberated them from Japanese rule at the end of World War II. So I was putting these USMC designs on the natives and it really opened my mind up because it was this great cultural mix of what is appropriate or what is cool. I realized that these values are totally interchangeable.

And in Japan especially, not only did I make a great connection with Mr. Kuronuma and began to get tattooed by him, but this connection with the Rockabillies was very important. I began going back to Japan regularly throughout the 80's and early 90's. Sometimes I would make three trips a year. In Tokyo these Rockabillies and their friends began getting more and more tattoos. It developed from being a little panther head, which was covered by the sleeve of a t-shirt. Then they started getting tattoos on their lower arms that were Western-style single images. Some of them even graduated to getting work on their chests and backs. But that sort of preceded this whole wave of interest in the retro look in the West and I think by the late 80's there was enough consciousness of it and enough of a resurrection of interest in general in the 40's and 50's among young hipsters that the retro look really became a trend, and through the Rockabilly bands like the Stray Cats that Bob Roberts had tattooed in New York in the early 80's. They had been into that look and they made it very big in Japan. So you had all this weird East-West fusion happening. I think by the end of the 80's tattooing had entered a truly post-modern phase where it began to refer back on its own history.

I think by the 80's you not only got tattooing that was new and original but also all kinds of other inspirations for tattoo motifs such as tattooing from pre-technological cultures like Haida images, and then there were also tattoos from recent history such as things from the 1940's and 50's. All these levels came into play at once. It was a real mishmash. And that's still going on today. And of course the expertise of the tattoo artists and the rise of the tattoo magazines have done a lot to accelerate the process.

Tattootime was the first publication to be done on tattooing since Bruno in Paris who did that book (C. Bruno. *Tatoués, qui êtes vous?* Bruxelles, Éditions de Feynerolles. 1974. 239 pp). But it was only available in French. There was Albert Parry's book, *Tattoo*, which was published by Macmillan in 1933, and there was Hans Ebenstein's *Pierced Hearts and True Love*, which was published by Derek Verschoyle in Europe in about 1953. And there was *Art, Sex and Symbol* in 1973. And that was it. But these books were done by fans. They saw tattooing from the outside. They assembled a lot of great information but I think it was a crucial difference to have the kind of reporting that we were trying to do from the point of view of people who were actually doing it and had been very involved in what had been a kind of hermetic pursuit.

And then not long after *Tattootime*, the tattoo magazines started to appear, and now there's probably a dozen magazines on the stands. Those magazines made more and more images available. Of course a lot of the tattoo suppliers were advertising in those magazines and making equipment available and so more and more people were getting into tattooing. By the early 90's public awareness was at a huge high. MTV broke through and everybody's perception changed. A lot of the bands were tattooed, and they were culture heroes and role models to the young people. So it became disseminated on a much wider basis.

Today there are tremendous talents coming into it. There are people coming out of formal art school training and then just people who are quite talented and who have built on the work of the people who broke ground before to lead it into new areas. The best analogy today is that it's like very sophisticated illustration, when illustration had reached the point where so many illustrators were completely facile with the air brush and with computer graphics, using Photoshop and all this other stuff. The appropriation of images has become instantaneous. There is instantaneous saturation of popular icons that immediately enter the tattoo realm. And the tattooers are plugged into all this. They're dialed into where all these things come from and so tattooing has become part of this image blitz that goes on all around the world. For instance in Tokyo there are young tattooers running street shops that are doing very Western style work. And it's changing all the time. In that way it's different from traditional Japanese tattooing, which didn't change much until the cross-fertilization with the West.

As a concrete example, when Sailor Jerry was sending pigments to Kuronuma in the 1960's in exchange for design advice he was specifically affecting the look of Japanese tattooing. He had a contact through Yasutaro Kida, who acted as a sort of a courier. Mr. Kida's son was studying architecture in the US and the father would go back and forth a lot, stopping in Hawaii. He was a tattoo fan who had traditional Japanese tattooing, and then he had Jerry do one of his arms with all these roses.

Another tattoo fan who acted as a cultural emissary was John O'Connell, a New York businessman who was based in Japan. His secretary was tattooed and Kuronuma had done a big pair of dragons on his belly. Interestingly enough, O'Connell is mentioned as a young fan in Parry's book "Tattoo" from the 30's. He maintained his tattoo interests but the only tattoo he ever got in Japan as far as I know was a pair of dragons on his belly by Kuronuma.

O'Connell would come back to the U.S. with photos of Kuronuma's work. Photos of Japanese tattooing were almost impossible to obtain in the

Bob Roberts. 1984. Rockabilly tattoo. (from *Tattootime* #3)

sixties. There were a few copies gleaned out of those *LIFE* magazine articles from the war. But O'Connell had incredible photos of the most sophisticated Japanese tattooing being done. But in spite of this cultural exchange, Japanese tattooing stayed relatively static. Even now, Horiyoshi III, Mr. Nakano in Yokohama, bemoans the fact that he can't try more unusual effects or even themes within the Japanese artistic canon that could be adapted to tattooing. For instance, Zen painting. He gets to do a little bit of that, but most of his customers are like the ones in New Jersey in 1955. They want a tattoo like the one their grandfather had. Nakano has amazing talent. He's as good as it gets. Fantastic.

Actually, quite a few of the middle aged Japanese tattooers are doing Western images now just because their clients call for it. There's a guy named Horihide (not Oguri) who works in a city near Tokyo who does really strong work, but it's that folk art looking style like kite painting. So they're all kind of adapting to the modern world. Kuronuma's father, interestingly enough, had always wanted to go to America and attempted to correspond with Charlie Wagner in the twenties.

I did the second *Tattootime* in 1983, the "Tattoo Magic" issue, and right about that time I had just broken off the association with Carafa. I had gotten him his investment back and it was apparent that our interests were diverging. I ended up doing five issues of *Tattootime* with the Hardy-Marks imprint and the layout was being done by my friend V. Vale [and his partner, A. Juno] who ran Re/Search Books in San Francisco whom I met through Leo. They had actually set all the type for the first *Tattootime* but Leo and I hand-pasted it up. I did issues two, three and four of *Tattootime* while I was still living in San Francisco, and then at the end of 1986 I moved my household to Honolulu. I was going to give up publishing because I figured it was too hard to work at long distance with people in the US. And then I met Mackinnon Simpson, a historian in Honolulu who's a real Macintosh nut, and he convinced me to buy a Mac and do the work myself. The very first book I laid out was *Tattoo Designs of Japan* with drawings by Horiyoshii III. That was in 1987.

And then I just started plugging along, cranking out books. I did books of designs like the tattoo flash book and got more and more interested in doing books that were focused on the history of the

art because I found that the idea of showcasing current work was being covered ad nauseam by the tattoo magazines. And I certainly couldn't keep up with the volume of work being produced around the world. I was still running my tattoo shop, still putting on a lot of tattoos. When I moved to Hawaii I was doing this commute every two weeks, going over to San Francisco to spend two weeks there, and then I would go back to Hawaii for two weeks. And I was beginning also to do my own artwork, watercolors and drawings. My emphasis in publishing shifted to the older stuff. I like seeing a lot of the new tattoos but I'm far more interested in viewing something by someone who has really developed a serious body of work over a period of time, or someone from the past who should be documented that people don't know anything about.

In the early 90's I was doing my own artwork and beginning to show it in galleries. I found that there was a tremendous dormant interest in tattooing as a subject among the "high art" world or whatever you want to call the legitimate art community because the high art world is always starved for content, new material. So I began getting involved in organizing these exhibitions and did a show called "Rocks of Ages" with La Luz de Jesus gallery in Los Angeles, and did a book to go along with that. I invited a number of artists from different places, basically friends of mine whose work I thought was interesting, to do their versions of this old kitsch religious tattoo design that I had been obsessed with when I was a kid.

Anonymous. Traditional Rock of Ages tattoo design.
(from *Rocks of Ages*)

Actually, the first show of tattoo designs in an art gallery was a show at the Museum of American Folk Art in 1972. That was the brainchild of Bert Hemphill, who was the father of collecting American Folk Art. Bert had been fascinated by Folk Art when he was a kid and began collecting stuff when he was 12 and 13 years old in the days when people considered folk art to be stuff like Revolutionary era weathervanes and knot work. And he really was the seminal figure that woke everybody up to the concept that this folk art is all around us and it has a great deal of soul and a lot of passion. Bert had done a few theme shows. He was the director of the Museum of American Folk Art, and he had done a theme show on magic.

And then he did a tattoo show. Mike Malone got wind of that and Malone was just starting to tattoo in New York, but he was primarily still working as a professional photographer. At that time I believe that Mike Malone and Thom deVita were the only people tattooing in New York City. After it became illegal in the early 60's, the other tattooers all moved out to New Jersey and Long Island.

Malone was in correspondence with me. I was trying to work on a book—even back then I was cooking on this book idea—and he contacted me and Sailor Jerry and I fed him some stuff, so he had a lot of real retro stuff. They put a fake tattoo parlor in the museum to look like Cap Coleman's tattoo shop. They borrowed some traditional Coleman flash from the Norwegian Seaman's Institute in New York. They had lots of machines, and they had some old signs and some of Wagner's stuff, but they also featured drawings and flash that Jerry and I did and photos of our work, so this was supposed to be like the "what's happening" new tattoo stuff at that time. That was the first museum show and it got a tremendous amount of attention in New York. It got panned very heavily too because it was way ahead of its time and the art critics were saying, "this is terrible, this isn't art" and that kind of crap.

So then there was a gap of about 20 years before anything really happened. Then, I did the "Rocks of Ages" show, and soon after that I met Bryce Bannatyne, who had a gallery in Santa Monica. He was very interested in doing a tattoo show and we ended up making a show of tattoo photos because although he isn't a photography dealer he thought photos would have the most impact. That was in 1992. And we published a catalog for that show.

From there we went to this "Pierced Hearts and True Love" show that the Drawing Center, in New York, approached me about. They initially approached me about that in 1992, and it took three and a half years to get that rolling because there was a funding problem. In the interim I had done the "Eye Tattooed America" show at the Ann Nathan Gallery in Chicago, and I made sure there were catalogs for all these shows because I figured the documentation would certainly outlive the exhibitions.

I had a solo show of my own paintings and drawings in Chicago and Ann Nathan bought a painting of mine, and then she was fascinated by the whole tattoo thing and wanted to do some sort of a tattoo show. And she said it could be anything. So the focus of that show was tattoo-inspired art. It wasn't literally flash although it did have a little bit of historic context. But it was work by both tattooers and other artists who had been inspired by the tattoo tradition. That show was put on in 1993 and traveled to a number places in the US and the "Forever Yes" photo show traveled to a number of places. It went to Texas, Honolulu, North Carolina and San Jose. All these shows have had impact. "Pierced Hearts and True Love" is the most ambitious one, and certainly the most straight-ahead historic one. It seems to be getting a lot of attention.

I think there's going to be a lot more awareness from both sides from tattoo people, whether they care about it or not, but they're aware that this art form can fit in and get some kind of validation on the museum level, and then from the fine arts people who maybe have very antiquated perceptions of what tattooing is all about and don't know anything about its history and think it all started with drunks and sailors in 1920.

There have been some good reviews on the New York show ("Pierced Hearts and True Love"). There was a long piece in the *New York Times* by their chief reviewer who took a somewhat dim view of it. The subtitle for the column was "But is it art?" and it was the typical stick-in-the-mud thing. He

didn't like the things as drawings and his argument was that these things didn't hold up—that they weren't interesting as drawings in themselves, which we all thought only showed his incompetence. Everybody in New York said it was the biggest opening they had ever seen in Soho, which is the big hot gallery district. There were about a thousand people there for the opening. The whole street was closed off. No cars could get through. People were lining up to pay to get in the door. So it was really a phenomenal opening and the whole run of the show was phenomenal. They sold hundreds and hundreds of catalogs. I made T-shirts, and sold dozens of those. The *Village Voice* gave it a full page review that was tremendously upbeat. Some of the large art magazines, including *Artforum* did a review of it.

And they had a great success with it in Williamstown (Williams Art Museum in Williamstown, Massachusetts) although this is a pretty remote New England college town. At the opening again, they had a huge amount of people and they had a rock band and drew in a lot of non-museum people. I think it will be a great success also when it goes to Miami. In southern Florida there are tons of tattoo shops.

The same thing happened with the "Eye Tattooed America" show. There were these huge rave-up crowds. I went to Terre Haute, Indiana, to talk there after the opening. That opening was the biggest one they ever experienced at this university museum; everywhere, it was the same story. It was in Iowa, it was up in Milwaukee. In Virginia they had an almost uncontrollable mob scene at the opening. And at Laguna Beach Art Museum last summer we got the whole LA tattoo crowd and it was packed. There were more people in the museum than they had seen in years. These things are giant successes for the museums themselves, and when this show goes to San Francisco it will be a real event, because it's the middle of summer and it will tap into all the tourist people in town and it will also tap into the enormous number of tattooed people and fans in the Bay area, and California in general.

When I think of the great tattoo artists who have come along in the last twenty years—of course in the seventies Jack Rudy was very important and Good Time Charlie Cartwright because they developed the single needle technique. Today, there are legions of them all over the world... Dan Higgs, who is one of my all-time favorite tattooers is a visionary tattooer with a bold style. It isn't for everybody but I think he's got more emotional depth and resonance than there is in the work of all these guys who are doing extremely slick illustrative kind of stuff. And for the epitome of that monochromatic photo-realist style with a fantasy swing to it Paul Booth seems to be the most incredible. He's one of those guys who can draw with an absolutely accurate light source. He does super melodramatic stuff, really wacky and stunningly executed.

Bob Roberts has had a tremendous impact. I think he's a great great tattooer. He happens to have a style that I really like. He's always been firmly based in that classic bold kind of retro thing, which he has even applied to Japanese style work. Another great tattooer is Zeke Owens. Zeke is a really important guy and a real eccentric and brilliant as a tattoo artist. He's one of the great unsung tattooers. If I did another *Tattootime* Zeke would be the center piece of it.

And there are a lot of other artists coming along. Tintin in France is fantastic. Again, it gets down to extremely personal taste. There are a lot of tattooers who are phenomenal technicians but I honestly don't think they have much depth or dimension or unique soul to their work. A lot of the people who are very popular are just big schlockmeisters. Basically it's just highly developed kitsch. A lot of the Europeans who are doing stuff that people rave over—a lot of the people getting tattoos are just yokels who have extremely dumb taste. And so what they pick as their faves cater to that kind of dumb thing.

There are tons of very sincere people and I'm glad to see all the great technical proficiency. There are probably more out there in the woodwork that I don't know about. It's far better than what it used to be in the old days.

But when you're talking art (and I don't know even how I make that distinction)—the kind of

thing that really will hold up and last and be of some real interest is the unique expression of an individual that's unlike anyone has ever seen. There are very few of them.

D.E. Hardy is the author and /or editor of the following titles, published by Hardy-Marks Publications, 700 Lombard St., San Francisco, California, 94133

Tattootime #1. The New Tribalism. 1982.
Tattootime #2. Tattoo Magic. 1983.
Tattootime #3. Music and Sea Tattoos. 1985.
Tattootime #4. Life and Death Tattoos. 1988.
Tattootime #5. Art from the Heart. 1991.
Tattoo Flash. 1990.
Rocks of Ages. 1992.
Eye Tattooed America. 1993.
Sailor Jerry Collins: American Tattoo Master. 1994.
Flash from the Past: Classic American Tattoo Designs. 1994
Pierced hearts and True Love: A Century of Drawings for Tattoos. 1995.
Freaks, Geeks & Strange Girls: Sideshow Banners of the Great American Midway. 1996.
McCabe, Michael. *New York City Tattoo: The Oral History of an Urban Art.* 1997.
Newton, Jeremiah, and Passalacqua, Francesca. *My Face for the World to See: The Letters, drawings, and diaries of Candy Darling, Andy Warhol Superstar.* 1997.
Hardy, Don Ed. *Tattooing the Invisible Man: Bodies of Work, 1955-1999.* 1999.

REFERENCES AND BIBLIOGRAPHY

CHAPTER 1: ANCIENT HISTORY

1. Spindler, Konrad. 1994. *The Man in the Ice: the Preserved Body of a Neolithic Man Reveals the Secrets of the Stone Age.* London: Weidenfeld and Nicolson. p. 172.
2. Péquart, Marthe, and Péquart, Saint-Juste. 1962. "Grotte du Mas d'Azil (Ariège), Une nouvelle galerie magdalénienne." *Annales de Paléontologie.* 48:167- 296.pp. 211-214 ; Scutt, R.W.B. & Gotch, C. 1985. *Art, Sex and Symbol.* London: Cornwall Books, p. 22.
3. Bianchi, Robert S. 1988. "Tattoo in Ancient Egypt." (pp.21-28) in: Arnold Rubin (editor), *Marks of Civilization.* Los Angeles: Museum of Cultural History, The University of California, p. 23.
4. Ibid., p. 27.
5. Ibid., p. 26.
6. Hambly, W.D. 1925. *The History of Tattooing and its Significance.* London: H.F. & G. Witherby, p. 333.
7. Rudenko, Sergei I. 1970. *Frozen Tombs of Siberia: the Pazyryk Burials of Iron Age Horsemen.* Berkeley: The University of California Press, pp. 110-114.
8. Polosmak, Natalya. 1994. "A Mummy Unearthed from the Pastures of Heaven." *National Geographic.* 186(4): 80-103, p. 82.
9. Jones, C.P. 1987. "*Stigma*: Tattooing and Branding in Graeco-Roman Antiquity." *Journal of Roman Studies.* 77:139-155, p. 147-149.
10. Quoted in: Berchon, Ernest. 1869. *Histoire medicale du tatouage.* Paris, p. 454-455.
11. Jones, op. cit., p. 143.
12. Scutt, & Gotch, op. cit., p. 138; Berchon, op. cit., pp. 456-457.
13. Berchon, ibid., p. 34,
14. Quoted by Scutt & Gotch, op. cit., p. 26.
15. Ibid.
16. Zimmerman, Konrad. 1980. "Tätowierte Thrakerinnen auf griesschischen Vasenbildern." *Jahrbuch des Deutches Archäologischen Instituts.* 95:163-196, p.167.
17. Jones, op. cit., p. 148.
18. Scutt & Gotch, op. cit., p. 26.

CHAPTER 2: POLYNESIA

1. Melville, Herman. 1846. *Typee: A Peep at Polynesian Life* (republished in 1963 as Volume I in The Standard Edition of the Works of Herman Melville. New York: Russell & Russell, Inc.), pp. 242, 247.
2. Kirch, Patrick V. 1997. *The Lapita Peoples.* Cambridge, Mass: Blackwell, pp. 1-19.
3. Ibid., pp. 131-132; Green, Roger C. "Lapita" in: Jennings, Jesse D. 1979. *The Prehistory of Polynesia.* Cambridge, Mass: Harvard University Press, pp. 28-48.
4. Taylor, Alan. 1981. *Polynesian Tattooing.* Honolulu: Institute for Polynesian Studies, pp. 6-7.
5. Ibid., p. 10.
6. Ibid., p. 3-14.
7. Bellwood, Peter. 1979. *Man's Conquest of the Pacific.* NY: Oxford University Press, Chapter 12.

Additional References:
Dodd, Edward. 1990. *The Island World of Polynesia.* Putney, Vermont: Windmill Hill Press.
Dodd, Edward. 1972. *Polynesian Seafaring.* NY: Dodd, Mead & Co.
Dumont d'Urville, J. 1841-1846. *Voyage au Pole du Sud et dans l'Oceanie.* Paris: Gide.
Green, Roger C. "Lapita" in: Jennings, Jesse D. 1979. *The Prehistory of Polynesia.* Cambridge, Mass: Harvard University Press.
Kleinschmidt, G. 1877. *Notes and Sketches of the Interior of Fiji.* Fiji Museum.
Stolpe, H. 1899. Über die Tätowierung der Osterinsulaner: *Abhandlung und Bericht des Königlichen Museum, Dresden: Festschrift 6.* Berlin: Friedlander.

CHAPTER 3: GIOLO

1. Gill, Anton. 1997. *The Devil's Mariner: a Life of William Dampier, Pirate and Explorer.* London: Michael Joseph, pp. 215-217; Wilkinson, Clennel. 1929. *William Dampier.* London: John Lane, p. 141 et seq.
2. Gill, op. cit., pp. 202-215.

Additional reference:
Dampier, William. 1906. *Dampier's Voyages.* Edited by John Masefield. London: E Grant Richards.

CHAPTER 4: JOSEPH BANKS

1. Adams, Brian. 1986. *The Flowering of the Pacific: Being an Account of Joseph Banks' Travels in the South Seas and the Story of his Florilegium.* Sydney, Australia: William Collins, pp. 9-13.
2. Ibid., chapter 5; Lyte, Charles. 1980. *Sir Joseph Banks: 18th Century Explorer, Botanist, and Entrepreneur.* London: David & Charles, p. 64-70.
3. Banks, Joseph. 1962. *The Endeavour Journal of Joseph Banks,* (edited by J.C. Beaglehole), (2 vols) Sydney, Australia: Angus & Robertson, V. I, p. 400.
4. Parkinson, Sydney. 1773. *A Journal of a Voyage to the South Seas.* London: Richardson & Urquhart, Plate XIII, p. 75; Plate XVI, p. 90; Plate XXI, p. 109.
5. Lyte, op. cit., pp. 200-214.

CHAPTER 5: BORNEO

1. Wright, Leigh R. 1972. *Vanishing World; the Ibans of Borneo.* New York: Weatherhill, pp. 6-22.
2. Bock, Carl. 1881. *The Headhunters of Borneo.* London, 1881. Republished by Oxford University Press, 1985, pp. 215-219.
3. Harrer, Heinrich.1988. *Borneo: Mensch und Kultur seit ihrer Steinzeit.* Innsbruck: Pinguin-Verlag, pp. 113-122.
4. Hose, Charles & McDougall, W. 1912. *Pagan Tribes of Borneo.* London: MacMillan & Co., V. II, p. 41.
5. O'Hanlon, Redmond. 1984. *Into the Heart of Borneo.* Edinburgh: Salamander Press, p. 8.
6. Harrer, op. cit., p. 125.
7. Ibid., pp. 263-266.

Additional reference:
Hose, Charles & Shelford, R. 1906. "Materials for a Study of Tatu in Borneo." *Journal of the Royal Anthropological Institute of Great Britain and Ireland.* 36:60-90.

CHAPTER 6: SAMOA

1. Rowe, Newton A. 1930. *Samoa Under the Sailing Gods.* London: Putnam, p. 11.
2. Krämer, Augustin F. 1903. *Die Samoa Inseln.* 2 vols. (English translation, 1994 Honolulu: University of Hawaii Press.), V. II, p. 8.
3. Gilson, op. cit., V. II, p. 16.
4. Gilson, Richard P. 1970. *Samoa: 1830 to 1900.* Melbourne: Oxford University Press, p. 65 et seq.
5. Ibid., pp. 72-73; Rowe, op. cit., p. 25.
6. Ellison, Joseph W. 1938. *The Opening and Penetration of Foreign Influence in Samoa to 1880.* Corvallis, Oregon: Oregon State College Press, p. 150.
7. Ibid.
8. Rowe, op. cit., p. 85.
9. Krämer, op. cit., V. II, pp. 77-94.
10. Ibid., p. 87.
11. Griffith, Richard P. 1953. *The World of Robert Flaherty.* New York: Duell. Sloan and Pearce, pp. 69-70.

Additional references:
Dell'Aquila, Mark. "Of Art, Pain and Honor." *Skin and Ink,* August 1994.
Marquardt, Carl. 1899. *Die Tätowierung beider Geschlechter in Samoa.* Berlin: Verlag von Dietrich Reimer.
[translated by Sybil Ferner as *The Tattooing of Both Sexes in Samoa.* Papakura, New Zealand: R. McMillan, 1984].
O'Brien, Frederick. 1919 *White Shadows in the South Seas.* NY: The Century Co.

CHAPTER 7: THE MARQUESAS

1. Dening, Greg. 1980. *Islands and Beaches.* Melbourne University Press, pp. 1-10.
2. Ibid., 110-113.
3. Ibid., p. 275.
4. Ibid., pp. 268-288.
5. Handy, Willowdean. 1922. *Tattooing in the Marquesas.* Honolulu, Hawaii: The Bernice P. Bishop Museum, p. 3.
6. Melville, Herman. 1846. *Typee.* London: John Murray.
7. Handy, Willowdean. 1965. *Forever the Land of Men: an Account of a Visit to the Marquesas Islands.* New York: Dodd, Mead & Co.
8. Handy, Willowdean. 1938. *L'art des Iles Marquises.* Paris: Éditions d'Art et d'Histoire.

Additional references:
Langsdorff, Georg H. von. 1813. *Voyages and Travels in Various Parts of the World.* London.
Steinen, Karl von den. 1928. *Die Marquesaner und ihre Kunst.* 3 Vols. Berlin: D. Reimer.

CHAPTER 8: NEW ZEALAND

1. Robley, Horatio. 1896. *Moko, or Maori Tattooing.* London: Chapman & Hall, p. 10.
2. Ibid., p. 35.
3. Sinclair, Keith. 1961. *A History of New Zealand.* London: Oxford University Press, pp. 24-26.
4. Ibid., pp. 27-29.
5. Robley, op. cit., p. 65.
6. Sinclair, op. cit., p. 128.
7. Ibid., p. 70.
8. Ibid., p. 131.
9. Graham, J.C. (editor). l965. *Maori Paintings by Gottfried Lindauer.* Honolulu: East-West Center Press, p. 17.

Additional references:
Beaglehole, J.C. 1961. *The Discovery of New Zealand.* London: Oxford University Press.
King, Michael and Marti Friedlander. 1972. *Moko: Maori Tattooing in the 20th Century.* Wellington, New Zealand: Alister King.
Sangl, Harry. 1980. *The Blue Privilege: The Last Tattooed Maori Women.* Richards Publishing & William Collins, Publishers. Auckland, New Zealand.
Simmons, D.R. 1986. *Ta Moko: The Art of Maori Tattoo.* Aukland, New Zealand: Reed Methuen Publishers Ltd.

CHAPTER 9: JAPAN

1. Richie, Donald and Ian Buruma. 1980. *The Japanese Tattoo*. New York: John Weatherhill, p. 11.
2. Van Gulick, W.R. 1982. *Irezumi: the Pattern of Dermatography in Japan*. Leiden: E.J. Brill, p. 6.
3. Richie, op. cit., pp. 11-13.
4. Ibid., pp. 14-15.
5. Ibid., p. 29.
6. Ibid., pp. 16-21.
7. Kaplan, David E. and Alec Dubro. 1986. *Yakuza*. Reading, Mass.: Addison-Wesley, pp. 25-26.
8. Richie, op. cit., pp. 21-22; Klompmakers, Inge. 1998. *Of Brigands and Bravery: Kuniyoshi's Heroes of the Suikoden*. Leiden: Hotei Publications, pp. 22-30.
9. Klompmakers, op. cit., pp. 9-13.
10. Robinson, Basil W. 1961. *Kuniyoshi*. London: H.M. Stationery Office, p. 25.
11. Scutt, R.W.B., and Christopher Gotch. 1986. *Art, Sex and Symbol: The Mystery of Tattooing*. London: Cornwall Books. pp. 166-167.

Additional references:

Hane, Mikiso. 1982. Peasants, Rebels and Outcasts. New York: Pantheon.

Tamabayashi, Haruo. 1936. *Bunshin Hyakushi*. Tokyo: Bunsendo Shobo. (Reprinted in 1987 by Nihon Irezumi Kenkyujo; Hatsubai Keibunsha, Tokyo).

CHAPTER 10: NORTH AMERICA

1. Sinclair, A.T. 1909. "Tattooing of the North American Indians." *American Anthropologist*, V. 11 no. 3;362-400, p. 393.
2. Ibid., p. 370.
3. Quoted in: Dubé, Philippe. 1960. *Tattoo-tatoué*. Montreal: Jean Basile, pp. 24-25.
4. Ibid., pp. 26-27.
5. Hambly, Wilfrid D. 1925. *The History of Tattooing and its Significance*. London: H.F. & G. Witherby, p. 51.
6. Sinclair, op. cit., p. 391.
7. Mallery, Garrick. 1888-1889. "Picture Writing of the American Indians." *Tenth Annual Report of the American Bureau of Ethnology*. Washington DC: US Government Printing Office, p. 394.
8. Ibid.
9. Bossu, Jean Bernard *Travels in the Interior of North America 1751-1762*. Translated and edited by Seymour Feller. 1962. Norman: University of Oklahoma Press, p. 6.
10. Dubé, op. cit., pp. 27-34; Einhorn, Arthur & Thomas S. Abler. 1998. *Tattooed Bodies & Severed Auricles: Images of Native American Body Modification in the Art of Benjamin West*. American Indian Art Magazine. 23 (4):42-53.
11. Hariot, Thomas. 1590. *Briefe and True Report of the New Found Land of Virginia*. London: Theodor de Bry. (Reprinted by Dover publications, New York, 1972), p. 35.
12. Einhorn, op. cit., p. 46.
13. Swan, James G. *The Northwest Coast*. First published in 1857 by Harper & Brothers; republished in 1972 by the University of Washington Press, Seattle. (bookjacket)

Additional references:

Sinclair, A.T. 1909. "Tattooing of the North American Indians." *American Anthropologist*. v. 11 no. 3;362-400.

Swan, James G. 1874. *The Haidah Indians of Queen Charlotte's Islands, British Columbia*. (Smithsonian Contributions to Knowledge # 267). Washington DC: Smithsonian Institution.

Swan, James G. 1878 "Tattoo Marks of the Haida." *Fourth Annual Report of the American Bureau of Ethnology*.
Washington DC: US Government Printing Office.

CHAPTER 11: SOUTH AMERICA

1. Sinclair, A.T. 1909. "Tattooing of the North American Indians." *American Anthropologist*, V. 11, no. 3;362-400, p. 362.
2. Ibid., p. 364.
3. Ibid., p. 366.
4. Clendinnen, Inga. 1987. *Ambivalent Conquests*. Cambridge University Press., pp. 17-18; 21-31.
5. Landa, Diego de. *The Maya*. Diego de Landa's Account of the Affairs of Yucatan. (Introduced and translated by A.R. Pagden), Chicago: J. Philip O'Hara Inc., p. 14.
6. Quoted by Clendinnen, op. cit., p. 74.
7. Ibid., p. 117.
8. Wright, Ronald. 1992. *Stolen Continents*. London: John Murray., pp. 167-170.
9. Quoted by Clendinnen, op. cit., p. 70.

Additional references:

Anton, Ferdinand. 1986. *Alt-indianische Kunst in Mexico*. Leipzig: E.A. Seeman Buch-und Kunstverlag.

Anton, Ferdinand. 1968. *Alt-Mexico und seine Kunst*. Leipzig: E.A. Seeman Buch-und Kunstverlag.

Chamberlain, Robert S. 1966. *The Conquest and Colonization of Yucatan, 517-1550*. New York: Octagon Books.

Stierlin, Henri. 1982. *L'Art Aztèque et ses Origins*. Fribourg: Office du Livre.

CHAPTER 12: ENGLAND

1. Scutt, R.WB and Gotch, C. 1986. *Art, Sex and Symbol: the Mystery of Tattooing.* London: Cornwall Books, pp. 165-166.
2. Parry, Albert. *Tattoo.* 1933. New York: Macmillan & Co., p. 102.
3. Scutt and Gotch, op. cit., p. 15.
4. Ibid. p. 170.
5. Ibid., p. 177.
6. Ibid., p. 55.
7. Ibid. p. 134.
8. Burchett, George. 1958. *Memoirs of a Tattooist.* London: Oldbourne.

CHAPTER 13: FRANCE AND ITALY

1. Berchon, Ernest. 1869. *Histoire médicale du tatouage.* Paris: Baillière et Fils. Part II, p. 54.
2. Ibid.
3. Ibid.
4. Ibid., Part I, p. 30.
5. Ibid., Part II, p. 203.
6. Ibid., Part II, p. 210.
7. Ibid., Part I, p. 31
8. Lombroso, Cesare. 1972. *Criminal Man, According to the Classification of Cesare Lombroso.* (Reprinted, with an introduction by Leonard D. Savitz), Montclair, N.J.: Patterson Smith, pp. 45-51.
9. Ibid. p. 24.
10. Beaumarchais, Pierre Augustin Caron de. P. 93; *The Barber of Seville and The Marriage of Figaro.* Translated by Vincent Luciani. Great Neck N.Y.: Barnes Educational Series, Inc. (1964) (Originally published in 1784 as *Le Mariage de Figaro*), Act II, scene 16.
11. Hugo, Victor. 1957. *Les Misérables.* Paris: Éditions Garnier Frères, pp. 338-339.
12. Scutt, R. W.B. and Christopher Gotch. 1985. *Art, Sex and Symbol: The Mystery of Tattooing.* London: Cornwall Books, pp. 161-162
13. Lacassagne, Alexandre. 1881. *Le Tatouage: Étude anthropologique et médico-légale.* Paris: Librarie J. B. Ballière et Fils, p. 85.
14. Ibid., pp. 48, 61, 69, 100.
15. Ibid., p. 63.
16. Ibid.
17. Ibid., p. 100.
18. Ibid., p. 48.
19. Ibid., p. 28.
20. Fletcher, Robert. 1882. "Tattooing Among Civilized People." *Transactions of the Anthropological Society of Washington, Volume II.* New York: Kraus Reprint
21. Lacassagne, op. cit., p. 82.

Additional references:
Delarue, Jaques & Giraud, R. 1950. *Les tatouages du "Milieu."* Paris: La Roulotte.
Graven, Jean. 1962. *L'Argot et le tatouage des criminels.* Neuchatel, Switzerland: Editions de la Baconniere.
Lacassagne, Jean. 1933. "Le tatouage ornamental." *Aesculape* 23: 258-263.
Lombroso, Cesare. "The Savage Origin of Tattooing." *Popular Science Monthly,* April, 1896.

CHAPTER 14: USA

1. Quoted in: Scutt, R.WB and Gotch, C. 1986. *Art, Sex and Symbol: the Mystery of Tattooing.* London: Cornwall Books. p. 90.
2. Fellowes, C.H. 1968. *The Tattoo Book.* Princeton, NJ: Pyne Press, Plate 67.
3. Ibid., facing Plate 58.
4. Ibid., Plate 63.
5. Ibid., Plate 69.
6. Ibid., Plate 78.
7. Parry, Albert. 1933. *Tattoo.* New York: Macmillan., p. 44.
8. Ibid., pp. 44-45; Scutt & Gotch, op. cit., p. 51.
9. Parry, op. cit., pp. 65-66; 104.
10. Ibid. pp. 47-48; 54; 131-132.
11. Anonymous. "An Old Tattooer Talks Shop." *Science Digest,* March 1945, p. 22.
12. Parry, op. cit. p. 66.
13. Fellowes, op. cit., facing Plate 58.
14. Tuttle, Lyle. 1985. "Professor Charles Wagner." *Tattoo Historian* #8. San Francisco: Tattoo Art Museum., p. 8.
15. Ibid., p. 20.
16. Winkler, John K. 1926. "When Art is a Skin Game." *Collier's Weekly.* Feb. 13., p. 11.
17. Tuttle, op. cit., p. 7 et seq.

Additional references:
Coons, Hannibal. 1942. "Skin Game Michelangelos." *Collier's Weekly,* Dec. 12.
Hardy, Don Ed. 1994. *Flash from the Past: Classic American Tattoo Designs, 1890-1965.* Honolulu: Hardy-Marks.

CHAPTER 15: THE CIRCUS

1. Dening, Greg. *Islands and Beaches.* Melbourne: Melbourne University Press, pp. 110-113.
2. Danielsson, Bengt. 1978. *Le Memorial Polynesien.* (Vol I) Papeete: Hibiscus Editions, pp. 430-431.
3. Craik, George L. 1830. *The New Zealanders.* London: C. Knight, p. 278.
4. Culhane, John. 1990. *The American Circus: an Illustrated History.* New York:
5. Henry Holt & Co.
6. O'Connnell, James F. 1836. *A Residence of Eleven Years in New Holland and the Caroline Islands.* Boston: B.B. Mussey. (Republished in 1972 by the Australian National University)
7. Press, Canberra. Edited by Saul H. Riesenberg), p. 43.
8. Ibid., p. 44.
9. Bogdan, Robert. 1988. *Freak Show.* Chicago: University of Chicago Press, pp. 243-249.
10. Scutt, R.WB and Gotch, C. 1986. *Art, Sex and Symbol: the Mystery of Tattooing.* London: Cornwall Books, pp. 154-155.
11. Parry, Albert. 1933. *Tattoo.* New York: Macmillan Co., pp. 63-68.
12. Tuttle, Judy. 1986. "Omi, You Were Great!" *Tattoo Historian,* No. 10, p. 16 et seq.
13. Bogdan, op. cit., pp. 62-68.
14. Culhane, op. cit., pp. 273-274.

Additional reference:
Hebra, Ferdinand. 1860-1875. *Atlas of Portraits of Diseases of the Skin.* London: W.West.

CHAPTER 16: ARABS, JEWS AND CHRISTIANS

1. Field, Henry. 1953. *The Track of Man: Adventures of an Anthropologist.* New York: Doubleday & Co., p. 12.
2. Ibid., pp. 12-13.
3. Ibid., p. iv.
4. Scutt, R.W.B. and Gotch, C. 1986. *Art, Sex and Symbol.* London: Cornwall Books, p. 64.
5. Ibid.
6. Thomson, M. W. 1959. *The Land and the Book.* London: Nelson, p. 91.
7. Ibid., pp. 93-94.
8. Ibid.
9. Ibid.
10. Dölger, F.J. 1929. Die Kreuz-Tätowierung im Christlichen Altertum. *Antike und Christentum.* 1:202-211, p. 202.
11. Ibid., p. 204.
12. Ibid., p. 202.
13. Ibid., p. 204.
14. Lithgow, William. 1632. *The Totall Discourse of the Rare Adventures & Painfull Peregrinations of long Nineteene Yeares Travayles from Scotland to the most famous Kingdomes in Europe, Asia and Affrica.* (1906 edition, Glasgow: James MacLehose and Sons), p. 253.

Additional references:
Carswell, John. 1956. *Coptic Tattoo Designs.* Beirut: The American University of Beirut.
Field, Henry. 1958. *Body Marking in Southwestern Asia.* Cambridge, Mass: The Peabody Museum.
Keimer, Ludwig. 1948. Remarques sur le Tatouage dans l'Egypte Ancienne. *Memoirs de l'Institute d'Egypte.* 53: 1-113.
Searight, Susan. 1984. *The Use and Function of Tattooing on Moroccan Women.* (3 vols) New Haven, Connecticut: Human Relations Area Files, Inc.
Smeaton, Winifred. 1937. Tattooing Among the Arabs of Iraq. *American Anthropologist.* 39:53-61.

CHAPTER 17: PROFESSIONAL OPINIONS

1. Joest, Wilhelm. 1887. *Tätowieren, Narbenzeichnen und Körperbemalen.* Berlin: Verlag von A. Asher & Co., p. 18.
2. Ibid., p. 60.
3. Ibid., p. 78.
4. Hambly wilfrid D. 1925. *The History of Tattooing and its Significance.* London: H.F. & G. Witherby, pp. 13-25.
5. Ibid., p. 17.
6. Ibid.
7. Ibid., p. 25
8. Parry, Albert. 1933. *Tattoo: Secrets of a Strange Art.* New York: Macmillan.
9. Haigh, Susanna. 1934. Special Review: "Tattoo," by Albert Parry. *Psychoanalytic Quarterly.* 3: 474-476, p. 475.
10. Bromberg, Walter. 1935. Psychologic Motives in Tattooing. *A.M.A. Archives of Neurology and Psychiatry.* 33: 228-232, p. 230.
11. Ferguson-Rayport, S. et al. 1955. The Psychiatric Significance of Tattoos. *Psychiatric Quarterly.* 29:112-131, pp. 121-122.
12. Raspa, Robert F. and John Cusack 1990. Psychiatric Implications of Tattoos. *American Family Physician.* 41: 1481-1486, p. 1481.
13. Ibid., p. 1483.
14. Favazza, Armando R. 1996. *Bodies Under Siege: Self-mutilation and Body Modification in Culture and Psychiatry.* (Second edition), Baltimore: The Johns Hopkins University Press, p. 153.
15. Coe, Kathryn, et al. 1993. Tattoos and Male Alliances. *Human Nature.* 4 [2]: 199-204, p. 202.
16. DeMello, Margot. 1995. The Carnivalesque Body: Women and Tattoos, pp. 73-79 in *Pierced Hearts and True Love: A Century of Drawings for Tattoos.* (Edited by Don Ed Hardy), Honolulu: Hardy-Marks Publications, p. 74.
17. Ibid., p. 79.
18. Rosenblatt, Daniel. 1997. The Antisocial Skin: Structure, Resistance, and "Modern Primitive" Adornment in the United States. *Cultural Anthropology.* 12 (3):287-334, p. 293.

19. Ibid., p. 324.
20. Zahavi, Amotz and Avishag Zahavi. 1997. *The Handicap Principle: A Missing Piece of Darwin's Puzzle.* Oxford: Oxford University Press., pp. xiii-xvi; 229-230.
21. Hardy, Don Ed. 1983. Tattoo Magic. *Tattootime.* 2: 41-51, pp. 48-49.
22. Lewin, Bertram D. 1973. "The Body as Phallus." (p. 28) in *The Selected Writings of Bertram D. Lewin.* (Edited by Jacob A. Arlow), New York: New York Psychoanalytic Quarterly.

Additional references:
Bromberg, Walter. 1972. Tattooing: Psychosexual Motivations. *Sexual Behavior.* 2: 28-32.
Goldstein, N. 1979. Psychological Implications of Tattoos. *Journal of Dermatology, Surgery and Oncology.* 5: 883-8.
Gittleson, NL et al. 1969. The Tattooed Psychiatric Patient. *British Journal of Psychiatry.* 115:1249-53.
Lewin, Bertram D. 1973. "The Body as Phallus." (p. 28) in *The Selected Writings of Bertram D. Lewin.* (edited by Jacob A. Arlow) New York: New York Psychoanalytic Quarterly.
Parry, Albert. 1934. Tattooing Among Prostitutes and Perverts. *Psychoanalytic Quarterly.* 3: 476-482.

CHAPTER 18: THE MARSHALL ISLANDS

Chamisso, A. von, 1986, *A voyage around the world with the Romanzov exloring expedition in the years 1815–1818 in the Brig Rurick,* Captain Otto von Kotzebue. (Translated by H.Kratz), Honolulu: University of Hawaii Press.
Eisenhart, O., 1888, Acht Monate unter den Eingeborenen auf Ailu (Marshall–Gruppe). *Aus allen Welttheilen* 19, 207–208, 223–226, 250–252.
Erdland, P.A., 1914, Die Marshall Insulaner. Leben und Sitte, Sinn und Religion eines Südsee-volkes. *Anthropos Bibliothek. Internationale Sammlung Ethnologischer Monographien,* Vol.2(1). Münster: Aschendorffsche Verlagsbuchhandlung.
Finsch, O., 1879, Reise nach den Marschall-Inseln. *Verhandlungen der Berliner Gesellschaft für Anthropologie, Ethnologie und Urgeschichte.* p. 414.
Finsch, O., 1886, Die Marschall–Inseln. *Die Gartenlaube.*34, 37–38.
Hager, C., 1886, *Die Marshall Inseln in Erd– und Völkerkunde,* Handel und Mission. Leipzig: G.Lingke.
Hasebe, Kotondo, 1932, Tattoos by people of the Marshalls. (Marshall-jin no irezumi) *Dorumen.* 1-5 (Quoted after translation kept at the Micronesian Area Research Center, University of Guam, Guam)
Hernsheim, F., 1887, *Die Marshall–Inseln. Mittheilungen der geographischen Gesellschaft in Hamburg* 1885–1886 (1887), 297–308.
Humphrey, O.J., 1887, *The wreck of the Rainier. A sailor's narrative.* Portland: W.H.Stevens & Co.
Kotzebue, O. von, 1821, *A voyage of discovery into the South Sea and Beering's Straits: for the purpose of exploring a north–east passage undertaken in the years 1815–1818, at the expense of His Highness the Chancellor of the Empire, Count Romanzoff in the ship Rurick, under the command of the Lieutenant in the Russian Imperial Navy, Otto von Kotzebue.* 3 vols. London: Longman, Hurst, Rees, Orme and Brown.
Kotzebue, O. von, 1830, *A new voyage around the world in the years 1823-1826.* 2. vols. London: H.Colbourn & R.Bentley.
Krämer, A., 1904, Die Ornamentik der Kleidmatten und der Tatauierung auf den Marschall–Inseln. *Archiv für Anthropologie* N.F. II.
Krämer, A., 1906, *Hawaii, Ostmikronesien und Samoa.* Stuttgart: Schweizerbartsche Verlagsbuchhandlung.
Krämer, A. & H.Nevermann, 1938, Ralik–Ratak (Marschall Inseln), In: G.Thilenius (ed.), *Ergebnisse der Südsee–Expedition 1908–1910. II. Ethnographie, B: Mikronesien.* Vol. 11: Hamburg: Friedrichsen & de Gruyter.
Kubary, J.S., 1887, Das Tätowiren in Mikronesien, speziell auf den Karolinen. In: W.Joest, *Tätowiren, Narbenzeichnen und Körperbemalen. Ein Beitrag zur vergleichenden Ethnologie.* Berlin: A.Asher & Co. Pp. 74–98.
Spennemann, Dirk H.R., 1992, *Marshallese Tattoos.* Historic Preservation Office Majuro Atoll, Republic of the Marshall Islands

CHAPTER 19: ARCTIC

Anderson, H.D. and W.C. Eells. 1935. *Alaska Natives: A Survey of Their Sociological and Educational Status.* Stanford: University of Stanford Press.
Apassingok, A., W. Walunga, and E. Tennant. 1985. *Lore of St. Lawrence Island: Echoes of Our Eskimo Elders, Vol. I: Gambell.* Unalakleet: Bering Strait School District.
Barfield, L. 1994. "The Iceman Reviewed." *Antiquity* 68: 10-26.
Birket-Smith, K. 1953. The Chugach Eskimo. *Nationalmuseets Skrifter, Etnografisk Raekke* 6. Copenhagen.
Boas, F. 1901-07. The Eskimo of Baffin Land and Hudson Bay. *Bulletin of the American Museum of Natural History* 15. New York.
Bogojavlensky, S. 1969. *Imaangmiut Eskimo Careers: Skinboats in Bering Strait.* (Unpublished Ph.D. Dissertation in Social Relations, Harvard University, Cambridge, Mass.)
Bogoras, W. (also Bogoraz, V.G.) 1904-1909. The Chukchee. *The Jesup North Pacific Expedition 7, Memoirs of the American Museum of Natural History.* New York.
Chamisso, A. von. 1986 (1836), *A Voyage Around the World with the Romanzov Exploring Expedition in the Years 1815-1818 in the Brig Rurik.* (H. Kratz, trans. and ed., reprinted 1986. Honolulu: University of Hawaii Press).
Chu, L.S.W., S.D.J. Yeh, and D.D. Wood. 1979. *Acupuncture Manual: A Western Approach.* New York: Marcel Dekker, Inc.
Coe, R.T. 1976. *Sacred Circles: Two Thousand Years of North American Indian Art.* Arts Council of Great Britain. London: Lund Humphries.
Collins, H.B., Jr. 1929. "Prehistoric Art of the Alaskan Eskimo." *Smithsonian Miscellaneous Collections* 81(14): 1-52.
Collins, H.B., Jr. 1930. "Notebook A." Unpublished Fieldnotes from the H.B. Collins Collection, Box 45, St. Lawrence Island. National Anthropological Archives, National Museum of Natural History, Smithsonian Institution. Washington.
Compilation. 1981. *Essentials of Chinese Acupuncture.* Oxford: Pergamon Press.
Coughlan, A. 1994. "Alpine Iceman Was a Martyr to Arthritis." *New Scientist* 144 (1956): 10.
Driscoll, B. 1987. "The Inuit Parka as an Artistic Tradition." Pp. 170-200 in *The Spirit Sings: Artistic Traditions of Canada's First Peoples,*.(D.F. Cameron, ed.), Toronto: McClelland and Stewart.
Fitzhugh, W.W. and S.A. Kaplan. 1982. *Inua: Spirit World of the Bering Sea Eskimo.* Washington: Smithsonian Institution Press.

Fortuine, R. 1985. "Lancets of Stone: Traditional Methods of Surgery Among the Alaska Natives." *Arctic Anthropology* 22(1): 23-45.

Gordon, G.B. 1906. Notes for the Western Eskimo. *Transactions of the Department of Archaeology, Free Museum of Science and Art* 2(1): 69-101. Field Notes. On File, Alaska and Polar Regions Archives, University of Alaska, Fairbanks.

Geist, O.W. 1927-34. Field Notes. On File, Alaska and Polar Regions Archives, University of Alaska, Fairbanks.

Gilder, W.H. 1881. *Schwatka's Search: Sledging in the Arctic in Quest of the Franklin Records.* New York: Charles Scribner's Sons.

Gordon, G.B. 1906. "Notes on the Western Eskimo." *Transactions of the Department of Archaeology, Free Museum of Science and Art,* 2(1): 69-101. Philadelphia.

Hakluyt, R. 1907-1910 [1589]. *Principal Navigations, Voyages, etc. of the English Nation.* 8 vols. New York: E.P. Dutton.

Harrington, R. 1981. *The Inuit: Life As It Was.* Edmonton: Hurtig Publishers Ltd.

Hawkes, E.W. n.d. "Notes on the Asiatic Eskimo." Unpublished notes from the Bogoras Papers, Box 131-F-4, fldr. E. 1.1 New York City Public Library.

Holm, G.F. 1914. "Ethnological Sketch of the Angmagsalik Eskimo." *Meddelelser om Grønland* 141 (1-2). Copenhagen.

Hughes, C.C. 1959. "Translation of I.K. Voblov's 'Eskimo Ceremonies.'" *Anthropological Papers of the University of Alaska* 7(2): 71-90.

Hughes, C.C. 1960. *An Eskimo Village in the Modern World.* Ithaca: Cornell University Press.

Kapel, H., N. Kronmann, F. Mikkelsen, and E.L. Rosenlov. 1991. "Tattooing." Pp. 102-115 in *The Greenland Mummies,* (J.P.H. Hansen, J. Meldgaard, J. Nordqvist, eds.) Published for the Trustees of the British Museum. London: British Museum Publications.

Kaplan, S.A. 1983. *Spirit Keepers of the North: Eskimos of Western Alaska* University Museum Publication. Philadelphia: University of Pennsylvania Press.

Krutak, L. 1998. *One Stitch at a Time: Ivalu and Sivuqaq Tattoo.* (Unpublished Master's Thesis in Anthropology, University of Alaska Fairbanks, Fairbanks, Alaska).

Krutak, L. 1998. "St. Lawrence Island Yupik Tattoo: Body Modification and the Symbolic Articulation of Society." *Chicago Anthropology Exchange* 27: 54-82. Winter.

Krutak, L. 1999. "Im Zeichen des Wals." *Tätowier Magazin* 5(39): 52-56.

Krutak, L. 1999. "St. Lawrence Island Joint-Tattooing: Spiritual/Medicinal Functions and Intercontinental Possibilities." *Études/Inuit/Studies* 23(1-2): 229-252.

Lantis, M. 1984. "Aleut." Pp. 161-184 in Arctic (*Handbook of the North American Indians,* vol. 5, D. Damas, ed.). Washington: Smithsonian Institution.

Leighton, D. 1982. Field Notes (1940) of Dorothea Leighton and Alexander Leighton. On file in the archives of the University of Alaska, Fairbanks.

Marsh, G.H. and W.S. Laughlin. 1956. "Human Anatomical Knowledge Among the Aleutian Islanders." *Southwestern Journal of Anthropology* 12(1): 38-78.

McGhee, R. 1996. *Ancient People of the Arctic.* Vancouver: University of British Columbia Press.

Nelson, E.W. 1899. The Eskimo About Bering Strait. Pp. 3-518 in *18th Annual Report of the Bureau of American Ethnology for the Years 1896-1897.* Washington.

Neuman, D.S. 1917. "Tattooing on St. Lawrence Island." *The Eskimo,* 1(11): 5. Nome.

Petersen, R. 1996. "Body and Soul in Ancient Greenlandic Religion." Pp. 67-78 in *Shamanism and Northern Ecology,* (J. Pentikainen, ed.) Berlin: Mouton de Gruyter.

Reuters. 1998. "Iceman May Be First Patient of Treatment: Ancient Acupuncture." http://abcnews.go.com.

Rudenko, S.I. 1949. "Tatuirovka aziatskikh eskimosov." *Sovetskaia etnografiia* 14: 149-154.

Rudenko, S.I. 1970. *Frozen Tombs of Siberia: The Pazyryk Burials of Iron Age Horsemen* (M.W. Thompson, trans.). Berkeley: University of California Press.

Scheper-Hughes, N. and M. Lock. 1987. "The Mindful Body: A Prolegomenon to Future Work in Medical Anthropology." *Medical Anthropological Quarterly* 1: 6-41.

Schuster, C. 1951. "Joint-Marks: A Possible Index of Cultural Contact Between America, Oceania and the Far East." *Koninklijk voor Tropen, Medeleling* 44, *Afdeling Culturale en Physiche Anthropologie* 39: 3-51.

Schuster, C. 1952. "V-Shaped Chest Markings: Distribution of a Design-Motive in and Around the Pacific." *Anthropos* 47: 99-118.

Silook, P. 1940. "Life Story" and "Tattooe of Man." Unpublished Notes from the Dorothea C. Leighton Collection, Box 3, Folder 67 and 68, pp. 103-114, and p. 1-2, archives, University of Alaska, Fairbanks.

Smith, G.S. and R. Zimmerman. 1975. "Tattooing Found on a 1600 Year Old Frozen, Mummified Body from St. Lawrence Island, Alaska." *American Antiquity* 40(4): 433-437.

Spencer, R.F. 1959. The North Alaskan Eskimo: A Study in Ecology and Society. *Bureau of American Ethnology Bulletin* 171. Washington.

Spindler, K. 1994. *The Man in the Ice: The Discovery of a 5,000-Year-Old Body Reveals the Secrets of the Stone Age* (E. Osers, trans.) New York: Harmony Books.

Stevenson, A. 1967. "Telltale Tattoos." *North* 14(6): 37-43.

Taylor, J.G. 1984. "Historical Ethnography of the Labrador Coast." Pp. 508-521 in Arctic (*Handbook of the North American Indians,* vol. 5, D. Damas, ed.) Washington: Smithsonian Institution.

Turner, L.M. 1887. *Ethnological Catalogue of Ethnological Collections made by Lucien M. Turner in Ungava and Labrador, Hudson Bay Territory, June 24, 1882 to October 1, 1884.* Prepared for the U.S. National Museum, May 1887. Smithsonian Institution Archives. Washington.

Wardwell, A. 1986. *Ancient Eskimo Ivories of the Bering Strait.* New York: Hudson Hills Press.

Weyer, E.M., Jr. 1932. *The Eskimos: Their Environment and Folkways.* New Haven: Yale University Press.

INDEX

MAGNETS FOR MISERY
TRAILER PARKS AND AMERICA'S DARK HEART OF WHITENESS
By Mark Van de Walle

Neither city nor country nor suburb, the trailer park is a mad mixture of the most decadent parts of all of the above. A fabulous nightmare about a dream of a man and a plot of land, and the freedom all that brings. The freedom to blow yourself to kingdom come while making crystal meth; the freedom to have affairs with your neighbor's underage daughter; the freedom to have sex with her in the middle of the day on the old couch that marks the place where your porch should be; and the neighbor's freedom to shoot at the two of you with the service .45 he brought back from 'Nam.

With all this freedom going on, the trailer park, of course, has style for miles: black-velvet Elvis paintings and John Wayne bourbon decanters; "Drop Kick Me Through the Goal Posts of Life, Lord Jesus;" and refrigerators that manifest the face of Christ. Which is why the trailer park is the place the UFO visits, the place where all the conspiracies come to roost, where all the gun nuts and religious kooks and drug runners and Angels, Hell's and otherwise, turn up.

In America, all our disasters happen in trailer parks. That's how you know they're disasters—because of the little bits of trailer scattered everywhere. Somewhere along the line, through a gradual process of accretion, through years of accident piled on mishap piled on dumb tragedy, trailer homes have been transformed from cheap, efficient, ready-made housing into something that is practically synonymous with every imaginable kind of disaster.

So whenever there's a flood, a hurricane, a twister, there's a string of massacred trailers left behind to mark its passage. Where trouble goes, footage of some poor bastard standing in front of the hole where his double-wide used to be is soon to follow. In short, trailer parks have become magnets, and as such, magnets for misery, a dark reflection of the (white) American Dream, indeed, of Whiteness, period.

Mark Van de Walle is a freelance writer in New York whose work has appeared in many publications including *Artforum* and *Travel & Leisure*. He has extensive skill in first-person shooter video games.

MAGNETS FOR MISERY

TRAILER PARKS AND AMERICA'S DARK HEART OF WHITENESS

Mark Van de Walle

TRAILER PARK LIVING/AMERICANA/POP CULTURE
Paperback, 7.25 x 9.5 inches, 150 pages, some photos
ISBN 1-890451-08-8 **$19.99**
(Cnd $30.99)

JUNO CATALOG

New Reprints!

PERFORMANCE ART/EROTICA/DISABILITIES
Paperback, 8.5 x 11 inches, 126 pages, lots of photos
ISBN 1-890451-09-6 **$16.99**
(Cnd $26.99)

BOB FLANAGAN
SUPERMASOCHIST
Interviews by A. Juno
New epilogue by Sheree Rose

Bob Flanagan (1952-1997) grew up with Cystic Fibrosis (a genetically inherited, nearly-always fatal disease) and lived longer than any other person with CF. The physical pain of his childhood was alleviated by masturbation and sexual experimentation, resulting in his life-long practice of extreme masochism.

In BOB FLANAGAN: SUPERMASOCHIST, the only book in existence on this amazing individual, Flanagan reveals, in deeply confessional interviews, his life story and sexual practices, and his extraordinary relationship with his long-term partner and mistress, photographer Sheree Rose. He tells how frequent near-death encounters modified his concepts of gratification and abstinence, reward and punishment, and intensified his masochistic drive. Through his insider's perspective on the various S/M communities, we learn firsthand about branding, piercing, whipping, bondage, and endurance trials. Surprisingly, the most extreme narratives are infused with humor, honesty, and self-reflective irony. Bob's sharp intelligence and lack of pretense belie a deep commitment to deciphering philosophical issues regarding body, power, sex, life, and death.

Bob Flanagan was the subject matter for the critically acclaimed film documentary *Sick*, winner of the Sundance Jury Award. A noted poet from the Los Angeles "Beyond Baroque" literary scene that included Dennis Cooper, David Trinidad, and others, Flanagan was also a celebrated performance artist who appeared at institutional venues in San Francisco, New York, and Los Angeles. A retrospective of his work—replete with a bed-ridden Flanagan suspended by his testicles—was mounted by The New Museum of Contemporary Art, New York in the fall of 1995, and met with wide acclaim.

This long-awaited reprint contains updated interviews, a new epilogue, and new photos by Sheree Rose.

"Bob Flanagan is our Virgil in this personal hell. His frank interviews… offer an eloquent tour through the psychic terrain of Sadomasochism, discussing the most severe sexual diversions with the humorous detachment of a shy, clean-living nerd. I came away from this book wanting to know this man."
　　　　　　　　　　　　　　　　—*Details*

New Reprints!

THE TORTURE GARDEN
By Octave Mirbeau

Translation by Alvah C. Bessie

Following the twin trails of desire and depravity to a shocking, sadistic paradise—a garden in China where torture is practiced as an art form—a dissolute Frenchman discovers the true depths of degradation beyond his prior bourgeois imaginings. Entranced by a resolute Englishwoman whose capacity for debauchery knows no bounds, he capitulates to her every whim amid an ecstatic yet tormenting incursion of visions, scents, caresses, pleasures, horrors, and fantastic atrocities.

THE TORTURE GARDEN is exceptional for its detailed descriptions of sexual euphoria and exquisite torture, its political critique of government corruption and bureaucracy, and its revolutionary portrait of a woman—which challenges even contemporary models of feminine authority. This is one of the most truly original works ever imagined. Beyond providing richly poetic experience, it will stimulate anyone interested in the always-contemporary problem of the limits of experience and sensation. As part of the continuing struggle against censorship and especially self-censorship, it will remain a landmark in the fight against all that would suppress the creation of a far freer world.

Written in 1899, this fabulously rare novel was once described as "the most sickening work of art of the 19th century."

Octave Mirbeau (1850-1917) was an exceptional writer who combined intensity of vision with a lifelong commitment to attacking arbitrary, unjust authority. As a journalist, Mirbeau railed against conservative art and political opinions as well as hypocritical public figures—which caused him to fight numerous duels. Till the end of his long career as a critic, novelist, and playwright, he was dedicated to permanent, sardonic, and vociferous rebellion against the status quo. He and his wife, a former actress and herself a luminary of wit and independence, held host to some of the most radical artists and writers of the day. After his death, she made their estate a retreat and haven for indigent writers, artists, poets, and sculptors possessing dreams and visions but little else.

FICTION/EROTICA/FEMINISM
Paperback, 8 x 11 inches, 175 pages
ISBN 0-9651042-6-5 **$12.99**
(Cnd $19.99)

"Alas, the gates of life never swing open except upon death, never open except upon the palaces and gardens of death. And the universe appears to me like an immense, inexorable torture-garden….What I say today, and what I heard, exists and cries and howls beyond this garden, which is no more than a symbol to me of the entire earth."
—Octave Mirbeau

Bestsellers!

DEVIANT DESIRES
Incredibly Strange Sex!
By Katharine Gates

DEVIANT DESIRES is a lavishly illustrated guide to the most fascinating and decidedly obscure outposts of the immensely diverse sexual subcultures found today in our own backyards. Self-described pervert Katharine Gates takes us on an anthropological expedition, investigating the origins and practices of fanatically precise fetishes and po-mo eroticisms.

"My friend Annie Sprinkle's partner in crime, Katharine Gates, has just written a book called DEVIANT DESIRES, published by the same woman who did RE/Search publications back when. **I cannot put it down**, or actually, that's not true. I HAVE to put it down after a few pages and just walk around with my mind blown for a while until I'm ready to go on.

"…[W]hen you read the interviews and Katharine's insightful observations, it is so insightful about how 'sex' is, so unstereotypical, that before you get very far, you start recognizing all these fetishist feelings inside yourself…. **It is literally the most erotically AND theoretically interesting sex book I've read in ages**. I think it should be covered on the front page of *The New York Times*."

—Susie Bright, on *www.susiebright.com*

EROTICA/SELF HELP/GENDER STUDIES
Paperback, 8.5 x 11 inches, 200 pages, lots of pictures
ISBN 1-890451-03-7 **$24.99**
(Cnd $38.99)

Katharine Gates has her own publishing company, Gates of Heck. She has worked extensively with Annie Sprinkle and other sexual pioneers. She studied anthropology at Yale University. She lives in New York City.

HOT RODS/TV & FILM/MUSIC
Paperback, 8 x 10 inches, 176 pages, with a lot of pictures
ISBN 0–9651042-9-X **$20.99**
(Cnd $32.99)

DRIVING ME WILD
Nitro-Powered Outlaw Culture
By Leah M. Kerr

"Definitely the most comprehensive documentary/retrospective on everything relative to the hopped-up internal combustion scene…. Leah M. Kerr should be credited with going out of her way to carefully research and record all the facets related to hot rodding….The faint at heart beware, 'cause this ain't your granddad's classic car book. Get ready for tattooed greasers, lowbrow at its best, and some of the finest from the photo archives of hot rodding and drag racing's legendary lensmen. Also included in the 175-page thriller: famous customizers, hot rod music, juvenile delinquent films, and even a chapter on women and minorities who push the sport of racing into the future."

—*Street Rodder*

"Wacky, accurate, unusual, historic, all of these describe the contents of DRIVING ME WILD….It is a must-read for the younger set and an interesting treatise for us older types. Kerr has done a terrific job of melding all things that we drag race fanatics hold dear, and she's done it with style. Buy one. Heck, do your friends, coworkers, and family a favor and buy one for them, too."

—*Drag Racer*

Leah M. Kerr is a screenwriter living in Los Angeles. She loves fast cars, especially those running on nitromethane.

www.JunoBooks.com